Wisdom With Understanding is Better Than Rubies

Lurine Karon Greenberg Fine Arts Collection

SIGNORELLI AND FRA ANGELICO AT ORVIETO

Distant panorama
of Orvieto (E.
Caroli, Orvieto)

Signorelli and Fra Angelico at Orvieto:
Liturgy, Poetry and a Vision of the End-time is published in the series
HISTORIES OF VISION
edited by Caroline van Eck, Vrije Universiteit, Amsterdam

Images are cultural constructions with their own poetics and histories,
but so is vision itself. The aim of this series is to reconstruct these histories.
It will be devoted to the study of works of art considered as ways of seeing,
viewing practices, and the various codifications of visual perception
connected with the arts and artistic theories through the ages.

IN THE SAME SERIES

The Web of Images
Vernacular Preaching from its Origins to Saint Bernardino of Siena
Lina Bolzoni

Sacred Traces
British Explorations of Buddhism in South Asia
Janice Leoshko

Jörg Breu the Elder
Art, Culture, and Belief in Reformation Augsburg
Andrew Morrall

Sara Nair James

Signorelli and Fra Angelico at Orvieto

Liturgy, Poetry and a Vision of the End-time

ASHGATE

© Sara Nair James, 2003

Published by
Ashgate Publishing Limited
Gower House
Croft Road
Aldershot
Hants GU11 3HR
England

Ashgate Publishing Company
Suite 420
101 Cherry Street
Burlington, VT 05401-4405
USA

Ashgate website: http://www.ashgate.com

British Library Cataloguing-in-Publication Data

James, Sara Nair
 Signorelli and Fra Angelico at Orvieto: Liturgy, Poetry and a Vision of the End Time – (Histories of Vision).
 1. Signorelli, Luca 1441–1523—Criticism and interpretation. 2. Angelico, fra, ca. 1400–1455—Criticism and interpretation. 3. Capella della Madonna di San Brizio (Duomo di Orvieto). 4. Mural Painting and decoration, Renaissance—Italy—Orvieto. 5. Visions in art. 6. Judgement Day in art. I. Title.
 759.5′0922

Library of Congress Cataloging-in Publication Data

James, Sara Nair
 Signorelli and Fra Angelico at Orvieto: Liturgy, Poetry and a Vision of the End Time / Sara Nair James.
 p. cm. – (Histories of Vision)
 Includes bibliographical references and index.
 1. Signorelli, Luca, 1441?–1523. End of the world.a. 2. Signorelli Luca, 1441?–1523—Criticism and interpretation. 3. Angelico, fra, ca. 1400–1455—Criticism and interpretation. 4. Mural painting and decoration, Italian—Italy—Orvieto. 5. Mural painting and decoration, Renaissance—Italy—Orvieto. 6. Judgment Day in art. 7. Cappella della Madonna di Brizio (Duomo di Orvieto). I. Title. II. Series.
 ND623.S5A66 2003
 751.7′3′0945652–dc21 2002043969

ISBN 0 7546 0813 1

Printed on acid-free paper

Typeset in Palatino by Manton Typesetters, Louth, Lincolnshire, UK and printed in Great Britain by Biddles Ltd, Guildford and King's Lynn.

Contents

With appreciation for their unflagging support and encouragement,
I dedicate this book to

Paul Barolsky,
who served as my Virgil

and

my children,
Stewart, Brooks, Margaret and Clark Laster,
who gave me levity

List of Illustrations

9 Wisdom and Eloquence: Signorelli as Renaissance Painter–Poet–Theologian

Colour plates

Preface

We are like dwarfs mounted on the shoulders of giants, so that although we perceive
more and at a further distance than they, not by virtue of any sharpness of our own
sight or the magnitude of our own stature, but because we are sustained and
elevated by their gigantic greatness.

(Bernard of Chartres (d. *c*.1130))

My journey with Luca Signorelli rests on a foundation laid by many. A
seminar paper on Michelangelo's *Last Judgment* in 1976 for the late Professor
Marjory Strauss at Old Dominion University first roused my curiosity about
Signorelli's important precedent. The idea of these paintings as a topic for
serious research, however, stems from a thoughtful remark by Professor
David Summers at the University of Virginia during a conversation in the
fall of 1989 related to his seminar on Michelangelo. He suggested that
Signorelli's important fresco cycle at Orvieto was largely overlooked, and
that perhaps I might investigate it. He was indeed right. Even in the face of
the recent surge of interest, the topic has proven to be rich, first as a
dissertation and now as a book. Professors Summers and Paul Barolsky
guided my research and helped me refine my thoughts. In addition, Professor
John Yiannias introduced me to the complex rhetoric of Byzantine fresco
cycles, a methodology that carries over into Italian examples.

I first experienced Signorelli's frescoes in the summer of 1990, but not in
the manner that I had expected. I arrived in the Piazza del Duomo, stunned
by the beauty of the cathedral and eager to see Signorelli's work. Once
inside the cathedral, I experienced a warm golden light streaming in from
the alabaster and stained glass windows along the south side of the nave;
the Cappella Nuova (or San Brizio), which fills the south transept, presented
a sharp contrast. I found the chapel dark, filled with scaffolding and the iron
gates chained shut with a sign I have learned to anticipate at Italian sites: 'In
restauro'. My heart sank. Over the next few days, dott. Lucio Riccetti, then
the archivist at the Opera del Duomo, arranged for me enter the chapel,
climb the scaffold and observe the restoration in progress. Seeing Signorelli's
and Fra Angelico's figures so closely that I could detect fingerprints in the
plaster and decorative wax was one of the greatest thrills of my art history
career. I returned to the scaffold during three subsequent visits, thanks again
to dott. Riccetti. In July 1997, I stood in the chapel with University of Virginia
colleague Dominique Surh and my sister Janet James, this time experiencing
the full view of the newly cleaned and scaffold-free chapel. Over the next
few days, dott. Riccetti arranged for me to enter the chapel, climb the scaffold
and observe the restoration in progress, which was a great privilege.

In reworking my dissertation into a book, I am grateful for the guidance and confidence of Paul Barolsky and my editors at Ashgate Publishing, Pamela Edwardes of London and Dr Caroline van Eck of Amsterdam. Their suggestions have strengthened this book immeasurably. Alan Bartram, Kirsten Weissenberg and Lucinda Lax have beautifully designed and orchestrated the book. One could hardly wish for a more competent or gracious publishing staff. In addition, Dr Gloria Kury gave advice, shared her research and generously contributed a large collection of photographs, including most of the black-and-white images in this book.

Faculty development funds from Mary Baldwin College and travel grants from the McIntire Department of Art of the University of Virginia and the Samuel H. Kress Foundation of New York supported my research. I am grateful to Dr Cynthia Tyson, President of Mary Baldwin College, and Dr James Lott and Dr Jeffrey Buller, past and current Deans of the College, for encouraging research and for granting me sabbatical leave for the academic year 1999–2000. I am grateful to Professor Lester Little, Director of the American Academy in Rome, for the opportunity to be a part of that stimulating community during the winter of 2000.

In Orvieto, I wish to thank dott. professore Romolo Tiberi and dott. Aldo Mattioni, who both served as Presidente dell'Opera del Duomo, Carla Bertorello, Raffaele Davanzo, Don Luigi Farnesi, dott. Lucio Riccetti, Monsignor Eraldo Rosatelli and dottssa Giusi Testa for granting me access to photographs, archives and works of art in storage, and for arranging visits to the chapel during restoration. I also thank the staffs of the Opera del Duomo, the Archivio del Duomo, the Archivio di Stato, the Archivio Vescovile and the Biblioteca Pubblica.

Many librarians have assisted me, including those at the Rosenwald Collection at the Library of Congress, the Library of the National Gallery of Art in Washington, DC, the Vatican Library, the École Française and the American Academy in Rome and the Kunsthistorisches Institut in Florence. Librarians at Mary Baldwin College and the University of Virginia were especially helpful with interlibrary loan requests. I am grateful to the Gabinetto dei Disegni at the Uffizi in Florence for allowing me to study Signorelli's drawings.

The research, ideas and assistance from many additional scholars have strengthened my work. They include: Diane Cole Ahl, Fletcher Collins, Jr, Father Justin Cunningham, O.P., Ulysse Desportes, Mary Tuck Echols, Virginia Francisco, Lawrence O. Goedde, Anthony Grafton, Hampton Hairfield, Tom Henry, Liana Di Girolami Cheney, Laurence Kanter, Gloria Kury, Sarah Kennedy, Deeana Klepper, Anne McGovern, Dugald McLellan, Mark P. O. Morford, April Oettinger, Sarah Hardison O'Connor, Dominique Suhr, Carol Taylor, William M. Voelkle, Carroll William Westfall and the late Marjory Strauss. Mentors whom I have not met, but whose insightful scholarship formed the foundation for my efforts, include Carol Lewine, Henry Maguire and John O'Malley. S. J. Susan Payne and Maureen Litchfield refined the line drawings and Lydia Petersson sought grants and research opportunities.

On a personal level, my sister Janet, as well as dear friends Bridget and Peter Rowe, adroitly chauffeured me to Italian towns, including Orvieto, to seek out Signorelli and his contemporaries in museums and churches. Finally, my children, Stewart, Brooks, Margaret and Clark Laster, have embraced Signorelli as a family member. They gave me the space to pursue this project, sometimes at considerable sacrifice. Two of them were rewarded with a view of the frescoes from the scaffold. Without the support and encouragement of family, cordial citizens of Orvieto and dear friends who have graciously tolerated my enthusiasm as well as my frustrations, this project would have been impossible.

The Feast of All Saints
1 November 2002
Gospel Hill
Staunton, Virginia

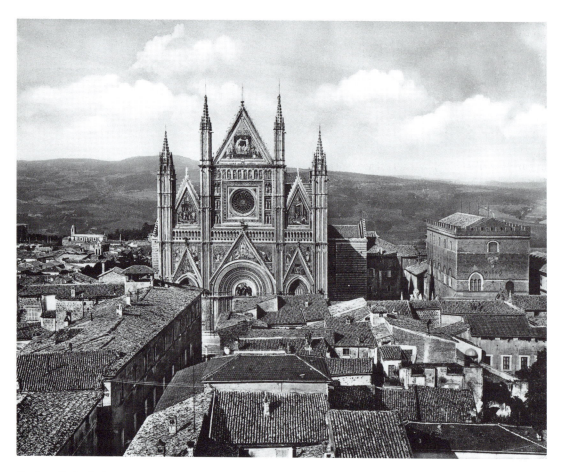

Orvieto Cathedral
exterior and city.
The Papal Palaces
lie to the south
(right) and east of
the cathedral
(Archivio Photos
Moretti, Orvieto)

Introduction

In early April of 1499, with the fresco season fast approaching, the Opera del Duomo of Orvieto, the lay governing body of the cathedral, entered into a contract with Luca Signorelli to complete the decoration of the south vault of the Cappella Nuova (as they called the Chapel of San Brizio), a project left unfinished by Fra Angelico in 1447.[1] Five years and two additional contracts later, Signorelli left as his legacy his masterwork and one of the most celebrated fresco programs of his day, one that stands as a watershed between the Early and High Renaissance in style, format and iconography. In designing the program, Signorelli eloquently balanced the confines of the architectural space and the demands of the commission – stylistic and programmatic – with his own serious yet promising, traditional and yet fresh, vision of the End-time. With larger, more vivid figures, more complex compositions and more multifaceted subject-matter, Signorelli's vision assumed unprecedented epic proportions. At Orvieto, Signorelli departed from the decorum and restraint characteristic of late quattrocento painting and ventured into uncharted waters, looking to grander models than those that had inspired his contemporaries.

A half-century later, Giorgio Vasari, with praise, noted that Signorelli played a seminal role in the formation of the High Renaissance style. He cited the frescoes at Orvieto as the most compelling evidence of Signorelli's innovations and described them as 'possessing bizarre and fantastic inventions'.[2] Beyond issues of style, however, Signorelli's inventions have been less understood. Yet, I have found the underlying issues of iconography, texts, theory and arrangement of the paintings to be the most compelling aspects of the program; here, I believe, lies the heart of Signorelli's vision.

In the vaults of the Cappella Nuova, poised over the altar amid heavenly hosts, prophets, patriarchs, apostles and saints, Christ initiates the final judgment on humanity. Beneath the celestial court, Signorelli's vision of judgment extends into the lunettes on the upper walls of the south bay (Pls 2–5). On the altar wall, *The Ascent of the Blessed to Heaven* is juxtaposed with *The Damned Led to Hell*. The adjacent lunettes on the side walls include *The Blessed in Paradise* on the viewer's left, facing *The Torture of the Damned* on the right. Events from the Apocalypse fill the corresponding spaces in the north bay. Turning to face the entrance, the viewer encounters *The Rule of the Antichrist* in the lunette on the right, adjoining *The Blessed in Paradise*. Moving counterclockwise from *The Rule of the Antichrist*, *Doomsday* arches over the entrance and *The Resurrection of the Dead* fills the lunette on the left, adjacent to *The Torture of the Damned*. With a disquieting sense of immediacy, Signorelli's

dynamic, monumental figures dramatically bring the events of Apocalypse and Judgment to life.

Overwhelmed by the colossal figures in the vaults and upper walls, it is easy to overlook the subtle treasures tucked into the gilded panels of the lower walls (or socle); yet, Signorelli's innovations here are equally inventive and considerably more subtle. In a radical break with tradition, the artist abandoned the tradition of imitating marble revetment or tapestries on the lower walls. Instead, he heightened the lower walls, divided it into sections and extended the already monumental program into that space (Pl. 9). Elaborate fields of rich, imaginative vegetal decoration, or *grotteschi*, surround portraits of authors flanked by literary scenes from both Dante and classical works that comment poetically on the theology of his principal narratives (Pl. 1). The literary scenes, painted in blue grisaille (monochrome), illustrate literary texts that are mainly drawn from Dante's *Divine Comedy*, the *Metamorphoses* of Ovid and Virgil's *Aeneid*. Finally, two burial *cappelline*, or little chapels, fill recesses in the facing walls of the north bay. No previous fresco cycle, as far as I am aware, includes religious and poetic scenes so juxtaposed, not to mention so completely interrelated; yet this fascinating and fundamental aspect of the program has not been recognized.[3]

Viewing the frescoes as a unified program, and questioning why Signorelli assembled these particular scenes and from what sources, reveals a complex, long-forgotten plan that, I believe, governed the choice, arrangement and meaning of the paintings in the Cappella Nuova. The intention of these paintings lies deeper than presenting narrative. Although associations between these frescoes and isolated liturgical sources have been recognized, no one has systematically investigated the importance of the Roman liturgy as a primary organizing force for the fresco program.[4] Looking at the cycle as an entirety and following liturgical clues, beginning with the words from the hymn *Te Deum laudamus* inscribed in the vaults, shows that the paintings invoke particular parts of the liturgical year: the biblical texts for the Feast of All Saints, Advent and Lent. These texts, along with certain dogmatic issues, are the primary unifying force in the Cappella Nuova. The local medieval dramas for Ognissanti (All Saints) and Corpus Christi, along with several versions of the Antichrist play (the local version is lost) and the well-known and often-referenced thirteenth-century *Golden Legend*, amplify the biblical texts. Additional spaces in the cathedral, especially the facing the Cappella Corporale and the tribune, reflect other favored liturgies. These spaces support each other in meaningful ways.

The idea that liturgy and rhetorical devices establish the choice and arrangement of scenes in artistic programs is not new to art-historical research. Some of the oldest surviving liturgical books include succinct illustrations of the scriptural texts that were read on particular days in the liturgical year. Likewise, since the fourth century, artists in Italy and Byzantium routinely arranged fresco scenes according to an underlying scheme beyond narrative, usually determined by liturgical texts or literary conventions. These arrangements powerfully conveyed a deeper message

to an audience accustomed to interpreting paintings as visual sermons. Recently scholars have begun to realize that such complexity was an accepted, though unspoken and unwritten, part of the artistic tradition.[5] However, no one has, to my knowledge, systematically looked for such a scheme in Signorelli's work.

Among foundational works for this book, Henry Maguire has shown that, liturgical texts as well as rhetorical formulae determined much about Middle Byzantine church decoration.[6] More immediate to the Cappella Nuova, Carol Lewine has successfully demonstrated that the paintings on the lower walls of the Sistine Chapel, in addition to illustrating parallel histories from the lives of Moses and Christ, reflect liturgical texts from Advent to Pentecost, with particular emphasis placed on Lent.[7] Only twenty years before beginning the Cappella Nuova, Signorelli had participated in executing this program. These rich iconographic traditions that permeated medieval and Renaissance mural decoration, drawn from books as well as from mural paintings, inspired Signorelli to new heights at Orvieto. I believe that the sixteenth-century audience – churchmen and the laity, erudite humanists and the illiterate – expected these multifaceted elements, and that they remain the most compelling part of the fresco program.

In addition to liturgical considerations, a penchant for veiled meaning and multiple levels of interpretation characterize medieval and Renaissance literary works and sermons; such rhetorical traits typify contemporary artistic programs as well. When viewed through contemporary humanist practices in manuscript illumination and rhetoric – especially that for poetry and sermons (just as the revival of Thomism emerged triumphant over other theological ideas) – long-forgotten threads emerge which join seemingly disparate scenes into a coherent whole. On another level, although scholars have noted the presence of imagery from Dante's *Divine Comedy*, no one has identified the deeper and more subtle ways in which Renaissance humanism, poetic theology and the poet–theologian Dante guided Signorelli. Finally, again reminiscent of Dante's epic poem, the paintings preach a silent sermon outlining the means to salvation.

The question naturally arises of why no one has uncovered these facets of the program before. Through time, distance and detachment from a handed-down tradition, the once well-understood subtleties of liturgically based fresco programs such as this one quietly slipped into oblivion. Artistic practices, audience expectations and theological emphases have changed since Signorelli completed his work in the heyday of fresco painting in the early sixteenth century. Roman Catholic spirituality shifted emphasis following the Protestant Reformation and the Roman Catholic Counter-Reformational responses and reforms later in the sixteenth century. Art reflects these changes. By the early seventeenth century, typological histories painted across church walls in the laborious, unforgiving medium of fresco lost favor to paintings in oil on canvas. The subtleties of the underlying rhetorical and liturgical themes within these fresco programs, once as captivating as variations on a familiar musical theme, were replaced by large altarpieces

that promoted the sanctity of the Roman sacraments and the primacy of the Roman Church.

Moreover, as illuminated liturgical books were dispersed to libraries and altarpieces were moved out of churches and into museums – facilitating public access and preservation, but sacrificing the original context – the function of the art slipped into oblivion. Immovable objects, such as frescoes, might be known only through reproductions – first engravings and later photographs; thus, individual episodes in fresco programs began to be interpreted as one might consider single framed paintings.[8] A fascination with formal analysis and simple narrative eventually obscured the original implications of the illuminations, altarpieces and chapel decorations, not to mention the understanding of the total experience. These works, however, adorned sacred spaces designed as settings for liturgical ceremonies. They interacted with the liturgy in a symbiotic relationship: the paintings illustrated specific texts, elaborated upon related discourses and reminded the participants of the tenets of their faith; at the same time, the rituals gave the art life and meaning. Orvieto was no exception: form followed function. Bathed in soft natural light and enriched by flickering candles and strains of liturgical music, the paintings embodied the mystery inherent in the ceremonies, an atmosphere now lost to harsh electric spotlights and the cacophonous drone of insensitive crowds.

Liturgy

Today, far removed from the autocratic control of a universal church, many readers are unfamiliar with the Roman liturgy and the related theater productions. Yet, in medieval and Renaissance Europe, the deeply ingrained liturgical calendar determined everyone's life routine. The liturgy, daily and annual, was (and still is) circular. Liturgy divided the day into eight hours for devotions, each with assigned texts. Citations of biblical texts were never random, nor did the officiating priest choose them for didactic purposes. Since the time of the early church, laity and clerics alike associated particular scriptural readings, hymns and prayers with the days on which they were read or with the liturgical hours for which they were appropriate. Day after day and year after year, as predictably as the sun rising and setting or as the seasons recurring, the hours, holy days, readings and hymns repeated in a regular cycle. Although most familiar to the clergy and members of religious orders (which then included a larger percentage of the population), the general population knew (and still know) the liturgical hours, if not from worship, then from the church bells that woke them, sent them to work, brought them home, called them to worship and lulled them to sleep. In rural areas of Europe, large field-side crucifixes near the roadbeds remind passersby of times when fieldworkers and shepherds were summoned to prayer by church bells ringing at regular intervals during the day. This practice continued into the nineteenth century, as is poignantly illustrated in Jean-François Millet's painting *The Angelus* (c. 1858).

The liturgical year begins with the Advent season, the four weeks preceding Christmas, and ends with the Sundays (up to twenty-seven) following the Feast of Pentecost. The last major feast of the liturgical year occurs toward the end of the Pentecost season: the Feast of All Saints, which is celebrated on 1 November and is followed immediately by All Souls' Day, or the Commemoration of the Departed, on 2 November. The date of Easter, always celebrated on a Sunday, recurs on a 'moveable' lunar schedule. Thus the dates of the accompanying seasons and holy days, such as the forty days of Lent that precede Easter, the Ascension forty days after Easter, and Pentecost, two weeks after the Ascension, vary according to the date of Easter. By the time of the Council of Nicaea (325), the assigned readings for Lent, the major Christian fast, dealt with penance and preparation for baptism, which occurred on Easter Eve. Lent ends with the events preceding Easter Sunday. Advent, on the other hand, hinges on the fixed date of Christmas and begins the fourth Sunday before 25 December. The texts for this four-week season, once also a penitential fast, prepare Christians for the coming of Christ, especially the Second Coming.[9]

Over time, the Church added many feasts and holy days other than those celebrating events in the life and ministry of Christ and his faithful followers. For example, the Feast of All Saints was established in Rome in 609, and the Feast of Corpus Christi, celebrated two weeks after Pentecost, began in Italy at Orvieto in 1264. Marian feasts particularly flourished, such as the Feast of the Assumption of the Virgin, celebrated on 15 August. Moreover, each Christian saint has a fixed day (usually the date of martyrdom or death), whether he or she is a local saint, such as local protector saints Faustino and Pietro Parenzo in Orvieto, or major saints, such as John the Baptist and Mary Magdalene.

Choral books, breviaries, lectionaries, missals and other manuals, always organized according to the liturgical year and often lavishly illustrated, contained the liturgical texts. *The Golden Legend*, a thirteenth-century compilation of legends that recounted virtuous deeds of biblical figures and saints, and related theater productions (liturgical dramas), also followed the liturgical calendar. Both the stories and the dramas concurred with and expanded upon the biblical texts cited in the liturgy. The archival library of the Opera del Duomo in Orvieto contains several such fourteenth- and fifteenth-century liturgical books in its archives. Other archives in the city hold texts of local medieval liturgical dramas, or *'rappresentazioni sacre'*, once performed by confraternal players on specific holy days. These texts, which elaborate upon scriptural texts cited in the corresponding liturgy, served as additional source material for artistic programs. In addition to narrating specific liturgical texts, the intensity and immediacy of Signorelli's frescoes reflect – indeed, they enact – liturgical drama. Whereas today's theater audience consciously acknowledges 'make-believe' or commemoration in dramatic productions, for medieval and Renaissance viewers, theatrical performances vividly recreated the historical event in the present, transcending time and space.[10] For those audiences, liturgical drama, like liturgy, presented the past and/or future as a present reality.

As with religious drama, religious art was intended to aid in salvation. Whether a work functioned as a devotional image or an exemplary narrative, it served a purpose beyond decoration. Unlike the transitory nature of theater, art remains ever-present, but usually it seems less immediate. Signorelli's frescoes, however, combine the best of both: omnipresent, they embody that sense of immediacy and renewed reality intended by the players and perceived by the audiences of those liturgical dramas and religious services.

Renaissance humanism and its foundations

In addition to liturgical considerations, Renaissance humanism, invigorated in the middle to late fifteenth century, helped guide Signorelli's bold steps at Orvieto and added deeper dimensions to the program as a whole. Humanist ideas directed the choice of literary texts, both readily recognizable and obscure ones, which inspire the paintings in the socle and informed the eloquent manner in which Signorelli structured the program. Modern scholars acknowledge the classical influence on the style and subject of late fifteenth-century art and architecture; less often do they incorporate the newly revived antique and medieval rhetorical, theological and poetic conventions that also shaped the iconography, structure and arrangement of artistic programs in Italy.[11]

In the fifteenth century, Florence, under the continuing patronage of the Medici family, especially that of Lorenzo 'Il Magnifico' de' Medici, continued to serve as the center of the humanist intellectual movement, as it had for over two centuries. However, by the late fifteenth century, Rome, under the auspices of the resettled papacy, achieved nearly equal status. The accession of theological scholar Sixtus IV to the papal throne, and his mission to confirm the primacy of the papacy and secure its stronghold in Rome, probably accelerated Roman developments.[12] The Roman renewal, led by Florentine Leonardo Bruni, began at the *Studium Urbis*, also called the Sapienza (later the University of Rome).[13] Fellow Florentine architect and writer Leon Battista Alberti also participated in intellectual circles in Rome. Under this and local leadership, humanists began to view classical art and architecture with an archaeological eye and to regard the forum and other ancient remnants as treasures rather than as ruins.[14] They also renewed interest in classical literature. Although the mixing of classical and Christian ideas and motifs in art and literature had been ongoing since ancient times, the tradition was revitalized in the face of archaeological excavations and textual discoveries.

A second humanist intellectual center developed simultaneously in Rome, the papal *studium* of the Roman Curia, also called the 'Studio del Sacro Palazzo', located at the Vatican. The Master of the Sacred Palace, who always came from the ranks of the Dominicans, headed the group and served as official theological advisor to the pope.[15] The duties of these scholars at the Vatican, in addition to serving as arbitrators on matters of official doctrine,

included articulating a *theologia rhetorica* to both affirm perennial truths of Christian doctrine and the important role of the church in salvation and support papal authority. They based their work on the writings of the ancient church fathers, ancient and medieval rhetorical manuals and scholastic theological treatises, especially the clearly articulated, systematic and all-inclusive works of Thomas Aquinas. By the late fifteenth century, after centuries of perseverance by the Dominicans, the *Summa Theologica* of Thomas Aquinas began to supplant the *Sentences* of Peter Lombard as the clearest and most reliable authority on Christian theology.[16] Scholars at the papal court embraced Thomist views on grace, wisdom and hierarchical order, as well as Thomas Aquinas's interest in classical learning.[17]

The Thomist revival represented not so much a change in theology as a clearer way to emphasize and confirm perennial truths. Aquinas's methodology had a foundation in the work of several Parisian scholars, first among them being Hugo of St Victor (d. 1141) (called 'a second Augustine' by his contemporaries and his followers), who led the scholars at the abbey of St Victor, inspiring, among them, Peter Abelard of Chartres (d. 1142). Unlike the otherworldly monastic scholars, such as Bernard of Clairvaux (d. 1153), these men applied grammar and dialectic reasoning to the study of the *sacra pagine* (holy scripture), just as they did to the study of any other subject, developing a clear, precise system. They based their methodology on that of St Augustine's *De Doctrina Christiana* and *Quaestiones in Heptateuchum.* Augustine's models promoted inquisitive investigation and, most important for Signorelli, allegorical interpretation.[18]

In the twelfth and early thirteenth centuries, Parisian scholars Peter Lombard (d. 1164), who was a pupil of Abelard of Chartres, Peter Comestor (died *c.* 1169) and Stephen Langton (d. 1228), among others, continued and expanded this scholastic method. Peter Lombard's *Four Books of Sentences*, in which he attempted to answer biblical questions using patristic writings, served as the standard doctrinal textbook from the twelfth to the late fifteenth century.[19] Peter Comestor had a deep interest in biblical history, as exemplified by his *Historia scholastica*, as well as in rhetoric and liturgy. He emphasized the historical and dramatic qualities of liturgy and noted that liturgical ceremonies vividly reenacted scripture; in fact, Comestor may have participated in early liturgical dramas.[20]

Finally, Stephen Langton systemized the Bible chapters following the order that Hugo of St Victor had suggested (we use his divisions today), wrote glosses of the entire Bible and moralized Ovid, among other things. He also designated certain feast days and seasons as especially appropriate for sermons: the Feast of the Nativity, the Feast of All Saints and Advent.[21] Two of the three feasts that Langton emphasized appear in the iconography of the Cappella Nuova; the third appears, among others, in the earlier fresco cycle of the tribune of Orvieto Cathedral. As a preacher and a teacher, Langton spoke against churchmen who confined themselves to their élite little circles. Instead, he advocated reaching out to the laity as well, stating that the sermon for the clerks was more 'precious', the popular sermon,

'more fertile and useful'.[22] Signorelli and those who advised him understood this directive. Although the iconography in the Cappella Nuova was aimed at an educated audience, Signorelli's paintings still speak to both the 'precious' group and to the populus at large.

In the thirteenth century, the era of St Dominic, Albert the Great and Thomas Aquinas, the Dominicans (the Order of Preachers) embraced and perpetuated scholastic methodology in their expository writing. These academic treatises were meant to clarify doctrinal matters and explain theological truths. The scholastic expositors developed a rigid structure, but at the same time their works became broader and more inventive in content.[23] Among their methods, the scholastics developed a systematic but often esoteric four-fold system of interpretation. These writings incorporated veiled metaphors, or allegory, which became the foundation of textual interpretation, especially in the academic *exposito*. The methodology carried over into Dominican sermons: 'thematic preaching' replaced the simple homily. Rather than target converts through missionary zeal, the preachers' thematic sermons aimed at instructing believers. Preaching manuals gave structural guidance for the sermon and analyzed scripture. Beginning with a biblical passage, the preachers explained its meaning and emphasized moral behavior. Although the public could understand basic principles in the sermons, the Dominicans, and more particularly the masters and doctors among them, simultaneously aimed their sermons toward a sophisticated audience, often clergy or clerks, or what Langton called the 'more precious' group.[24] Step by step, from one proposition to the next, they led the audience through the interpretative process. Ostensibly, Dominicans wished to provide laymen with the tools through which they could work toward salvation. The sermons did not so much appeal to the emotions, in the manner of the sermons of their Franciscan counterparts, but to the intellect.[25] St Bonaventure had spoken of this difference, saying, 'the Preachers [Dominicans] put learning before holiness, the Minors [Franciscans] put holiness before learning'.[26]

Fifteenth-century humanists, including Florentines Pico della Mirandola and Marsilio Ficino, looking back to Aquinas, patristic writings and classical sources, embraced the methodology with a new energy and saw that it offered new possibilities for Christian–Platonist philosophies.[27] By the late fifteenth century, a complex myriad of deeper meanings extending to the minutest details had become a hallmark of Renaissance theological discourse, most evident in sermons. Seemingly antithetically, making the difficult appear facile characterized Renaissance literature as well.[28] Intellectuals valued narrative art, whether literature, sculpture, or painting, not only for style, but also for the brilliance of placing carefully concealed deeper meaning within the subtleties of the story. Along with the complexity, making the difficult appear facile characterizes Renaissance rhetoric, another literary device that carried over into art. Heretofore unnoticed, these literary devices, along with Dominican theology, play an important part in Signorelli's fresco program.

Scholarly foundation and new contributions

Recent scholarly insights broaden our understanding of Signorelli's murals and form the basis for further study. Various analyses explore such issues as style, especially the handling of the monumental nude figure, and important themes, including the scenes from Dante's literature, the Antichrist, the influence of classical sources and the Orvietan context of the paintings.[29] Jonathan Riess argues that the frescoes, dating from the cusp of the millennium and a half (1499–1504) reflect apocalyptic fears.[30] A sense of foreboding is undeniable, but a strict millennial focus not only neglects the lower walls, but also obscures the deeper meanings of the program as a whole.

Several authors have written on scenes from the *Divine Comedy* in the Cappella Nuova, but primarily from a descriptive point of view. Scholars have never satisfactorily explained the deliberate choice to include only illustrations of the first eleven of the thirty-three canti of *Il Purgatorio*; the choice, as I will demonstrate, reflects both liturgical and thematic concerns. As will become evident, Dante served Signorelli as a mentor in a broader sense and in a more subtle manner than previously acknowledged. The artist was less concerned with Dante's work as narrative than with the doctrine that his poem expounded. Even the most obvious references to Dante do not simply glorify the great poet. Rather, they facilitate the overall message of the chapel, a message that, to my knowledge, has not been revealed until now.

Moreover, few scholars have addressed the remaining grisaille scenes in the socle beyond an attempt to identify them – often incorrectly; yet more scenes are included from classical sources than from Dante. Drawn largely from moralized versions of Ovid, these scenes, like those from Dante, contribute to the full meaning of the chapel by reinforcing the message of the frescoes above. Poetic theology in the socle frescoes has been noted, but neither the theme nor the rhetorical conventions behind it have been noted systematically throughout the chapel. Finally, Signorelli's role as an epic poet–theologian has not been fully developed.[31]

The iconographic and compositional scope and complexity of the program, as well as the handling of the monumental nude – all striking aspects of the chapel – were quickly overshadowed by the subsequent achievements of Michelangelo, Raphael and others less than a decade later; but, as has less often been acknowledged, these later accomplishments were dependent on Signorelli.[32] Yet, soon after he completed the Cappella Nuova, Signorelli's art did strongly influence the young Michelangelo in his epic fresco cycle of Creation in the Sistine Chapel and later in his vision of the Last Judgment, and Raphael in his frescoes in the papal apartments of the Vatican, especially in the Stanza della Segnatura. By exploring and developing the issues outlined here, I hope to demonstrate cohesion and a deeper level of meaning by viewing the fresco program as a whole in light of Renaissance humanism, rhetorical practices, and the Roman liturgy. In so doing, I hope this study will not only illuminate the Cappella Nuova but also other programs with similar elements.

Orvieto and the Cathedral

The frescoes in the Cappella Nuova at Orvieto are uniquely Signorelli's and his masterwork; they are uniquely Orvietan as well. The murals reflect the history of the city and the cathedral, the funding of which institution was closely tied to the popes who lived there. Though scholars note that Signorelli's paintings reflect certain contemporary events and customs, Dominican sermons and isolated texts, some previously unmentioned local traditions, humanist scholars, noble families and the local Dominican theological center also helped to mold these frescoes. An examination of major events in Orvietan history from the late eleventh century, when the popes first discovered the city's virtues, to Signorelli's era provides the context for the iconography of the cathedral, and the Cappella Nuova in particular. Furthermore, the historical survey will demonstrate that additional traditions and events influenced the iconography of the chapel. Moreover, Orvieto had a long tradition of ecclesiastical scholarship; in the fifteenth century, a number of European humanists maintained residences there. Thus, in addition to the general populus and devout pilgrims, the audience for which Signorelli planned the Cappella Nuova would have included erudite humanists and churchmen.

An Umbrian city with Etruscan origins, Orvieto commands a magnificent site: a high, steep plateau of volcanic rock, a site easily fortified and virtually impregnable (Frontispiece). The splendid Gothic cathedral crowns the summit, its zebra-striped walls of basalt and travertine and glistening mosaic façade towering above the golden-colored city, built of native tufa (Frontispiece and Fig. 1.1). The cathedral continues to serve its constituents and remains an important pilgrimage site, for the relic from the Miraculous Mass at Bolsena rests there, enshrined in its original fourteenth-century reliquary. Though perhaps not immediately apparent, Signorelli's frescoes reflect the cult of the relic.

The miracle at Bolsena and the relic of the sacred *corporale*

The relic of the bloodstained *corporale*, or altar cloth, from the Miraculous Mass at Bolsena has dominated religious life in Orvieto ever since it arrived in the city. Legend recounts that this miracle of the bleeding host overcame the doubts concerning transubstantiation held by the officiating Bavarian

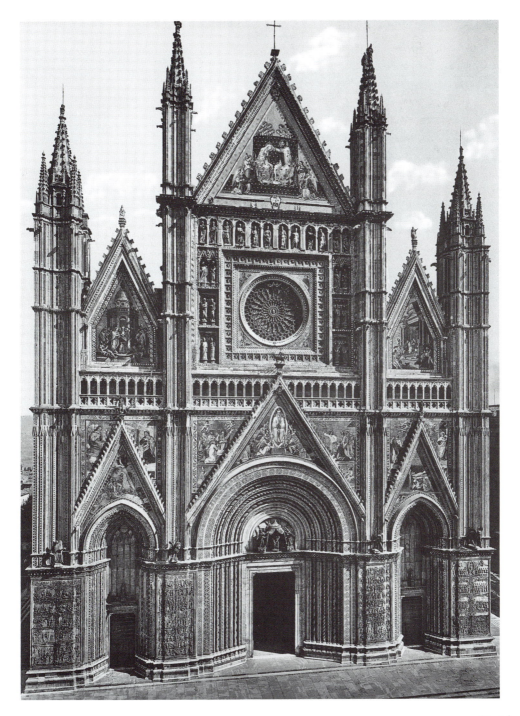

1.1 West façade of
the Cathedral of
Orvieto (Archivio
Photos Moretti,
Orvieto)

1.2 Cappella
Corporale Ugolino
d'Ilario da Orvieto
and Fra Piero di
Puccio 14c. *Pope
Urban IV kneels
before the Relic at the
City Gate* (Archivio
Photos Moretti,
Orvieto)

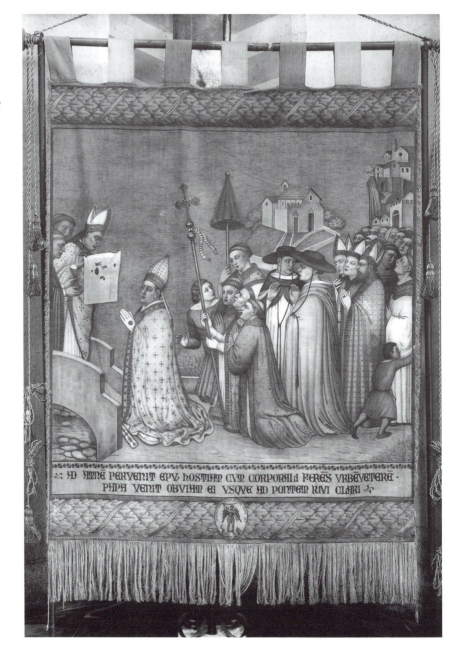

priest, who had stopped over in Bolsena following a pilgrimage to Rome
that had failed to convince him of the real presence of Christ in the Eucharist.
Though no contemporary documents support the story, the fourteenth-
century reliquary, the frescoes in the Cappella Corporale and the
contemporary liturgical drama for Corpus Christi recount the legend.
According to these sources, Pope Urban IV, in residence at nearby Orvieto
in 1263 when the miracle occurred, requested that the *corporale* be brought

to him (Fig. 1.2).[1] He and his retinue, which included Thomas Aquinas and several other Dominicans, allegedly greeted the party with the relic at the city gate, after which Aquinas enthusiastically promoted its veracity. On 11 August 1264, Pope Urban promulgated from Orvieto the bull *Transiturus de hoc mundo* that instituted the Feast of Corpus Domini (Corpus Christi) to honor the gift of the Eucharist and to confirm the doctrine of transubstantiation.[2] At the pope's request, Thomas Aquinas composed the liturgy for the feast.[3] Though probably celebrated in northern Europe first and before the official bull, in Italy the Feast of Corpus Christi was celebrated first at Orvieto.[4] Such affirmation of transubstantiation was especially important to the citizens of Orvieto, who, earlier in the century, had driven Cathar heretics from their city. Among other things, Cathars denied the presence of Christ in the Eucharist and all of the sacraments. Thus, the people of Orvieto and the strong Order of Dominican friars there had a proprietary relation to the relic and the newly sanctioned Feast of Corpus Christi. The celebration of Corpus Christi in Orvieto quickly became an equal partner with, and later superseded, the Feast of the Assumption of the Virgin, to which Orvietans had given special reverence from at least the late twelfth century.[5]

Papal connections and building programs: 1154–1447

Even before the Miraculous Mass at Bolsena, the popes had recognized the virtues of Orvieto. The lofty site made the city an ideal residence for the papal court and an important part of the papal states. From the eleventh century onward, the pope maintained an aggressive political presence in central Italy. Together with his court, he moved from palace to palace in the manner of his northern European secular counterparts, the Holy Roman Emperor and the king of France. Several central Italian cities hosted the pope and his retinue during the years of wandering, housing them in the bishop's palace. Outside Rome, only Orvieto and Viterbo (and eventually Avignon) had papal palaces.[6]

Orvieto rose to prominence for many reasons. First, its proximity to Rome and midway position along the major trade route between Rome and Florence made it convenient. Second, its impregnable site made it safe from invading forces: Orvieto was last conquered in the first century BC by the Romans under Julius Caesar. The complex system of underground tunnels and cellars within the city, only recently given notice,[7] perhaps also contributed to its defense. Third, its Guelf political sympathies insured the papal loyalty of its citizens. Finally, the relatively cool summers due to its elevation, its fresh water supply and healthy atmosphere, not to mention its long-famous white wine, also increased its appeal. Thus Orvieto, along with Viterbo, hosted the pope and his retinue more than other Italian cities, including Rome, from the twelfth to the fifteenth century. After that, the pope and his court no longer traveled, but remained firmly ensconced in the Vatican. However, if a difficult

political situation in Rome made papal flight prudent, Orvieto remained the closest refuge.

The frequent presence of the papal court in Orvieto was a boon to the economy of the city and undoubtedly contributed to the magnificence of the cathedral, which is surprisingly grand for a small city lacking the strong economic base of cities such as Florence and Siena. In the late Middle Ages, as today, the city's population numbered approximately 20,000. Times of papal residence coincide with periods of major activity in the construction and decoration of the cathedral and the Cappella Nuova. Adrian IV (1154–59) was the first pope to spend significant time in Orvieto. His successor, Innocent III (1198–1216), a militant opponent of the Cathar heresy, precipitated a key event in the spiritual life of the city, one that subtly figures in Signorelli's frescoes.[8] In 1199, as the conflict with the Cathars in Orvieto reached crisis level, Innocent appointed Pietro (Pier) Parenzo as city governor with the specific mission of purging Orvieto of the heresy. Soon after, on 21 May 1199, the Cathars murdered him in the city streets. Parenzo was immediately acclaimed a martyr, which fostered a cult, first celebrated with a feast in 1200. In 1215, Pope Innocent III canonized him.[9]

In addition to crusades, Pope Innocent had a second method of fighting heresy: mendicant preachers. Initially the beggar friars, wandering the countryside preaching in imitation of the ministry of Christ, had caused controversy. Did their lifestyle and vow of poverty too closely resemble the method of the Cathars? Would they undermine the monastic system or be an embarrassment to the regal splendor of the papal court? By 1206, Pope Innocent, recognizing their usefulness, sanctioned Francesco of Assisi (St Francis) and Domenico di Calaroga of Spain (St Dominic) and their followers, the Franciscan and Dominican friars, to preach. Pope Honorius III, successor to Innocent, continuing to see the value of converting heretics through nonviolent preaching, confirmed the Dominican Order.[10] Soon after, in 1227, Pope Gregory IX confirmed the Dominican *studium generale* in Orvieto, a school of theology, and one of the first in Europe.[11] Pope Urban IV (1261–64), a Frenchman who was crowned in the Dominican Church in Viterbo and who spent most of his papacy in Orvieto, also left important legacies to the city.[12] In 1263, he began a papal palace, perhaps the first outside Rome, and consecrated the new Dominican Church in Orvieto.[13] In that same year, the Miraculous Mass allegedly occurred in nearby Bolsena, prompting Urban's spiritual legacy to the city.

The new cathedral and the foundations of the iconography

On 15 November 1290, Pope Nicholas IV laid the cornerstone for the present cathedral and dedicated it to the Assumption of the Virgin, a miracle to which the city had a long history of special devotion.[14] A decade later, cathedral authorities called Sienese architect and sculptor Lorenzo Maitani to stabilize the building and design a façade. He enlarged the choir and

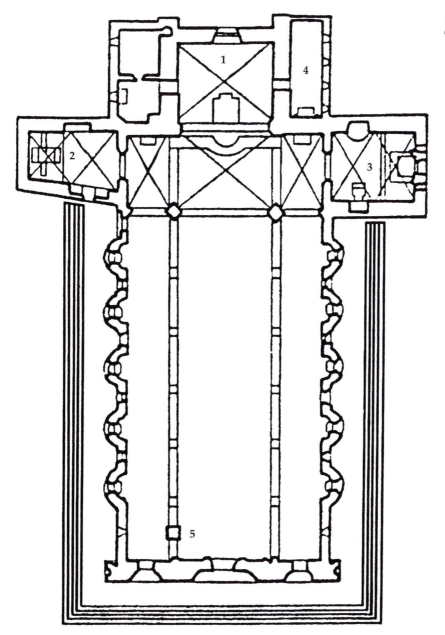

Cathedral cornerstone laid 1290

1. Tribune: reconstructed and painted 1357–64
2. Cappella del Corporale: built 1328–34; painted 1350–56
3. Cappella Nuova: built 1408–44, painting by Fra Angelico: 1447; painting by Luca Signorelli: 1499–1504
4. Library of Antonio Albèri: built and painted 1500–06
5. Baptismal font: 1406, by sculptors Luca di Giovanni and Sano di Matteo

1.4 Lorenzo
Maitani, *Last
Judgment*, southmost
pillar of façade of
the cathedral
(author)

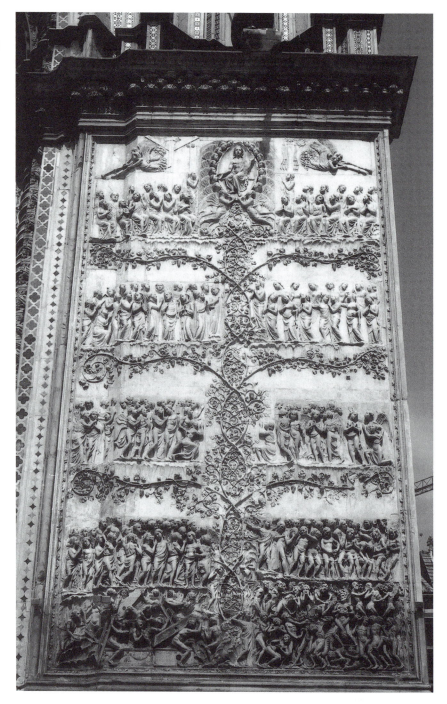

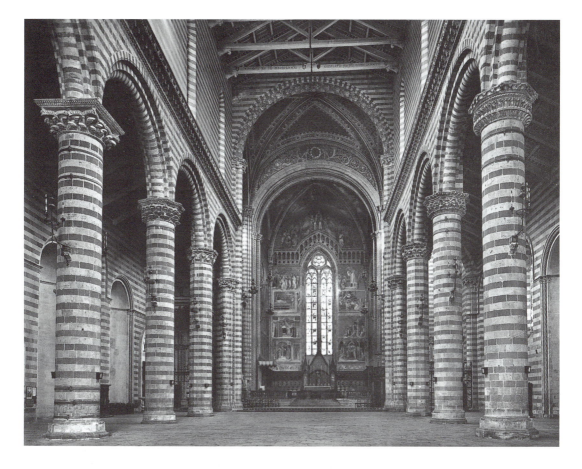

planned a transept with two chapels (*c.* 1308–30), spaces that were not finished until long after his death (Figs 1.3–1.5).

 Situated on higher ground, the Cappella del Corporale (1328–56) in the north received priority, for it would house the venerable *corporale* and its magnificent reliquary. A pair of Orvietan priest–artists, Ugolino di Prete Iliario and Fra Piero di Puccio, painted there the legend of the relic and other miraculous Masses and depicted the Passion and Resurrection of Christ (Fig. 1.6). The decoration culminated in a stained glass window over the altar of the Resurrected Christ. The chapel thus honors the Feast of Corpus Christi, Holy Week, and Easter.[15] The same pair of artists continued in the tribune (1357–64) with an extensive Marian cycle, which honors the dedication of the cathedral to the Assumption of the Virgin (Fig. 1.7). The paintings chronicle her life and recognize all feasts associated with her and the young Christ.[16] Beneath each episode in both fresco programs, the artists included detailed inscriptions, taken from liturgical texts.[17]

 The two-bay Cappella Nuova, planned since the time of the architect Maitani in the early fourteenth century as a south transept to form a pair with the Cappella del Corporale in the north, was built between 1408 and 1444. Constructed between two preexisting buttresses, the new transept absorbed a

1.5 Interior: view of nave to the east (Archivio Photos Moretti, Orvieto)

1.6 View into the Cappella Corporale. Frescoes of the Passion of Christ, Corpus Christi and other miraculous Masses by Ugolino di Prete Iliario da Orvieto and Fra Piero di Puccio (1328–56; north transept) (Archivio Photos Moretti, Orvieto)

sacristy and a chapel dedicated to the Magi previously commissioned by the Monaldeschi family.[18] However, a bequest left by Tommaso di Micheluccio in 1397, a significant gift among many left for a facing chapel in the south transept, specified the dedication of the new chapel to the Assumption of the Virgin.[19] Lancet windows were installed over the altar and round alabaster windows were built into the upper side walls.[20] The space was sufficiently complete by 1425 for the Opera del Duomo to call Bartolomeo di Pietro and Giovenale di Orvieto, a painter and mosaicist respectively, to decorate the vaults.[21] Nothing apparently came of this endeavor, for over twenty years elapsed before documents record further mention of painting for the chapel. The first furnishings arrived in 1446.[22] The following year, the newly elected Nicholas V (1447–55) gave the next papal support to the city, perhaps in remembrance of his namesake's generosity, by allowing Fra Angelico to leave the decoration of his private chapel in the Vatican Palace for the summer of 1447 to begin decorating the Cappella Nuova with frescoes indicating a plan for a Last Judgment. Fra Angelico never finished, but the scaffold remained in place.[23]

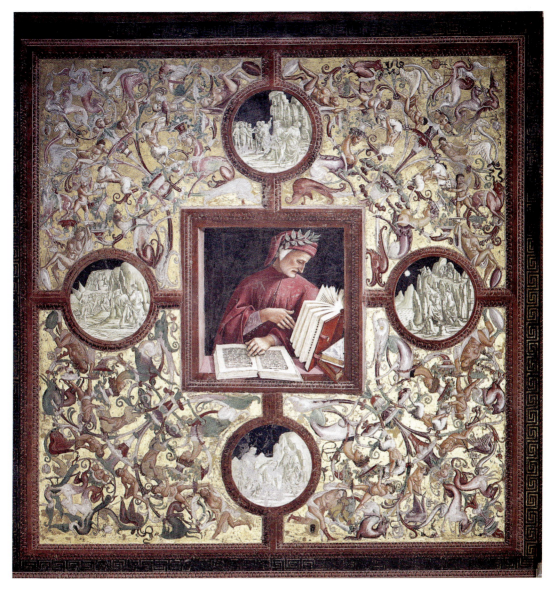

1 Southeast socle, left: Dante with canti I-IV of the Purgatorio (by permission of the
Opera del Duomo of Orvieto)

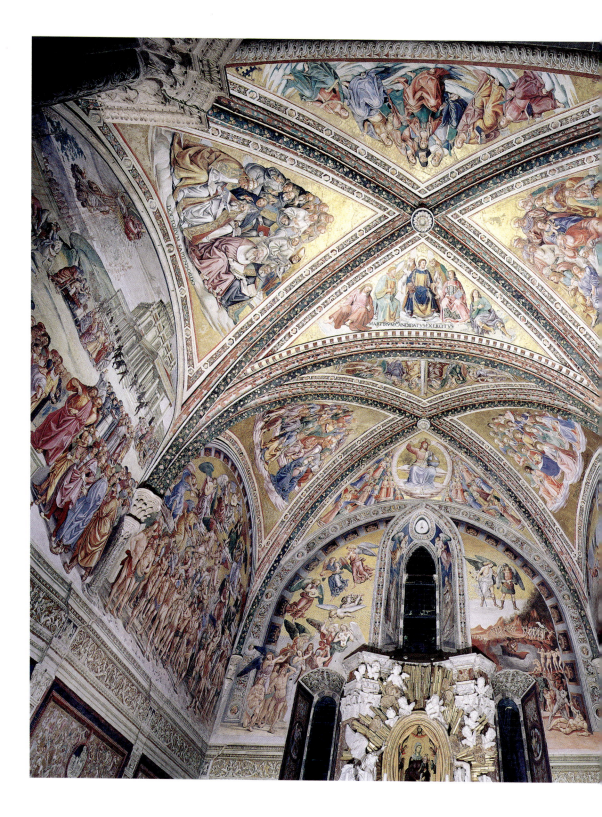

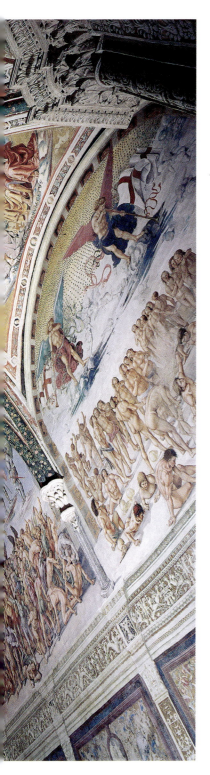

2 Panorama of the ceiling and walls of the Cappella Nuova facing the altar (south): Last Judgment, Antichrist, Resurrection of the Dead, and parts of the socle (Photo: Scala / Art Resource, NY)

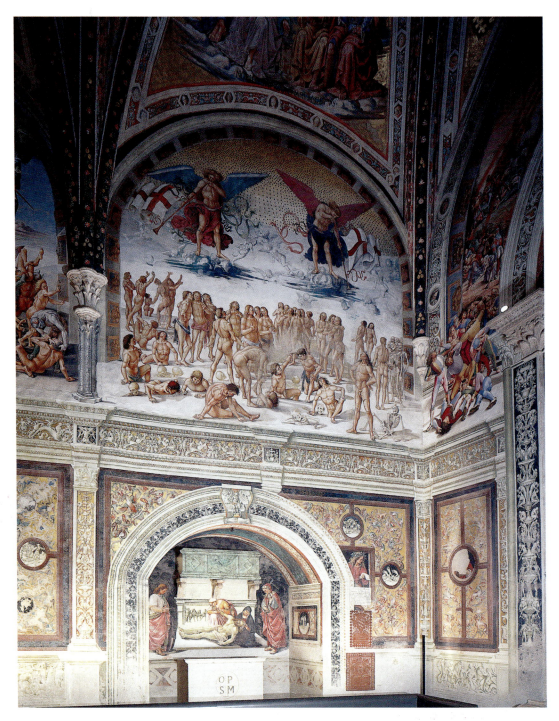

3 View to northwest: vault, left wall with the Resurrection of the Dead and the Cappellina della Pietà and entrance wall with Doomsday (by permission of the Opera del Duomo of Orvieto)

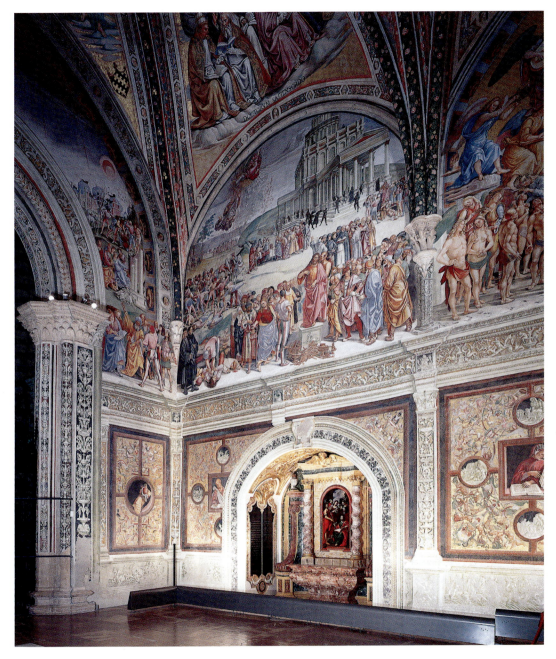

4 View to northeast: Cappella Nuova: vault, right wall with the Rule of the Antichrist and Cappellina della Magdalena and entrance wall with Doomsday (by permission of the Opera del Duomo of Orvieto)

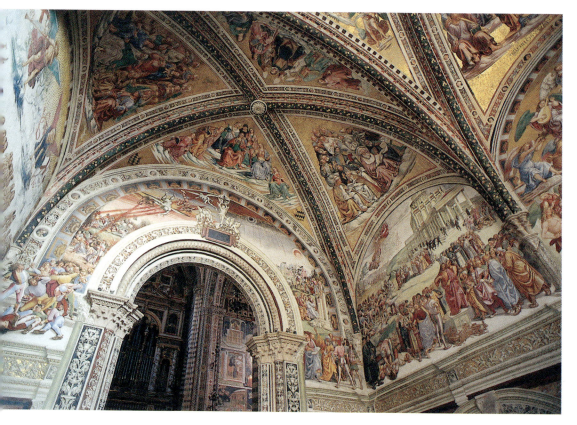

5 View to north: entrance with Doomsday flanked by the Resurrection of the Dead and the Rule of the Antichrist. North vaults above (by permission of the Opera del Duomo of Orvieto)

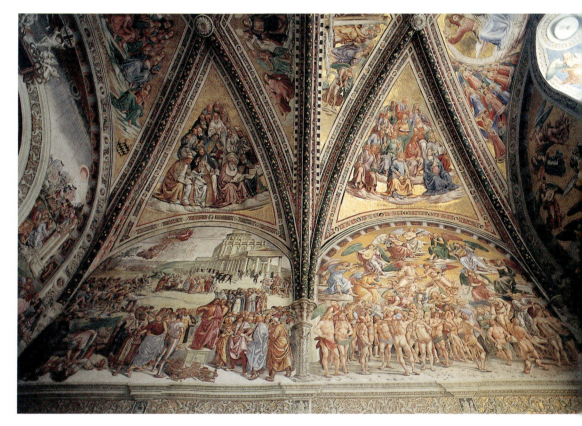

6 View of east wall lunettes and vaults: The Rule of the Antichrist with Doctors of the
Church above and the Blessed in Paradise with the Apostles Led by the Virgin Mary
above (by permission of the Opera del Duomo of Orvieto)

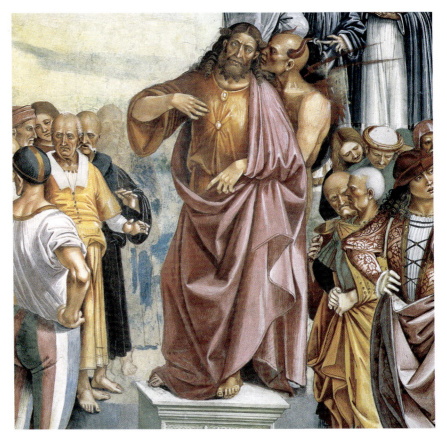

7 Detail of the Antichrist and the Devil from The Rule of the Antichrist (by permission
of the Opera del Duomo of Orvieto)

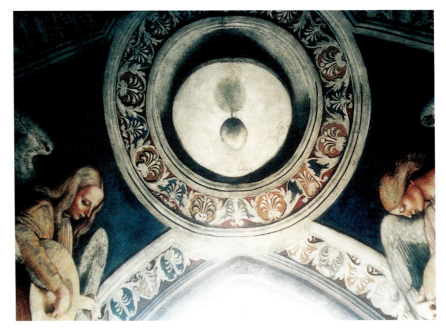

8 Detail, central window: illusionistic egg (author)

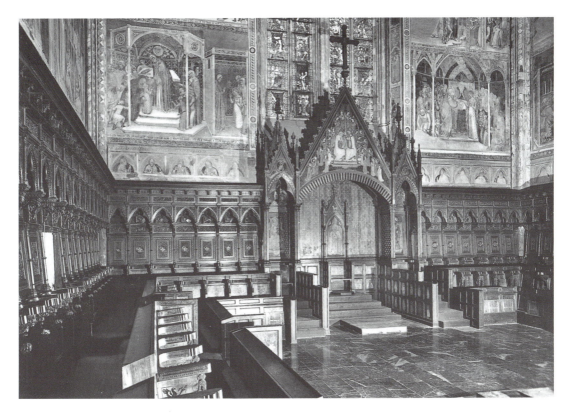

Dominican presence and influence

Besides papal patronage, throughout the Middle Ages Orvieto held close ties to the Church through many of its prominent citizens. The Mendicant Orders had a strong presence in Orvieto, particularly the Dominicans and Franciscans, who counted among their brotherhoods members of the powerful rival families of the city, the Monaldeschi and Filippeschi.[24] Moreover, from the beginning the prestigious Dominican Order exerted the most influence in the city, the cathedral, the relic, and ultimately to the Cappella Nuova. Scholars have noticed the Dominicans present in the frescoes and Dominican influence in the iconography, especially in the scene depicting *The Rule of the Antichrist* (Pl. 19). However, rather than looking to local theologians as a well-known document clearly directs,[25] they cite Dominicans and related events in Florence and other cities.[26] Less often noted, Dominicans play a prominent role in the frescoes in the Cappella del Corporale as well. Finally, as I will demonstrate here and in Chapter 9, the fresco programs in the Cappella del Corporale and in the Cappella Nuova bespeak Dominican involvement on deeper levels than previously realized.

From their origin in the early thirteenth century, the Mendicants had stood in marked contrast to the cloistered orders. These wandering friars became an integral part of city life, preaching and teaching. In addition to taking the vows of their orders, the Dominicans and the Franciscans, because

1.7 View into Choir. *Scenes of the Life of the Virgin Mary* by Ugolino di Prete Iliario da Orvieto and Fra Piero di Puccio (1357–64) (Archivio Photos Moretti, Orvieto)

they worked among the people (unlike cloistered monks), understandably felt the need for full priestly privileges, which included performing all the sacraments. In the mid-fourteenth century certain churchmen questioned the special privileges of the Mendicants, especially the authority to perform the sacrament of penance. Popes Innocent VI and Sixtus IV (a Franciscan theologian) reaffirmed the priestly privileges of the Mendicants, especially those regarding penance.[27] By the last quarter of the fifteenth century, penance – an essential preamble to the sacraments of the Eucharist, baptism, confirmation, and extreme unction – superseded all others as the central Christian sacrament.[28] In 1476, through his powers of intercession, Pope Sixtus promulgated his bull *Salvator Noster*, which granted to the living the privilege to purchase indulgences on behalf of those already deceased to reduce time spent in Purgatory.[29] Alexander VI, who resided in Orvieto before and during Signorelli's project, amplified these privileges, granting that the Mendicants, through their privilege of performing the sacrament of penance, had the additional authority to release souls from purgatory,[30] a privilege bestowed just before Signorelli began painting in the Cappella Nuova.

From the outset, the Dominicans, the Order of Preachers, had fervently embraced the mission to preach, save souls, and keep doctrine pure, which set them apart from all other Orders, Mendicant and otherwise. They took a special interest in combating heresy. Their doctrinal mission caused them to be intense intellectuals, with the need to be theologically sophisticated and capable of defending their ideas in systematic sermons and treatises.[31] Franciscans, for example, aimed their preaching at the heart and sought to save individual souls. They left corporate salvation, details of church doctrine and other such legalistic and scholarly issues to the Dominicans.[32] Their art reflected the difference in the missions of the orders. For example, whereas Franciscan art, such as that at Assisi, depicts exemplary narrative, Dominican art, such as that of the Guidalotti Chapel (later renamed the Spanish Chapel) at the Dominican Church of Santa Maria Novella in Florence, emphasizes doctrinal issues. Dominican iconography, like their sermons, tends to be dense, systematic, and subject to multiple levels of interpretation.[33]

Certain theological issues were of particular interest to the Dominicans, as reflected in the treatises, glosses and sermons of such scholars as Thomas Aquinas and Albert the Great. Dominicans especially sought to clarify the controversies concerning the Blood of Christ and transubstantiation, issues vital to the theological message of the entire cathedral of Orvieto, not the least part of which is the Cappella Nuova. In addition to protecting Eucharistic doctrine, the Dominicans maintained an intimate tie to the Feast of Corpus Christi from its inception in the 1260s and appeared throughout Europe in manuscript illuminations and panels depicting the procession of Corpus Christi (Fig. 6.2).[34] The Orvietan relic of the *corporale* not only proved the truth of transubstantiation, but also demonstrated the necessary role the Church and its sacraments played in salvation, supporting Dominic's cause. In addition to promoting the miracle of the Eucharist, Dominicans especially

venerated St Mary Magdalene, who was sustained by miraculous Eucharistic feedings during her forty years in the desert, and served as protectors of her relics. The cult of Mary Magdalene was highly celebrated in Orvieto; she also plays an important role in the iconography of the Cappella Nuova.[35]

Dominican scholarship at the papal court and throughout Italy gained momentum in the mid-fifteenth century, earlier than generally recognized, forming the foundation for theological developments in the century to come.[36] The iconography of the Cappella Nuova further demonstrates Dominican influence in the shift from the traditional emphasis on the hopelessly sinful state of individuals to a more positive view of human beings as rational creatures created in the image of God who, through piety, penance and good deeds, could work their way to heaven. Although existing documents do not elaborate upon specific Dominican contributions to the iconography of the cathedral or the Cappella Nuova, documentary references, along with strong visual and circumstantial evidence, indicate the extensive involvement of Dominicans, as I will discuss in later chapters.

Thus, when Luca Signorelli arrived in 1499, the two facing chapels in the transept honored the feasts and relics most revered by Orvietans: Corpus Christi through the cult of the Eucharist and the *corporale* from the Miraculous Mass at Bolsena in the north, and the Assumption of the Virgin and the relics of local saints in the south. A friar (presumably a Dominican) and a priest had decorated the Cappella del Corporale and the tribune; a Dominican friar–artist had begun the fresco program in the Cappella Nuova. Signorelli's advisors for his iconography in the Cappella Nuova were Dominican theologians, and his spiritual mentor, Dante, was a product of Dominican education. Upon Signorelli's departure in 1504, the Cappella Nuova, with its ties to holy days and liturgies not honored in the earlier cathedral decoration, as well as its vision of beginning and end, promise and retribution, expanded considerably a liturgical plan for the cathedral mural decoration begun two centuries earlier.

Fra Angelico and the Formulation of a Liturgical Plan

The contract between Fra Angelico and the Opera del Duomo

Fra Angelico appears to have been first approached on behalf of the Opera di Santa Maria (Opera del Duomo) of Orvieto for the commission for the Cappella Nuova in May 1446 by master glassmaker, Francesco di Baroni of Perugia.[1] Details of the encounter are not recorded, such as whether Baroni specifically sought Fra Angelico, who was in Rome in the midst of a project for Pope Nicholas V (1447–55). The next mention occurs at the 11 May 1447 meeting of the Opera, at which time they discussed decoration for the bare walls and vaults of the recently completed chapel.[2] Soon after, the Opera called the revered artist 'Fra Giovanni da Fiesole', arguably the finest painter of religious narrative of his day.[3] The letter and cathedral documents point out that the painter was a Dominican (the Dominican Order is also called the 'Order of Preachers'): 'Frater Johannes Petri, ordinis Predicatorum', which must have had some importance to the Opera. Perhaps the strong Dominican presence in Orvieto, along with the tradition of priest–artists who decorated the Cappella Corporale and part of the tribune of the cathedral, caused the Opera to take particular interest in hiring a Dominican artist for the Cappella Nuova. The Opera del Duomo of Orvieto found in Fra Angelico a serious Dominican and a respected theologian, who only in the previous year declined the offer of the archbishopric of Florence from Pope Eugenius IV. Angelico was an intellectual who was able to a plan a program compatible with the two fresco programs already in the cathedral and a reliable artist capable of supervising and executing the work.[4]

As Fra Angelico and the Opera del Duomo of Orvieto came to an agreement, the artist would have found himself in a thriving intellectual center with close ties to the papal court. Local nobles, cardinals and intellectuals had palaces throughout the city. The Monaldeschi family, including Gentile and Arrigo Pietro Antonio Monaldeschi della Vipera o della Sala (1437–49), controlled the political arena of the city, and Francesco Monaldeschi della Montagna served as bishop. Members of this noble family had helped to attract Fra Angelico to the city, gave money toward the decoration of the Cappella Nuova and later would assist in hiring Signorelli.[5]

Moreover, several leading humanist scholars from outside Orvieto maintained residences there during the time Fra Angelico worked there, including Venetian Cardinal Pietro Barbo and German Dominican Cardinal Nicholas

of Cusa.[6] Above all, the city held a sense of history within its ancient walls, evident in such impressive medieval buildings as the Palazzo Communale, the center of government; the papal and episcopal palaces, the center of ecclesiastical authority; the large Dominican church and convent, an ongoing center of intellectual activity; and the magnificent cathedral, the pride of the city. The intellectual community, along with a populus steeped in civic pride and reverence for the city's major feasts, would provide a broad audience for Fra Angelico's fresco program.

In initial conversations with the representatives of the Opera, Fra Angelico would have learned that the cathedral was dedicated to the older of the two most revered feasts in Orvieto, the Assumption of the Virgin, and that the Cappella Nuova also honored this feast: a cult statue of the Assumption of the Virgin already hung in place over the altar.[7] Fra Angelico would also have learned of the iconography of the other spaces in the cathedral, including the dedication of the facing chapel to Corpus Christi (Fig. 1.6), and the Marialogical programs of the choir, for this iconographic environment formed the framework within which he would have to work (Fig. 1.7). Moreover, the chapel itself, with rough walls pierced by at least eight windows, was remarkably different from the uninterrupted expanse of wall surface that Signorelli found a half-century later.[8]

Within these established parameters, the Opera gave Fra Angelico a certain measure of freedom in the decoration of the chapel. In fact, it appears that the artist suggested the Last Judgment iconography. The cathedral documents state that 'the master should be awaited … that it was necessary to listen to him, and once he had been heard the Opera could go on to give him the commission'.[9] Such a deferential comment exemplifies the great respect held by the Opera del Duomo for the Dominican artist's ability and theological expertise. The predisposition of the Opera toward Fra Angelico, furthermore, implied prior unrecorded conversations or correspondence regarding the program and the iconography, for the acceptance of his ideas by the Opera appears to have been a *fait accompli*.

Fra Angelico began work immediately, accomplishing a great deal in the three months of summer. Such speed would indicate that Fra Angelico had developed the iconography, including perhaps some of the preparatory drawings and cartoons, in advance. Some of his cartoons, in fact, were reused from the Chapel of St Nicholas in Rome, which would have accelerated the execution of the figures at Orvieto.[10] In August, Fra Angelico departed Orvieto, leaving his worthy colleague Benozzo Gozzoli in charge to complete the Prophets, and Pietro di Nicola of Orvieto to complete the decorative framework. Angelico's contract with the Opera del Duomo required that he return each summer until he completed his work, an obligation that, probably because of pressing papal commissions in Rome and perhaps financial trouble in Orvieto, went unfulfilled.[11]

Christ and the heavenly court

In the two vanes of the vaults that he completed, Fra Angelico unequivocally established a Last Judgment theme and thereby determined much about the iconography of subsequent decoration. Certain canons, such as the place of Christ, the Blessed and the Damned, were so firmly established that an artist would never depart from them; others left room for some invention (Fig. 2.1 and Pls 2 and 11).[12] In addition, Fra Angelico initiated a liturgical structure and the vision of hope inherent in the Last Judgment that would establish the format and tone of the work that would follow.[13] Before coming to Orvieto, Fra Angelico had completed an altarpiece of the Last Judgment for his convent of San Marco in Florence; afterwards he would render another. Within the confines of the convention, Fra Angelico conveyed in all of his works portraying the Last Judgment theme a theological message that includes repentance and intercession. These themes had roots in the Thomist theology of the Dominican Order, which gave a positive view of the nature of mankind, and consequently a sense of hope at the Judgment, as opposed to the sense of despair inherent in most medieval Last Judgment compositions.

Fra Angelico began work in the *vela* (vane or literally 'sail') directly above the altar. An almond-shaped mandorla encloses the figure of Christ, seated on a globe. A host of sweet-faced angels painted on a smaller scale fills the remaining space. With his head slightly tilted and eyes cast downward, Christ appears remote, but gentle, the *Salvator Mundi*, or the Savior of the World, rather than the wrathful judge.[14] The presence of the orb, on which his left hand rests, confirms Christ's redemptive role. Rather than forming a condemning gesture, Christ raises his right hand above his head and tenderly bids the blessed to join the ranks of redeemed saints who flank him. Two of Christ's five stigmata, or wounds, those in his side and right hand, provide further signs of mercy and compassion. The blood and water that had poured from these wounds at the Crucifixion relate to the sacrament of the Eucharist, which would be celebrated on the altar below, and to the Feast of Corpus Christi, celebrated in the facing Cappella Corporale.

Following the convention of Last Judgment compositions, Fra Angelico and his colleague Benozzo Gozzoli portrayed Old Testament prophets to the left of Christ (Fig. 2.2). An inscription below the figures reads: TE PROPHETARUM LAUDIBILIS NUMERUS. The poetic words are appropriated *verbatim* from the first lines of the fourth-century Ambrosian hymn, *Te Deum laudamus*, which is sung regularly at the celebration of the Mass, or the Eucharist.[15] Some of the prophets hold recognizable attributes.[16] Angelico deviated from standard practice by including John the Baptist, whom he set slightly apart from the group and closest to Christ. A youthful figure with a scruffy beard, he wears his characteristic hair cloak under his robe. Next to John the Baptist, an old man in the center, perhaps Aaron, holds a rod in his right hand. Moses, to the right, foremost among the Old Testament prophets, also appears as an old man and holds two tablets with an inscription from the first commandment (Exodus 20:2), rendered in Hebrew letters.[17] Two identifiable figures

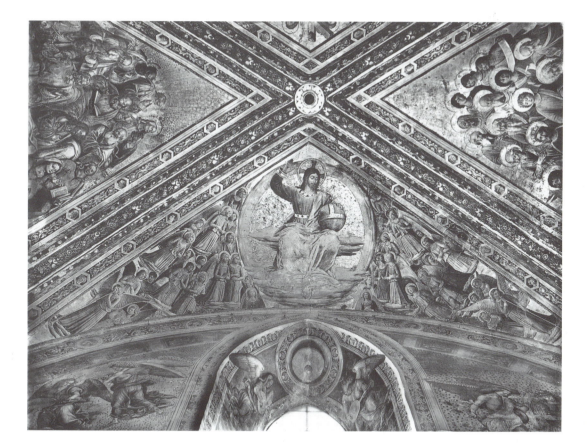

occupy the second row: King David, who wears a crown and holds a harp; and probably Isaiah, prophet of the Virgin Birth and the Passion of Christ, who generally sits with the major Old Testament figures. The remaining generalized figures above could be any of the other prophets. Fra Angelico mixed the general and the specific, making the figures more universal, a practice that Signorelli would later follow.

The final area decorated by Fra Angelico and his shop was the traditional border of rich foliage, gilded fruit and flowers that cover the ribs.[18] Many of the plants, such as the pomegranates (which often substitute for the apple of Adam and Eve), hold symbolic value. Flanking the ribs and outlining the interior space of the *vele* are rows of anonymous, but individualized, heads. Giotto and others had used such decorations. Such faces, witnesses to Christ's judgment, could represent the unsentimental, fresh beauty that Thomas Aquinas associated with the Elect.[19] At the same time, they also could represent those unnamed saints who are celebrated on All Saints' Day.

2.1 South vault; detail of Christ as judge (Fra Angelico), 1447 (Archivio Photos Moretti, Orvieto)

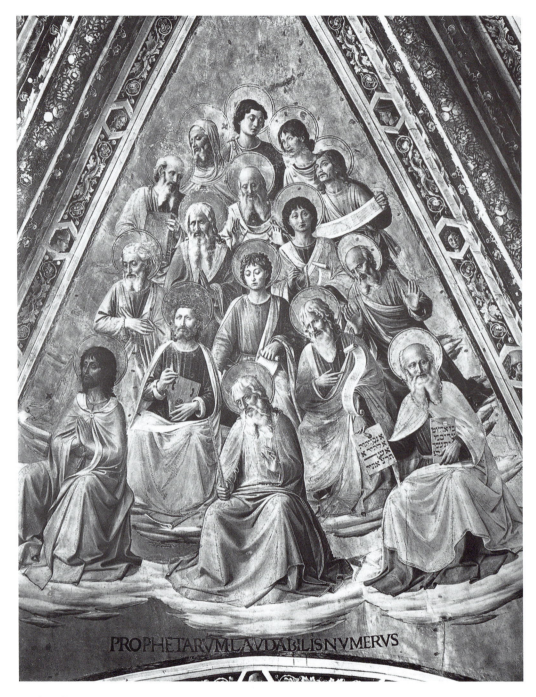

2.2 Prophets (Fra
Angelico and
Benozzo Gozzoli),
1447 (Archivio
Photos Moretti,
Orvieto)

The Roman liturgy for the Mass

Although the two *vele* completed by Angelico and Gozzoli follow Last Judgment iconography, Fra Angelico clearly emphasized Christ's mercy and his redemption of humanity, themes that concurred with the liturgical texts for the Mass. Several biblical passages used during the celebration of the Mass link the Eucharist and the Last Judgment and give hope of eternal life to the worshiper. For example, the scripture that forms a part of the liturgical text for the consecration of the elements, or bread and wine, of the Eucharist states:

So Jesus said to them, 'Very truly, I say unto you, unless you eat the flesh of the Son of Man and drink his blood, you have no life in you. Those who eat my flesh and drink my blood have eternal life and I will raise them up on the last day; for my flesh is true food and my blood is true drink. Those who eat my flesh and drink my blood abide in me and I in them.' (John 6:53–56 (NRSV))

In addition, the following Pauline text from the liturgy for the Mass also links the Last Judgment and the Eucharist: 'For as often as you eat this bread and drink this cup, you proclaim the Lord's death until he comes' (I Corinthians 11:26 NRSV). The continuation of the text links the Last Judgment and the Eucharist, stressing the importance of sincerity and, indirectly, penance:

Whoever, therefore, eats the bread or drinks the cup of the Lord in an unworthy manner will be guilty of profaning the body and blood of the Lord. Let a man examine himself … for anyone who eats and drinks without discerning the body eats and drinks judgment upon himself. (I Corinthians 11:27–29 (NRSV))

The admonition offered by the Judgment theme balances the redemptive qualities of Christ the Redeemer and the sacrament of the Eucharist, preceded by penance. These offers of mercy guide the fervent worshiper toward salvation.

In Assumptione Beata Maria Virginis

The iconography of the Last Judgment harmonizes with the dedication of the chapel to the Assumption of the Virgin. With frescoes in the tribune of the cathedral depicting the Assumption and the Coronation of the Virgin already in place, the Last Judgment was the logical alternative, for the miracle of the Assumption supports the fundamental Christian belief in the afterlife and gives the faithful hope of resurrection and heavenly reward on the Day of Judgment.[20] The liturgical texts, especially the Epistle reading, for the Feast of the Assumption link the Judgment and bodily resurrection, and promise life to the faithful in the world to come.[21]

But in fact Christ has been raised from the dead, the first fruits of those who have died. For since death came by a human being, the resurrection of the dead has also come through a human being. … and we will be changed. For this perishable body must put on imperishability, and this mortal body must put on immortality. When this perishable body puts on imperishability, and this mortal body puts on immortality, then the saying that is written will be fulfilled: 'Death has been swallowed up in victory'. (I Corinthians 15:20–21; 53–54 (NRSV))

The legacy of Fra Angelico

Although Fra Angelico finished only two sections of the vault and left drawings for just two more, these paintings not only revealed a tightly constructed program of Judgment and the beginning of a liturgical plan, but also they established certain irrevocable perimeters for the subsequent decoration. Whether Angelico intended allusions to the liturgical texts for the Feast of All Saints, as unequivocally confirmed by Signorelli in the north vault of the chapel, cannot be firmly established by the paintings he left. Three facts, however, indicate that such may have been his purpose. First, by emphasizing redemption rather than damnation, the artist reflected the hopeful spirit of the liturgy for the Feast of the Assumption of the Virgin and that of the liturgy for the Eucharist. Second, all Roman liturgical texts for the Feast of All Saints, '*Omnium Sanctorum*', reflect a theme of judgment and mercy. Finally, the depiction of Christ as *Salvator Mundi*, emphasizing mercy rather than damnation, follows contemporary liturgical manuscript practices for the decoration of the beginning of the office for the Feast of All Saints. Two more or less contemporary examples illustrate the point. The first, a fourteenth-century breviary once owned by a della Rovere cardinal, introduces each liturgical office with a small scene painted into the initial letter. The center of the elaborate 'O' of '*Omnium Sanctorum*' depicts an enthroned *Salvator Mundi* in a gilded mandorla. Three seraphim flank and support the throne. Christ raises his right hand in blessing; the left holds a book. The same imagery appears in the initial 'O' of '*Omnium Sanctorum*' in a beautifully illustrated fifteenth-century choral book in Orvieto.[22] These *Salvator Mundi* figures concur with Fra Angelico's depiction in the Cappella Nuova.

Even in the unfinished state of these paintings, a fifteenth-century viewer would have recognized the references to the Last Judgment and the familiar *Te Deum laudamus*; they would have understood how these aspects concurred with the Mass and the dedication to the Feast of the Assumption of the Virgin. Thus, Fra Angelico began a salvation iconography tied to the Roman liturgy that joins the themes of judgment, the Mass and the Assumption of the Virgin. Over fifty years later, his successors understood and honored the framework of the Roman liturgy as they fulfilled and elaborated upon his intention.

Orvieto after Fra Angelico: popes, patrons, plague and progress

During the half-century following Fra Angelico's departure, the Opera del Duomo sporadically discussed the unfinished fresco decoration of the Cappella Nuova.[23] They sought a reputable artist who would complete the program in a manner compatible with the theme and figures left by Fra Angelico, and one whom they could trust to stay with the work until finished. Periodically, from 1481 onward, the Opera pursued artists from the papal court to complete the frescoes, whose subject of the Last Judgment now, near the turn of the millennium and a half, was most timely. Little came of these efforts.

Papal involvement in the city continued and intermittently stimulated interest in the Cappella Nuova. Although he never again granted Fra Angelico release time to return to Orvieto, Pope Nicholas V continued other support to the city. For example, in a letter of 1449, the pope gave money for the restoration of the Episcopal Palace in Orvieto, originally a project of Nicholas IV.[24] After a brief interlude of Spanish rule, Pope Pius II (1458–64), who wrote admiringly of Orvieto and its cathedral in Book IV of his *Commentaries*, visited the city in 1463, accompanied by Cardinal Nicholas of Cusa.[25] The visit rekindled interest in the decoration of the Cappella Nuova. Just before the pope's arrival, a delegate on behalf of the estate of the late bishop of Orvieto, Francesco Monaldeschi (served 1420–43), pleaded for the continuation of the decoration of the Cappella Nuova. Pius granted the request, proposing a chapel dedicated to the Assumption of the Virgin, but apparently the Opera del Duomo of Orvieto did not act upon it right away.[26] Perhaps instigated by Pius and the Monaldeschi family, the relics of the local protector saints, S. Pietro Parenzo and S. Faustino (who both died fighting heresy), were transferred to the chapel by 1469.[27] Documents record that a stained glass window depicting the Assumption of the Virgin was installed over the altar in 1471.[28]

Additionally, many leading humanist scholars, including Cardinal Nicholas of Cusa, Cardinal Pietro Barbo and Antonio Albèri, continued to maintain residences in Orvieto at the end of the century.[29] Soon after, Pope Sixtus IV (1472–84) supported Orvieto from Rome. He appointed a nephew, Giorgio della Rovere, bishop of Orvieto in 1476. In 1477, Sixtus accorded plenary indulgences for Corpus Christi, continuing in the tradition established by Pope Urban IV and furthered by Pope John XXII, this time allowing the monies collected to be used for the restoration, building and decoration of the cathedral. This decree was confirmed in 1481.[30] Sixtus's successor, Pope Innocent VIII, never visited Orvieto, for a six-year siege of the plague gripped the city for most of his papacy. According to entries in the contemporary diary of notary Tommaso Silvestro, the numbers of dead were staggeringly high.[31] The plague took its toll on the city in many other ways as well. Although the Opera sporadically renewed attempts to find a painter, the city remained troubled. In 1479, documents record discussions by the Opera regarding the unfinished fresco decoration. The Opera solicited several artists between 1479 and 1499, beginning with Pier Matteo d'Amelia of Rome,

mentioned in documents of 1481.[32] All of the artists recorded in the documents had served the papal court in Rome; sadly, all proved elusive, unavailable or mediocre. A decade-long, fruitless saga began in May 1489, when the Opera del Duomo first called Pietro Perugino, 'the most famous painter in all of Italy and who had experience in the Apostolic Palace in Rome where it is said he painted many pictures …' to finish the project.[33] Several pages of documents record the futile efforts of the Opera to lure Perugino back to Orvieto. Documents imply that the Opera intended to mete out Perugino's commission, which perhaps frustrated the artist. Moreover, initially the socle was not to be elaborate; in fact, it probably was not part of the commission.[34] Perugino did come to Orvieto in 1489, worked briefly, and left for Rome, perhaps because of plague, perhaps for other commissions, of which he had many. In 1492, the Opera managed to keep him in town long enough to paint two evangelists and two doctors of the church on the facing upper walls of the tribune to accompany the Marian frescoes there.[35] A letter dated 2 June 1492 to the Commune of Orvieto from Cardinal Giuliano della Rovere (future Pope Julius II and cousin of Bishop Giorgio della Rovere of Orvieto) requested that Perugino be released temporarily from his contract in Orvieto so that he might finish works in progress in Rome at Santissimi Apostoli.[36] Soon thereafter Perugino began to work on an almost industrial scale, supervising large workshops in Florence and Perugia for both fresco and panel painting. Perugino continued to frustrate the Opera: as soon as they lost hope of securing his services, the artist would express interest and then quickly disappear. In 1497, Il Pastura (Antonio di Viterbo), an artist of far less stature than others mentioned in the documents, received brief consideration, as did a few others.[37]

Upon arrival in Orvieto in 1494, Pope Alexander IV (1492–1503) found the city in a wretched condition, owing in large part to the six years of plague. Alexander resided in Orvieto between 1494 and 1503, the first pope to actually live there for an extended period since before the papacy had moved to Avignon. He renewed its strength as a papal city, even designated it the citadel of the Holy See, and funded projects there. His son Cesare Borgia briefly served as city governor.[38] Alexander occupied the papal throne when the Opera del Duomo hired Signorelli. Though no record exists of direct papal gifts toward the Cappella Nuova project, the presence of the papal court in Orvieto was always an economic boon. Furthermore, the relief from the plague gave additional incentives to refurbish the city and complete unfinished projects. The pope spent little time in Rome, though long enough to build the Borgia Tower at the Vatican and to commission Pinturicchio to decorate the papal apartments there, decorations that interfered with his commissions in Orvieto. With the departure of Alexander, the period of extended papal residence in Orvieto ended for good.[39]

Documents indicate that Signorelli did not work on the Cappella Nuova in 1502, probably because of financial difficulties in Orvieto. Instead, he worked in Cortona, returning to Orvieto in 1503,[40] the same year in which Cardinal Giuliano della Rovere ascended to the papacy as Pope Julius II,

following the ten-day reign of Pius III (Piccolomini). Whether Signorelli's return related to the ascent of Julius is not documented. However, considering Julius's personal reverence for the relic – he would stop in Orvieto in 1506 specifically to pray before it prior to his campaigns against the French and he would include this event in Raphael's Stanza d'Eliodoro in the Vatican – it seems reasonable that he would have wanted the decoration finished.[41] Perhaps his cousin, Bishop Giorgio della Rovere, appealed for support. Whether Julius applied pressure or gave funds, direct or indirect, is a moot point. However, the fact remains that Signorelli did the bulk of his work on the chapel walls in the first two years of Julius's pontificate and completed his fresco program just before Bishop della Rovere died.

3
Tradition and Innovation

Orvieto in 1499

Although the scaffold remained intact in the Cappella Nuova, the Opera del Duomo did not successfully contract with an artist to succeed Fra Angelico until they hired Luca Signorelli. In April of 1499, the Opera del Duomo again addressed the decoration in the Cappella Nuova, this time more purposefully. The few years immediately preceding 1499 had been relatively good ones for Orvieto. The need to acknowledge the respite from six years of plague and the ensuing economic prosperity created a climate conducive to the pursuit of artistic projects. Perhaps the modest funds bequeathed to the coffers of the Opera del Duomo by two members of the prestigious Monaldeschi family, specifically designated toward the decoration of Cappella Nuova, provided additional incentive.[1]

On 8 March 1499, after nine years of pursuing and waiting, the Opera made a last written appeal to the elusive Perugino to honor his contract to complete the vaults in the Cappella Nuova.[2] A month later, the Opera turned its attention to Luca Signorelli. Capable, reliable and experienced, Signorelli had painted for popes, cardinals, prelates and distinguished families all over central Italy. He was in town on 5 April, as the discussions began. Opera documents from that date describe the new candidate, Luca di Cortona, as 'the most famous painter in all of Italy [as had Perugino's before him], bringing his experience in many places', a credential that the Opera obviously valued. Moreover, two additional lengthy documents of the same day discuss the terms of his contract in detail.[3] The Opera sought a responsible artist whom they could trust to finish the work, and one who was willing to complete the program in a manner compatible with the theme and figures left by Fra Angelico. What in Signorelli's background prepared him for the opportunity that he seized in the twilight of his career as a fresco painter, a commission that cemented his reputation as one of the great artists at the dawn of the High Renaissance? Why, at the pinnacle of his career, after his extraordinary accomplishments at Orvieto, did he curtail his involvement in fresco painting?

Signorelli and his contemporaries

For various reasons, as mentioned in the previous chapter, none of Signorelli's well-established colleagues from the papal court proved suitable for the commission. The Opera del Duomo had considered and had actually called a few of these candidates, including most notably Pinturicchio and Perugino, but the endeavors proved unsuccessful. Perhaps the Opera considered some artists whom today we might expect to have been contenders. Because of works in progress, reputation, reliability or inexperience, these artists, if discussed at all, were dismissed quickly, for such musings do not appear in the documents.

Unmentioned contemporaries who come to mind today might include Leonardo da Vinci, who was only about eight years younger than Signorelli. In the mid-1490s, Leonardo worked for the duke of Milan (to whom Leonardo had presented himself as a military engineer). The artist had a reputation as slow, easily distracted and unreliable, for he rarely finished a project. Worse yet for the Orvieto project, Leonardo did not like the fast pace or unforgiving nature of fresco painting. In 1499, he left Milan, having just painted his mural of the *Last Supper* in the refectory of S. Maria del Grazie in an experimental medium that was unsuccessful. He wandered from Florence to Rome to Venice and Parma and even traveled as an engineer with the army of Cesare Borgia. He returned to Milan in 1508 and emerged in Rome in 1513. With the unfinished portrait of a smiling Florentine woman among his possessions, he left Italy for good in 1516 at the call of the French king. He died there as he had lived: as a brilliant but eccentric, versatile but impractical, wanderer.

Among the younger generation of artists in 1499, Michelangelo, aged twenty-four, was a prodigious sculptor in Rome. He was completing the *Pietà* for the tomb of the French Cardinal Jean Bilhères de Lagraulas at Old St Peter's. He had trained in Florence, initially in the workshop of Ghirlandaio, where he mastered various drawing and painting media. Although as an apprentice Michelangelo had assisted with the frescoes in the chancel of the Church of Santa Maria Novella in Florence and had proved adept, he left painting around 1490 to pursue sculpture at the academy of Lorenzo de' Medici. In 1499, his collected works consisted almost exclusively of sculpture. At the same time, sixteen-year-old Raphael, a native of Urbino, served Perugino as a precocious apprentice in Perugia. Though he may have collaborated with his master in the fresco decoration at the Collegio del Cambio there, he had not yet established an independent reputation. His earliest signed painting, the *Marriage of the Virgin*, dates from 1504. In 1499, neither Raphael nor Michelangelo had played a primary role in, let alone planned and supervised, a fresco program.

Thus, that spring, in the eyes of the Opera del Duomo of Orvieto, Luca Signorelli was undisputedly the most qualified candidate available in Italy to finish their Cappella Nuova. He had proved himself capable as a fresco painter at Loreto, then in the Sistine Chapel project of the 1480s, and most

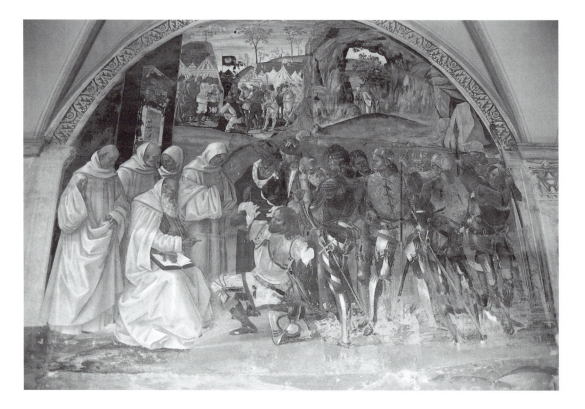

3.1 Signorelli, *Benedict Exposes Totila's Sham* from the Life of St Benedict, Monteoliveto Maggiore (author)

recently at the Benedictine monastery of Monteoliveto Maggiore, near Siena (Fig. 3.1). At Monteoliveto, he worked within a proscribed iconographic framework, probably under the tutelage of an advisor, but at the same time, he demonstrated a flair for giving new vision to traditional subjects.[4] Capable, reliable and always above reproach, he fulfilled commissions in a timely manner and had gained respect in central Italy as well as in the urban centers of Rome and Florence. His reputation, according to Vasari, was that of an affable, accommodating, gracious gentleman.[5] A well-respected artist in his own right with a reputation as a versatile and inventive painter, Signorelli demonstrated by his *œuvre* that he could conform his work to that already in place and meet the demands of a complex iconographic program without sacrificing his artistic integrity.

Training and the development of a style

A native of Cortona, a hill town in the southeastern corner of Tuscany, Signorelli had trained with Piero della Francesca in nearby Arezzo, entering Piero's shop between 1460 and 1465. He seemed to have entered the workshop with some experience. In 1494, Luca Pacioli, in his treatise *Summa de arithmetica et geometria*, listed ten living artists who had mastered perspective. He elaborated on Signorelli alone, calling him 'the most worthy disciple of our

master Piero.'[6] Vasari's late sixteenth-century account described his relation-
ship with Piero as more than an ordinary apprentice by calling him a *creato*,
one who assisted in an important way and who especially internalized the
marks of the master's style. Vasari also recorded that Signorelli assisted
Piero with the frescoes of the *Story of the True Cross* in the Bacci Chapel of the
Church of San Francesco in Arezzo.[7]

Piero's mark, indeed, is evident in Signorelli's style and technique. Signorelli
learned the solid modeling, broad shadows, and good drawing that character-
ized his master's mature style. He adopted his master's emphasis on figures
over landscape by placing monumental figures in the foregrounds of
compositions and he internalized his skill with continuous narrative.
However, whereas Piero preferred stately, serene, figures with strong
silhouettes, Signorelli favored the energetic. He used movement for dramatic
power and unparalleled complexity.

Signorelli also learned technical skills in Piero's shop, including the
mechanics of fresco painting and transferring designs to walls. Several of
Signorelli's drawings contain squares for transfer to a larger surface, another
technique he would have learned from his master.[8] Like Piero, Signorelli
excelled most in fresco painting, where he was more dramatic than in his
panels. Perhaps the nature of the fresco medium caused him to move
spontaneously, as he painted more broadly in fresco. His figures in fresco
appear more plastic, whereas those in his panels seem comparatively hard-
edged. Fresco painting, however, demands heavy physical labor and the
artist must work quickly and confidently. Perhaps, in spite of his superb
mastery of the medium, especially at Orvieto, the strenuous labor and
demanding pace explain why Signorelli turned almost exclusively to panel
paintings after leaving Orvieto. By 1506, Signorelli was nearing sixty years
old. Lacking the physical endurance of youth and no longer as nimble,
perhaps the risk of injury, such as a tumble from the scaffold, may have
appeared too great.[9]

Signorelli's prior work

Signorelli's experience in both panel and fresco painting prepared him to
complete work begun by Fra Angelico. Like Angelico, his style stemmed
from the Florentine tradition, one based on linear compositional structure. In
addition to style, he had absorbed the Florentine tradition of narrative frescoes
from his master, who had worked in Florence at S. Egidio with Domenico
Veneziano while Fra Angelico was painting frescoes in the Convent of San
Marco. Signorelli's reputation for original and inventive compositions, both
religious and mythological, traits that only recently have received proper
notice,[10] would come to the attention of the Opera in Orvieto. His early
panel of the *Flagellation* (c. 1480, Brera, Milan) shows a fine mastery of the
nude figure in motion, though more static than his later work. He uses some
chiaroscuro here, although it appears more dramatic in works done after

1490. Placing the primary subject near the picture plane and closing the space with elaborate classical architecture increase the viewer's sense of immediacy and heighten the narrative drama. Supporting classical scenes in grisaille appear on the architecture as faux sculpture, as they will in Orvieto.

In addition to completing many panel paintings, Signorelli had satisfied several important fresco commissions. His early frescoes included the Sagrestia della Cura (c. 1477–80) in the Basilica at Loreto. The relic there, the house of the Virgin Mary, miraculously flown by angels from Ephesus to Loreto, made it a prestigious place for a commission. Signorelli's murals decorate one of the pair of octagonal domed sacristies commissioned by Cardinal Girolamo Basso della Rovere, a relative of the bishop of Orvieto and nephew of Pope Sixtus IV; Melozzo da Forlì (1477–94), also a painter to Pope Sixtus IV, decorated the other. Loreto was an important precursor to Orvieto, for Signorelli exhibited his monumental style as well as his ability to organize the space and plan a grand scheme based on figure compositions. Furthermore, he proved reliable: he completed the commission in three years.

As would be the case in Orvieto, the visionary ceiling at Loreto provides a striking contrast with the earthly realm below. At the apex of the vaults, angels gracefully flutter atop clouds as they play musical instruments, while evangelists and fathers of the church, immersed in books or scrolls, sit below. The lower walls contain pairs of monumental apostles on six walls with facing scenes of the *Doubting of Thomas* and the *Conversion of St Paul* on the remaining two. Focusing on the figure, Signorelli diminished, even eliminated, the landscape setting. Convincing borders of *trompe l'œil* (or illusionistic) architecture unite the compositions. The figures often overlap the edges, as they do at Orvieto, as they turn and interact with one another, which gives an increased sense of depth to the otherwise shallow space. The size of the figures and their position close to the picture plane increase the viewer's sense of immediacy, yet as they absorb themselves in conversation or experience a miracle, the apostles remain oblivious to the intrusion of onlookers. Dramatic gestures and poses make the scenes reminiscent of a theater-in-the-round performance in progress, with figures standing on the edge of proscenium openings. The size of the compositions and the figures within them would increase to colossal proportions at Orvieto.

Shortly after completing the sacristy in Loreto, Signorelli joined Perugino, Botticelli, Ghirlandaio, and others in decorating the lower walls of the Sistine Chapel in Rome (1482–83) for Pope Sixtus IV. Around 1480, especially in Rome, the longstanding practice of stacking episodes in fresco narratives gave way to continuous narrative figure arrangements set into a single large expanded-field composition. Figures in the foreground remained about the same size, but the scale of the compositions and complexity of the landscape increased and incorporated subordinate action.[11] Like the artists for the Sistine project, who subdued their individual styles for the sake of the total effect, Signorelli showed his facility to adapt to the demands of this commission, much as a musician would perform differently in concert with others than in a solo performance. Perhaps the Opera del Duomo later recognized his

adaptability, for the artist they sought needed to keep his work compatible with that left by Fra Angelico.

Perugino directed the Sistine project, undoubtedly aided by theological advisors.[12] The artists effectively narrated sixteen fresco compositions depicting the lives of Christ and Moses tied to biblical chronology and to the Roman liturgical readings for the weeks between Advent and Pentecost. Facing scenes, as well as inscriptions, pair meaningfully according to a parallel typology.[13] *Trompe l'œil* architecture, painted in an ornate classical style, divides the scenes. This decorative motif, featuring elaborate gilded *grotteschi* on the pilasters, was inspired by paintings the artists saw in the newly rediscovered Domus Aurea.[14] Signorelli must have internalized the lessons learned in Rome, for such complexities in form and content emerged again at Orvieto.

Vasari recorded that Signorelli and Perugino trained together in the studio of Piero della Francesca, and that they remained friends and collaborators.[15] His affiliation with Perugino, along with his own commissions in Perugia around 1484, which included an altarpiece in the cathedral (signed and dated 1484), may have brought Signorelli in contact with the local humanist circle, which included Orvietan native Antonio Albèri, who, by 1499, served as archdeacon and librarian of his home cathedral.[16]

Examples of Signorelli's innovative iconography in panels from the 1490s include a *Circumcision* (National Gallery, London), an *Adoration* (Louvre, Paris), a *Nativity* (National Gallery, London), and a *Crucifixion with Mary Magdalene* (Uffizi, Florence).[17] Each variation remains soundly based in traditional iconography and in biblical and theological texts, while simultaneously each offers a broader view of a well-worn subject. In his *Circumcision*, rather than depicting the traditional moment of the *Nunc dimittis* prayer (Luke 2:29), Signorelli more dramatically portrayed an awestruck Simeon, amazed to realize God's promise to see the Christ (Luke 2:26).[18] In the *Adoration* and the *Nativity* panels, Signorelli set the stage *in medias res*,[19] as he would do in the narrative lunettes and grisaille tondi at Orvieto. Moreover, the *Nativity* includes the unique portrayal of the census at Bethlehem in the background. The *Crucifixion*, a continuous narrative composition, focuses on Mary Magdalene wailing at the foot of the cross, while other related events appear subordinate in the background. Signorelli expressed his vision of Mary Magdalene as an exemplar of the remorseful, penitent sinner again in similar panels at Borgo San Sepolcro and Cortona. Perhaps, as with the haggard figures of the Magdalene by Donatello (Museo Opera del Duomo, Florence) and Desiderio da Settignano (S. Trinità, Florence), these unusual portrayals reflect the contemporary obsession throughout Italy with her cult.[20] Mary Magdalene subsequently played an important role in the Cappella Nuova, where Signorelli depicted her at least five times.

Humanists held Signorelli's innovative iconography in high regard, as indicated by the patronage of Lorenzo de' Medici, the leading humanist patron in Florence in the late quattrocento. In addition to painting for Lorenzo, Signorelli would have had contact with one of the greatest intellectual circles in European history. Surely the experience in this rarified environment, where

he was exposed to the writings and discussions of these men, had a lasting impact on Signorelli's work. The humanist scholars in Lorenzo's household included such men as Poliziano, Marsilio Ficino, and Pico della Mirandola. Lorenzo also sponsored an academy of sculpture headed by Donatello's pupil, the now elderly Bertoldo, and attended by the young Michelangelo. Signorelli would have known the collection of fine antique sculpture in the Medici garden. Unlike his contemporaries, who collected art for contemplation or pleasure, Lorenzo de' Medici collected art for study, and for that purpose he established a school.[21] Previous humanist scholars and other intellectuals had discussed art, but here for the first time the theory of art became an important topic in intellectual circles, separate from the studio environment. Poliziano, a philosopher/poet in the famed Medici intellectual circle, wrote a book entitled *Panepistemon*, which outlined the fifteenth-century intellectual system that included the arts. Earlier theorists, such as Leon Battista Alberti or Leonardo da Vinci, had advocated the intellectual aspect of artists' endeavors but they did not classify the arts within a system. Poliziano placed the arts, which included sculpture and painting, under philosophy within the subcategory *'actualis'* (practical) and the division *'graphike'* (a humanist term related to *'disegno'*). Thus, art was not only made (*'actualis'*), but when perceived as a branch of philosophy, part of the liberal arts, it was a subject worthy of intellectual endeavor: a theory.[22]

Among artists in Florence, Signorelli shared with his older contemporary Antonio Pollaiuolo (1429?–98),[23] and his younger contemporary Michelangelo, an interest in the nude figure, vigorous motion and accurate anatomy, especially muscles and how they work. Signorelli used more complex figure arrangements and denser compositions than Pollaiuolo, who tended to focus on pairs of nude men fighting. Unlike Pollaiuolo, Signorelli did not limit himself to male nudes; unlike Michelangelo, he rendered male and female figures with equal accuracy.

While in this stimulating environment, Signorelli produced a *Madonna and Child* (Fig. 3.2, Uffizi, Florence) and probably the *School of Pan* (Fig. 3.3, formerly Berlin, destroyed in World War II), both inventive subjects built upon enigmatic iconography. The former is mysterious. The rectangular panel resembles a mock frame holding a tondo of the Virgin and Child. Above them, prophets with scrolls depicted in a pair of small grisaille medallions witness the fulfillment of their prophecies in the tondo below, where a somber Madonna in the foreground plays with her child in a pastoral setting. The Madonna and Child seem in no way connected to either the figures or the buildings behind. The idyllic landscape contains classical architecture and a rock bridge, reminiscent of Leonardo da Vinci's *Madonna of the Rocks* (Louvre, Paris, *c.* 1483). The centrally planned temple, like that in Signorelli's Washington, DC, *Crucifixion* predella, is imaginative, but would not be structurally sound. Four nude male figures appear in the background, two of which play wind instruments. The meaning of these pastoral figures remains elusive. Michelangelo's subsequent *Doni Tondo* (Uffizi, Florence, 1503) surely owes a debt to this painting. In the *School of Pan*, a unique

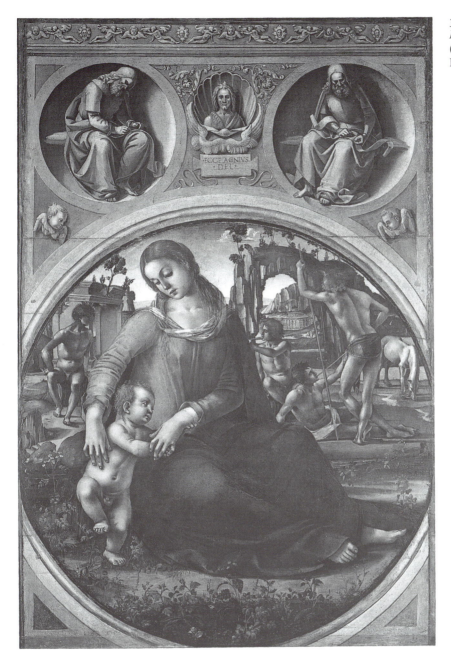

3.2 Signorelli,
Madonna and Child
(Uffizi Gallery,
Florence)

subject, Signorelli showed a facility for portraying erudite subjects. He also
proved adept at handling complex composition. He reduced the background
and focused on the figure; at the same time, he demonstrated his mastery of
the nude. He not only verified his ability as a superb painter, but also
displayed confidence and capability with complex iconography, qualities
that served him well at Orvieto.

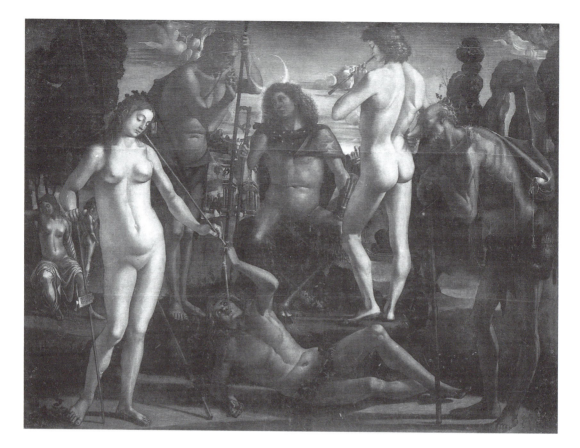

3.3 Signorelli,
School of Pan
(formerly in Berlin;
now lost)

On the eve of the commission at Orvieto, the wealthy Benedictine monks at Monteoliveto Maggiore, high in the hills near Siena, had hired Signorelli to decorate the vaulted Grand Cloister with the life of St Benedict. Although remote, and in Signorelli's day inaccessible in the rainy season, the wealthy monastery maintained strong papal ties.[24] These Benedictines, like the members of the Opera del Duomo in Orvieto, had sought the finest painter available. This project concurred with the progressive works of Signorelli's late fifteenth-century contemporaries, such as those of Filippino Lippi in the Carafa Chapel in Rome and his New Strozzi Chapel in Florence, as well as those by Pinturicchio in Spello, churches in Rome and the Borgia Apartments of the Vatican.[25] As in the Sistine Chapel program, each of these fresco cycles is composed of expanded-field compositions with figures comfortably placed in complex landscape or architectural settings; each narrates a high-minded history, praising the life and deeds of a saint. Illusionistic pilasters in the ornate classical style enframed each scene.

Moreover, as he had done in the Sistine Chapel and would do in Orvieto, Signorelli worked within the iconographic parameters and probably with theological advisors, perhaps including the abbot and patron, Fra Domenico Airoldi. On the west wall Signorelli painted eight histories of St Benedict's miraculous powers, as narrated by St Gregory.[26] Rather than be confined by

the directives of the commission, Signorelli inventively restated these stories, arranging narrative segments for maximum dramatic impact. He included two scenes never previously represented in painted narratives of St Benedict's life, perhaps motivated by iconographic concerns or by available space.

Although much of the *a secco* painting (paint applied to the surface after the plaster has dried) has worn away, and other areas are badly scratched and damaged, the fine handling of the figures and the power of narration remain visible. In this, his largest and most complex cycle to date, Signorelli extended the curved lunettes at Monteoliveto Maggiore a meter or more below the springing of the arch with *trompe l'œil* architectural decoration to increase the size of the compositions. Decorative designs on the pilasters repeat, again recalling similar illusionistic architecture separating scenes in the Sistine Chapel. At Monteoliveto, Signorelli proved himself a technical master, though he painted more conservatively than he would at Orvieto. He used *spolveri* and incision for transferring his designs.[27] As he would in Orvieto, he successfully concealed the *giornate* (seams delineating a day's work). To give the figures plasticity, he employed hatching for shading, visible only at close range. He used this practice in his drawings, as did contemporary artists Ghirlandaio and young Michelangelo. Signorelli did not use the technique in panel painting, and it appears to be unique to him in fresco painting.

Signorelli also demonstrated his ability to organize complex space with narrative clarity. He placed the part of the story he wished to emphasize in the foreground, and wove the supporting scenes into the mid-ground and background. This organization recalls his collaboration with Perugino and others in the Sistine Chapel fresco of *Christ Delivering the Keys to St Peter*. However, at Monteoliveto Maggiore Signorelli's figures stood larger, more dynamic and closer to the picture plane. The compositions point toward innovations to come at Orvieto. Surely the grandeur of Signorelli's composi-tions attracted him to the authorities in Orvieto, for they also needed a similarly organized, comprehensive concept for their unfinished chapel.

At Orvieto, Signorelli not only built upon his training and prior experience, but several innovations make his work there unusual and extraordinary. The compositional focus on the figure, the mastery of the human form, especially the nude in complex action poses, and the large scale of the figures immediately set Signorelli's work apart from that of his contemporaries. The skill and grace with which he rendered figures in the Cappella Nuova are especially striking when viewed at close range. The subtle modeling, enhanced by the use of hatching, blends together when viewed from the floor. Three of the four lunettes and one half-arch at Orvieto exclusively portray the human figure: *The Blessed in Paradise*, *The Ascent of the Blessed to Heaven*, *The Torture of the Damned*, and *The Resurrection of the Dead*. The last two lunettes focus on the monumental nude. Male figures dominate, as male bodies were considered more perfect than female bodies.[28] The figure looms large at Orvieto, literally and metaphorically. Monumental figures crowd so close to the picture plane that viewers have no escape from the action,

increasing the sense of immediacy to overwhelming, even terrifying, proportions.

Drawings for Orvieto

The documents state that on at least two occasions Signorelli presented drawings for the Cappella Nuova to the Opera del Duomo, although we do not know if any of them are among those that survive.[29] Several figure studies related to the project in Orvieto show that Signorelli, like his contemporaries Leonardo da Vinci and Michelangelo, worked out ideas in sketches. In addition, two chalk drawings, both depicting the same pair of figures, appear highly finished in the manner of presentation drawings.[30] Scholars have long recognized Signorelli's ability as master draftsman with a remarkable facility for handling the human figure in both types of drawing. Presentation drawings and sketches emerge simultaneously in the late quattrocento and, by the early cinquecento, appear often. In addition, more drawings survive from this time forward, the value of a drawing by a respected artist increased dramatically, as did the availability of paper to replace the more expensive, not to mention less desirable, uneven surfaces of animal skin, vellum and parchment.

The two aforementioned chalk drawings, both entitled *Nude Carrying a Corpse on His Back* (Fig. 3.4), can be identified with two specific figures in the lower right of the fresco of *The Torture of the Damned* (Pl. 16).[31] They are surely the most sublime of Signorelli's known drawings. A nude male figure standing in a gentle contrapposto stance arches his powerful back to bear the weight of the nude corpse slung across his shoulders. This figure shows Signorelli's fine understanding of human anatomy, both in form, though some schematization is apparent, and in his ability to make it a vehicle of subtle expression. The figure's back demonstrates the artist's familiarity with late antique statuary, such as the *Torso Belvedere* (Vatican Museum), which he would have seen in Rome. The slighter build of the corpse, on the other hand, could be that of a woman. With his left arm firmly planted on his relaxed hip, the man confidently cradles the left leg of the corpse with his right arm. The left arm of the corpse droops flaccidly across the left arm of the man who carries it. Limp and drained of the color of life, the corpse appears 'dead to the very nails', as Signorelli's older contemporary, Leon Battista Alberti, when giving directives on how to depict a corpse in his *Della Pittura*, described the body of the ancient hero Meleager.[32] Alberti, who valued such a subtle display of skill, would have especially approved the contrast between the power of the living and the flaccidity of the dead.

The drawing of four male figures in combat, *The Demon and the Damned*, strikingly resembles the tormented figures in *The Torture of the Damned* and the figures in the tondi surrounding the oak-crowned author on the west wall.[33] This red-and-black chalk drawing on natural colored paper has a

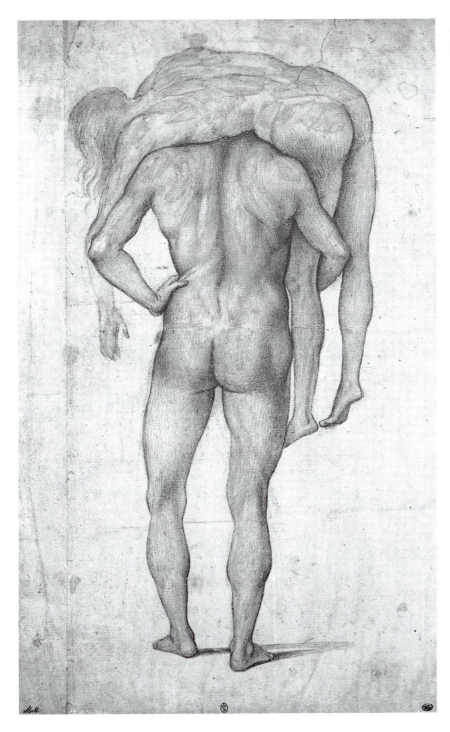

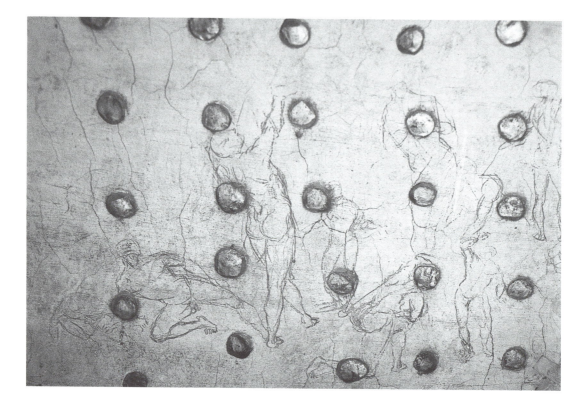

3.5 Signorelli, sketch, Resurrecting Bodies, detail from upper portion of *The Resurrection of the Dead* (author)

faint grid on the back. Small holes around the central standing figures and cut marks around the profile of the face give evidence of transfer. Among other drawings close to the Orvietan fresco cycle are two struggling nude figures; a standing male and a kneeling female; two pairs of figures, two women and two men in combat; and a drawing in black chalk (perhaps graphite) of the standing *Archangel Michael*.[34] The archangel figure resembles the center archangel in the upper part of *The Torture of the Damned*. Each drawing shows Signorelli's skill at rendering human figures in action, but none depict specific figures in the Orvietan frescoes.

The most remarkable of the drawings to survive are the small, black carbon figures that Signorelli drew directly on the upper part of the fresco of *The Resurrection of the Dead*, between the heads of the trumpeting angels (Pl. 17; Fig. 3.5). The sketch measures approximately 70 cm by 35 cm, with no figure taller than about 20 cm. Visible only at close range (or with binoculars), the figures could be seen more clearly during the 1990s restoration, when the scaffold allowed access to them.[35] The twelve figures depict nude men in a variety of active poses, stretching with new life. Signorelli never intended the figures to be a part of the composition; the *pastiglia* and gold leaf that originally obscured them have partially worn away with time. No figure recurs in the composition below, though the subject of the drawing is clearly *The Resurrection of the Dead*. Neither did they function as mystical figures moving closer to God, for they are too small to be visible from below.

Signorelli's intention seems to have been to work through ideas, planning the composition to be painted below.

The eve of the contract

Thus, on that spring day when the Opera del Duomo agreed to hire Luca Signorelli to finish the work in the Cappella Nuova, no other painter in Italy was better fitted for the job. Signorelli had an impeccable reputation, an impressive œuvre, and experience with prestigious patrons. He was reliable, capable and, perhaps at this point most important of all, agreeable and willing. For the artist, the primary motivating force was hardly salary. The commission and payments were sparingly meted out. Documents later record complaints by the artist that he was operating at a loss.[36] In the end, Signorelli was forced to enlist Guidobaldo di Montefeltro, duke of Urbino, to intervene on his behalf to secure final payment.[37] For Signorelli, the incentive must have been the opportunity: he was in town on the eve of the commission. The Opera offered, and he quickly accepted, one of the most prestigious commissions available, and potentially one of the largest. Although Signorelli would honor the wishes of the Opera, including making his figures compatible with those of Fra Angelico,[38] in the end his powerful vision, the seeds of which are evident in his previous work, would prevail. The final product would be dynamic and extraordinarily innovative in style and iconography, demonstrating contemporary rhetoric, theology and humanist scholarship. Surely in those first days of April 1499, Signorelli must have been full of anticipation.

4
In Festo Omnium Sanctorum

Signorelli's initial contract

The initial contract between Luca Signorelli and the Opera del Duomo of Orvieto for the remaining two *vele* of south vault of the chapel, dated 5 April 1499, came with many conditions,[1] a factor that did not seem to impede the artist. He quickly satisfied this contract, his first of three, completing the work between 25 May and 25 November 1499. His phenomenal speed, coupled with the fact that the ribs had been decorated throughout the vaults by Angelico's shop, supports the theory that Angelico left sketches, and therefore iconography and inscriptions, on the *intonaco*.[2] The contract stipulated that Signorelli had to paint all figures from the waist up, be present for all painting and mix the colors himself. His figures were to be 'as beautiful and perfect … conforming and similar to the figures that are in the said chapel'. The Opera required that he follow their directions, maintain the theme of judgment and keep his style compatible with Angelico's and, presumably, his program, which would need to fit into the implied iconography of the cathedral as a whole. Perhaps Signorelli understood from the beginning that the iconography for the Cappella Nuova would include a gathering of the saints at the End-time, a theme that, as I will demonstrate in this chapter, becomes more evident in the north vault; perhaps this expansion developed from conversations between the artist and his theological advisors.

South vault: the heavenly court fulfilled

APOSTLES

Fra Angelico's *desegni* initially guided Signorelli's work as he filled in the missing parts of the Last Judgment in the south vault (Pl. 11). The Prophets already in place at the left hand of Christ sat in expectation of their counterpart, the Apostles. Signorelli included with them the Virgin Mary and placed her closest to the right hand of Christ to balance the earlier figure of John the Baptist who leads the Prophets. A ghostly halo to the left of the Virgin indicates that he resituated her, bringing her closer to the other figures in the composition. The inscription, GLORIOSUS APOSTLORUM CHORUS, or the Glorious Company of the Apostles, demonstrates a continuation with the

liturgical source quoted by Fra Angelico in the inscription under the Prophets, for it recites the succeeding line from the *Te Deum laudamus*. *Spolveri*, especially visible in the beard of St Peter, reveal that Signorelli used pricked cartoons to transfer drawings.

Occasionally in medieval and Renaissance Last Judgment compositions, the Madonna and John the Baptist lead the Apostles and Prophets respectively, with their positions flanking Christ as intercessors simultaneously forming a Deësis configuration. Today's audience might not immediately recognize the Deësis; in fact, published literature on the chapel does not discuss it. Nevertheless, fifteenth-century worshipers would have recognized the imagery as a subtle reminder of God's grace.[3] Together with Christ the Savior, the Virgin Mary and John the Baptist emphasize the redemptive powers of Christ and support the message of salvation through penance that unfolds in the chapel, a message in which intercession and mercy are essential components. They harmonize with iconography for the dedication of the chapel to the Assumption of the Virgin, the Last Judgment and the celebration of the Mass.

Liturgical texts inspired another meaningful configuration that the fifteenth-century audience would have recognized but that modern scholars have not mentioned. Prominently seated in the front center among the Apostles, St Peter, who holds a pair of gold and silver keys, sits beside St Paul, who clutches a sword. Although St Paul is not an apostle in the strictest sense, the pairing occurs often in medieval art;[4] the basis lies in the liturgy, especially in the Eucharistic prayer from Rite I of the Roman Mass:

In union with the whole Church we honor Mary, the ever-virgin mother of Jesus Christ our Lord and God. We honor Joseph, her husband, the apostles and martyrs, Peter and Paul, Andrew, James [the Major], John, James [the Less], Philip, Bartholomew, Matthew, Simon and Jude … May their merits and prayers gain us your constant help and protection …[5]

Thus, Sts Peter and Paul, along with the Virgin Mary, appear in the fresco as they do in the liturgy: as first among the apostles and as a pair. Hymns for the Feast of All Saints call upon the intercessory powers of the Virgin and single out Sts Peter and Paul:

> Alma cunctorum celebremus omnes
> Festa sanctorum, modo qui micantes
> Aetheris regno sine gaudent
> Gaudio magno.
>
> Prolis aeternae genitrix Maria,
> Unicum mundi decus et honestas
> Spenddet insignis solio nitenti
> Inclita virgo.
>
> Cum suis Petrus sociusque Paulus,
> Regis inmensi proceres, triumphant
> Atque festivas clamides amicti
> Stemmate vernant.[6]

The final apostle with individual characteristics is John the Evangelist, who sits above and slightly to the left of the Virgin, and thus closer to Christ than any other apostle. Beardless and youthful, he holds an open book that faces the viewer and points to the page with his right hand. His elevated position and the open book on his lap – probably his apocalyptic writings – give further support for the intention of the Last Judgment.

ANGELS SIGNIFYING THE JUDGMENT

Angels holding the instruments of Christ's Passion fill the final *vela* in the south vault. Such angels commonly appear in many Last Judgment com-positions, including prior works by Fra Angelico and Giotto, and the subsequent one by Michelangelo. Eight androgynous youths fill the triangular space. Two pairs of angels stand in the center to support the cross and the column; four hold the sponge, the nails, the lance and the crown of thorns. In each corner, another pair of angels vigorously blows trumpets. Usually these standard bearers appear above Christ; they can be understood to do so here as well. Head to head with, and yet at the same time facing, the Savior, as only the curved vault would allow, the pairing creates a cause-and-effect correspondence: Christ, displaying his wounds of the Passion, faces the instruments of his torture. Although the inscription does not recite a liturgical text, the wording, 'SIGNA IUDICIVM INDICANTIA', places unusual emphasis on judgment and draws a parallel between the unfair judgment of Christ and that perfect judgment by Christ at the Second Coming. The instruments also emphasize both the humanity of Christ and the corresponding miracle of Christ's flesh in the Eucharist.

'Masters of the Sacred Page'

Signorelli's work in the south vault evidently satisfied the Opera del Duomo, for they wished him to continue with the north vault. At this point, since his initial contract was for the south bay only, he stopped and consulted with the Opera, who directed his attention to verbal advice he received from a group of theologians, as recorded in the document dated 25 November 1499.[7] The Opera del Duomo, we recall, was a lay board, as it is today, functioning much as a modern vestry.[8] Such a board would handle contracts and oversee the work. They would have approved the theme, but doubtfully the details, of the theological content of the frescoes. The contract implies that Fra Angelico's *disegni* included only the south vault, and that, based on Angelico's beginnings, local theologians developed the rest of the iconography. The document clearly instructs Signorelli to follow their direction.

The broader implications of this encounter are important, for the document provides greater insight into Signorelli's program and artistic practices in general than usually recognized. As scholars have noted, this is the first record of an artist receiving theological advice.[9] The wording of the document

indicates that they, not members of the Opera board, primarily advised Signorelli and confirms what modern scholars suspect: that theologians routinely advised artists on matters of religious iconography.[10] The brief mention of the advisors, and only after Signorelli requested the subject of the paintings for the north vault; the lack of detail; and the absence of mention in later documents together indicate a procedure so commonplace that records simply were not kept. Moreover, the manner of the advising, also implied in the document hiring Fra Angelico, appears to have been that of informal discussions. The artist probably presented sketches to the theologians, as the documents indicate Signorelli did to the Opera. Discussion would have ensued, from which sketches for the full Opera board would have evolved. The informality would allow free exchange both on the part of the artist and of the advisors and for changes as the work progressed. Surely other artists conversed informally with theological advisors. Artistic programs often developed in phases, as appears to be the case at Orvieto. Michelangelo's project for the Sistine Ceiling, for example, changed and grew more complex as he, and presumably his advisors, developed the iconography for the program. His remaining drawings and a letter document his early ideas and his process toward erudite meaning and extraordinary grandeur,[11] inspired, in all likelihood, by Signorelli's model at Orvieto.

The contract, moreover, identifies Signorelli's advisors as: '*venerabiles Magistros Sacre Pagine hujus Civitatis*', or 'venerable Masters of the Sacred Page (Holy Scripture) of our City'. Scholars have disregarded the title as ornate language; however, it actually indicates well-educated theologians, the equivalent of university faculty today. In Orvieto, such faculty served the *studium generale*, adjacent to the imposing Church of S. Domenico (some eighty meters in length) in the northeast precinct of the city and a ten-minute walk from the cathedral. The local Dominicans had operated the *studium* for over 270 years.[12] It was appropriate that they, rather than laymen, should direct Signorelli. In the final chapter, I will demonstrate that Signorelli's paintings resemble Dominican spiritual expositions and the writings of Dante (who was educated by the Dominicans), thereby confirming the identity and role of these advisors. Finally, the plural form specifies that a group of local theologians directed Signorelli, diminishing the theory of a single advisor. However, perhaps one or two scholars served in a closer advisory capacity than others. The unrecorded conversations implied in the document would provide the ideal avenue for the artist and a lead advisor or two to meet informally. These scholars were ideal advisors for expanding a program that had been started a half-century before by a fellow Dominican.

Antonio Albèri and Fra Tommaso

If Signorelli had a lead advisor or perhaps two, they would have been scholars closely associated with, if not one of, the local resident humanists or the Dominican theologians at the local *studium generale*. Two possibilities

have emerged, one from each group. The undisputed leader among humanist intellectuals in Orvieto in the late fifteenth century was Antonio Albèri (d.1506). Many scholars believe that Albèri played a role in forming the iconography of the chapel.[13] He would have been an ideal advisor, though his association with the Dominicans there and evidence of his role in Signorelli's iconographic plan are circumstantial. A noble native of Orvieto, Albèri held doctor-of-laws degrees (both canon and civil), maintained a palace in the city and patronized civic and cathedral projects. He served as archdeacon, canon, and librarian of the cathedral.[14] Albèri would have known other local humanists; he had also moved in humanist circles in Perugia, where he was a lecturer of the *studio*, or school, at a time when Signorelli might have met him while he was working there.[15] His ties to papal circles included forty-four years as advisor and secretary to the Piccolomini family. He first served Archbishop Aeneas Silvius Piccolomini, later Pope Pius II, and tutored his nephew, later Pius III. Among the few appointments made by Pius III during his three-week papacy was to ordain Albèri as bishop of Sutri and Nepi, small cities just north of Rome, along the road to Orvieto.[16] With these connections, he probably moved in Roman humanist circles as well.

Orvietan scholar Luigi Fumi cites Cardinal Balbo's *Commentario* and notary Tommaso di Silvestro's contemporary diary, both of which, he claimed, credit Albèri with advising Signorelli on the iconography of the program. He also mentions Albèri's library and his illuminated choral manual as confirmation that this man advised Signorelli.[17] Whereas the presence of the library and illuminated manuscript alone do not substantiate the claim that Albèri advised Signorelli, details about them support his association with the Cappella Nuova and the Dominican Order. The library, built between 1489 and 1501 to house some three hundred books, fits along the south wall of the tribune of the cathedral, abutting the Cappella Nuova and the first Palazzo Papale.[18] The fresco program in his library bears conceptual resemblances to the iconography of the Cappella Nuova. The humanist ideas, the mix of contemporary and traditional meaning, and the program of famous authors have much in common with the iconography of the Cappella Nuova. The two programs probably would have had more in common had Albèri lived to complete his library.[19] The presence of a contemporary program in such close proximity to the Cappella Nuova that resembles it in concept (that of a series of famous scholars), especially in the theme of the lower walls of the chapel, supports the theory that Albèri played a major advisory role in the iconography of the Cappella Nuova.

Finally, Albèri's choral book, to which Silvestro refers, illuminated by Fra Valentino d'Ungheria, initially belonged to the library of the Dominicans in Orvieto ('*biblioteca di padri Predicatori*'). Subsequently it was transferred to the archives at Opera del Duomo, where it remains today.[20] The Dominican authorship of this book indicates that Albèri had an association with the Dominicans in Orvieto; the fact that it rested in their library may be even more significant. Another manuscript bearing Albèri's *stemma* (coat of arms)

has an unusually lengthy entry for the Feast of All Saints.[21] The extensive enumeration and elaboration of the groups of saints, the same ones that appear in the vaults of the Cappella Nuova, lend further credence to Albèri's role in the iconography of the Cappella Nuova.

Finally, in 1504, Albèri presented his own design for paintings to adorn the walls of the crossing of the cathedral of Orvieto, and offered to bear the expense himself.[22] The proposal never materialized. By then, Albèri was a bishop in nearby cities, and as Fumi suggests, he was busy with the decoration of his library. He died the following year. It is important, however, that Albèri did devise the plans for two painted spaces in the cathedral. The designs of the illuminated choral books and these two fresco programs, one of which we know to be erudite, would indicate his qualifications to counsel Signorelli on iconography for the Cappella Nuova.

A second important theologian in Orvieto, Fra Tommaso, was not only closely associated with Albèri, but would have been an important link to humanist circles in Rome. A Dominican and native of Orvieto, Fra Tommaso served in 1455 as prior of S. Domenico, then as a *magister* (master teacher)[23] at the *studium* of the Sacred Palace at the Vatican in the 1480s. The Masters of the Sacred Palace also advised the pope on matters of doctrine. Fra Tommaso would have been part of the humanist circle in Rome that had revived classical and medieval literature and rhetorical practices; he also would have known the Roman churchmen who maintained residences in Orvieto. In 1493, he returned to Orvieto from Rome to become prior of the Dominican *studium* in Orvieto.[24] With his background, experience and position among the local theologians named in the documents, he, too, would have been a logical advisor to work closely with Signorelli on details of theology.

The north vault: the saints in glory

In the second phase of decoration, Signorelli's painting style and iconography increased in complexity. No longer constrained by Fra Angelico's drawings, the artist continued in the north vault with more stylistic freedom. His work, however, complemented the earlier master's style and continued his iconography (Pl. 11). Fra Angelico's reserved Prophets sit against a gold background, frozen forever in a timeless space. Like friars at prayer, they appear self-absorbed and reflective. On the other hand, Signorelli painted with intensity and sweeping energy. The larger figures, pressed closer to the picture plane, exhibit greater movement as they turn and converse with one another like humanist theologians engrossed in discussion. In spite of the eternal quality imposed by the gold background, Signorelli appears to have captured a moment in time.

In the south bay, Signorelli and his theologians expanded Angelico's judgment theme in the vaults to include a gathering of the elect at the Judgment, a logical outgrowth implied in the inscriptions from the *Te Deum laudamus*, which Signorelli would continue. The remaining four *vele* hold

Martyrs, Doctors of the Church, Patriarchs and Virgins, who represent the community of the faithful, the virtuous who have earned a place in heaven, which emphasizes the promise of heavenly reward for those who seek it. The inscriptions alone, however, present insufficient evidence to tie the vaults to the Feast of All Saints, for the *Te Deum laudamus* is not exclusive to that feast. However, the liturgical texts for the feast confirm the correlation between frescoes and liturgy.

The Feast of All Saints originated in 610 with the dedication of the Pantheon in Rome (an ancient temple built to honor all the gods) as a church to honor all the saints, especially those less-recognized saints who have no appointed feast day. The feast also celebrates Christ's victory over the pagans.[25] All Saints' Day and the following Day of the Commemoration of the Dead continue to be important, especially in Italy. The first reading for the Feast of All Saints, Ecclesiasticus 44 (from the Apocrypha rather than the usual Old Testament source), names a few virtuous persons, but most of those extolled are long forgotten by name; their deeds, however, are important in the sight of God.[26] The New Testament reading, Revelation 7:2–12, commemorates the triumph of Christ over false gods, creates a vision of the judging Christ and echoes the promise of eternal life. The decoration of the vaults follows scripture: Christ sits in judgment, surrounded by groups of holy persons, some of whom have identifying attributes, although most remain anonymous.

The third and last group of saints that the *Te Deum laudamus* specifies, the Martyrs, bears as an inscription the next sequential line of that hymn: MARTYRUM CANDIDATUS EXERCITUS: 'Te gloriousus Apostolorum chorus, te Prophetarum laudibilis numerus: te martyrum candidatus laudat exercitus: te omnes electi voce confitentur unanimes beata trinitae, unus deus …'[27] The remaining *vele* have descriptive inscriptions that allude to liturgical texts for All Saints' Day: NOBILIS PATRIARCHARUM CETUS, DOCTORUM SAPIENS ORDO and CASTARUM VIRGINUM COHORS. Thus, the six groups of saints in the vaults, when viewed as an entirety, concur with the groups of the faithful who will receive heavenly reward indicated in the Gospel lesson for the Feast of All Saints: the Beatitudes (Matthew 5:1–12). The Apostles represent the poor in spirit, the Prophets are those who mourn, the Patriarchs represent those who hunger and thirst after righteousness, the Virgins signify the pure in heart, the Doctors of Wisdom, or Confessors, embody the peacemakers and the Martyrs are those who are persecuted for righteousness' sake.[28] The antiphon, or musical response to the Gospel reading, recounts these groups of angels and saints: 'Angeli, archangeli, throni, dominationes, principatis, potentates, virtutes celorum: Cherubim, atque seraphim: partiarche & prophete; sancte legis doctores, apostoli omnes, Christi martyres, sancti confessores, virgines domini, anachorite, sanctique omnes, intercedite pro nobis.'[29] Moreover, the liturgy for the Feast of All Saints in Albèri's fifteenth-century choral book elaborates upon the same groups of saints as those in the vaults, naming each group and pleading intercession.[30] These unique hymns indicate that in Signorelli's day, this feast was especially revered in Orvieto.

The liturgical texts for the Feast of All Saints as well as texts read during the Advent season also support the aforementioned Deësis configuration. The texts invoke the intercession of these figures, including John the Baptist, along with the groups of saints illustrated in the north vault.[31] Supporting literature reflects the Deësis composition as well. The Virgin and John the Baptist lead processions of saints in the vision of the gathering of all of the saints put forth in *The Golden Legend*.[32] They also play important intercessory roles in the Orvietan *Rappresentazione sacra*, or liturgical drama, for the Feast of All Saints, a drama that does not regularly occur in other cycles.[33] The drama concurs with the standard liturgical texts as well as with those used at Orvieto Cathedral. The text, written in Italian verse, paraphrases the liturgical texts for All Saints' Day. The drama begins with Christ surrounded by all of the court of Paradise, including the Virgin and John the Baptist, who come to celebrate Mass. The groups of heavenly hosts and saints enumerated in the antiphon cited above also participate in the liturgical drama. Angels, archangels, virtues and potentates speak first, followed by the Virgin Mary, Patriarchs, Prophets, Virgins, St Peter, John the Baptist, a priest, a scholar, Martyrs, Doctors and Confessors. The saints look down on the world and sing praises to Christ, as they seem to do in the Cappella Nuova. The saints sing a *Sanctus*, a standard text used during Mass. Another hymn sung in the drama reflects words of the Beatitudes. The drama concludes with petitions for the forgiveness of sins and a glorification of Christ, the Lamb of God.[34]

In addition to reflecting liturgical texts, the arrangement of the groups of saints in the vaults reflects liturgical practice. The Patriarchs form a pair with the adjacent Prophets in the *vele* of the west vault, a pairing that also occurs in the antiphon cited above. These Old Testament figures fill the liturgical left side of the chapel, that from which the priest reads the Old Testament lesson. Facing the Patriarchs, Doctors of the Church occupy the *vela* beside the Apostles. The Apostles and Doctors fill the liturgical right, the side from which the priest reads the Gospel lesson.[35] The configuration is hierarchical, with Prophets and Apostles seated closest to Christ. Additional hymns for the Feast of All Saints recount the same groups of saints in hierarchical order. As in the liturgical drama and the liturgy, hymns for that feast also invoke the intercession of the Virgin Mary and John the Baptist and concur with the Deësis configuration begun by Fra Angelico.

The following hymn occurs in many liturgical manuals for the Feast of All Saints, including those in Orvieto:

> Jesu Salvator sæculi
> Redemptis ope subveni:
> Et pia Dei Genitrix
> Salutem posce miseris.
>
> Coetus omnes Angelici,
> Patriarcharum cunei,
> Et Prophetarum merita
> Nobis precentur veniam.

Baptista Christi prævis,
Et Claviger æthereus,
Cum ceteris Apostolis,
Nos solvant nexu criminis.

Chorus sacratus Martyrum,
Confessio Sacerdotum,
Et Virginalis castitas
Nos peccatis abluant.[36]

PATRIARCHS

The Patriarchs, identified with the inscription NOBILIS PATRIARCHARUM CETUS, were the Hebrew leaders. The number in the vaults does not correspond to those in the Bible, for the *vela* could never accommodate all; thus, Signorelli, following the spirit of the Feast of All Saints, balanced generalized, universal figures with a few specific ones.[37] Few have distinguishing attributes. The elderly bearded figure in the center of the front row probably represents Abraham, flanked by Jacob, Isaac and Joseph.

DOCTORS OF THE CHURCH

The inscription DOCTORUM SAPIENS ORDO, or the Order of Wise Doctors, identifies fifteen doctors of the church, who are listed in the liturgical drama and in the vespers liturgy for the Common Commemoration of Saints.[38] Individual dress and attributes identify most of the theologians with reasonable certainty. The four Fathers of the Latin Church sit on the front row: St Basil as a bishop, St Jerome as a cardinal, St Gregory the Great as a pope and St Augustine as a bishop. St Thomas Aquinas, tonsured and wearing a Dominican habit of a white robe and black cappa, sits behind Sts Gregory and Augustine, and leans forward to converse with them. The prominence Signorelli gave Thomas Aquinas concurs with the important role his writings play in the iconography of the Cappella Nuova. Particularly notable are his *Summa Theologica* and his *Summa Contra Gentiles*, the latter written while he resided in Orvieto. Although such iconographic emphasis on Aquinas is unusual outside of Dominican structures before the Council of Trent, his presence indicates the important role the local Dominican advisors played in advising Signorelli and the awareness of the recent humanist revival in Rome of Thomist theology.

The second row contains five figures. St Bonaventure wears a Franciscan habit, the cowl visible beneath the elaborate cope that indicates his office of cardinal–bishop of Albano. St Francis and St Dominic, wearing habits of their Orders, flank St Bonaventure, just above St Thomas Aquinas. As the founders of the first two and most important Mendicant Orders, these saints often appear together in Italian art. A Franciscan friar and St John Chrysostom, dressed in bishop's attire, form the pair on the right. St Bernard of Clairvaux, wearing a Cistercian's white habit, sits above St Bonaventure. Important as a theologian, and one with whose Order St Dominic was first associated,

Bernard also defended the faith against the Cathars in southern France. To his right is an elderly Dominican, perhaps Albert the Great, teacher of Thomas Aquinas. St Anselm, bishop of Canterbury and one of the fathers of scholasticism, St Anthony of Padua, a Franciscan, and another anonymous Franciscan sit at the top. Local preferences rather than papal decree dictated the choice of most of the doctors represented; few were among the official Doctors of the Church sanctioned by the Roman Church in 1499, although subsequently some received the honor.[39] Instead, these men represent founders of the Mendicant Orders and theologians deemed appropriate to the by the Masters of the Sacred Page of Orvieto.

MARTYRS

The seven Martyrs, MARTYRUM CANDIDATUS LAUDAT EXERCITUS, all men, sit between the Doctors and the Patriarchs. Just as the groups of the saints along the side walls are arranged according to a liturgical format, so the longer *vele* that lie parallel to the altar have symbolic arrangement. The Martyrs sit foot-to-foot with the *Angels with the Signs of Judgment* in the south vault and head-to-head with their female counterparts, the Virgins, in the corresponding *vela* of the north vault. They line up with the *Signs of Judgment* and *Christ*, for they, like Christ, were unfairly judged and condemned to death for the Church. Following the lead of the figure groups in the south bay and the adjoining *vele* of Virgins and Patriarchs, these figures are mostly anonymous. The dress of five Martyrs indicates their office. St Stephen, the first Christian martyr, wearing the garb of his office of deacon, sits in the center between two bishops. Positioned slightly lower are two more deacons, holding books. Two more figures occupy the corners.[40]

VIRGINS

The inscription, CASTARUM VIRGINIS COHORS, identifies eight women wearing flowing robes in the *vela* over the doorway as the *'Retinue of Chaste Virgins'*.[41] The figures are slightly smaller and closer together than those in the other groups to accommodate the pair of Monaldeschi coats of arms in the lower corners. Six women hold books or scrolls in the manner of the sibyls (pagan prophetesses) who often appear in Renaissance art as parallel female figures to the Old Testament prophets. Three carry palms of martyrdom, making their head-to-head placement with the Martyrs and alignment with the Signs of Judgment and Christ all the more appropriate. The woman at the top center wears a white-trimmed dark veil, perhaps the habit of a nun. The women flanking her also cover their heads with veils; the others wear their veils as shawls.

An intriguingly beautiful, richly dressed woman seated in the front center conspicuously offers forth in her upraised left hand a silver-covered ointment jar (Fig. 4.1).[42] It has not always been recognized that this figure, leader of the Virgins, represents Mary Magdalene, an image that conforms to a tradition

4.1 Mary
Magdalene. Detail
of central figure
among the Virgins
(author)

with early Christian origins.[43] The attribute verifies this identification, as
that symbol belongs to Mary Magdalene alone of all female saints.[44] Her
right hand, lowered, palm up, seems to beckon the viewer to her. Second,
her abundant uncovered fair hair, flecked with gold leaf in the manner of
Botticelli's Venus (*Birth of Venus*, *c.* 1485, Uffizi, Florence), drapes across her
shoulders and is elaborately knotted in front. Her elegant, rose-colored cloak
encloses a turquoise gown, lavishly decorated with golden *pastiglia*. Both the

golden hair and rose-colored costume conform to the traditional depiction of the Magdalene.[45]

Directly below Mary Magdalene, at the top of the archway over the door, a cherub supports a white circle inscribed 'OPSM' (the monogram still used by the Opera del Duomo), which resembles a Eucharistic wafer (Pl. 18 and Fig. 5.2). The symbolism fits, as the wafer not only recalls the Eucharist, but also it relates to this saint. Mary Magdalene lived forty years in the desert, praying continually. At certain times during the day, angels elevated her and fed her heavenly manna.[46] Her penance was sufficient not only to regain purity of heart, the virtue of virginity, but also the lead place among the Virgin saints.

The theological writings of Thomas Aquinas concur with the portrayal of Mary Magdalene as a virgin. He states that virginity alone is not a virtue, since it is in humans by nature. However, when considered in relation to chastity, Aquinas deemed virginity a special virtue, especially in cases where it is maintained to safeguard integrity. Aquinas states that although physically virginity lost in sin cannot be recovered, the virtue of virginity, purity of heart, can be restored through penance: 'In a like manner a person who has lost virginity by sin, recovers by repenting, not the matter of virginity but the purpose of virginity ...'[47]

MARY MAGDALENE: THE EXEMPLARY PENITENT SINNER

Mary Magdalene serves the greater metaphor in the chapel. Of all the saints in the chapel, she recurs most often, four appearances in all. She is essential to the Resurrection iconography in each of the facing *cappelline*, or little burial chapels, recessed in the north lower wall socle. Here she fills her earthly role as a virtuous Christian, as opposed to her heavenly role among the saints in the vaults. She appears in the center of the Pietà composition along with the city's martyr saints and the Virgin Mary, in the 'Cappellina della Pietà' (Pls 3 and 24). The position suits in many ways. First, the Bible records her presence at the Crucifixion and that she was the first witness to the Resurrection. Second, earlier in the fifteenth century she was declared a patron saint of Orvieto.[48] Her final appearances occur in corresponding compositions in the facing *cappellina* dedicated in her honor, the 'Cappelle Sancta Maria Maddalena', under the Antichrist, now destroyed. First, the lunette once depicted the *Resurrection of Lazarus* flanked by his sisters, Mary Magdalene and Martha. Moreover, she and Martha faced each other in the tondi in the side walls.[49] The surviving altar panel depicts Mary Magdalene with uncovered golden locks dressed in a rich, red cloak. She extends her left hand, as she does in the vaults to display a large ointment jar, identical in shape to that above (Fig. 4.2).

The donors, the Monaldeschi family, and the Dominican Order also revered Mary Magdalene.[50] Orvietan citizen and Dominican friar Trasmondo Monaldeschi commissioned an altarpiece by Simone Martini (*c.* 1320) in which Mary Magdalene presents him to the Virgin Mary (Museo Opera del

4.2 Altarpiece of
Mary Magdalene,
Museo del Opera
del Duomo, Orvieto
(Archivo Photos
Moretti, Orvieto)

Duomo, Orvieto).[51] Moreover, an illustrated Orvietan choral manuscript once owned by Antonio Albèri holds a vespers hymn for the feast of St Mary Magdalene that once resonated throughout the cathedral, telling of the penitent saint, absolved of her sin, being translated into glory.[52]

Mary Magdalene's penance and devotion, moreover, are extolled by the author of the *Ovide moralisé*, whose work, as we will see, appears in the socle and contributes to the greater message of the chapel. The author obliquely

paired Mary Magdalene with St Paul, for, like him, she converted from a life of extreme sinfulness to one of deep penance and dedication to Christ, demonstrating that those who were most sinful proved most fervent repentant Christians. She also proved, according to that author, that a woman's faith was more ardent than a man's.[53] This medieval allegory concurs with her seat of honor: Mary Magdalene faces Christ across the vaults of the chapel as first among the Virgins, first among the penitent and faithful. Mary Magdalene fits into the devotional life of the Church and the Cappella Nuova as the exemplary penitent sinner. She also fits into the iconography for Corpus Christi, and frequently appears in manuscript illuminations for that feast (Fig. 6.2).[54] Repeatedly in the Cappella Nuova, she provides a beacon of hope and promise to the worshiper, illustrating the individual's responsibility to merit his or her own fate through penance and affirming the reward of redemption available to those who truly repent.

New contract, new vision

Signorelli's third and final contract marks an era when the Opera del Duomo showed greater confidence in the artist; for him, it signified the beginning of a new vision and greater freedom. Again, he had proved capable, willing and prompt. Documents indicate he finished by January 1500. Such speed demanded the assistance of a large workshop. That payroll contributed to Signorelli's complaint of 6 January 1500 to the Opera that he was working at a loss and needed compensation, which they gave him.[55] By February, when the weather does not permit fresco painting, Signorelli had left Orvieto for Cortona. He returned to Orvieto by 23 April, for a document records that he had presented drawings (disegni) to the Opera for the entire project. Four days later, the Opera awarded him a detailed contract and the final payment for the vaults.[56]

Rather than mete out the commission, as they had done before, the Opera authorized Signorelli to proceed with the judgment theme. He agreed to work with the histories given to him, implying that he continued to work with advisors, though this time the Opera did not specifically charge him to consult with them. The contract further indicates that Signorelli presented designs for three upper walls, but that the arch over the doorway remained unresolved.[57] Signorelli extended the Last Judgment into the upper walls and expanded the scale, subject, iconography and vision to unprecedented heights, producing a compellingly dramatic vision. Free of the limitations imposed by the narrow vele, Signorelli had liberty to invent within the proscribed boundaries.

Using illusionistic architectural motifs and linear perspective, reminiscent of the division of the walls of the Sistine Chapel, Signorelli transformed the Gothic chapel into a seemingly deeper and wider space.[58] He so adeptly extended the architectural elements below the springing of the Gothic arches that the viewer can hardly discern where actual architectural components

stop and illusion begins. One glance into the distinctly Gothic Cappella Corporale across the cathedral, similar in size and shape, illustrates his brilliant ability with illusionistic space and his novel reorientation of the vertical thrust of the architecture. He abandoned the tradition of stacking paintings on the walls, usually three high, as Ugolino de Prete had done in the Cappella Corporale and Fra Angelico had done in Rome (and probably would have done at Orvieto), and as Ghirlandaio was currently doing in the church of S. Maria Novella in Florence. Instead, he used expanded-field, continuous narrative compositions as he had done at Monteoliveto Maggiore.

Signorelli boldly focused on the figure in a way not seen before. He increased the scale of the figures, making them even larger than those in the vaults, and pressed them equally close to the picture plane, often spilling them beyond the fictive architectural frames. In an equally unusual manner, Signorelli set the events against a timeless empty landscape, void of vegetation and architecture, and gilded the sky, devices which make the setting universal. The gold sky united Signorelli's lunettes with the gold Fra Angelico initiated in the *vele* above. To increase the sense of depth, he sprinkled the golden skies, which gradually faded to blue toward the horizon, with *pastiglia*. Byzantine painters also recognized the value of making settings universal through minimal architecture and landscape and solid gold backgrounds, but without the use of energetic figures that overlap the architectural frame – which at Orvieto bring the picture space and the viewer together. Moreover, although the fictive architecture divides the paintings into arched segments, they should not be viewed as a sequence of events, but rather as panoramic windows through which the viewer experiences all things happening at once. Perhaps theatrical presentations,[59] liturgical dramas that Signorelli witnessed, influenced his dramatic presentation of the figures on a bare stage. Certainly texts from liturgical dramas supplement those of the liturgy in his paintings. As at Loreto, upon entering the chapel viewers immediately feel as if they have entered a theatrical performance in progress. In the traditions of the Mass and liturgical drama,[60] Signorelli's paintings do not commemorate, but enact the mysteries of, the faith. The viewer is a witness, rather than a spectator, to an ever-present reality of future, rather than the usual past, events.

South bay lunettes: *The Last Judgment*

PARADISE AND PUNISHMENT

Surrounding the altar in the south bay, Signorelli depicted an enveloping image of the Final Judgment at the feet of the judging Christ at the moment the angels above blast trumpets to initiate the event: 'Lo! I tell you a mystery. We shall not all sleep, but we shall be changed, in a moment in the twinkling of an eye, at the last trumpet' (I Corinthians 15:51–52). Tradition dictates the placement of the Elect and the Damned on the right and left of the judging

Christ, respectively (Pl. 2). *The Ascent of the Blessed to Heaven* appears on the liturgical right (Pl. 14; or the viewer's left when facing the altar); *The Damned Led to Hell* occupies corresponding position on the liturgical left (Pl. 15). In the adjacent lunettes, *The Blessed in Paradise* and *The Torture of the Damned* expand upon the theme of judgment (Pls 13 and 16). Reminiscent of an oversized altarpiece, the action in the lunettes progresses from outside inward to the altar.

To fill the large lunettes adjacent to the altar, Signorelli expanded the tranditional Last Judgment composition by depicting not only the events that accompany judgment, but also by including departed souls awaiting judgment either in paradise or in a place of perpetual punishment.[61] Here each group tastes the first fruits of their eternal rewards. Several passages of scripture state that immediately after death the soul awaits final judgment in either paradise or in a place of torture: 'then the Lord knows how to rescue the godly from trial and to keep the unrighteous under punishment until the day of judgment …' (II Peter 2:9, NRSV).[62]

Beginning with *The Torture of the Damned* on the liturgical left (Pl. 16), Signorelli replaced the usual nightmarish vision of ghoulish creatures and bizarre torments with an arid landscape depicted in the light of day, which follows scriptural descriptions.[63] All of the figures – angels, damned, and devils alike – have human form. While armored archangels above impassively keep watchful guard, humans and devils below wage vicious hand-to-hand combat, evenly matched – same size and similarly vigorous.[64] Only the devils' horned helmets and lurid skin-tones – depicted in the iridescent colors of putrid flesh – distinguish them from the Damned. Signorelli followed closely the psalm for the Feast of All Saints: 'the wicked see it and are angry; they gnash their teeth and melt away. The desire of the wicked comes to nothing' (Ps. 112:10, NRSV). Related scripture that describes the horror of damnation stresses the eternal separation from God for unbelievers and the wicked: 'in flaming fire, inflicting vengeance on those who do not know God and on those who do not obey the gospel of our Lord Jesus. These will suffer the punishment of eternal destruction, separated from the presence of the Lord and from the glory of his might' (II Thessalonians 1: 8–9, NRSV). In the left corner flames lap toward the adjoining half-lunette that depicts *The Damned Led to Hell*, pointing to the destination of the damned on Judgment Day. Contrasting the fate of the damned, the facing mural depicts *The Blessed in Paradise* (Pl. 13) as they experience the first stage of grace. This scene also echoes the psalm for the Feast of All Saints: 'Happy are those who fear the Lord … They rise up in the darkness as a light for the upright … Their hearts are steady, they will not be afraid; in the end they will look in triumph on their foes' (Ps. 112:1, 4, 8, NRSV).

THE JOURNEYS TO HELL AND HEAVEN

Above the altar, Signorelli set *The Damned Led to Hell* (Pl. 15) on the outer banks of Ante-Inferno, following descriptions in Dante's *Inferno*, Canto III.

The figures are smaller in order to include several scenes in a limited space. In the right corner, devils seize the Damned as they pour over the threshold into Hades. A scarlet, horned Minos, pitchfork in hand, winds his snaky tail around his body as he pronounces judgment on the condemned, who stumble past him toward the bark of Charon. Along the far shore of the River Styx in the background, wailing victims falter toward the flaming pit of hell that roars along the horizon. In an unusual approach, Signorelli depicted the journey rather than hell itself. As in the scripture for Advent, torture remains enigmatic, left to the viewer to imagine.

Signorelli's contrasting portrayal of *The Ascent of the Blessed to Heaven* (Pl. 14) fits several readings for the Feast of All Saints. The white robes in which they are clothed match the New Testament reading for All Saints' Day: 'they have washed their robes and made them white in the blood of the Lamb' (Revelation 7:14, NRSV). Moreover, to leave the depiction of glory to the imagination of the viewer concurs with the Epistle for the Feast of All Saints: 'I consider that the sufferings of this present time are not worth comparing with the glory about to be revealed to us ... For in hope we were saved. Now hope that is seen is not hope ... but if we hope for what we do not see, we wait for it with patience' (Romans 8:18, 24–25, NRSV).

The bliss of the Blessed stands in stark contrast to the frightful plight of the Damned in the adjacent scene of Ante-Inferno; yet, in another unusual interpretation, Signorelli joined *The Ascent of the Blessed to Heaven* with *The Damned Led to Hell* above the altar (Pl. 2). The union is no longer apparent, for the large, eighteenth-century altar hides the composition below the windows. As with Michelangelo's subsequent *Last Judgment* (Sistine Chapel, Vatican, 1535–41), such an ominous proximity of Damned and Blessed over the altar stresses the accountability of each individual, reminding celebrant and communicant alike of the precarious state of each soul as it inescapably stands for eternal judgment and that the final pronouncement rests not on earthly position, but on faith, worthiness, and purity of heart.

INTERCESSION

Three lancet windows over the altar provide the only natural light for the chapel. The splayed surfaces of the jambs provide space for images. In 1503, the Opera filled these windows with clear glass for weatherproofing and to maximize the light in the chapel.[65] The decoration of the window jambs continues the themes of intercession, repentance and salvation. In the jambs of the two smaller windows, Signorelli depicted the four archangels, Raphael, Gabriel, Uriel and Michael, in tondo-shaped frames (Pl. 2). They appear here not as warriors, as they do in *The Torture of the Damned* and *The Damned Led to Hell*, but as intercessors, appropriate to the celebration of the Mass below and to the theme of salvation through penance.

The tondi in the jambs beside *The Damned Led to Hell* show the pair of archangels who brought revelation: Raphael and Gabriel. The outer tondo

depicts the Archangel Raphael with Tobias, who carries a walking stick. Raphael led Tobias through the City of Rages and restored his blindness (Tobit 3:17). The image of deliverance contrasts with the scene of earthly destruction on the adjacent wall. The story forms an analogy to the restoration of sight to the spiritually blind through penance and the Eucharist. The inner tondo shows the Archangel Gabriel of the Annunciation holding a lily in his left hand and in his right hand, a small tablet with an inscription reading '*Ave Maria*'. The messenger archangel complemented the images of the Assumption of the Virgin that once adorned the chapel walls and central window.

Beside *The Ascent of the Blessed to Heaven*, the jambs contain the two archangels who wrestled triumphantly with demons: Uriel and Michael (Pls 2, 14 and 15). The outer tondo holds Uriel wrestling with a demon. The apocryphal Book of Enoch states that Uriel presides over the world and over Tartarus, the lowest part of the underworld: hence the demon. Uriel also speaks on the limitations of human wisdom and the End-time.[66] The inner tondo shows the archangel Michael with scales in his traditional role of weighing souls. The jambs of the tall central window contain full-length, life-size, facing portraits of two locally revered bishop saints, both identified by inscriptions: San Brizio (left) and San Constanzo (right). San Brizio was an early bishop of Tours. San Constanzo of Bernocchi, a Dominican at Santa Lucia in Fabriano (d. 1481) and a younger contemporary of Fra Angelico, was a gifted preacher and prior of San Marco in Florence.[67] A life-size intercessory guardian angel hovers above each bishop, each looking down and playing a lute (Fig. 4.3).

The top of the splayed opening of the central lancet holds one of the most sublime images in the chapel: a remarkable illusionistic painting of a large suspended egg (Pl. 8). The light from the window appears to model the egg and the suspended saucer from which it hangs, casting subtle shadows on the surfaces in front. Often ostrich eggs were suspended over medieval and Renaissance altars to the Virgin.[68] Signorelli's master, Piero della Francesca, used the motif in his *Madonna and Child with Saints* for Federigo da Montefeltro (Brera, Milan, 1472–74). Most often associated with Easter, eggs have long been a Christian symbol of birth and rebirth, hope and resurrection. Kneeling worshipers at the altar would see the egg as they looked up to receive the Eucharistic wafer. Again, such symbolism, situated directly below the enthroned Christ, is a fitting centerpiece for a chapel that stresses divine mercy, redemption through penance and the sacrament of the Eucharist.

The vision: in festo omnium sanctorum

Signorelli, working within the boundaries established by Angelico, un-equivocally confirmed the theme of All Saints for the vaults and south walls of the Cappella Nuova. He beautifully choreographed the heavenly hosts and biblical figures in the south vault to correspond with the saints of this

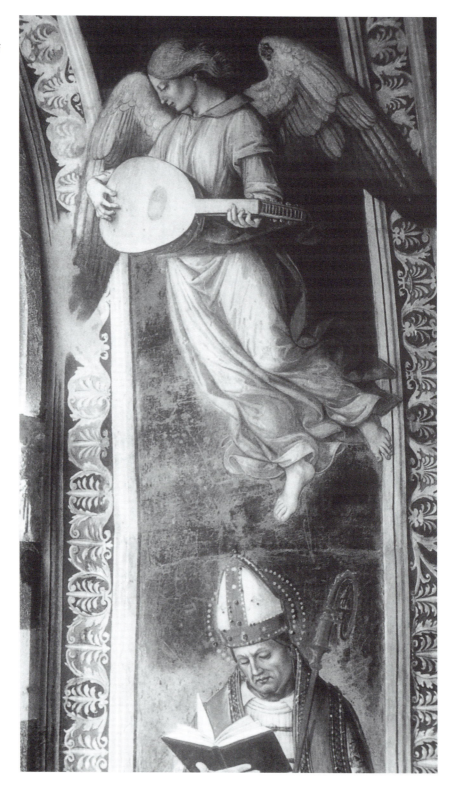

world who have received heavenly reward, exemplars for the worshiper: Doctors of the Church, Patriarchs, Martyrs and Virgins. St Mary Magdalene, the penitent sinner and an intercessor, leads the Virgins and faces Christ across the space of the vaults (Pls 2–4 and Fig. 4.1). Her prominence in representations of the Last Judgment is unprecedented, but it concurs with the themes of intercession, penance and Resurrection. The vision of the Feast of All Saints spills down into the walls of the south bay, where vivid examples of punishment and reward confront the worshipers, silently urging them to choose the path of righteousness. Intercessory archangels tucked into the window jambs, saints and heavenly hosts in the vaults, and the merciful Christ above the altar call attention to heavenly reward, attainable by mortals who seek it, as set forth in the liturgy for the Feast of All Saints. For the corresponding walls of the north bay, Signorelli turned to Advent, the next major season of the calendar year but the first season of the liturgical year. Thus the first, Advent, faces the last, All Saints. Advent texts, moreover, carry some of the same themes of foreboding, penance and preparation for the End-time as do those for All Saints' Day.

Finally, the function of the chapel remains unresolved, although it appears to be funerary. The resting place of the martyrs, the Cappellina della Pietà, established in the mid-quattrocento, later expanded into a burial chapel (Pl. 24). Although in 1500 only the relics of the protector martyr saints rested in a *cappellina* there, a facing tomb dates from the time of Signorelli. Subsequently other important churchmen were interred there.[69] Such associations concur with the judgment theme of the Feast of All Saints. In addition, in the seventeenth century, documents refer to the Cappella Nuova as the 'winter chapel'.[70] The liturgies for the Feast of All Saints and Advent concur with the winter season and I believe confirm the preference for this chapel in the wintertime. Moreover, a January stroll through the deserted, fog-enshrouded streets of Orvieto, a frequent and long-enduring occurrence, and a visit to the frigid cathedral teach the visitor the meaning of 'bleak midwinter' and 'stone cold'. Indeed, in the depths of winter, the southern exposure makes the Cappella Nuova far brighter than the rest of the cathedral, though not appreciably warmer.

5
Adventus

Liturgical sources

Just as Signorelli depicted on the upper walls of the south bay a panoramic vision based on liturgical texts for the Feast of All Saints, so in the corresponding spaces of the north bay he relied on the liturgy for guidance. The three large compositions present events of the End-time, forming an ominous prelude to those in the south bay: *The Rule of the Antichrist, Doomsday*, and *The Resurrection of the Dead* (Pls 3–6). The choice of these scenes has intrigued viewers for centuries, for events from the Apocalypse rarely occur in mural painting.[1] Only in the last decade had German artists combined apocalyptic and Last Judgment scenes in block book illustrations of St John's apocalyptic vision, such as the *Nuremberg Chronicle*, but few related to Signorelli's choices.[2] What caused Signorelli to select these three scenes in lieu of the many more familiar representations of the Apocalypse? Here the texts do not so much narrate as illustrate the liturgical texts for the next major liturgical season following the Feast of All Saints, the four weeks of Advent. The sequence in which these texts occur in the liturgical calendar determines the choice and arrangement of scenes. In fact, Advent opens the liturgical year and All Saints helps bring it to a close; thus, when the paintings are read as a narrative, the story begins here.

Advent is both celebratory and apprehensive. In the early Christian and medieval Church, Advent served as a six-week penitential fast preceding Christmas, reduced to four weeks by the fifteenth century. Much as Lent prepares the faithful for the celebration of Easter, Advent remains a time of preparation, not so much for the birth of Christ, but for his imminent return in judgment, which, of course, at Orvieto happens in the south bay.[3] Each reading for the first Sunday in Advent – the Epistle, Romans 13, the Gospel lessons, Mark 13 and an alternative, Matthew 24 – admonishes the faithful to repent, keep the faith and prepare for the second coming of the Messiah; it also links the Last Judgment to the Apocalypse.[4]

Therefore whoever resists authority resists what God has appointed, and those who resist will incur judgment … For salvation is nearer to us now than when we became believers … Let us lay aside the works of darkness and put on the armor of light … (Romans 13:2, 11–12, NRSV)

[Jesus said,] 'But about the day or hour no one knows … Therefore, keep awake – for you do not know when the master of the house will come … or else he may find

you asleep when he comes suddenly. And what I say to you I say to all: Keep awake'. (Mark 13:32, 35–36, NRSV)

Jesus said to his disciples, 'For as in the days of Noah were, so will be the coming of the Son of Man … they knew nothing until the flood came and swept them all away, so too will be the coming of the Son of Man … Therefore you must be ready, for the Son of Man is coming at an unexpected hour'. (Matthew 24:37–39, 44, NRSV)

The seventh chapter of Matthew, the Gospel lesson for the second Sunday in Advent, repeats the forewarnings to respect authority, to live by God's commandments, and to be alert for the End-time. These verses imply impending apocalyptic events; additional Advent scriptures foretell more specifically of Doomsday. The somber tone of Signorelli's paintings concurs with these admonitions. These vivid stories prophesying the End-time were a fertile ground for a bold and ingenious artist. Signorelli rose to the occasion to be inventive as he powerfully expressed the apocalyptic visions put forth in these Advent texts.

The Rule of the Antichrist

In the Cappella Nuova, the narrative sequence begins with the rule of the most heinous of all false prophets: the Antichrist (Pls 7 and 12).[5] The only scriptural references to false prophets occur in the liturgical readings for the Advent season, especially those for the first Sunday in Advent. The Gospel lesson for the first Sunday in Advent opens with an allusion to the reign of the Antichrist:

Then Jesus began to say to them, 'Beware that no one leads you astray. When you hear of wars and rumors of wars, do not be alarmed; for this must take place, but the end is still to come … For in those days there will be suffering, such as has not been from the beginning of the creation that God created until now … And if anyone says to you at this time, "Look, here is the Messiah!" or "Look! There he is!" – do not believe it. False messiahs and false prophets will appear and produce signs and omens, to lead astray, if possible, the elect. But be alert. I have told you everything …' (Mark 13:5–6, 19, 21–23, NRSV)

The Antichrist is cited by name in I John 2:18 and 4:3 and II John 1:7, where he is consistently portrayed as a heretic, a deceiver, and one who denies the incarnation and divinity of Christ. Additional apocalyptic texts that imply the Antichrist include Revelation 12–13 and Daniel 7. Scripture states that the reign of the Antichrist will precede that of Christ at the Second Coming. St Paul's epistle echoes the words of Christ in Mark 13 as he cautions of the wicked deeds of the 'lawless one' in II Thessalonians 2, the reading for Ember Sunday in Advent:

Let no one deceive you in any way; for that day will not come unless the rebellion comes first and the lawless one is revealed, the one destined for destruction. He opposes and exalts himself above every so-called god or object of worship, so that

he takes his seat in the temple of God, declaring himself to be God ... The coming of the lawless one is apparent in the work of Satan, who uses all power, signs, lying wonders, and every kind of wicked deception for those who are perishing, because they refused to love truth and be saved. For this reason God sends them a powerful delusion, leading them to believe what is false, so that all who have not believed the truth but took pleasure in unrighteousness will be condemned. (II Thess. 2:3–4, 9–12, NRSV)

Literary sources embellish the biblical texts. The oldest of these is the Antichrist legend, first recorded in the tenth century by Adso.[6] The story subsequently appeared in *The Golden Legend* under the Advent season.[7] From these sources developed the Antichrist liturgical dramas, well known throughout Europe and Orvieto in the Middle Ages.[8] Tommaso di Silvestro, notary, canon, and organist of the cathedral, recorded in his diary that a drama of the Antichrist was performed at the Orvieto Cathedral on Sunday, 20 August 1508.[9] This probably was not its first performance in Orvieto. New, however, was that this liturgical drama enacted events that now appeared freshly painted in monumental form on the walls within the cathedral. Finally, the story of the Antichrist appears in the fourteenth-century *Ovide moralisé* as part of the dream of the Tiburtine Sibyl, who tells the story of Christ and the Last Judgment.[10] These literary works not only warn of false prophets in general, but also they specifically caution of the malice and deceit of the Antichrist. In addition to recounting scriptural admonitions, Signorelli's depiction of the Rule of the Antichrist closely follows these related literary sources.

Moreover, just as the history of Orvieto shaped the liturgical scenes in the facing Cappella Corporale, local history and contemporary issues play a secondary role in these paintings. The subject of the Antichrist was timely. As the year 1500 approached, precarious political situations and the fear of Turks on the eastern horizon contributed to a general pessimism throughout Europe. Following Revelation 20, contemporary cataclysmic events were often analyzed in light of the upcoming millennium and a half. Recent theologians had warned of the Antichrist, including three Dominican authors: St Vincent of Ferrer, Annius of Viterbo and St Antoninus of Florence,[11] abbot of the Convent of San Marco while Fra Angelico was a friar there. More recently Savonarola, also a Dominican at San Marco, had preached against excesses and warned of calamity.[12] Though millennial fears may have contributed to Signorelli's iconography, the close alignment between the Rule of the Antichrist and the liturgical texts for Advent makes a more compelling case as the primary source. Moreover, the painting presents more universal ideas than apocalypticism driven by contemporary politics, for *The Rule of the Antichrist* also warns of the dangers of moving away from wisdom and emphasizes the vital role played by Christian dogma and the Church in salvation. Echoing scripture for the first Sunday in Advent, false prophets and heresy posed threats to the church structure, were anathemas to salvation and, more immediately, were issues with a long history in Orvieto. These matters particularly concerned Dominicans and thus the Masters of

the Sacred Page, who adjudicated doctrinal issues. Moreover, as mentioned earlier, the Cappella Nuova enshrined the two local heresy-fighting martyrs, both murdered by heretics – one, the city governor, Pietro Parenzo, was assassinated by Cathars.[13] Since the fourth century, Christians had called Cathars by the name 'Antichrist'.[14]

The Rule of the Antichrist is the most complex composition of all of the frescoes; it is also probably the last one to be finished.[15] Signorelli used a continuous narrative format with several sequential scenes incorporated into a single, well-integrated composition, as he did in the two scenes that follow in the narrative sequence. The action moves from left to right in the foreground, then from the right to left in the middle-ground and background. In the convention of epic poetry, Signorelli began his story of the Antichrist *in medias res*.[16] Two witnesses standing in the lower left corner lead the viewer into the narrative; they also concur with biblical texts: 'I will grant my two witnesses authority to prophesy ...' (Rev. 11:3, NRSV). Many scholars have said, with little concrete evidence, that these men represent the two artists who painted the chapel. The cleric on the right has traditionally been identified as Fra Angelico. However, he does not wear a Dominican habit with a *cappa*, or cape, nor does he have the traditional tonsure as the Dominicans do in the vaults above. Instead he wears the black, sleeved coat of a canon and his hair, although cropped, covers part of his forehead and the upper part of his neck. Traditionally the figure on the left is called Signorelli, based on a portrait of two men in Orvieto.[17] Neither face, however, matches either Signorelli's portrait in Giorgio Vasari's study in Arezzo or Vasari's woodcut illustration of Signorelli in his *Lives of the Artists*.[18] Anonymous witnesses appear in Adso's commentary and in the Antichrist drama; Leon Battista Alberti also refers to them in his text on painting.[19] Thus, in accord with the biblical text, epic literature, and medieval and Renaissance theater and art, these men serve as anonymous commentator figures, or *festaiuoli*, who mark the beginning of the narrative.

Signorelli focused his composition upon an unsettling pair of figures: the Devil and the Antichrist (Pl. 7). Rather than follow tradition and depict the Devil as a gruesome composite beast of fantasy, Signorelli portrayed him as a life-sized human, differentiated only by his nudity, scarlet horns and bat-like wings. As with the devils in *The Torture of the Damned*, situated diagonally across the chapel, such a life-like image amplifies the insidiousness of the evil and the duplicitous nature of Satan, who beguiles and can be indistinguishable from other human beings. Although the portrayal of Satan may seem clear to the viewer (as evil often is when viewed by an outsider), the audience appears oblivious – a frightening admonition to the worshiper.

At first glance, the Antichrist resembles Christ; a second glimpse reveals a disturbingly sinister image. Poised on a rostrum before a crowd in the manner of an orator or a preacher, this figure wears the traditional garments of Christ, but in dissonant colors – an orange tunic and violet mantle. His blank stare, slightly pointed ears and dark, horn-like curls intensify his evil appearance. With strangely wooden gestures he awkwardly leans back to

his left, as if interrupted by the Devil that presses close behind him and whispers into his sinister ear. Signorelli inseparably intertwined the two figures, who seem to share one pair of arms. A closer look reveals that the arms belong to the Devil, as he prepares to slip unseen into the body of the Antichrist as if he is donning a costume – the proverbial wolf in sheep's clothing – vividly demonstrating that the Antichrist and Satan are one and the same. Signorelli literally followed the description of false prophets put forth in the Gospel reading for the second Sunday in Advent:

[Jesus said,] 'Beware of false prophets, who come in sheep's clothing, but inwardly are ravenous wolves. You will know them by their fruits. Are grapes gathered from thorns, or figs from thistles? In the same way, every good tree bears good fruit, but the bad tree bears bad fruit. A good tree cannot bear bad fruit. Every tree that does not bear good fruit is cut down and thrown into the fire'. (Matthew 7:15–19, NRSV)

In the right background, the Antichrist and his followers stand in front of the Temple of Solomon, where he slays the prophets Enoch and Elijah, who have come to expose his falsehoods. Soldiers in the distant center appear as black silhouettes as they approach the Temple of Solomon, where legend states the Antichrist's throne is located.[20] Another group of soldiers peers down from a flat-roofed area of the temple, just below the two-story dome. More soldiers with spears in hand swarm across the temple steps. The Antichrist appears a third time, again in the center background, where he performs false miracles, including a mock resurrection. A classical city with a triumphal arch, probably Heavenly Jerusalem, occupies the left background. All of the vignettes comply with scripture, *The Golden Legend* and stage directions for the Antichrist drama.[21]

 Prominent in the mid-ground, directly behind the Antichrist and near the temple, stand two groups: six men in eastern garb and four clerics. Two men wear turbans, one red and one white, as another man peers over their shoulders. Two bald, bearded men to the right absorb themselves in books. A man with his back to the audience wearing a purple turban and a white garment seems more absorbed in the discussions of the adjoining group of clerics – four Dominicans, a canon and one Franciscan – than in the books of his eastern colleagues. Behind the Antichrist, the round-faced, stocky Dominican preacher who leads the group and leans toward the adjoining group is surely the greatest of Dominican preachers and theologians, Thomas Aquinas. Aquinas lived, taught, and wrote in Orvieto. Signorelli's depiction matches biographers' descriptions of Aquinas as a stout man, a rare attribute among mendicant friars.[22] This small group, like the voice of the prophet crying in the wilderness, attempts to prepare the way for the Second Coming. The single Franciscan in the group points leftward to the otherwise unnoticed battle raging in the sky: St Michael has overcome the Antichrist, the signal of the beginning of the End-time according to the Antichrist legend and drama.[23] The cosmic battle, as well as the proximity between the Antichrist and the devil, resemble that in Wolgemut's woodcut of the Antichrist in his *Liber chronicarum* (or *Nuremberg Chronicle*) (Fig. 5.1); three copies were held in

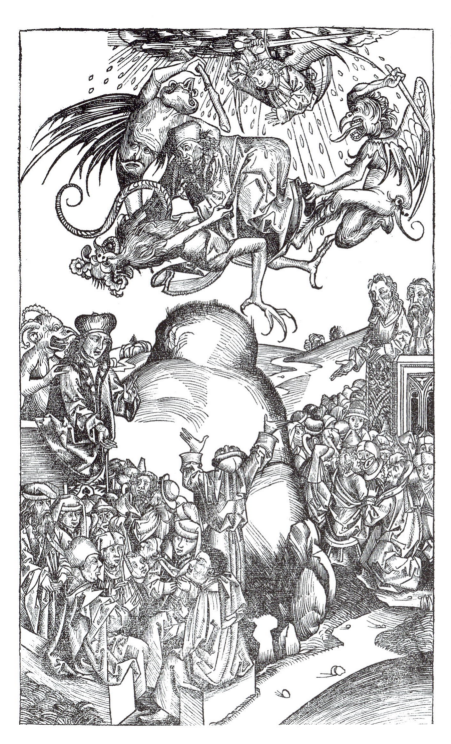

5.1 'Preaching of the Antichrist' from the *Nuremberg Chronicle* folio CCLXIIr (Archivio Fotografico, Vatican Museums)

Orvieto.[24] In the foreground beneath, another battle ensues, perhaps directed against heretics. Like laser beams, the red and golden rays that emanate from the archangel in the sky bloodlessly strike those below, delivering instant death. These events logically lead the viewer's eye to the left to the next scene in the chronological sequence: Doomsday.

DOOMSDAY

The saga of the Apocalypse continues over the doorway with the frightening sequence of events of Doomsday, or the destruction at the end of the world (Pls 3, 4 and 18). Signorelli's vivid depiction follows the description in both Advent texts and related apocalyptic scripture. Although the narrow, arched space over the doorway is limited and awkward, Signorelli managed to use it to its maximum advantage, employing continuous narrative that moves from right to left, depicting prophecies and their fulfillment. At the top, five cherubs cluster at the springing of the arch. Four cherubs support a bare plaque, while one holds up the monogram of the Opera del Duomo of Orvieto (also called the Opera di Santa Maria), a white circle divided into four sections by a red cross and inscribed with the letters OPSM, as an acknowledgment that they commissioned the fresco cycle (Fig. 5.2).[25]

The right side of the arch, that closest to the *Rule of the Antichrist*, continues the liturgy for the first Sunday in Advent; simultaneously it suggests the liturgical texts for All Souls' Day (the Commemoration of the Dead, which follows the Feast of All Saints). In the center foreground, an elderly man dressed in an eastern tunic and turban, probably a prophet, admonishingly points overhead toward the cataclysmic events above as other men of various ages and occupations look up and listen (Fig. 5.3). A woman dressed in flowing robes, probably a sibyl, stands beside the prophet to the left. She points to an open book in her left hand and speaks to someone on her right, while a woman looks over her shoulder to read the text. The words of the *Dies Irae*, a hymn for the first Sunday in Advent, identify the prophet as David and the woman to his left as the Cumaean Sibyl.

> Dies Ire, dies illa
> Solvet saeclum in favilla
> Teste David cum Sibylla
>
> Day of wrath, Day of Ire
> When the world dissolves in Fire
> As David and the Sibyl did prophesy.[26]

The mournful hymn, which continues with laments of penance and impending judgment, is not only a personal meditation on a Gospel lesson for the first Sunday in Advent, but also it was sung (and still is) on All Souls' Day. Subsequent verses of this hymn, as well as other Advent hymns and scripture, describe the destruction that occurs in the background. Furthermore,

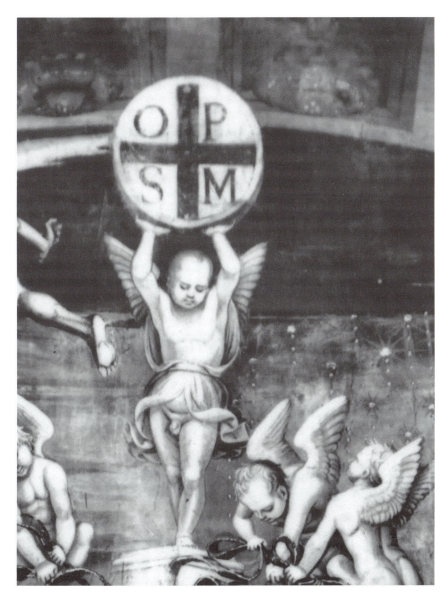

5.2 Monogram of Opera del Duomo, Orvieto; detail of upper portion of *Doomsday* (Archivio Photos Moretti, Orvieto)

the position of *Doomsday*, facing the judging Christ in the vaults and scenes above the altar of the Blessed and Damned being transported to their eternal reward and punishment, carefully follows that text:

[Jesus said] 'There will be signs in the sun, the moon, and the stars, and on the earth distress among nations confused by the roaring of the sea and waves. People will faint from the foreboding of what is coming upon the world, for the powers of heaven will be shaken. Then they will see the "Son of Man coming in a cloud" with power and great glory. Now when these things begin to take place, stand up and raise your heads, because your redemption is drawing near'. (Luke 21:25–27, NRSV)

5.3 Prophet and Sibyl, detail of *Doomsday*, lower inside right of the arch (Archivio Photos Moretti, Orvieto)

This description also appears in *The Golden Legend* and in the speech of the ten sibyls before the senators of Rome in the *Ovide moralisé*.[27]

The annihilation of a city by flood looms on the horizon in the background. In the mid-ground, discord has broken out. Some people are being bound while others attempt to escape. Overhead, golden stars, formed from *pastiglia* (gold leaf suspended in hot wax), plunge from the heavens, past the moon turned red and the blackened sun, as described in another Gospel reading for first Sunday in Advent and in St John's vision of the End-time:

[Jesus said] 'But in those days, after that suffering, the sun will be darkened, and the moon will not give its light, and the stars will be falling from heaven, and the powers in the heavens will be shaken ...' (Mark 13:24–25, NRSV)

there came a great earthquake: the sun became black as sackcloth, and the full moon became like blood, and the stars fell on to the earth as a fig tree drops its winter fruit when shaken by a gale ... for the great day of their wrath has come, and who can stand before it? (Revelation 6:12–13 and 17, NRSV)

The admonitions intensify in an Epistle reading for the second Sunday in Advent:

First of all you must understand this, that in the last days scoffers will come, scoffing and indulging their own lusts and saying 'Where is the promise of his coming?' ... But the day of the Lord will come like a thief, and then the heavens will pass away with a loud noise, and the elements will be dissolved by fire, and the earth and everything that is done on it will be disclosed ... (II Peter 3:3–4, 10 and 13, NRSV)

The horror continues on the left side of the arch. Above, four winged figures, two white and two red, descend from the reddened sky, spitting fire to strike dead those below. The earth smolders. Those spared attempt to flee flames from the sky and those lapping at their heels, as prophesied in Luke 21:26. Signorelli carefully varied his figures, not repeating gestures or poses. Young men and old, widows and young mothers clutching infants, frantically run for their lives. A group of young men tumbling out in front of the fanciful architecture appears to have escaped – although the viewer knows better. The front-runner pauses to look back and up, which leads the viewer to the last event in the sequence.

THE RESURRECTION OF THE DEAD

The narrative culminates with *The Resurrection of the Dead* (Pls 3, 5 and 17). Never before had the promise of bodily resurrection been affirmed with such prominence or rendered so dynamically.[28] This fundamental Christian doctrine is implied in scripture readings and in *The Golden Legend* entry for Advent. Readings for All Saints' Day and All Souls' Day, as well as the prophet Ezekiel, which tell of the bones of the dead rising from their graves and the local liturgical drama for Corpus Christi, affirm the dogma.[29] The Gospel reading for the second Sunday in Advent describes the resurrection of the dead: 'the blind receive their sight, the lame walk, the lepers are cleansed, the deaf hear, the dead are raised, and the poor have the good news brought to them ...' (Matt. 11:5, NRSV).

The Resurrection of the Dead presents a joyful celebration. To initiate the event, two imposing angels, double the size of the figures below, stand in the upper part of the lunette where the light blue sky turns to gold above. Free of the armor necessary to restrain the Damned in the adjoining fresco, the gigantic angels, wearing billowing loincloths and their heads bent downward,

vigorously trumpet the dead to new life. Rather than groaningly pushing open lids of sarcophagi, as in Maitani's sculpture on the cathedral façade (Fig. 1.4), here the newly alive joyfully strain to free themselves of self-sealing, cement-like graves. Once fully released, they appear rapt and triumphant, for they realize that they are heaven-bound.

Signorelli again exploited the possibilities of the continuous narrative format, showing several events occurring simultaneously; he also indulges in the freedom to be inventive in the handling of the human form. The figures, mostly male, exhibit diverse poses, as well as various stages of resurrection: some are still skeletons; others reclothe bone with flesh. All appear in the prime of youthful beauty; the ravages of age and disease are gone. Once whole, some of the resurrected look in wonder at their new bodies, stretching their limbs and marveling at the miracle of the reclothing of the flesh; others greet and embrace each other. St Paul states in the epistles read to commemorate the dead on All Souls' Day that Christians will bear the image of the earthly body in the resurrection, although it is raised up imperishable and transformed to resemble that of Christ at the Resurrection (I Corinthians 15:42–50; Philippians 3:21). Subsequently scholars interpreted these passages to mean that the spiritual body would be perfect, invincible, unsentimental and unsensual; thus, Signorelli's figures appear confident and unselfconscious in their nudity.[30] St Augustine stated concerning the resurrection, 'Thus there is a measure, an orderly function, of each separate part, and, correspondingly, a measure or stature of the whole body, which consists of all its parts.'[31] Likewise, Renaissance artists, including Leonardo da Vinci and Signorelli, used a systematic canon of proportion for 'perfect' bodies.[32] Although Augustine considered female bodies to be imperfect male bodies, he wrote that even females would attain the perfection of manhood at the resurrection;[33] so they do with Signorelli. Meanwhile, as read in the epistle lesson for All Souls' Day, a few figures in the upper background, those alive at the time of the Resurrection of the Body, watch in awe:

For the Lord himself, with a cry of command, with the archangels call and with the sound of God's trumpet, will descend from heaven, and the dead in Christ will rise first. Then we who are alive, who are left, will be caught up in the clouds together with them to meet the Lord in the air; so that we will be with the Lord forever. (I Thessalonians 4:16–17, NRSV)

Perhaps another reason for such unparalleled emphasis on the resurrection of the body was to confirm a fundamental doctrine renounced by Cathars and other heretics. Cathars believed that Christ was never fully man, thus rejecting both the doctrine of the Incarnation and that of the Resurrection. They also denied the unification of body and soul at the End-time. However, that the body and an immortal soul together form an individual is not only essential to Christian doctrine, it makes the thought of the separation of body and soul at death frightening; thus, the reunification in the resurrection of the body is a consolation.[34] Thomas Aquinas affirmed the uniqueness of

each individual at conception, and that the personality of the soul is expressed through the body; thus Signorelli individualized each face in the paintings.[35]

The Resurrection of the Dead occurs first on Judgment Day and thus this scene unites the apocalyptic scenes in the north bay with the events of the Judgment in the south bay and vaults. Resurrection iconography, moreover, concurs with the dedication of the chapel and the cathedral to the Assumption of the Virgin. The example of Mary, who represents all of humanity, gives the faithful hope of bodily resurrection in the afterlife. The theme also fits into the larger plan of the building. We recall that the original stained glass window of the Assumption in the Cappella Nuova once faced a window of the Resurrected Christ in the Cappella Corporale. As with transubstantiation – which the Eucharist, the relic of the *corporale* and Corpus Christi celebrate – Resurrection is a metamorphosis, a transformation, and a miracle; it offers new life and is, along with penance, an essential step to salvation.

The iconographic plan for the Cappella Nuova, however, does not terminate here. Although documents imply that initially the Opera did not include the lower walls in the contract,[36] Signorelli expanded a program that could easily stand on its own into the lower walls. Perhaps Signorelli's project grew as it progressed. The overall iconography that joins the scenes of the upper walls gains richer, deeper meaning with the support of the scenes in the lower walls, a subject that will be discussed in the following chapters.

6
Liturgy Meets Poetry

Description, sources and meaning of the socle

The final contract for the decoration of the Cappella Nuova (1502–04) was for the lower walls (Pls 1–4 and 10).[1] Since the earlier contracts do not mention this space, the plan for elaborate decoration there appears to have been developed as Signorelli was in progress. In function and in appearance, Signorelli's socle resembles that of no other fresco program, although its roots lie in other decorative traditions. Although, in many ways, Signorelli's inventions here are his most subtle and most sublime, they are also his most ignored. Breaking with a long-established tradition of painting the lower walls of fresco cycles in imitation of decorative marble facing or tapestries, Signorelli extended the iconographic program into these spaces. Here, imbedded in elaborate panels of gilded *grotteschi*, the artist incorporated a series of author portraits surrounded by scenes from literature. In the socle, Signorelli's poetic theology and his intentions as an epic poet–painter are most evident, although scholars have not fully recognized these important aspects of the program.[2]

Signorelli divided the upper walls from the lower ones with an elaborate painted architrave, and decorated the *basamento* with oblong grisaille panels resembling antique relief sculpture. Between, he used ornate tall pairs of illusionistic pilasters crowned with fanciful capitals to divide the space into richly decorated panels, truncated in the north bay by a pair of facing burial *cappelline* recessed into the walls. Each *cappellina* originally contained a large biblical scene on the arched back wall and a pair of round cameo scenes painted in grisaille on the shallow facing walls that reflected the saints to which each was dedicated. The gilded panels, three on each long side wall, are covered with tendrils of *grotteschi*, each different. The centers of these panels contain illusionistic square windows through which half-length portraits of men holding open books boldly emerge. Some wear laurel or oak crowns, affirming their identity as authors or poets. Their expressions vary: some are pensive and absorb themselves in their work, while others appear to be in an energetic state of receiving divine inspiration. Illusionistic bands of faux porphyry outline and subdivide the panels, usually into quarters that operate in matching 'ink-blot' pairs. The center of each dividing band contains a tondo with a scene in blue and white grisaille on a dark blue field. Two of the large panels contain smaller scenes folded into the *grotteschi* of each corner. Emblems and scenes of virtuous literary characters, drawn

mainly from the epic poetry of Dante, Ovid and Virgil, fill the tondi in the south bay, while those in the north bay feature battle scenes. These tondi resemble antique designs for agate cameos that depict gods, goddesses and emblems, some of which were quite complex in design.[3] As with cameos that adorn Renaissance portraits and manuscript borders, these scenes relate to the corresponding author. I will demonstrate that Signorelli carefully arranged the scenes according to a symbolic protocol. Using the format of the daily office of the liturgy, they concur with the penitential theme of Lent and support the overall iconography of the Cappella Nuova.

Each wall flanking the entrance contains a single portrait of a man looking out of a round window – one figure leans out and up. Nothing ties them to a literary tradition. On the facing altar wall, the large eighteenth-century altar now covers about half of the original decoration. The visible area contains double vertical rows of small scenes arranged in alternating tondi and rectangles painted in grisaille. Another author panel surrounded by four scenes once adorned the center of the altar wall. Two documents describe the pre-eighteenth-century decoration and they do not agree.[4] A drawing by Signorelli of an anonymous man may represent the absent poet.[5]

Liturgical sources for the *cappelline*

LENT AND HOLY WEEK

The last monumental biblical scenes in the Cappella Nuova are those in the two facing recessed burial *cappelline* in the north bay; these scenes also illustrate the final liturgical texts referenced in the chapel. At this point, Signorelli turned from the liturgical texts for All Saints and Advent to the texts for Lent, the other major penitential fast of the year. Here he illustrated two key events recounted in texts read at the end of Lent. As mentioned previously, the original decoration in the Cappellina della Maddalena included a tondo on the right of *The Resurrection of Lazarus*; the corresponding tondo on the left honored his sister Martha. The altarpiece, the only portion of the decoration to survive, represents his other sister and the dedicatory saint, Mary Magdalene (Fig. 4.2).[6] Signorelli placed the *bona fide* resurrection performed by the true Christ below the lunette representing *The Rule of the Antichrist* as an auspicious contrast to the false resurrection performed by the Antichrist, which appears among the supporting scenes in the background (Pl. 4). Moreover, *The Resurrection of Lazarus* gives promise to other mortals, which is fulfilled in the facing upper wall fresco of *The Resurrection of the Dead*. The miracle of Lazarus, moreover, was reenacted in an Umbrian liturgical drama; a text from Perugia survives.[7] Liturgically, the Gospel reading for the fifth Sunday in Lent (John 11:1–44), that just before Palm Sunday (which initiates Holy Week, the last week of Lent), recounts the Resurrection of Lazarus. The Gospel of St John, the only record of the story of Lazarus, states that this definitive miracle revealed Christ's life-giving powers and

brought about Christ's death, a scene of which it faces in the Cappellina della Pietà (Pls 3 and 4).[8] This event leads directly into Passion Week.

The liturgical text that invokes the image of the Lamentation of Christ, as represented in the Cappellina della Pietà, is the Gospel reading for Good Friday (John 18:1–40; 19:1–37), which concludes Christ's Passion at the end of Lent (Pl. 28). In the center of the composition, Mary Magdalene, paradigm penitent sinner, mournfully kneels before the corpse of Christ. The facing lunettes in the *cappelline* pair poetically and on several levels. First we see brother and sister, man and woman, all repentant sinners. Both *The Resurrection of Lazarus* and the *Pietà* relate to the themes of resurrection and transformation depicted above and to the theme of metamorphosis that will emerge in the tondi in the socle. In medieval Christian allegorical expositions, the raising of Lazarus foreshadows the sacrament of penance: Lazarus, a mortal human, repents, confesses and is absolved of his sins.[9] A twelfth-century poet stated, 'After the raising of Lazarus it was said to the disciples: *loose him*. By this it is clearly shown that God quickens a repenting sinner, but he is never loosed save by the ministers of the Church.'[10] The medieval expositors never lost sight of the essential role of the Church in salvation; neither did Signorelli and his advisors.

The remaining walls of the socle are the most complex and least understood; yet, I have found that they are equally important to the overall iconography of the chapel. Here, tucked among tendrils of *grotteschi*, lie mysteries of the faith told in the more accessible medium of poetry. The decorative program draws from several traditions of long standing that help illuminate their form and function.

The influence of classical motifs

The rich classical decoration in the socle reflects the renewed interest in classical antiquity, kindled by the rediscovery of Nero's Domus Aurea in the 1480s. The frescoes in this ancient monument inspired ornate classical motifs in contemporary art, especially among artists in Rome.[11] Intellectuals and artists had enthusiastically rushed to the ancient palace, known through ancient descriptions. Signorelli and his colleagues working in the Sistine Chapel were among those early visitors. Torches in hand, they descended through a millennium's worth of fill dirt and barbarian ruin into what must have seemed magical chambers, with whole ceilings and upper walls decorated in imaginative motifs, sometimes incorporating vases, candelabra, animals, and fanciful figures into architectural borders and vine-covered fields. In Signorelli's era, this type of ornamentation was often called *fantasie* or *invenzioni*.[12] Later it became known as *grotteschi*, or 'grotesques', deriving from the underground 'grotto' location. Several of these artists, including Pinturicchio, Ghirlandaio and Raphael, left their signatures; others, including Francesco de Hollanda and Filippino Lippi, made drawings that resemble the decorations there.

Although classical motifs were known through other antique monuments, the frescoes of the Domus Aurea inspired artists to use *grotteschi all'antica* more inventively in architectural borders, ushering in what Hellmut Wohl appropriately calls the 'ornate classical style' of the late fifteenth and early sixteenth centuries.[13] The convention of using classical vegetal decorations, including garlands, rosettes and symmetrically arranged leaf patterns to define illusionistic architectural features, such as friezes and pilasters, appears in the lower walls of the Sistine Chapel, and subsequently in frescoes by Pinturicchio, Filippino Lippi, Ghirlandaio, Perugino, Botticelli and others. Signorelli used classical borders of garlands, rosettes and bucrania (bovine skulls) in his *Flagellation* panel (Brera, Milan, late 1470s) and in the sacristy at Loreto (1477–80). The background of the *Flagellation* includes a fanciful tripartite marble arch, which immediately recalls the Arch of Constantine near the forum of ancient Rome. Figures in action rendered in grisaille on Signorelli's arch, presumably enacting narratives, imitate relief sculpture. Just before coming to Orvieto, Signorelli used illusionistic architecture covered with *grotteschi* at Monteoliveto Maggiore to separate his lunettes, although not nearly as inventively as he did at Orvieto. Later Raphael would cover the white field of the upper walls and vaults in the Vatican loggia (1513) with *grotteschi*, remaining closer to the decoration in the Domus Aurea than Signorelli and the artists of his generation.

For all of the Renaissance artists, *grotteschi* signified more than ornament. Contemporary humanist intellectuals associated *grotteschi* with the classical style for funerary chapels and mystery chambers.[14] If Signorelli made this funerary association, such decoration would suit a chapel that held sacred relics and, beginning with the Cappellina della Maddalena in his day, tombs of important churchmen. Moreover, if he associated *grotteschi* with antique mystery chambers – places where members of ancient mystery cults performed rites and admitted initiates to the company of the faithful – the recurring themes of rebirth, renewal and metamorphosis in the Cappella Nuova would concur with those practices as well: the two principal feasts in Orvieto celebrate transformation. The Feast of Corpus Christi celebrates the gift of the Eucharist, the elements of which transform into the body of Christ during the Consecration of the Host by the priest. The Feast of the Assumption of the Virgin celebrates the hope of miraculous transformation in the Resurrection of the Body and the life in the world to come, as promised to all the faithful in the scriptures for that feast as well as those for the Feast of All Saints and Advent. Finally, the Lenten texts relate to penance, a sacrament of renewal that must precede the Eucharist. Thus, the fresco cycle of the Cappella Nuova not only illustrates the events of the End-time as described in particular liturgical texts, but it also speaks to the quest for membership in the company of the faithful through a spiritual transformation, a theme that will unfold here and in subsequent chapters.

Programs of famous people

The series of portraits in the square panels in the socle of the Cappella
Nuova has several precedents. The socle of the Old Strozzi Chapel in S.
Maria Novella in Florence, comprising marbleized plaster panels with
individualized, yet anonymous, faces in the center perhaps served as
inspiration. The context is similar: the upper walls of both chapels depict
extensive Last Judgment programs designed by Dominicans. In addition,
these paintings resemble the contemporary practice of illustrating a series of
famous men and women, most often in libraries. Such programs appear,
among other places, at the Villa Carducci in Legnaia (Andrea del Castagno),
the Studiolo in the Ducal Palace at Urbino (Justus of Ghent?) and the unfinished
decoration of the library of Archdeacon Antonio Albèri in Orvieto. A consistent
protocol required that people who shared similar interests or characteristics
be grouped together. Whereas classical and modern orators or other secular
intellectuals might appear as a pair, classical philosophers and poets were
never placed side by side with Christian theologians and biblical characters,
although they might occupy corresponding positions (that is, facing positions
or in a row below). The program in closest proximity, Albèri's unfinished
library consists of monochromatic paintings in the lunettes and around the
windows, probably executed by Signorelli's assistants, that illustrate groups
of poets and philosophers, ancient and contemporary, classical and Christian.
The walls between the alternating lunettes and window jambs have shields.
The shield to the right of each arch identifies the discipline that each group
of scholars characterizes. The individuals who represent most disciplines are
conventional; others represent personal choices. Predictably, Homer and Virgil
represent poetry (Fig. 6.1), Galen and Hippocrates illustrate medicine, and
Ovid and Juvenal embody oratory. On the other hand, Albèri included Pope
Pius II at the top of the window among the theologians who illustrate canon
law, flanked by Dominican Thomas Aquinas and Franciscan St Bonaventure.
These men represent Albèri's patron pope and the lead theologians of the
two major Mendicant Orders. Surely, Augustine, Boccaccio and Dante would
have had a place in the unfinished lunettes on the facing walls.[15]

The role of manuscript illuminations

Although antique traditions and displays of famous people unquestionably
influenced Signorelli's socle decoration, the painted panels most closely
resemble in form and function a less commonly recognized source: manuscript
illumination.[16] Since ancient times, illuminated manuscripts traditionally
opened with an author portrait. By the late fifteenth century, artists had
added elaborate borders into which they placed narrative vignettes and
edifying symbols. By separating the socle into richly decorated panels holding
portraits and scenes from literature, Signorelli transformed the space into
what I believe resembles monumental introductory pages of illuminated

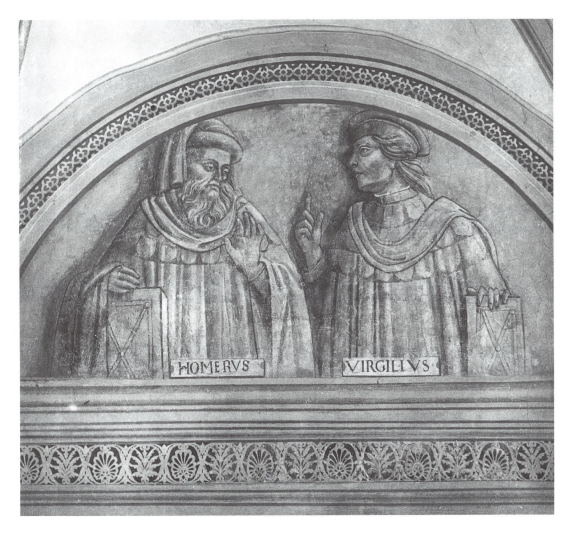

6.1 School of Signorelli, Homer and Virgil, lunette from the Library of Antonio Albèri in the Cathedral of Orvieto (*c.* 1500) (Gabinetto Fotografico Nazionale, Rome)

manuscripts, complete with explanatory antique-style 'cameos' in the decorative borders to silently expound upon the author they surround.

Wealthy fifteenth-century intellectuals continued to commission elaborately decorated books, even after the advent of printing. By the late 1480s, illuminated manuscripts exhibit an increasing interest in *all'antica* architectural borders as a form of embellishment to signify the importance of the text. For example, the intricate borders of the initial page from a manuscript of Genesis contain cameos with illustrations of the Creation, Fall, and Cain and Abel.[17] Nearly identical scenes in a different format occur in another contemporary Genesis manuscript.[18] Some manuscript illustrations are less text-bound and more symbolic. The office for the Feast of Corpus Christi in a fifteenth-century Florentine choral book begins with a large illustration of the festival procession (Fig. 6.2). The border is densely filled with imaginative composite creatures, reminiscent of Signorelli's in the Cappella Nuova. Tucked in among the marginalia are little portrait medallions: God the Father at the top, the

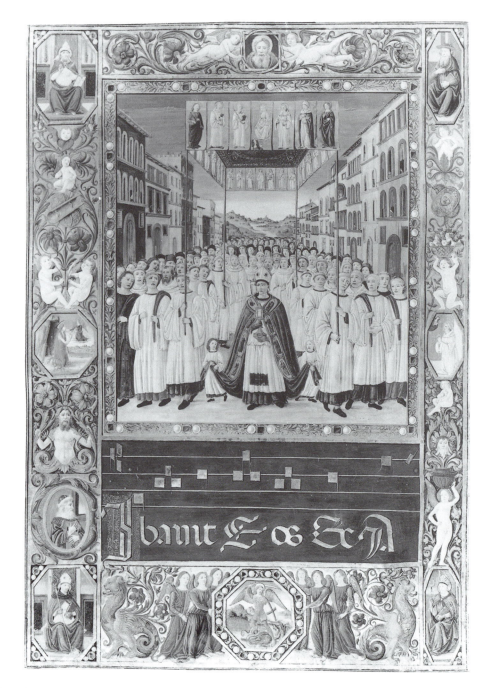

6.2 Procession of
Corpus Christi.
*Altavante degli
Attavante*, corali,
c. 7v., 1505,
Biblioteca
Laurenziana,
Florence

four Doctors of the Church in the corners, and on the sides, St Dominic and Mary Magdalene face each other, kneeling in prayer.[19]

The convention of including classical allegories in manuscripts appears in a ninth-century copy of the *Comedies* of Plautus, to which a rich floral border was added in the fifteenth century. The left-hand page shows the author's portrait at the top and the papal coat of arms at the bottom. In the side margins, three grisaille cameos appear to illustrate classical emblems or stories that relate to the story.[20] One emblem appears to illustrate a personification of Justice.

Another fifteenth-century Florentine manuscript shows this tradition in a religious treatise (Fig. 6.3).[21] A huge illusionistic architectural frame, heavily embellished with gilded *grotteschi* and classical architectural motifs, fills the page and surrounds a circular portrait of St Jerome. A small circular 'cameo' of Justice fits into the arched pediment above. Just below, the dove of the Holy Spirit spreads his wings before the golden frieze and emits red rays to signify his inspirational role in St Jerome's texts that follow. Between these text boxes and flanking pilasters, in the guise of a Renaissance humanist scholar in his study, reminiscent of the van Eyck painting of the same subject then in the Medici collection (now in Detroit), the church father works at his desk, here located on a balcony overlooking Florence. Four small classical cameos embellish the corners. The patron and his wife, much in the manner of the Lenzi family in Masaccio's *Trinity* at S. Maria Novella (*c.* 1427, Florence), kneel on either side between the columns and the pilasters, accompanied by family and court intellectuals. Below, in an illusionistic *basemento*, Marsyas and other mythological characters painted in grisaille on a gold field enact their dramas, each of which relates metaphorically to the writings that follow.

The materials and motifs in these manuscript illuminations – blue, red, and gold leaf, tendrils of *grotteschi*, architectural embellishments, author portraits and classical 'cameos' with stories to allegorize the text – appear in a different medium but a similar style and role in the Cappella Nuova. Signorelli extended the allusion to illumination further than appearance, however. Just as a written commentary glosses literature or allegorizes scripture or a book of homilies explains scripture, these wall panels imitate both the appearance and the purpose of the glosses and commentaries that gave the artist inspiration, narrative and instruction. When understood as allegories, as they are in manuscript practices, these grisaille cameos poetically amplify the liturgical texts illustrated on the walls above through allegory, and form the foundation for the visual sermon that unfolds in the chapel.

Identification of author portraits and literary scenes

The inclusion of the authors and scenes from poetry turns on several principles that were a long-standing part of literary and artistic tradition, although the full importance of this feature of the socle has not been recognized. However, unlike displays of famous people and manuscript illuminations, no inscriptions

6.3 Sigismondo de'
Sigismondi, scribe
and Monte di
Giovanni di
Miniato, illustrator.
Didymus
Alexandrinus. *De
spiritu sancto*, MS M.
496, f. 2r, The
Pierpont Morgan
Library, New York,
(photo: David A.
Loggie)

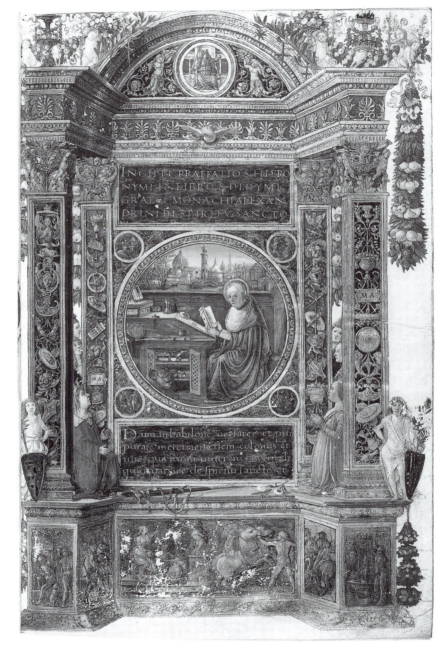

identify the portraits in the socle of the Cappella Nuova, nor does any
contemporary document record Signorelli's intention.[22] Thus, appearance,
context and the surrounding tondi provide the only identifying clues. Whereas
in the south bay the tondi, for the most part, are readily recognizable, those in
the north are far more elusive. All, however, even in a general way, contribute
to the overall message in the chapel.

Only one portrait, Dante's unmistakable profile, surrounded by Canti I–IV of his *Purgatorio*, seems certain (though the earliest descriptions of the chapel call this poet Petrarch) (Pl. 1).[23] The profile view emphasizes Dante's typical angular features: long, bony nose, high cheekbones, sunken cheeks and toothless jaws. He looks down to study a book. His clothing, the traditional red, collarless, long-sleeved cloak, red capuchon (a loose cap with short hood hanging to one side), and a laurel wreath crown, matches that of the pilgrim Dante in each of the eleven tondi from *Purgatorio* in the socle as well as in numerous other portraits.[24] Dante appears in the same garb and profile pose in the background crowd of the Antichrist fresco, and similarly in Raphael's slightly later group of poets on Mount Parnassus in the Stanza della Segnatura in the Vatican (*c*. 1509–11).

Tentatively identified in the nineteenth century as 'Virgil', until recently the name of the bareheaded author to the right of Dante went unchallenged (Pl. 21).[25] This author wears a blue, long-sleeved tunic. His frenzied blond hair appears electrified as he looks up from his book and stares intensely toward the altar – as if responding to divine inspiration. However, his clothing does not match that of Virgil as Signorelli portrayed him in the eleven tondi from *Purgatorio*, nor does a laurel wreath identify him as a poet. The panel surrounding this portrait contains two sets of cameos: four large cameos around the portrait depict Canti V–VIII of *Purgatorio* and four smaller, irregular-shaped compositions tucked into the corners contain four labors of Hercules. The most consistent modern identity for this man is that of Statius, which I believe is appropriate, for he plays an important role in Dante's journey through Purgatory. As a Christian (which, of course, Virgil was not), Statius supplants Virgil and leads Dante in the final steps through Purgatory toward Paradise. He appears first in *Purgatorio* XXI: 91, and delivers a lengthy dialogue on the relationship of soul and body in *Purgatorio* XXV. Riess further supports the choice with the presence of Hercules' labors, which Statius recounts in his epic, *Thebaid*.[26]

A panel matching those in the south bay, an author flanked by four tondi, now hides behind the imposing eighteenth-century altar. The damaged top tondo survives, visible only during restoration. It depicts a prone man, arms raised as if to defend himself from the blows of the man standing over him. The restorers have identified the figures in the tondo above the author as Romulus and Remus, but without convincing reason.[27]

Interestingly, three similar confrontation scenes lie in a vertical line. Immediately above the aforementioned tondo, in the illusionistic architrave that separates the scenes of Heaven and Hell from the socle, a grisaille scene depicts a pair of unidentified figures in similar hand-to-hand combat. Above the architrave where *The Blessed Led to Heaven* once joined *The Damned Led to Hell*, two figures (named by the restorers Cain and Abel) mirror the combat of the scenes below. If so, then who is the author? Who would suit a position below the intersection of Heaven and Hell and between religious and mythological poetry? Loscalzo calls him Virgil, and suggests the scenes are from the *Aeneid*, Clementini called him 'Statius'; I believe other portraits

represent these poets.[28] I therefore suggest that this poet might have been Boccaccio surrounded by scenes from his *Genealogies*. Like Dante, Boccaccio was an Italian poet who wrote of the afterlife and moralized the writings of the classical poets.

The readily recognizable scenes of classical heroes who surround the pair of authors below *The Torture of the Damned*, like Dante and Christ, enter and return from the underworld. The poet nearest to the altar on the left-hand side of the wall is traditionally identified as 'Ovid' (Pl. 22). This man appears in three-quarter view and wears Renaissance dress – a red, long-sleeved, ribbon-bedecked tunic, similar to that of Dante. A poet's laurel crown rests over his closely fitting dark cap. He seems actively engaged in scholarly discourse. He holds his place in his text and looks eagerly toward the poet in the next panel, as if in silent conversation. The surrounding cameos portray four scenes from the Rape of Persephone, which Ovid recorded in Book V of his *Metamorphoses*. If, as in the tradition of manuscript illuminations, the cameos describe the author that they surround, then the identification as 'Ovid' fits. With the dominance of scenes from his *Metamorphoses* on the two walls below *The Damned Led to Hell* and *The Torture of the Damned*, moreover, his presence is important to the chapel, second only to Dante.

The somber poet depicted in profile on the right below *The Torture of the Damned* looks toward Ovid. He wears a laurel crown on his golden hair, and is dressed in a gold, natural wool-lined cloak with a broad collar and rolled sleeves. Though traditionally identified as 'Horace', the face and clothing match identically those of Virgil in the eleven scenes from *Purgatorio* illustrated on the facing and adjacent walls (Pl. 23).[29] The four cameos surrounding the portrait share the common theme of trips into the underworld, although only one of the scenes depicts Aeneas's voyage.[30] The scene to the right depicts Hercules and Theseus in Hades, and the remaining two, Orpheus in Hades. It is appropriate to place Virgil next to his fellow pagan Roman poet Ovid and facing Dante. Furthermore, as with Dante and his *Purgatorio* and Ovid and his *Metamorphoses*, Virgil and his *Aeneid* serve important roles in the iconography of the chapel.

On the entrance-side of the *cappelline* in the north bay, each wall has a portrait surrounded by three cameos (Pls 3 and 4). Beside the Cappellina della Pietà, the youngest of the poets wears an oak-leaf crown on his golden curls (Pl. 25).[31] He looks down at a scroll – all of the other authors hold books – yet he wears Renaissance costume: a red, full-sleeved gown. Traditionally he is called 'Lucan', and the two flanking grisaille tondi are identified as scenes from the death of Pompey in the *Pharsalia*. However, these scenes do not concur with the text. The *Pharsalia* records many brutal fights, but no clubbings occur, as illustrated here. Furthermore, the death of Pompey clearly occurred in a boat, and not by hand-to-hand combat.[32] Far more reasonable, although more obscure, is Donato Loscalzo's identification of the poet as the youthful Roman poet Tibullus, who opened his *Elegies* (book I, verse 10, lines 1–10) with the horrors of war, illustrated in the two flanking tondi.[33]

The facing wall beside the Cappellina della Maddalena contains a portrait of an old man with a bald head and gangly body (Pl. 20) reminiscent of Donatello's prophet figure 'Zuccone' that stood on the Campanile in Florence, a figure that Signorelli would have known.[34] His age contrasts the youth of the author across the chapel. This man is the only portrait figure to wear a classical toga. He looks down to a book that he appears to read, for he gently touches the page with his fingers. The author is customarily identified as 'Homer', again based on Dante's list of poets in Limbo. However, no attributes associate him with traditional depictions of Homer, nor do the surrounding scenes match the traditionally identified text describing the Shield of Achilles from Homer's *Iliad*, although recently others have questioned this identification.[35] Dante describes Homer with a sword rather than as blind in *Inferno* IV: 86, but no sword appears in Signorelli's painting. In the Studiolo of the Duke of Urbino (1470s) and in Raphael's subsequent Mount Parnassus in the Stanza della Segnatura of the Vatican Palace (*c.* 1508–11), Homer appears as he did in classical busts: old, with a full beard, curly gray hair extending to his jaw line, and crowned with a laurel wreath. In both representations, he blankly raises his head with eyelids closed and gropes because he is blind. The portrait of Homer in Albèri's library portrays him as old with long hair and a beard, though his blindness is ambiguous (Fig. 6.1). Signorelli's figure, however, is not blind, because his open eyes follow his fingers on the page. The figure, then, clearly is not Homer. The most plausible identification to date for this man is Sallust, surrounded by scenes from his *Conspiracy of Catiline*.[36] The story, dating from the first century BCE, recounts the victory of the Romans over the insidious conspirator Catiline.

A strict protocol governs the arrangement and choice of the scenes. In the south bay, the scenes that reflect Christian ideas, those from Dante's *Purgatorio*, are not only nearest to the altar, but also to the right of Christ. The scenes representing classical heroes who, in the Middle Ages and Renaissance, represented Christian virtues, largely taken from the *Ovide moralisé*, occupy the less revered position to Christ's left, below Old Testament Prophets, *The Torture of the Damned*, and *The Damned Led to Hell*. In the north socle, below the apocalyptic scenes, classical heroes enact events from Roman history. Throughout, the complementary literary scenes continue the themes of the victory of good over evil, perseverance, penance and renewal, themes that concur with the Lenten texts and the other penitential fast, Advent; they also complement the texts concerning judgment read at the Feast of All Saints.

Finally, the panels flanking the entrance beneath *Doomsday* display perhaps the most imaginative *grotteschi* in the chapel (Pls 3 and 4). The predominantly green and red vegetal design, set against a brilliant field of gold leaf, is divided into bilaterally symmetrical quarters. Growing from the lavish tendrils are satyrs, goats, winged horses, and composite figures of half-man, half-goat with lavender hind parts. A pair of large birds with elaborate tail feathers, resembling Birds of Paradise, each feeding from a cornucopia, appears in the upper part of the lower panel. A single portrait bust in a circular frame is set into the center of each field. The men hold no books and

wear no laurel crowns and no grisaille histories appear. Facing the entrance, the face on the left has been destroyed (Pl. 26). The figure on the right wears a turban, identifying him as eastern. Though tradition calls him 'Empedocles', without books or histories, it is impossible to confirm this identification (Pl. 27).[37] Above the portrait, a pair of nude men with wings growing out of their hips stands in the upper corners holding a cartouche where Luca Signorelli left his monogram 'L.S.' to indicate his authorship.

Audience

The socle in the Cappella Nuova represents the conventions of classical motifs, programs of famous people and manuscript practices elevated to a new level of complexity in both decorative use and iconographic function. Although the general populus would recognize the narratives in the vaults and lunettes, and perhaps would recognize the liturgical associations, Signorelli's complex, multi-level iconography points toward a sophisticated audience: the clergy and local humanist scholars. Signorelli and his advisors challenge the audience on a deeper intellectual level to seek out the hidden meaning, to scrutinize visual texts in the same manner they would analyze written ones. Simultaneously the paintings illustrate examples of sermon rhetoric, the use of parables and allegories, for the students of theology, the clerks. Finally, on a more basic, sensory level rather than on higher intellectual planes, like the poetic cadences of the allegories they illustrate, the cameo paintings delight, instruct and edify the general audience. The relationship of the socle to the upper walls, the Roman liturgy and classical rhetoric and poetry, along with the emphases on metamorphosis, or spiritual rebirth and a new life of virtue, resurrection and the message of salvation through penance unfold in detail in subsequent chapters.

Purgatory and *Il Purgatorio*

As scholars have long noted, Dante's epic poem, the *Divine Comedy*, plays an important role in Signorelli's eschatology.[1] For Signorelli to invoke Dante was logical, for of all the studies of the world to come, the *Divine Comedy* provides the most poetic, the most visual and the most accessible analysis. Signorelli acknowledged his debt to the poet by representing his image more than that of any other individual. Dante appears twice in the background crowd of *The Rule of the Antichrist*, once on either side of the rostrum, reverse images of the same cartoon (Pl. 12). His portrait in the socle is the only one that can be identified unequivocally (Pl. 1). Signorelli, moreover, made visual references to Dante's imagery, particularly in the scenes on the upper walls depicting *The Damned Led to Hell*. The most direct and systematic borrowing from the poet, however, occurs in the southeast corner of the socle, where Signorelli included the first eleven canti from Dante's *Il Purgatorio*. On the southeast wall, Canti I–VIII recount Dante's journey through Ante-Purgatory, created by the poet as a necessary place of instruction and preparation for the late repentant before earning admission to Purgatory proper.[2] The crossing into Purgatory in Canti IX–XI appears on the south wall. The choice and subject of these scenes has puzzled scholars for centuries. Rarely is Purgatory represented in art; more rarely still is Ante-Purgatory shown.[3] Thus, some scholars speculate that Signorelli intended to continue Dante's narrative.[4] No one, on the other hand, has adequately explained why Signorelli included these canti or how they pertain to the overall message of the fresco cycle. However, by considering these paintings in the context of the greater whole, I intend to show that they perform a unique role that is vital to the iconography of the chapel. Since Dante's *Il Purgatorio* has a Christian subject, Signorelli strategically placed these scenes to the right of Christ beneath the Apostles and the lunettes representing *The Blessed and Heaven*, the ultimate destination of the shades in Purgatory. In so placing them, the artist emphasized the value of purgation for salvation.

Purgatory and *Il Purgatorio*: definition and structure

Although Purgatory has been a part of Christian belief since the fourth century, not until 1254 did a pope, Innocent IV, provide a brief written definition.[5] Roman theology holds that sins uncompensated at death require

time in Purgatory, the length of which varies according to the failings of the individual. Most Christians, those not so wicked as to go immediately to Hell or so pure as to go directly to Heaven, spend time in Purgatory, to purge themselves of sin and prepare for heaven. Unlike Hell and Paradise, which are eternal in their time as well as in their darkness and light, Purgatory disappears at the Last Judgment, and, as with its ultimate transitory existence, time spent there has a beginning and an end, measured by the same lights and rituals as on earth. Dante emphasizes the temporality of Purgatory by traveling only by daylight and by alluding to the liturgical hours to indicate the passage of time.

Thomas Aquinas had discussed the existence and purpose of Purgatory in several polemical attacks on groups of infidels and heretics, as well as in his *Summa contra Gentiles*, written mostly between 1263 and 1264 when he resided in Orvieto. He stressed the positive aspects of purgation. Dante, educated in Florence by the Dominicans of Santa Maria Novella two generations later, followed his lead. Dante wrote the *Purgatorio* in the early 1300s, giving probably the most systematic and detailed studies of Purgatory ever written. Dante clarified church doctrine and made it specific.[6] Signorelli's exclusive and systematic depiction of the *Purgatorio* demonstrates that he intended to explicate the doctrine of Purgatory rather than to illustrate Dante's narrative.[7] Moreover, the inclusion of Purgatory supports Signorelli's hopeful message, for Purgatory is a positive place: with one entrance and one exit, all souls who enter there are Heaven-bound.[8] Signorelli emphasized the positive value of purgation by placing the scenes to the right of Christ, beneath the lunettes representing *The Blessed in Paradise* and *The Ascent of the Blessed to Heaven*, the ultimate destiny of the shades in Purgatory. One scholar has noted that the *Purgatorio* is structured like a Mass; indeed these canti emphasize contrition, penance, purgation and renewal, attributes which form the heart of a Mass.[9] In addition, these canti allude to the universal sacraments of penance, baptism, confirmation, the Eucharist and Extreme Unction, and thereby stress the essential role of the Church in salvation.

Most pertinent for a chapel with strong emphasis on the means to salvation, of all one hundred canti of the *Divine Comedy*, only the eleven that Signorelli chose methodically recount the eight liturgical hours of a full day. As such, they form a temporal and daily parallel to the broader liturgical references to All Saints, Advent and Lent in the Cappella Nuova and the other liturgies represented in the Cappella Corporale and the choir of the cathedral that together form the major parts of a liturgical year. Moreover, only these eleven canti give specific instructions for purgation, hour by liturgical hour. In addition to the liturgical format and the lessons in penance, these canti emphasize penitential piety, which concurs with contemporary theological issues regarding the sacraments and papal primacy and support the overall message in the chapel. As previously noted, in late fifteenth-century Rome, penance superseded all others as the central Christian sacrament, as it was the indispensable first step.[10] Only a priest could absolve one of sins, after which satisfaction had to be remitted through prayer, pilgrimage, alms,

works or the purchase of indulgences. In 1476, Sixtus IV promulgated a bull that granted to the living the privilege of purchasing indulgences on behalf of deceased individuals to reduce their time in Purgatory.[11] The Church, indeed, held supreme power over the spiritual lives, and now the interim and afterlives, of its subjects. In a city with strong papal ties, the iconography of this chapel, like the facing Cappella Corporale, illustrates the essential role of the Church, and ultimately the pope, in salvation. A fifteenth-century worshipper, especially a cleric or member of a religious order, would recognize these allusions both in Dante's text and in Signorelli's paintings.

While traveling through both Inferno and Paradise, the pilgrim Dante observes his surroundings as a spectator. By contrast, while working his way through Purgatory, especially Ante-Purgatory, Dante actively participates and learns, as he engages the 'shades' in conversation. Dante finds that each group he encounters is distinctive, and each, except for the Contumacious (those separated from ritual) has its own prayer or hymn, which, in turn, corresponds to a liturgical hour. The intervals of recitations, hymns and conversations contrast the eternal silence of Hell; the somber tone of lament contrasts the eternal praise in Heaven. Just as Dante's Late Repentants have a last opportunity for salvation, so Signorelli's program reminds the faithful on earth that they have the opportunity to prepare for the hereafter and to reduce purgatorial punishment.

Instruction begins in Canto I in the wee morning hours with Matins on Easter Sunday and continues through Matins in Canto IX. In Canto X, which takes place on the morning of Easter Monday, Dante and his mentor and guide Virgil cross from Ante-Purgatory into Purgatory proper. At the end of Canto XI the first phase of purgation is complete: instruction ends as a new day begins. This is the turning point of the *Purgatorio*: the struggle is past and salvation seems secure. Beginning in Canto XII (118–26), Dante experiences the gradual lightening of his burden, as the seven 'P's (*peccata* = sin) fade and the first is erased. The mood becomes uplifting. The title, *La Commedia*, or the '*Comedy*', indicates a successful ending; that conclusion begins in Canto XII of *Il Purgatorio*. As with the scenes of Heaven and Hell above, he portrayed the journey and not the destination. The scenes from the *Purgatorio* relate thematically and allegorically to other histories in the tondi of the lower level, to the hemicycles, and to the figures in the vaults. They form an instructional handbook in the means to salvation, following the lead of Dante's poem by giving accessible human examples to show that salvation is available for all who seek it through penance.

Seldom recognized is the fact that Signorelli's apocalyptic epic gives a hopeful outlook on the world to come that is instructive, a distinct departure from terrifying, unpromising medieval Last Judgment scenes such as that by Maitani on the cathedral façade (Fig. 1.4). Dante's writing plays an important role here. By following the instruction given to him in Purgatory, Dante teaches mankind how to live in this life so that they might attain heavenly reward without the preamble of Purgatory. Signorelli echoed this directive in his fresco cycle by demonstrating visually, step by step, the means to salvation, as Dante before

him had done in lyrical verse. As with the *Divine Comedy*, this encouraging message and instruction form the heart of Signorelli's fresco series.

Signorelli's vision of Dante

Signorelli was not the first artist to illustrate a portion of Dante's *Divine Comedy*. The most notable contemporary to illustrate Dante's text is Botticelli;[12] another contemporary manuscript comes from the ducal library at Urbino.[13] As book illuminators, these artists systematically illustrate the narrative. Their styles differ, and so do the points they choose to stress; neither do they concur with the points Signorelli emphasized. Botticelli's delicate drawings depict a bird's-eye point of view throughout, wherein the viewer feels detached, a spectator rather than a participant. The Urbino manuscript portrays the scenes in color, sometimes offering more than one illustration of a canto. The figures remain small in the landscape setting, and they too seem remote. In Signorelli's work, on the other hand, the point of view of the spectator is the ground line of the figures. His powerful figures press close to the picture plane, so the viewer feels intimately involved. Ancillary scenes in the continuous narrative fit into background spaces. The viewer, then, like Dante, is a fellow traveler and not a bystander. Like his fellow illustrators, Signorelli closely followed the word of the text, but chose vignettes that speak to the overall message of the chapel: salvation through penance. Signorelli set Purgatory against the rocky landscape of the Mount of Purgatory. Unlike the Urbino manuscript, Purgatory does not appear lush and green, but rather stark and bare. Moreover, Dante and Virgil match their appearance in their respective facing portraits in the chapel.

The narrative of *Il Purgatorio* begins in the tondo below the portrait of Dante and moves upward and clockwise, the directions Dante takes through Purgatory, as opposed to the downward, counterclockwise route of his journey through Inferno (Pl. 1). The text of Canto I establishes the time as Easter Sunday morning by describing the pre-dawn eastern sky with Venus in sight (I.13–15), a reference to the liturgical hour of Matins. Dante emphasizes the pilgrimage aspect of his journey in the last seven lines of Canto I, as he compared his passage to the journeys of classical heroes Aeneas and Odysseus (Ulysses), both of whom once appeared in the chapel.[14] Contemporary Christian intellectuals believed that these heroes also traversed the waters that separate Hades from Purgatory. In fact, the tall mountain that sent a whirlwind to sink Odysseus's ship was thought to be the Mount of Purgatory.[15]

In Canto I, Signorelli emphasized preparation. Virgil stands on the left, and Cato the Elder, an old man with a beard, on the right. Dante, the central figure, kneels before Cato, the guardian of Ante-Purgatory. The water before them is the river Lethe, mentioned in *Inferno* XXXIV, which carries the sins washed off in Purgatory into Hell below.[16] Virgil, with his right arm outstretched and his hand crooked, implores Cato to allow them passage

into Purgatory. The ensuing ritual of cleansing and initiation suggests the sacrament of baptism.[17] Cato instructs Virgil to gird Dante with the reed of humility and to cleanse him of the filth of Hell (I.28–36; 49–51; 100–126). Virgil wipes Dante's face with the moisture of dew (I.121–29), a symbol of God's grace.[18]

Signorelli used a continuous narrative to show four vignettes from Canto II, each of which emphasizes humility or penance. In the text, a description of Aurora at daybreak establishes time, along with references to a hymn and to a psalm, both sung at Lauds on Easter (II.46–48). Psalm 114, 'Out of Egypt I have Called My Son' (II:7–10), continues the theme of spiritual pilgrimage, as it alludes to the journey of the children of Israel out of Egypt as a metaphor for moving from sin into new life in a promised land.[19] Canto II not only fits the themes of penance and grace shown throughout the chapel, but also it reflects the importance of allegorical interpretation. Dante also used this Exodus passage to illustrate to the Can Grande della Scala the traditional four levels of interpretation: literal (historical), allegorical, tropological (moral) and anagogical (mystical).[20] Signorelli employed this literary device in his iconographic plan for the chapel, which unfolds here and in later chapters.

Dante and Virgil stand on the rocky shore in the right foreground (II:9). With one hand shading his brow, Dante peers in the direction of an angel in the left foreground who escorts a group of new arrivals. Virgil speaks to Dante, saying:

> 'Down, down!' he cried, 'Fold hands and bow thy knees;
> Behold the angel of the Lord! Henceforth
> Thou shall see many of these great emissaries.' (II:28–30)

In the mid-ground, Dante, on bended knee, and Virgil beside him greet the angel (II.28–30). In the left background, Dante and Virgil face the group of shades, distinguishable by their nudity. The text states that the shades notice that Dante breathes (II.67–69). One shade, Casella, steps forward to investigate and embrace Dante (II.70–78). Slightly further along the path, Cato points upward, directing the shades, as well as Dante and Virgil, up the steep incline toward Purgatory (II.118–23) and rebukes them:

> 'Run to the mountain, slough away the filth
> That will not let you see God's countenance.' (II:122–23)

The slough refers to the old skin, which when shed like a snake's, produces new strength. Cato urges them to remove the cloak of sin and seek new life.[21]

Dante encounters four groups of Late Repentant wanderers in Ante-Purgatory: the Contumacious (Canto III); the Indolent (Canto IV); the Unshriven (Canti V and VI); and the Preoccupied Rulers (Canto VII and VIII). The shades implore intercessory prayers from Dante, prayers offered by the living faithful on behalf of souls in Purgatory to reduce their time there. Moreover, it will be remembered, at the dawn of the sixteenth century the living had even more power over those in Purgatory through the

purchase of indulgences; more recently, Pope Alexander IV had declared that Dominicans and other Mendicants had the power to release souls from Purgatory.[22]

Canto III begins with a discussion of the powers of the soul and ends with a request for intercessory prayer. Signorelli portrayed this canto in two vignettes. In the right foreground, Virgil, standing beside Dante, looks up to marvel at the vast cliff of the Mount of Purgatory. Early in their journey Virgil explains to Dante (III:90–96) that the Mount of Purgatory would be more difficult to climb in the beginning than at the end. The sun indicates early morning and the liturgical time of Prime, 6:00 a.m. Here the travelers experience the first daylight of their journey, as Inferno receives no light and they entered Purgatory before daybreak. They face west, and the rising sun's rays warm their backs. Then, startled, Dante looks at Virgil, hands outstretched, as he realizes that he alone, the only living being, casts a shadow (III:16–18). In the background, Virgil faces a group of shades standing on the far left. With Dante to his right, he backhandedly gestures to the Mount. The first group of Late Repentants, the Contumacious, is detained at the base of the cliff. Unlike the groups that follow, the Contumacious have no special prayer or hymn, for, as the Excommunicated, they cannot receive the sacraments or participate in rituals of the Church.[23] One shade, Manfred, points to Dante and speaks, imploring prayers of intercession when he returns home (III:103–45).

In Canto IV, Dante and Virgil climb to the first ledge of Ante-Purgatory, where they meet the second group of Late Repentants, the Indolent (Fig. 7.1). The continuous narrative of the tondo, portrayed in ascending order, contains three parts. As they begin the steep ascent of the mountain to the Second Terrace, Dante and Virgil stand in the foreground, craning their necks back to survey the upward road ahead (IV:15–24). Just before the road makes a sharp turn, Dante and Virgil sit on a rocky ledge in the left midground (IV:52–54). Virgil points to the sun at the midmorning position half way up in the sky (IV:55–57), which coincides with Terce (9:00 a.m.). He comforts Dante, who feels overwhelmed by the journey ahead, by explaining that the ascent of the Mount of Purgatory becomes easier later (IV:85–96). In the background, Virgil and Dante encounter Belacqua lazily resting in the shadow of a boulder (IV:106–9). He bemoans the futility of pressing on and begs Dante's intercessory prayers (IV:127–36). The canto ends at noon, the liturgical hour of Sext (IV:139–40), setting the hour for Canto V.

The journey continues in the four tondi encircling the author (Statius?) to Dante's left (Pl. 21). Canto V appears beneath the portrait, but the sequence is different from that of the preceding group. The scenes still move upward, but from bottom to top, left to right. All four canti take place on the second terrace of Ante-Purgatory, and all concern the third and fourth groups of Late Repentants. In Canto V, Dante and Virgil meet the Unshriven, those who died violently and repented on their deathbeds, but without the sacraments of penance or the Last Rites (V:52–60). They sing the *Miserere*, Psalm 51, known as the prayer of the Unshriven. The most frequently used

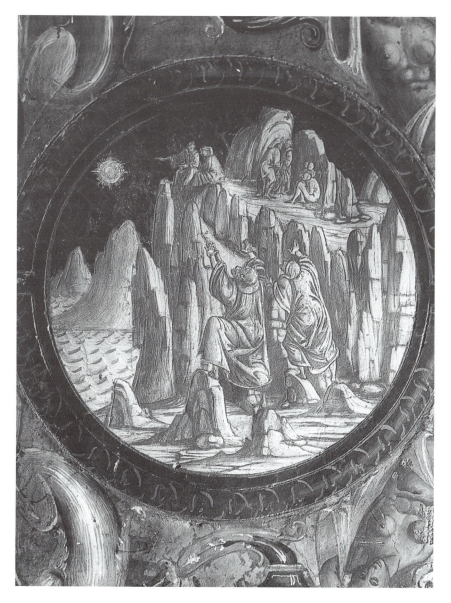

7.1 Canto IV (detail of Dante panel) (Gabinetto Fotografico Nazionale, Rome)

of the seven penitential psalms, it specifically addresses divine judgment and God's grace, as the author, King David, laments his sins, praises the might of God, and begs for mercy, a clean heart and renewal. The singing of Psalm 51 opens the Great Litany on the first Sunday in Lent. Some Orders, including the Dominicans, recite Psalm 51 at Sext.[24] Dante and Virgil stand in the center foreground, flanked by shades. Dante looks over his right shoulder to the shades behind him. They stop singing their psalm, for he startles them with evidence of his mortality: a shadow. Two shades, Jacopo del Cassero and Buonconte di Montefeltro, step forward from the crowd and gesture toward him (V:23–30). As the crowd in the right background watches,

7.2 Canto VI
(detail of Statius
panel) (Gabinetto
Fotografico
Nazionale, Rome)

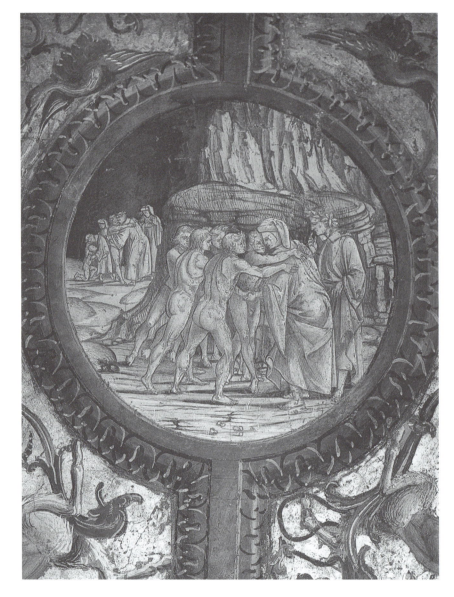

these two shades, standing in the center mid-ground, tell their stories and beg Dante's intercessory prayers.

The encounter with the Unshriven continues into Canto VI and another liturgical hour (Fig. 7.2). Reference to the sun's position indicates mid-afternoon and None, sung at 3:00 p.m. The theme of None, perseverance, fits Virgil's temperament, as he says they will press on as long as they have light (VI:51–54).[25] In the foreground, Signorelli depicted Dante and Virgil pressed by an eager crowd of shades, some of whom Dante recognizes (VI:10–23). Two shades, Federigo Novello and Farinata the Pisan, embrace him and beg intercessory prayers. In the background, Virgil and Dante encounter the poet

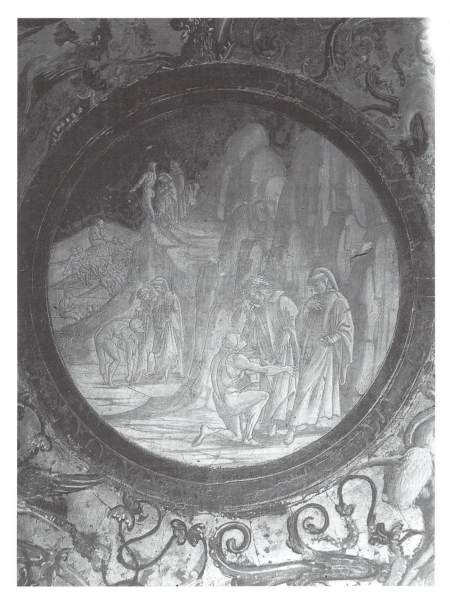

7.3 Canto VII (detail of Statius panel) (Gabinetto Fotografico Nazionale, Rome)

Sordello, who recognizes Virgil as a fellow Mantuan (VI:72–75). Dante watches as Sordello kneels before Virgil, who leans over and touches his back. Just beyond, Sordello stands and embraces Virgil while Dante continues to observe (Vl:74–75). The text dialogue recounts corruption in Italy, including the warring Capulets and Montagues of Verona (later made famous by Shakespeare) and the Monaldeschi and Fillipeschi families of Orvieto (VI:74–151).

Sordello provides a transition between the Unshriven and the Negligent Rulers. In the Canto VII on the left, Signorelli began by showing a moment of deeper recognition as Sordello asks the travelers their names (Fig. 7.3). Upon realizing Virgil's full identity, Sordello falls to his knees, as Signorelli

portrayed him in the right foreground. Virgil looks down into Sordello's face as Dante draws back in surprise:

> Like one who sees what takes away his breath,
> Who half-believes, and then must hesitate
> And doubt: 'It cannot be,' he saith;
>
> So seemed that shade; and then, returning straight,
> He stooped before him, and with bended head
> Embraced him where the humble clasp the great. (VII:9–15)

Sordello, as a poet, is free to move around in Ante-Purgatory. He offers to guide Virgil and Dante to Peter's Gate, the entrance to Purgatory proper (VII:40–42), where he will relinquish his post to the poet Statius.

A cliff rises directly behind the group. In the mid-ground, where the rock opens for the upward path, Sordello leans over to draw a line on the ground with his finger (VII:52–54). He explains to Dante and Virgil the rule of the mountain, which prohibits ascent after sunset. Virgil urges that they continue as far as possible (VII:62–69). Accordingly, in the background, the three have ascended further and stand on a low ledge overlooking the shades below in the Valley of the Princes, populated by the fourth group of Late Repentants, the Negligent Rulers. These rulers, preoccupied with matters of state, ignored their religious duties. They repent by singing the intercessory hymn *Salve Regina* (VII:82–93). Here the hymn, sung at dusk, signifies Vespers at 6:00 p.m.[26] The *Salve Regina* fits appropriately, for not only does it implore the intercession of the Virgin Mary, but also it alludes to the valley of tears, and thus, obliquely, to where the rulers dwell. The valley foreshadows earthly paradise at the peak of the Mount, which the pilgrims will visit later. Moreover, at this point Dante subtly indicates an improved state: he substitutes the word *anime*, or rational soul, for *ombre*, or shade.[27] The themes of exile and pilgrimage establish a liturgical link between the Christian in this world and the souls in the next yearning for entrance into Heaven.[28]

Canto VIII on the right depicts further encounters with the Negligent Rulers (Fig. 7.4). In the first six lines Dante alludes to sundown, the time when sailors and pilgrims yearn for home. Following textual description, two angels brandishing swords stand guard on top of twin rocky promontories, placed at an angle in the center of the picture space (VIII:25–30). Sordello points to the Negligent Rulers in a valley beneath the twin peaks. These shades sing *Te Lucis ante Terminum*, a hymn of St Ambrose sung at nightfall in the Compline liturgy (VIII:13). The hymn implores protection against temptation and evil dreams; the vision that follows later addresses the hymn's plea.[29] A serpent makes its nightly appearance in front of this group (VIII:97–102). The guardian angels ritually drive it away, a reminder of Adam and Eve in the Garden of Eden. In the background, beyond the valley, Sordello and subsidiary guides advise Dante and Virgil (VIII:43–66).

Three final scenes from the *Purgatorio* appear in a vertical row on the adjacent wall under the half-lunette of Heaven and bridge the transition

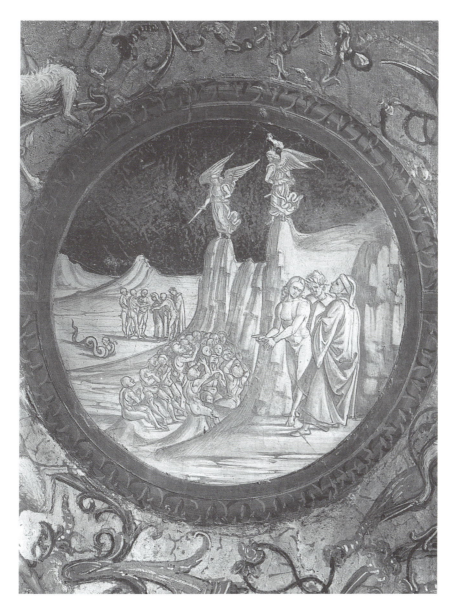

between Ante-Purgatory and Purgatory proper, where Signorelli concluded his narrative. The top scene, a rectangle, depicts Canto IX. The text obliquely indicates that night has fallen and the hour is about 9 p.m., or Matins. Dante's allusion to the swallow's folded wings indicates nightfall and rest. Signorelli divided this picture space into two areas, with craggy rocks filling the right background and a huge eagle filling the sky on the right side. Dante, the only living soul, sleeps on the grass under a hovering eagle, which figures in his dream (IX:19–21). Directly behind Dante, Virgil speaks with Lucia, who has come to lead them onward (IX:32–36). During the

dream, Dante receives baptism by fire.[30] This is his second baptism; as we recall he received baptism by water in Canto I:

> Dreaming, I saw him circle for a while,
> Then terrible as lightning, he struck down,
> Swooping me up, up to the sphere of fire.
>
> And there it seemed the bird and I both burned;
> The heat of that imaginary blaze
> Was so intense it woke me from my sleep. (IX:28–33)

On the far left, an angel, sword in hand, sits at the top of a staircase and guards the gate of Purgatory. The angel also holds the two keys of gold and silver (heaven and earth), a gift from St Peter that represents the authority of the Church to loosen the bonds of sin. The three stairs represent the steps of penance: confession, contrition and satisfaction; the angel symbolizes the ideal confessor (IX:76–115).[31] Dante kneels as Virgil stands in front of the angel with his hand on Dante's shoulder. As decorum would demand in the presence of an angel, Dante has removed his capuchon and placed it over his heart, exposing his tight-fitting undercap (IX:109–11). He bows his head and beats his breast. Although Signorelli did not illustrate the details of the encounter, the angel will inscribe the letter 'P' for *peccatum* on Dante's forehead seven times with the point of a sword (IX:75–114). The number identifies them as the seven deadly sins, which gradually will be purged on the seven upper cornices of Purgatory.

With Matins of a new day, the church brings to its congregation the thought of Parousia, or the Second Coming of Christ (the subject of the walls and vaults of the chapel), for it was a widely held belief that the event would occur at midnight.[32] As Virgil and Dante prepare to enter Peter's Gate ahead, Dante discerns the sweet refrain of another Ambrosian hymn, *Te Deum laudamus*. Legend holds that St Ambrose composed the hymn at his conversion.[33] Significantly, here the hymn celebrates the entrance of a new soul into Purgatory, which acknowledges that a conversion or a metamorphosis has occurred.

The center tondo depicts Canto X in three vignettes (Fig. 7.5). The fading moon mentioned in the text indicates the pre-dawn of Easter Monday (X:14–15). In the left foreground, Dante and Virgil walk through the Rock Gate, called the Needle's Eye, to the first cornice of Purgatory, the place of the Proud (X:1–16). This crossing recalls the rite of passage in the sacrament of confirmation. Once through the gate, but before encountering the Proud, Dante and Virgil survey three narrative relief sculptures, the only art to appear in the *Divine Comedy*, depicting acts of great humility, the virtue opposite Pride (X:31–33). Dante announces that God was the artist who created these works (X:75), perhaps a veiled admonition to artists concerning Pride. As with the *Biblia pauperum*, the *Speculum humanae salvationis*, and, more particularly, the *Ecloga Theoduli* of Baudri of Bourgueil, a system of correspondences draws parallels between exemplary classical heroes and

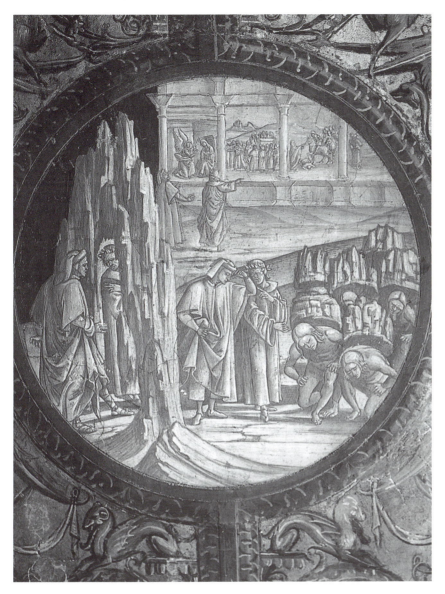

7.5 Canto X (south wall) (Gabinetto Fotografico Nazionale, Rome)

biblical figures from the Old and New Testaments.³⁴ The first panel depicts the Annunciation, as the Virgin Mary humbly accepts her role as Mother of God (X:34–45). The next scene illustrates a procession with the Sacred Ark during which King David put aside his majesty to dance before the Lord (X:55–66). The third panel portrays the Roman Emperor Trajan on horseback, stopping his cavalry in order to secure justice for a poor woman (X:73–93).³⁵

Finally, in right foreground Signorelli depicted Dante and Virgil surveying the plight of the Proud (X:100–139). Six figures, all named in Canto XI, appear weighted down by stones on their backs, which force them to stoop and bow their formerly haughty heads (Fig. 7.6). Pride is the most basic of

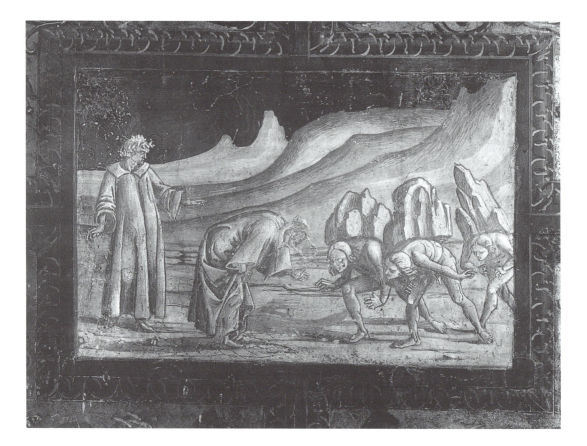

7.6 Canto XI
(south wall)
(Gabinetto
Fotografico
Nazionale, Rome)

all sins, both original and actual. As with other sins in lower Purgatory, such as Envy and Wrath, Pride is perverted, selfish love and must be overcome first in order to conquer the remaining six of the Seven Deadly Sins.[36] Pride also reduces love and hinders salvation, for unlike earthly goods that reduce when shared, love increases. A discourse follows on penance and the metamorphosis of the soul (X:109–11; 121–27), themes that recur throughout the Cappella Nuova.

Pride is basic and deadly, so essential to conquer that Dante devotes two canti to it. Three of the six prideful shades appear again in Canto XI. Interestingly and probably not coincidently, Dante's only mention of artists comes here. Four of the men he names are painters: illuminators Oderisi of Gubbio and Franco Bolognese, followed by Cimabue and Giotto. As an artist himself, perhaps Signorelli emphasized God's sculpture in Canto X and does not venture beyond Canto XI, the place of the artists, for fear of being haughty like Marsyas or Arachne, who suffered punishment for challenging the gods.

Dante offers tools for conquering Pride. The first seven tercets of Canto XI form an embellished paraphrase of the Lord's Prayer, one which occurs at all liturgical hours. The eighth through twelfth tercets are an intercessory prayer, entreating the Lord to act on behalf of the deceased in Purgatory. When the

prayer ends, Virgil inquires of one of the Proud the direction of the ascent (XI:37–42). Virgil stands to the left, arms spread, while Dante assumes the bent posture of the Proud (XI:73–78) in order to meet the gaze of Omberto Aldobrandesco, who asked to see a living man. The three souls recount their stories of falls from high position and subsequent humiliations; each laments his sins and repents of his Pride (XI:82–138). Omberto, the aristocrat, warns of the sin of pride in family (XI:67–79). Oderisi, the artist, warns of pride in high achievement, and recalls the fleeting duration of the moment, noting that Franco Bolognese exceeded his art, and that Giotto replaced Cimabue. Finally, Salvani, the Sienese despot who urged the destruction of Florence, warns of the pride of domination and bemoans his presumptuousness. In the final tercets, Oderisi hints of the poet's approaching exile that will humble Dante to the point of begging.

The dawn of a new day in Canto XI represents a decisive moment in Signorelli's fresco program. Only the ascent of the Mount of Purgatory remains. Beginning in Canto XII, Dante feels his load gradually lighten as the first of the 'P's fades. Although subsequent scenes may allude to purgatorial matters, the sequential narrative stops here. The struggle is past, initiation is complete, and fulfillment of the promise of Heaven appears imminent.

The first scene in the next row below *The Ascent of the Blessed to Heaven*, a tondo representing the emblematic scene of the *Triumph of Charity over Envy*, is Signorelli's final scene that relates to the *Purgatorio* and the liturgy (Fig. 8.3).[37] As Dante and Virgil ascend the third terrace in Canto XV, they hear the shades singing the *Beati misericordes*. As with the other hymns, the first line represents the rest of the text, which is based on the fifth beatitude, 'Blessed are the merciful'. None of the Beatitudes speaks specifically to the virtue of Charity, but theologians, including Thomas Aquinas, consider Mercy, the opposite of Envy, to be the closest Beatitude to Charity.[38] Dante's narrative has now filled Signorelli's purpose. At this point, the artist invokes classical literature for further parallel allegories that support the importance of humility, penance and purgation in the quest for salvation.

8
Classical Allegories

Emblems and scenes from classical literature fill the area of the socle of the Cappella Nuova adjacent to the scenes from *Il Purgatorio* and below *The Damned Led to Hell* and *The Torture of the Damned* (Pls 2–4, 20, 22, 23 and 25). Today's audience may find the practice of mixing pagan myths and Christian histories inappropriate, even an anathema. However, Signorelli drew his ideas from a long-standing literary and artistic tradition. In art and literature of the Middle Ages, certain classical heroes were perceived as paradigms of Christian virtue and precursors of Christ.[1] In fact, works by classical authors were 'glossed', or annotated, with interpretations that demonstrated Christian morality. Nowhere, however, as far as I know, did an artist incorporate such an extensive series of pagan images into a Christian program. Scholars have not adequately recognized the presence and purpose of the feats of classical heroes in the chapel, even though they outnumber the scenes from Dante and, as I will suggest, play a role equally pertinent in the overall iconography of the chapel.[2] Moreover, the significance of parallel relationships, or typology, sermon rhetoric, and the reliance on moralized glosses have been largely overlooked. I have found, however, that these classical scenes play a significant role in the overall iconography of the chapel, one comparable to that of the scenes from Dante, which they complement. I intend to demonstrate that Signorelli, operating in a manner consistent with the current humanist literary conventions, used selected classical myths as Christian allegories of virtue and examples of the path to salvation. The mythological heroes serve as typos for Christ. In addition, he created on the lower walls a visual gloss of the theologies above.

The myths that Signorelli chose to illustrate tell not of gods, but of heroes born of the union of a god and a mortal, such as Aeneas or Perseus, who perform extraordinary feats for the cause of good. Some heroes enter the Underworld, perform feats there, and return. Ovid, in his *Metamorphoses*, and Virgil, in his *Aeneid*, recounted most of the stories that Signorelli illustrated in the socle, especially those in the southeast corner. Many of the myths also appear in Boccaccio's comprehensive fourteenth-century anthology and gloss of classical literature, *Genealogie deorum gentilium libri*, or the *Genealogy of the Gods*. Most pertinent to our purpose, however, Signorelli's paintings reflect the moralized versions of Ovid's *Metamorphoses*. The selected stories follow the order of Ovid's poem, each followed by a moralized explanation. The general thesis of the moralized texts of Ovid is that the virtuous deeds of certain classical heroes prefigure Christian ethics and call to mind the life

and death of Christ. The *Ovide moralisé*, probably written in the fourteenth century and composed in rhymed French, was, along with Boccaccio, the most widely used of such books.[3] A Flemish version with woodcut illustrations, largely a picture book of Ovid's stories, was published in Bruges in 1494.[4] More particular to Signorelli, however, is an illustrated Italian edition, the *Ouidio Methamorphoseos vulgare*, printed and published by L. A. Giunta in Venice, 10 April 1497. A strong compositional affinity between a scene of Juno from the Venetian text of Ovid and Signorelli's depiction of Book X of the *Purgatorio* makes a compelling case for Signorelli having studied this particular gloss of Ovid before he embarked on his artistic program at Orvieto (Figs 8.1 and 7.5).[5]

The enduring classical tradition

From the time of the church fathers, scholars had sought to reconcile classical myths with Christian thought. In fact, they borrowed the Greek term 'theology' from pagan writings. So, too, the concept of the poet as a theologian had its origins in the classical past and with the church fathers. Aristotle had distinguished a fictitious poetry from one that imparted wisdom and truth through metaphors and parables. The early Christian fathers applied the term 'poeta theologus' to both pagan and Christian ideas. In the fourth century, St Augustine and St Jerome reasoned that a story could have more than one meaning, often obscure ones in addition to the obvious. St Augustine defended veiled meanings in literature in his *City of God*:

The differing interpretations produce many truths and bring them to the light of knowledge; and the meaning of an obscure passage may be established either by the plain evidence of the facts, or by other passages of less difficulty. Sometimes the variety of suggestions leads to the discovery of the meaning of the writer; sometimes this meaning remains obscure, but the discussions of the difficulties are the occasion for the statement of other truths.[6]

Beginning with St Jerome, scholars developed a system of correspondences between classical myths and Christian scripture.[7] A classical myth could be an allegory for a Christian virtue or a biblical story with the heroes prefiguring Christ or one of the saints. They based their rationale on St Paul, who said in his Epistle to the Romans, 'For whatever was written in former days was written for our instruction, so that by steadfastness and by the encouragement of the scriptures we might have hope' (Romans 15:3).[8] In the minds of the church fathers and medieval theologians, the fact that St Paul wrote these words to the Romans and not to the Hebrews justified the moralization of classical mythology. In the eleventh century, Baudri of Bourgueil gave these parallels a systematic foundation. He states, for example, that

The books of the pagans contain not only examples of immorality but also of virtue: Diana's chastity, Perseus' victory over the sea-monster, the labors of Hercules. All

8.1 *Oiudio Methamorphoseos vulgare*, f. 31r. L. A. Giunta, Venice, 1497, Library of Congress, Washington, DC

.IIII.　　　　　　XXXI

gliola di Ceres era secõdo fauolegia Ouidio in lo inferno apresso Plutone:laql era nepote di Ioue:Alacui segurta Iuno ando per le furie de linferno.

Cap.　　　　　　XXV.
De la uia de linferno.

A uia de linferno e sata tuta lapiagia E ua i giu & e tuta copta di saffi & li si ne larboro uenenoso i táto che gli aiali chene gustano semuorono subito.El luoco e séza alchuno parlaméto cõ molto buio: & lanime che ceuano nõ posono fauelare: & ene qsta uia tuta piena di nebie lequale escono deli fiumi isernali:p qsta uia discendono lanime licui corpi sono sepeliti.Et qlle aie licui corpi non sono sepeliti uao errado p lo módo céto anni.Et ene qlla uia tuta piena di spi

ne,impertanto coloro che cestano fano quella uia:& hane desoto a se mille uie:onde in qllo luoco se puo andare & hane linferno mille porte:& cusi como laqua del mare riceue ogni aq di fiumi : Cusi qste porte riceueno tute lanime,pcio che fo opinione de glian tichi che tute lanime andasero alinferno,Et ptáto se destinguia li luochi del inferno:pcio che parte nescono in palacio e qlle sono piu tormétate che laltre,Altre sono ale fine dil teto:equelle meno sono tormétate,Altre sono che fano quelle medesime arte:che faceão al'módo,Nondimeno posto che qsta uia ricresesse a lũo pur semise ad ãdare & ãdo a liferno p lo grãde dolore che li hauia.　Cap.　　XXVI.

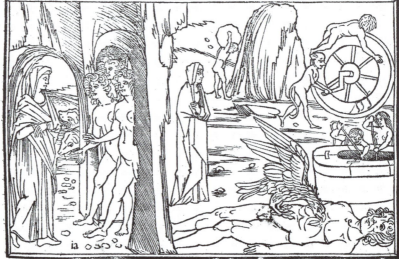

De lo inferno.

On obstante la oscurita dela sopradita uia:Iuno ando & itro alfondo del iferno.E quã do cerbero: elqual p altro nome edito Ianitor:elquale ha tre capi de cãe:uide Iuno comincio alatrare:& i táto Iuno entro : e uide le dee infernale cioe le tre sorelle Alecto:Tisiphone meghera

Costoro sono quelle che hãe officio di condure le furie,ma p diuersi modi secondo che in altro luoco apare:leq le tre sedeano su la porta epetenauale li capili:iquali erano ogni capilo uno serpe.Ma uedendo Iuno se leuaron su & alhora Iuno intro in lo palazo de lo inferno.

De le pene de linferno.

these stories have allegorical meanings. This is especially true of the Bible. But I have wished to cite Greek feignings, so that the entire literary tradition shall serve for our instruction. All the world speaks a single language, and all mankind shall teach us. I bring forth the fables of the pagans as prisoners, and rejoice in the spoil ...[9]

Fulgentius, in his fifth-century *exposito* on Virgil, claimed the poet appeared to him in a dream and explained the hidden meaning of his epic poem the *Aeneid*. His work influenced Bernardus Silvestris in the thirteenth century and, indirectly, Dante a century later.[10]

The triad of fourteenth-century Italian poets, Dante, Petrarch and Boccaccio, justified certain pagan writings, philosophical and poetic, as precursors of Christian theology and defended the practice of moralizing these works. Petrarch, citing St Augustine, said that although the pre-Christian poets, the *prisci poetae*, did not achieve the goal of perfect knowledge of God, since they lived before Christ and therefore did not know God's grace, they deserved admiration for going as far as human powers were capable. Petrarch and others believed that these ancient poets realized the existence of one God and that the pagan gods were false.[11]

Like Petrarch, Boccaccio defended the power of fictional narrative, the veil of obscurity over a deeper truth, as pleasing on a superficial level to the uneducated and at the same time a mental exercise for the sophisticated scholar who recognized its hidden truths, which both gratify and enlighten. Boccaccio's summa, the *Genealogy of the Gods*, and the moralized versions of Ovid's *Metamorphoses* stand as testaments to the serious scholarly endeavor to reconcile the pagan poets with Christianity. Boccaccio claimed that it was appropriate for Christian scholars to study classical mythology, for certain pagan poets taught righteousness.[12]

The author of the *Ovide moralisé* used the same justifications as his predecessors for joining Christian and pagan ideas. He began the text by saying,

If scripture doesn't lie to me, all that is written in books, whether for good or evil, is for our instruction ... Anyone to whom God gives good fortune and grace to attain wisdom and knowledge ought not to refrain from speaking and expounding what is proper, for one ought not to hide wisdom, since wisdom kept under wraps is worth no more than riches buried underground.[13]

The thesis of the moralized texts of Ovid is that the morality of certain classical heroes prefigures Christian ethics and recalls the life and death of Christ. The authors believed these stories held Christian significance, and that the secrets hidden within were revealed to those who sought the truth.[14] The authors ended the moralizations of Ovid by stating:

Thus whoever fixes on the fable alone doesn't care what it is really about ... Whoever knows how to expound the letter can derive from the fable a meaning that is good and consistent with truth. Indeed, even sacred Scripture is difficult and obscure in many places and seems to be mere fable. He who cannot derive another meaning which Scripture does not seem to have at its literal level, and who would

believe, through ignorance, that there is no other meaning there, would certainly deceive himself and place his own soul in damnation.[15]

In addition to the value of allegory, the moralized texts of Ovid share with Ovid's great poem and Dante's *Il Purgatorio* a theme of spiritual rebirth. Ovid taught that spiritual perfection is achieved through metamorphosis:

> My soul would sing of metamorphoses.
> But since, o gods, you were the source of these
> Bodies becoming other bodies, breathe
> Your breath into my book of changes: may
> The song I sing be seamless as its way
> Weaves from the world's beginning to our day.[16]

For Christian rebirth, or metamorphosis, the first step is penance; renewal comes through the Eucharist. The devout Christian rejoices in the new nature achieved through penance and the Eucharist and looks forward to the ultimate metamorphosis at the End-time, the acquisition of a new spiritual body at the Resurrection of the Body.

The rhetoric of both the *Ovide moralisé* and the *Ouidio Methamorphoseos vulgare* fits the traditional form and content of the academic *exposito*, with its four levels of meaning that elaborate upon a moral truth.[17] These texts, like sermons and the writings of Dante, conceal layers of theological truths in familiar moralizing stories. The author of the *Ovide moralisé* defined the purpose of allegory:

Many others have made valid attempts to do what I propose without accomplishing their whole purpose; and although I am not endowed with more wisdom and knowledge than those others who believe they could do this, in undertaking this task I put faith in God, who hides and conceals his secrets from wise and knowing men, but reveals them to beginners who diligently seek Him ... The truth that lies hidden beneath the fables will be clear to one who can discern the meaning in them ...[18]

Signorelli followed this line of thinking when he placed allegories from classical mythology in a cathedral with humanist and papal ties.

Finally, both Boccaccio and Petrarch discussed the need poets had for solitude and meditation.[19] Boccaccio states that poets need uninterrupted solitude, away from the distractions of the world, in order to contemplate divine things. He lists men who sought such peace in nature so that they could better serve God.[20] Signorelli also understood this need for solitary contemplation when he created the socle in the Cappella Nuova. He situated the stories in a separate place, made the paintings smaller and painted them in grisaille (monochrome) so that they would not bring attention to themselves. The tumultuous action in the upper walls draws attention away from the socle. When the eye meets but does not does study the socle, the elaborate *grotteschi* decoration surrounding the scenes effectively veils them in obscurity. Those who wish to know the truths hidden within the scenes must seek them out.

Artistic precedents: mythological heroes in Christian settings

The tradition of subtly placing pagan figures – philosophers and poets, mythological heroes, planetary gods, sibyls and signs of the zodiac – into the religious artistic programs and illuminated manuscripts occurred throughout Europe in medieval and Renaissance artistic programs.[21] Of all the classical heroes, Hercules appears most often as a precursor of Christ; he appears most often in the Cappella Nuova as well. In the ninth century, Theodulf of Orléans interpreted Hercules as an *exemplum virtutis*, or as the personification of 'Virtue'.[22] The treatment in art concurs with the literary appraisals. By the eleventh century, Hercules was interpreted as the virtue 'Fortitude'.[23] Nicola Pisano portrayed Hercules on the pulpit in the Pisa Baptistery (*c.* 1260), probably the first heroic nude in Italian art since classical antiquity. The figure is variously labeled as 'Daniel' or 'Fortitude', but the classical nudity and the attribute of the lion's skin firmly establish the identity, in my mind, as Hercules.[24] The position of the figure on the Pisa Pulpit is analogous to that of the classical figures in the Cappella Nuova. He stands below and supports the main biblical narratives – literally: he resembles a caryatid.

Florentines honored Hercules as a protector, a sort of pagan patron saint.[25] A sculpture of *Hercules's Victory over Caucus* by Andrea Pisano appears among the lowest relief sculptures on Giotto's campanile (*c.* 1335). Moreover, embedded in the vegetal decoration surrounding the doorway on the north side of the cathedral, Porta della Mandorla (*c.* 1390), scenes of Hercules performing his Labors alternate with angels holding scrolls (Fig. 8.2). The style is decidedly classical in the bold contrapposto stance and naturalistic musculature. Again, nudity, attributes and actions confirm the identity.

Christian and pagan figures never appear randomly in artistic programs; each served a purpose. Sibyls, interpreted as female counterparts of the Old Testament prophets, appear in supportive positions on pulpits in Siena (Nicola and Giovanni Pisano, Siena Cathedral, *c.* 1265) and Pistoia (Giovanni Pisano, S. Andrea, *c.* 1300), analogous to that of Hercules at Pisa. In addition, four sibyls occupy the quadrants of the vault of the Carafa Chapel in S. Maria sopra Minerva in Rome (1488–90), a position usually held by prophets or evangelists. In addition, the Roman legend of Virginia and grotesque motifs appear there as well. Pinturicchio used similar *grotteschi* in the Baglioni Chapel in S. Maria Maggiore in Spello, where sybils also look down from the vaults (1500–1501). Soon after Signorelli completed work at Orvieto, Michelangelo would alternate pagan sibyls with Old Testament prophets on the Sistine Chapel ceiling (*c.* 1508–12). In the papal apartments of the Vatican (*c.* 1508–10), Raphael would include the classical philosophers in his *School of Athens* to form a parallel to religious figures in the facing *Disputà* (or *School of Religion*); he also illustrated the story of Aeneas as an allegory.

Ovid had praised Orpheus's poetic gifts (*Met.* X:85–107). Petrarch regarded Orpheus highly as well, suggesting that he might have invented poetry.[26] Orpheus appears in the same capacity among the inventors of arts and skills in the lowest zone of Andrea Pisano's sculptural reliefs on the campanile in

8.2 Hercules, detail
from the Porta della
Mandorla, Florence
Cathedral (photo:
author)

Florence. He appears alongside Daedalus, conqueror of the air, and Apollo, who represents the sun. More peculiarly, Jupiter wears the tonsure and garb of a mendicant friar, with a chalice in his right hand and cross in his left. The planetary gods also occur in the Guidalotti Chapel at S. Maria Novella (later renamed the Spanish Chapel). Outside of Florence, the medieval inlaid pavements and the sculptural program of Siena Cathedral include both pagan and Christian stories and heroes (c. 1260). Mercury, disguised as a teacher, and the planetary gods appear alongside biblical characters on the capitols lining the exterior arcade of the Doge's Palace in Venice (c. 1430).

By the late fifteenth and early sixteenth centuries, however, mixing classical heroes with biblical stories did not always meet with favor. At Rimini, Sigismondo Maletesta took the tradition too far when he renovated the church of S. Francesco into a humanist shrine (c. 1465). To say that the pope disapproved is an understatement, for Pope Pius II, in an elaborate ceremony on the steps of St Peter's Basilica in Rome, publicly condemned Sigismondo to Hell for this and his other egregious sins – the only such papal ceremony in history! Moreover, Rabelais and Luther, among others, spoke out against this literary practice.[27] With the onset of the Protestant Reformation and subsequent Roman Catholic Counter-Reformation, the practice waned. Thus, what was fairly commonplace in the Middle Ages and Renaissance is all but forgotten today.

Emblems of virtue

On the southeast and south walls in the Cappella Nuova, Signorelli followed the scenes from Dante's *Purgatorio* with three emblematic scenes below *The Ascent of the Blessed to Heaven*; two survive. The upper tondo depicts *The Triumph of Charity over Envy*, a scene that bridges the transition between Purgatory and classical mythology, as it appears in both (Fig. 8.3).[28] Charity, who holds a suckling child to her breast, stands atop a prone woman who bites her hand. In the background, torch-bearing, winged *putti* flank the figures. The second scene, a rectangle, depicts *The Triumph of Chastity*.[29] Finally, Clementini describes the now-destroyed lower tondo as depicting the figure of Faith.[30] All three virtues concur with the iconography in the Cappella Nuova.

Classical heroes in the Cappella Nuova

JOURNEYS INTO AND OUT OF THE UNDERWORLD

Signorelli shifted to classical sources for the authors and grisaille scenes in the remaining parts of the south bay socle. Two rows of classical scenes appear below *The Damned Led to Hell*, while the adjacent west wall, below *The Torture of the Damned*, features two portrait panels, Ovid and Virgil,

8.3 *The Triumph of Charity over Envy* (south wall socle below *The Ascent of the Blessed to Paradise*) (Gabinetto Fotografico Nazionale, Rome)

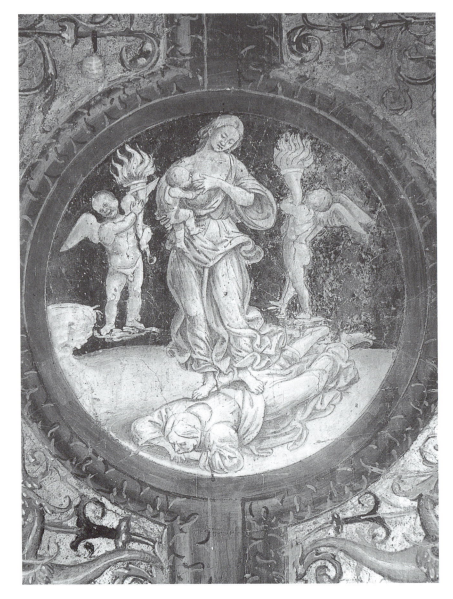

surrounded by supportive literary scenes from classical mythology. Probably others now destroyed or hidden behind the altar concurred as well. Finally, in the north end of the chapel, as mentioned in Chapter 6, Signorelli illustrated scenes from Roman history.

The most common theme among the poetic scenes is the descent of half-god, half-mortals into Hades, performing deeds there and returning to earth: Persephone, Orpheus, Aeneas, Hercules and perhaps Odysseus (Ulysses).[31] Several late medieval commentaries compare these classical myths to the attainment of virtue. These myths, like Christian theology, stress renouncing the love of earthly things, imperfect things, as a necessary step for the

attainment of spiritual perfection.[32] In addition, medieval and Renaissance intellectuals interpreted these journeys as conquests over death, comparing them to those performed by Christ, not only in his Harrowing of Hell and his Resurrection, but also in raising several mortals from the dead, including most notably Lazarus, who appeared in the east-wall *cappellina* below *The Rule of the Antichrist*. *The Rape of Persephone* also forms a parallel to the Assumption of the Virgin, which in Signorelli's day appeared in the window and in a statue over the altar. These scenes mirror the images on the adjacent and facing walls as they admonish the faithless and demonstrate the rewards of exemplary morality. Iconographically, classical heroes who enter and return from the Underworld in pursuit of spiritual perfection form a parallel to the scenes from Dante's *Purgatorio*, where the pilgrim Dante sought to cast off worldly values in pursuit of spiritual ones.

PERSEPHONE

On the left side of the southwest socle, below *The Torture of the Damned*, stands the portrait of Ovid flanked by four tondi depicting *The Rape of Persephone* (Pl. 22 and Fig. 8.4). This myth appears in Ovid's *Metamorphoses* and in moralized versions of the poem. The top tondo depicts *The Questioning of Persephone*. On the left, four women stand beside a stream (*Metamorphoses* V:372–95). Diana, or the hunting goddess, as the text calls her, stands on the left holding her bow. Persephone stands beside Diana with her skirt full of violets and white lilies, symbols of her humility and purity. A helmeted Athena, wearing military guise and carrying a spear, stands in the center. Ceres, mother of Persephone, appears on the far right. Moving clockwise around the portrait, the scene to the right shows the abduction: a man holds a struggling woman on a fanciful chariot while another man drives (*Met.* V:390–400). The bottom tondo shows *Pluto Sinking into the Pool of Cyane*, as he traveled to Inferno beneath. Cyane melts in the foreground in sadness for losing Persephone (*Met.* V:408–38). Scholars have called this scene *Pluto and the Passage of Mount Aetna*, but the tondo clearly illustrates the pool of Cyane, as does the woodcut illustration in the *Ouidio Methamorphoseos vulgare*.[33] Moreover, the text of this segment of the myth emphasizes the descent into Hades rather than the power of Pluto. The final scene, on the left, shows a weeping Ceres, who mourns the loss of Persephone as she futilely pursues Persephone's abductors on her own richly decorated chariot, driven by a *putto* (*Met.* V:440–62).[34] The author of the *Ovide moralisé* interprets Ceres' search for her daughter as the Church trying to recover faithful souls who have wandered astray.[35] Certainly, Signorelli, too, embraced this goal in his fresco program.

ORPHEUS

The two scenes on the bottom and left of the poet to the right, Virgil, operate as a pair (Pl. 23 and Fig. 8.5). They recount the Ovidian story of Orpheus's

8.4 *The Rape of Persephone*; detail of the Ovid panel (Gabinetto Fotografico Nazionale, Rome)

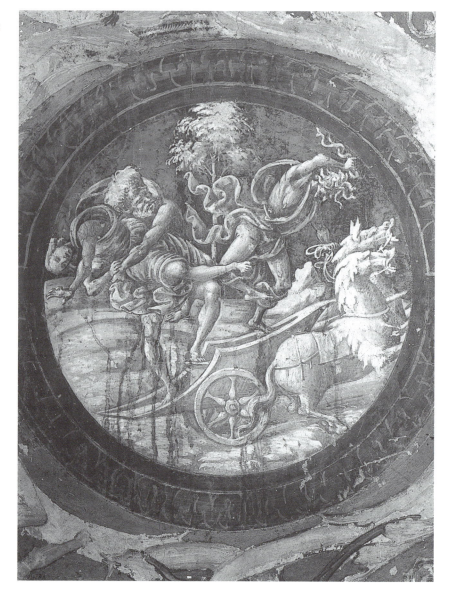

ill-fated attempt to rescue his beloved Eurydice from Inferno (*Met.* X:1–107). The lower scene shows *Orpheus Charming the Demons of Tartarus*, the gloomiest part of the Underworld, with music so beautiful that both shades and torturers stand still. The charm works, and he is allowed to take Eurydice, but with the admonition not to look back at her until he has passed the valley of the Avernus; but, alas, Orpheus cannot resist, and Euridyce slips back into the Underworld to remain forever. The tondo on the left depicts Orpheus at the climactic moment when he realizes his loss.

The author of the *Ovide moralisé*, William of Conches and Boccaccio all likened Eurydice to sensuality, Orpheus to reason and his song to penance.[36]

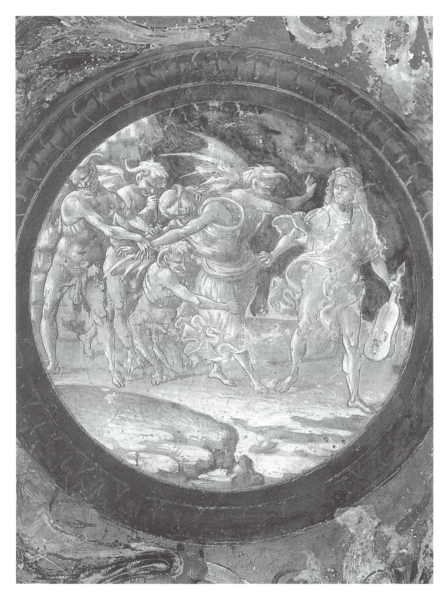

8.5 *Orpheus in the Underworld*; detail of the Virgil panel, left side (Gabinetto Fotografico Nazionale, Rome)

Having died from a snakebite, Eurydice corresponded to Eve, and thus symbolized sensual love. According to the allegory, Orpheus, or Reason, went to Hell to rescue Eurydice, or Sensual Love. Orpheus begged forgiveness for his sins, so God in his pity returned her to a state of grace. When Orpheus, of his own free will, returned to his sinful ways, his insincere repentance caused Eurydice to be sealed forever in Hell.[37] Thus, the Christian allegory warns of the penalty for insincere penance. The author of the *Ouidio Methamorphoseos vulgare* states additionally that Eurydice represents the kingdom of the Jews.[38]

Heroic exemplars

HERCULES: EXEMPLUM VIRTUTIS

Hercules appears on three walls of the south bay in the Cappella Nuova. Some of the scenes depict his famous Labors; others depict his additional heroic feats. To the right of the altar, below the scene of *The Damned Led to Hell*, Signorelli depicted two scenes from the life of Hercules; other scenes depicting Hercules either may have been obliterated or hidden by the eighteenth-century altar.[39] Clementini identified the lower scene on the left, a tondo, now destroyed, as Hercules armed with the three-pointed spear of Pluto.[40] The top scene, also a tondo, shows *Hercules' Victory over Nessus the Centaur* (Fig. 8.6).[41] The unusual depiction follows Ovid, who tells that Hercules killed the fleeing centaur with an arrow that he shot into its back with such force that it came through his chest.[42] Hercules, shown from the back, holds the head of the subdued centaur with his left foot as he pulls the arrow from his back. With his dying breath, the duplicitous Nessus, unable to win Hercules' beloved Deianira for his own, gave the unsuspecting maid a disguised death potion, which, in turn, Liachas delivered to Hercules. The author of the *Ovide moralisé* states that Nessus' violation of God's commandment condemned his soul to the devil; thus, Signorelli placed this scene of baseness below *The Damned Led to Hell*. In the end, however, Hercules, like Christ, will triumph over death.[43]

The right panel under *The Blessed in Paradise* depicting Statius (?), in addition to its standard-size tondi representing scenes from Dante, has four small scenes tucked in the *grotteschi* in each corner that portray feats of Hercules (Pl. 21 and Fig. 8.7). Perhaps the corresponding four little scenes in the outer corners of the panel of Virgil represented more scenes of Hercules, but extensive damage makes identification impossible. In the lower left, a standing male nude with his arms raised over his head holds an object, perhaps a club. A figure lying on his back, resting on its right elbow and raising his left hand in defense against the blows from a standing figure, perhaps represents the *Slaying of Lichas*. This scene from Ovid follows Hercules' lament when he realized the centaur Nessus had tricked his beloved and that he would die, a lament that has been compared to that of Christ from the cross.[44]

The other scenes depict three of the Labors of Hercules. The upper left tondo depicts Hercules, wearing a cloak, killing the Nemean Lion. The Labor of the Nemean Lion, the first of Hercules' Labors, corresponds to David and Goliath or Sampson and the lion.[45] The badly damaged, upper-right tondo shows Hercules, wearing the lion-skin as a cloak, performing the second Labor. Here he wrestles with the many-headed beast, the Lernaean hydra, which symbolizes the duplicity of evil. Since to sever the necks causes more to sprout, Hercules sears them, thereby overcoming the monster.[46] In the lower right, Hercules, stripped naked, breaks off the horn of a reclining bull. Ovid recounts that Hercules defeated the river god Achelous, who took the form of a bull, by breaking off his horn.[47]

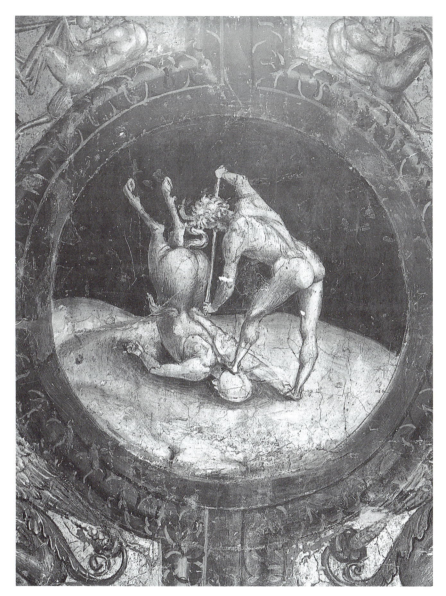

8.6 *Hercules and Nessus the Centaur;* south wall socle below *The Damned Led to Hell* (Gabinetto Fotografico Nazionale, Rome)

The right tondo of the Virgil panel shows the twelfth and most difficult labor of Hercules, his journey into Hades to rescue Theseus (Pl. 23). First, he must subdue Cerberus, the three-headed dog who guards the entrance. Signorelli depicts Hercules standing in front of Cerberus's cave with his foot on the beast's head and a chain around his lower neck that he pulls hard to subdue the beast. A ghostly shade appears behind in the entrance to the cave. With his back to the viewer, Theseus, dressed in full armor, holds a shield in his left hand and raises his right arm to brandish a sword. Between his legs lies the corpse of Pirithous.[48] In performing this feat and rescue,

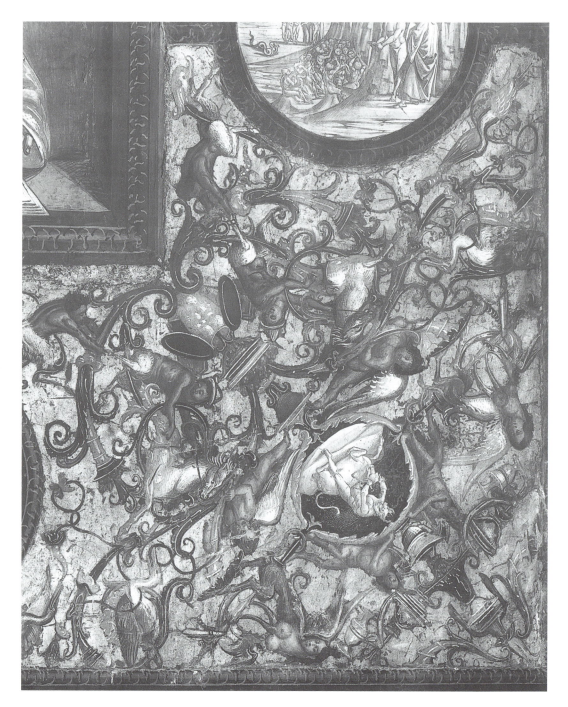

8.7 *Hercules and Achelous as a Bull* (detail of Statius panel) (Gabinetto Fotografico Nazionale, Rome)

Hercules mirrors Christ in Limbo vanquishing the devil and releasing the virtuous Hebrews of the Old Testament.[49]

Hercules fits into the iconography of the chapel as a parallel figure to Christ. The circumstances of his birth were considered Christ-like, in that he was a man born of a god and a mortal woman. Because of his mother's mortal flesh, he was destined to suffer terrible pain and die. Hercules endured temptations, but chose the path of right action, not of ease. His life on earth was difficult, full of trials, which he overcame. His triumphs were more than victories over brute force: his deeds, performed with ingenuity, were also triumphs of nobility over baseness, truth and justice over evil, a strong theme in Christian ethics. Hercules, in performing feats in the Underworld and returning to earth, was interpreted as having made conquests over death, as Christ did in several of his miracles and in his Resurrection. Moreover, only supernatural forces could defeat Hercules. Like Christ, Hercules was by nature invincible; no one could punish him against his will. Finally, Hercules was unable to die except by his own will; the same was true of Christ, who, from the cross, gave up his spirit to God. Declaring that Hercules deserved the honor of immortality, Jove, king of the gods, resuscitated his son and made him live again in glory for eternity.[50]

Hercules serves as a paradigm of virtue whose pre-Christian life prefigures that of Christ. He purged himself of sin through his Labors, a parallel to the Christian sacrament of penance. The feats of Hercules complement the scenes from the *Purgatorio*, for he, too, in allegorical terms, was a penitent sinner; the spiritual journey was his life's work. His sin, killing his wife and children, was grievous; yet, in his deep remorse he showed great character and a virtuous soul. By purging himself of sin through his Labors, he performs penance, a parallel to the Christian sacrament (which Dominican friars could perform, as of a recent declaration by Alexander VI). As a remorseful and penitent pilgrim who wins favor in the sight of the deities, Hercules conforms to the devotional life of the chapel, and corresponds to Dante and Mary Magdalene. Moreover, the Labors of Hercules fit appropriately in the small outer tondi under *The Blessed in Paradise* with scenes from *Purgatorio*, for like the penitent sinner and Dante the Pilgrim, Hercules, when faced with the crossroads of Vice and Virtue, chose the rough path of Virtue.[51] Although this scene does not appear among those visible in the Cappella Nuova, the conscious choice of the difficult path of Virtue concurs with the iconography of the chapel. Hercules, then, simultaneously plays several roles in the Cappella, all of which rest on a long and respectable tradition.[52]

AENEAS: EXEMPLUM SAPIENTIA

Several scenes from Virgil's *Aeneid* appear in the Cappella Nuova, some depicting Aeneas and others depicting other heroes. The tondo above Virgil's portrait on the west wall gives the opening scene of Aeneas' visit to Hades (Pl. 23 and Fig. 8.8). The Cumaean Sibyl guides Aeneas in the Underworld, a parallel to Virgil leading Dante on the facing wall. On the left of the

8.8 Aeneas in the
Underworld: *Aeneas
and the Cumaean
Sybil before the Cave
of Cerberus* (detail of
the Virgil panel,
upper) (Gabinetto
Fotografico
Nazionale, Rome)

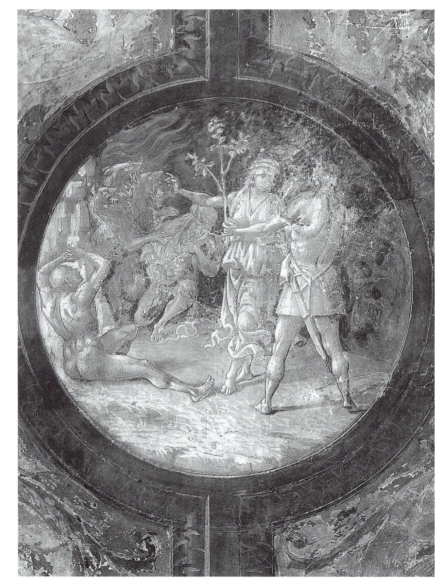

composition, the sibyl, golden bough in hand, points Aeneas toward the
cave of the triple-headed monster–guardian, Cerberus. In the center, a snarling
Cerberus leaps out from the cave to taunt a lethargic, long-haired male
youth, seemingly caught in mid-swoon and wearing only a capuchon. A
snake slithers away from his left foot. Another older nude male, seated just
to the left of the opening of Cerberus' cave, holds his locked hands above his
head and appears to wail. These figures represent some of the many
personifications that Virgil lists, perhaps Sleep and Grief (*Aeneid* VI:269–87).

Signorelli also illustrated scenes from the *Aeneid* below *The Damned Led to
Hell*. The upper scene in the outer row, a rectangle, depicts Aeneas Speaking

with Deiphobus during his voyage through the Underworld (*Aeneid* VI:494–530) (Fig. 8.9).[53] The assailants target the face of the victim, as was the case with Deiphobus, whom Odysseus (Ulysses) eventually killed. Moreover, Fugentius compared Deiphobus to the Antichrist.[54] The middle scene in the adjacent row represents three demons beating three victims, perhaps the savage floggings witnessed by Aeneas as he crossed the threshold into Hades (*Aeneid* VI:557–73) (Fig. 8.10).[55] In this passage, the demons flog sinners as they confess their hidden sins. Certainly brutal punishment in Hell for deceit and hidden sins fits in a chapel in which atonement is an overriding theme.

8.9 Aeneas in the Underworld: *Aeneas Witnesses Deiphobus*; south wall socle below *The Damned Led to Hell* (Gabinetto Fotografico Nazionale, Rome)

The author of the *Ovide moralisé* likened Aeneas to Christ, who deigned to come from Heaven to be a man. Allegorically, the golden bough becomes the rod of Jesse.[56] His father, Anchises, was mortal, but his mother was the goddess Venus. Like Christ performing deeds of grace, mercy and charity, Aeneas showed pity and delivered the simple people who kept the faith and the law; like Christ harrowing Hell, he descended into the Underworld to deliver his father as well as his wet nurse, whose body he subsequently buried properly, and then returned to earth. At his death, the virtuous Aeneas received the god-given reward of apotheosis.[57]

In his commentary on Virgil, Bernardus Silvestris interpreted Aeneas' descent into Hades as an allegory of the attainment of wisdom. He stated

8.10 Aeneas in the Underworld: *Floggings*; south wall socle below *The Damned Led to Hell* (Gabinetto Fotografico Nazionale, Rome)

that the wise man descends, through virtue and reason, to the contemplation of worldly things; when he realizes their frail and transitory nature, he renounces worldly values in favor of spiritual truths.[58] Boccaccio also praised Aeneas' virtuous deeds, including the wisdom he showed by entering Hades, and lamented, 'Surely if Vergil had known and worshipped God in due form, nothing but that which is holy could be found in his works.'[59]

PERSEUS: EXEMPLUM FORTITUDINIS

Below *The Damned Led to Hell*, two scenes in the outer row depict the most famous episode of Perseus's life, the Rescue of Andromeda. The upper scene, a tondo, depicts Perseus on rearing horseback with sword raised to free Andromeda from the snares of the dragon (Fig. 8.11). The rectangular scene below shows Perseus, the gorgon head in hand, at the banquet table taking Andromeda as his bride (Fig. 8.12). Ovid told the story in his *Metamorphoses*; later it was moralized.[60] Boccaccio also told of Perseus in his *Genealogy of the Gods*. In so doing, he employed the traditional four levels of interpretation as he told of Perseus decapitating the gorgon Medusa and being lifted aloft by his winged heels. First, he recounted the literal or historical level: the narrative. Next, he employed the moral level, comparing Perseus to a wise man's

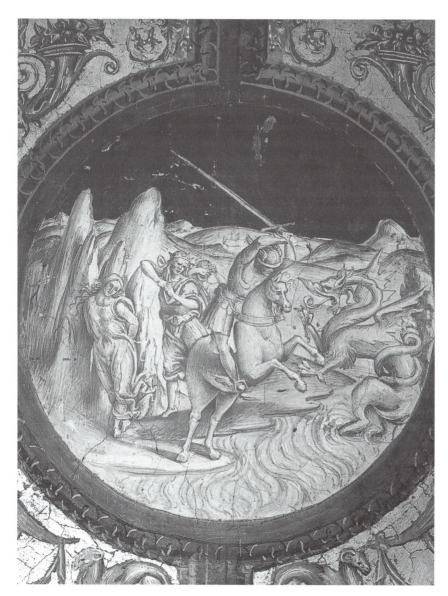

8.11 *Perseus Rescuing Andromeda;* south wall socle below *The Damned Led to Hell* (Gabinetto Fotografico Nazionale, Rome)

ascent to virtue after gaining triumph over sin. On the allegorical level, he noted that the pious man rejects worldly things and seeks heavenly thoughts. Finally, on the anagogical level Boccaccio interpreted the story as the victory of Christ over the princes of the earthly world to ascend his heavenly father, a parallel to the Ascension of Christ.[61]

Perseus and Hercules have much in common. Like Christ, each was half-mortal, half-god. Perseus' mother, Danäe, conceived him through a shower of gold from Zeus, an event moralized as a parallel to the Virgin Birth. Although their mortal parentage prevented their immortality and barred their admission to the Olympian assembly, both performed many superhuman feats. Medieval glossers perceived Perseus and Hercules as Christ-like figures

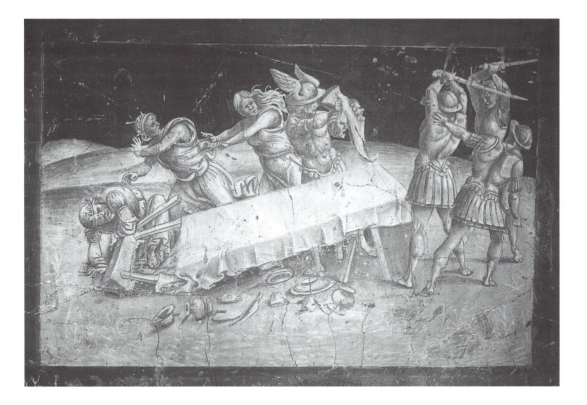

8.12 *Perseus at the Banquet Table*; south wall socle below *The Damned Led to Hell* (Gabinetto Fotografico Nazionale, Rome)

in their faith and their perseverance in the cause of right, and compared their feats to the Labors of Adam and the Passion of Christ. As scholars began to identify classical heroes with Christian virtues, Perseus became Courage.[62] In rescuing Andromeda, Perseus not only demonstrates faith, but also that good overcomes evil even in the face of a seemingly impossible task. The *Ovide moralisé* states that just as Christ's birth illumined the world, Perseus also brought light into the world. He severed error with the double-edged sword of truth and chased away ignorance. The author compares Andromeda to Eve, who fell because of the apple. Their marriage symbolizes the union of Christ and the Church.[63]

MELEAGER: EXEMPLUM MARTYRIUM

The final Ovidian hero to play an important role in the iconography of the chapel is the seldom-recognized hero Meleager, who appears in the background of Signorelli's fresco of the *Pietà* in the burial chapel below *The Resurrection of the Dead*. Illusionistic decoration on the faux classical sarcophagus behind the Pietà group depicts men partially clothed with classical drapery who mournfully carry a corpse (Pl. 24 and Fig. 8.13). This image of the dead Meleager frequently adorned classical sarcophagi. From these classical models Renaissance painters adapted their compositions of Christ's Entombment.[64] Based on this Renaissance tradition, scholars routinely

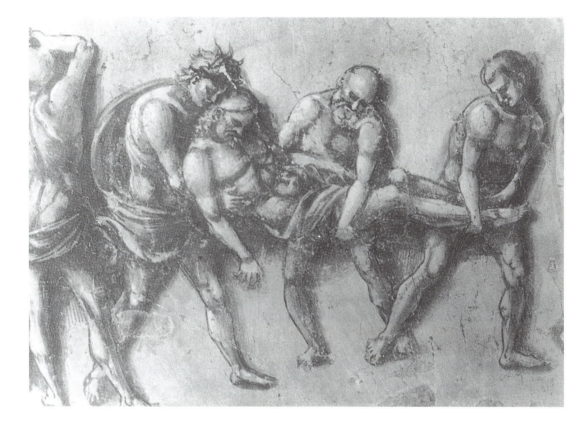

identify this scene as the *'Carrying of the Body of Christ'*.[65] Instead, I believe the image portrays the *Carrying of the Corpse of Meleager* and that it is the first known portrayal of that scene since classical antiquity. The scant drapery of the corpse bearers does not concur with Renaissance portrayals of the figures that carry Christ to his tomb. Moreover, decorum would call for a classical scene for a classical sarcophagus. Finally, like Hercules and Aeneas, the moralized Meleager prefigures Christ. The author of the *Ovide moralisé* established a mystical connection between the death of Meleager and the death of Christ.[66] The author of the *Ouidio vulgare* was even more direct, stating that the Calydonians committed the sin of extravagance and that the innocent Meleager died for the purgation of the sins of all.[67] Dante alluded to the metaphor in *Purgatorio* XXV:22–24, when Virgil calls upon Statius to describe the relationship between soul and body. The body, then, could be none other than that of Meleager borne home by comrades, as described by Ovid (*Metamorphoses* VIII:513–36). Signorelli also used the allusion to tie the death of Meleager to the figure of Christ in the *Pietà*.

8.13 *Carrying of the Corpse of Meleager,* detail from the sarcophagus in the background of the *Pietà* composition in the Cappellina della Pietà (Archivio Photos Moretti, Orvieto)

Roman history

The two facing authors and accompanying cameo scenes in the north socle continue the literary tradition with two more types of literature: the elegy and history writing. The sources, however, are less familiar and therefore less agreed upon by scholars. Perhaps Signorelli and his advisors intended to be elusive by using obscure texts, a rhetorical practice that concurs with the value placed on obscurity and veiled meanings by medieval and Renaissance writers and theologians. As mentioned in Chapter 6, the author below *The Resurrection of the Dead* may be the youthful Roman poet Tibullus, who opened his *Elegies* with a description of the horrors of war, illustrated in the two flanking tondi (Pl. 25). Tibullus continued his text with prophecies of Rome and the opposing ages of Saturn and Jupiter, times which Signorelli's contemporaries, including Cristoforo Landino, interpreted as apocalyptic.[68]

Facing Tibullus and below *The Rule of the Antichrist* is Sallust, who is surrounded by scenes of the wicked anarchist Catiline, as recounted in Sallust's *The Conspiracy of Catiline and the War of Jugurtha* (Pl. 20).[69] His nature and deeds form a parallel to the beguiling and thoroughly evil character of the Antichrist above. Moreover, Cataline's deeds fulfill the warnings of war given by Tibullus in his *Elegies*. The first scene depicts the release of five prisoners, who soon afterwards are executed (Chapter XVI). This event initiated the havoc portrayed in the second scene, where Catiline rages throughout Italy. The final scene, partially destroyed, shows the death of Catiline (Chapter XIX). The scenes in the north bay, on a basic level, also fit the overall theme of Psychomachia in the chapel (the constantly waging battle between the forces of good and evil for the human soul), a frequent subtext in medieval and Renaissance art.

Analysis

We saw in Chapter 5 that meaningful correspondences join facing and diagonally facing lunettes on the upper walls of the Cappella Nuova. Correspondences could also reflect an allegorical relationship between a saint depicted on one level or in one area of a fresco cycle and the life of Christ or theologies on the level above.[70] The audience understood the saint as an *exemplum virtutis* (an example of virtue); that is, as a fellow human being who performed deeds through which he/she attained heavenly reward. In this manner, the classical heroes in the socle of the Cappella Nuova, the lowest level, relate to the higher theological scenes above.

Just as a poetic chorus echoes a point, Signorelli used liturgical themes, allegory and moral lessons to reinforce his message. Signorelli's poetic heroes on the lower walls illustrate human examples and thereby function as visual parables or allegories. Using examples from scripture, Christian legend, Dante and classical literature, Signorelli repeatedly demonstrated that each individual must wrestle with the choices and decide the path of

his final destiny until the final Day of Judgment. Invoking the theme of the penitential season of Lent, they persuade, instruct and guide the worshiper through penance, a spiritual metamorphosis required for membership in the company of the faithful. This instructive sermon is the heart of Signorelli's fresco program; liturgy is the unifying thread that joins theology and poetry, Apocalypse and Judgment. The pilgrim, whether Dante, Aeneas, Hercules or the worshiper, journeys steadily toward salvation, encouraged by the allegories in the lower wall panels, counseled by the theological stories in the lunettes, inspired by the host of intercessory saints depicted in the vaults, cleansed by the Eucharist, and assured by the example of the Assumption of the Virgin. The pilgrim finds further security in the familiar ritual of the liturgy, depicted on the walls and experienced personally through daily participation in the Mass or through the tolling of church bells sounding the hours, a practice which still continues in many Italian towns, including Orvieto.

9

Wisdom and Eloquence: Signorelli as Renaissance Painter–Poet–Theologian

This is the virtue of eloquence, that there is nothing foreign to it that it cannot be extolled. Who will hesitate to say that wisdom and eloquence together move us more than either does by itself? Thus we must insist upon eloquence and yet not depart from wisdom, which is the better of the two.[1]

(Robert of Basevorn, *The Form of Preaching* (c. 1322), quoting Pope Leo I)

In the preceding chapters, I have noted novel aspects of Luca Signorelli's traditional and yet fresh vision of the End-time and reconstructed a long-forgotten iconographic plan for the paintings. The plan was shaped by the Roman liturgy and literature – that of Dante, the ancients and medieval glossers of classical myths. Signorelli's stylistic inventiveness and icono-graphic complexity, however, extend deeper still. Contracts for the frescoes, the artist's working procedures and the arrangement, subject, scale and style of the paintings, reveal further seldom-noticed innovations that confirm Signorelli's key role in forming the High Renaissance style.[2] Moreover, although scholars have noted that Signorelli's art reflects fifteenth-century humanism and the ensuing interest in antique art, architecture, ornament and increased naturalism in the rendering of the human figure, humanism touched Renaissance art in more subtle ways as well. As mentioned earlier, by the late fifteenth century, a variety of theological and rhetorical conventions were revived by the humanists that carried over into art. These conventions influenced the selection and arrangement of scenes on the walls. Narrative art was valued not only for style, but also for the faculty of integrating deeper meaning into the story. In the manner of a well-crafted sermon, Signorelli's paintings bring wisdom and eloquence together to move, instruct and inspire the viewer.

Additionally, just as Virgil literally, rhetorically and figuratively guided Dante in the *Divine Comedy*, Dante the poet–theologian, himself educated by Dominicans two centuries earlier, inspired Signorelli not only in subject but also on more subtle and increasingly arcane levels than previously realized. A hopeful sermon on salvation through penance emerges to form the final unifying element of the fresco program, an obvious purpose in Dante's poem, but an unnoticed intention of Signorelli's paintings. This sermon conforms to the four-fold method of exposition that originated with the scholastics and was used in theological treatises, especially those of the Dominicans. Signorelli, like Dante, internalized this method from his

Dominican advisors. Finally, Signorelli extended the poetic model to painting, including epic structure, metaphor, and the license to be audaciously inventive, thereby creating a more complex, evocative art. Signorelli, reflecting contemporary artistic theory, simultaneously introduced a new vision of the artist as one with poetic license, free to be bold, inventive and expressive. Within these seemingly incongruent underlying facets of the program, I believe, lie the ultimate richness of the Cappella Nuova and the genius of Luca Signorelli.

Changing paradigms and innovative responses

The initial contract, made in the spring of 1499, shows the expectations and values held by the patron, the Opera del Duomo, as well as the trust and responsibility they were willing to place in the hands and intellect of the artist. Upon careful reading, the contract also reveals new values in art and in the Renaissance vision of the artist. For example, whereas Fra Angelico's contract for the chapel of 1447 makes no mention of the handling of figures or the master's involvement, but, as was the custom, discusses expensive materials and specified the quality and cost of gold and blue pigments, Signorelli's contract requires simply that the artist supervise the mixing of colors. The quality and value of the materials are not specified. Instead, for the first time in a surviving contract, a lengthy discourse regarding the number and beauty of the figures stipulates that Signorelli must paint the figures from the waist up, including all faces, and always be present to supervise the painting.[3] Signorelli could add figures to the designs if he chose, but he could not reduce the number. The new emphasis is on mastery, especially that of the figure. Thus, the worth of the number, beauty and variety of the figures supersedes that of the ornamental use of expensive materials. The value of the work of the master, a progressive idea articulated in the mid-fifteenth century by Leon Battista Alberti and internalized by his successors, develops as an important issue.[4] The Cappella Nuova, then, is not a monument to precious material, but to the new Renaissance value of the painter and artifice.

In what manner did Signorelli meet the expectations of his patrons and how did he handle the freedom that they had given him? As mentioned earlier, Signorelli, like his progressive contemporaries, employed the expanded-field composition. Unlike the others, who placed small figures deep in landscape settings, Signorelli boldly placed monumental figures in the foreground and de-emphasized the setting, as he had done at Monteoliveto Maggiore. Paramount among the directives articulated by the Opera del Duomo was the rendering of the human figure, a skill at which Signorelli excelled. Innovations are immediately apparent. Signorelli's focus on the unselfconscious nude figure, especially in a religious setting, was unparalleled. Two of the lunettes at Orvieto, *The Torture of the Damned* and *The Resurrection of the Dead*, focus on the active nude.

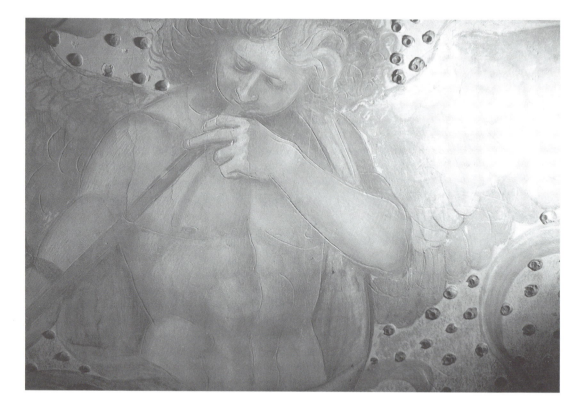

9.1 *The Resurrection of the Dead*; detail of Angel on the left. Note transfer marks from tracing (author)

Signorelli's swift working procedure, especially regarding the nude figure, not only shows new technical mastery, but also unprecedented boldness. He first transferred his drawings conservatively, using the tedious method of pricked cartoon and *spolveri* (charcoal dust pounced through the holes), as had his master, Piero della Francesca, at Arezzo. At close range, *spolveri* are visible in Signorelli's images in the vaults, for example in the beard of St Peter, who sits on the front row among the Apostles in the vaults. Like Piero, he did not cover the dots with a painted outline, nor did he need to do so, for *spolveri* are indiscernible from the floor. Then, in the figures on the upper walls, he used a stylus to trace cartoons directly into the damp plaster, a technique previously used on occasion by Fra Angelico and Masaccio, among others. The procedure is evident in rounded indentations, especially notable in the raking light in the large trumpeting angels in the upper portion of *The Resurrection of the Dead* (Fig. 9.1).[5] As he worked, Signorelli became increasingly bold. Strokes designating some of the monumental figures, especially among those in the lower part of *The Torture of the Damned*, appear sharp and of uneven depth, so freely rendered that he obviously took the method one step further and sketched freehand, sometimes making changes as he drew, or later as he painted (Fig. 9.2). Finally, in the half-lunette of *The Damned Led to Hell*, Signorelli confidently painted directly on the plaster.[6]

Shadows of changes, or *pentimenti*, appear in Signorelli's frescoes, alterations that he did not bother to hide.[7] Following the directive of Horace, in

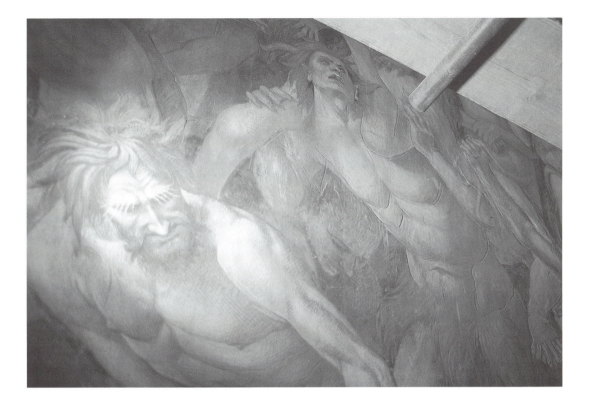

the 'Grand Manner', error, or change, was permissible in things seen at a distance, for it was the whole effect rather than detail that was important.[8] An empty halo on the right-hand side of the *vela* of the Apostles indicates that although Signorelli apparently repositioned the Virgin Mary, he saw no need to remove the earlier halo. Several figures in the lunette of *The Torture of the Damned* show alterations as well, as raking light reveals. The painted silhouettes of the figures do not always match the lines incised in the plaster. Sometimes multiple incisions betray alterations at the stage of the sketch; sometimes outlines in paint do not follow the incisions, indicating later modifications. In a similar fashion of pondering as he worked, Signorelli sketched ideas in carbon directly on the walls in the central portion of *The Resurrection of the Dead*. The sketch depicts the same event as below, but Signorelli did not duplicate the composition. Instead, we witness his process as he thought ahead conceptually to what would follow.

In leaving indications of process, Signorelli concurred with a great predecessor, Donatello, by then deceased, and a younger contemporary, Michelangelo, whom he undoubtedly knew from time spent together in the household of Lorenzo de' Medici in the early 1490s. Several of Donatello's bronze sculptures, notably the pulpits for San Lorenzo, show thumb prints from the clay model, which in turn appear in the bronze cast. Moreover, Donatello's *Annunciation* (Church of S. Croce, Florence, 1432–34) and Michelangelo's *Madonna of the Stairs* (Casa Buonarroti, Florence, c. 1491),

9.2 *The Torture of the Damned*. Detail of figure with transfer marks (author)

which he sculpted under the tutelage of Donatello's pupil Bertoldo in the school of Lorenzo de' Medici, both have borders of unpolished marble. Like his predecessors who left reminders of the malleable clay and the rough stone block, Signorelli did not obscure modifications in his frescoes for several reasons. Most pragmatically, fresco is an unforgiving medium; correction means replastering. Second, in an age before optical lenses, such minor alterations so high above the viewer would not be visible. Moreover, alterations, such as corrected sketches, empty haloes, rough stone edges and fingerprints, show facture – properties of the material, method and process – and intellectual activity. Alterations reveal *audacia*, boldness and confidence on the part of the artist; *invenzione*, the freedom to invent; and *fantasia*, the use of one's imagination.[9] These facets not only demonstrate the new freedom the contract allowed and the value the patrons held for the work of the master, but also the actual thought process of creative genius.

Visual rhetoric

Besides stylistic inventiveness and textual considerations, such as incorporating liturgical and textual material into narratives, scholars have demonstrated that rhetorical techniques enhanced the meaning of mural programs, especially Byzantine ones.[10] Scholars have also noted reliance on rhetorical devices in the art of the Italian Renaissance.[11] Signorelli's program of paintings, as we shall see, reflects the ideals of oratory and conforms to various parts of rhetoric: *ekphrasis* (vivid description), invention (what to include), disposition (how to arrange it), elocution (how to express it), antithesis (juxtaposition), metaphor and poetry.[12] In the words of Cicero, the paradigm rhetorician for medieval and Renaissance scholars, 'the orator's virtue is pre-eminently manifested either in rousing men's hearts to anger, hatred or indignation, or in recalling them from these same passions to mildness and mercy'.[13] It is not happenstance that Cicero sits at the feet of Rhetoric on the royal portal of Chartres Cathedral and, accompanied by Prinius and Quintilian, epitomizes rhetoric in Albèri's library in the cathedral of Orvieto.

The vivid, life-like quality of Signorelli's figures, along with their number and the variety of movements they portray as they enact every emotion imaginable, have long been noted by viewers and scholars.[14] The vivid portrayal complies with rhetorical *ekphrasis*, or description so detailed that the event comes to life and stirs the emotions.[15] Scholars from Dante and Petrarch to fifteenth-century humanists, including Lorenzo Valla and Leon Battista Alberti, discussed the challenges in writing, painting and sculpture, of creating compositions filled with life-like images with *varietà* and in *relievo*, or images in a variety of poses that appear so three-dimensional and so life-like that they trick the eye.[16] Nowhere is the value of making an image life-like more vividly recounted than in Vasari's sixteenth-century description of Donatello working on the prophet figure he called *Zuccone*, demanding that it speak to him or otherwise be cursed: '*Favella, favella, che ti venga il*

cacasangue!'[17] The new energy of Signorelli's figures in the Cappella Nuova and their seemingly unrestrained motion, influenced not only by Donatello's model, but also probably by Pollaiuolo's athletic nudes, invigorated the paintings and drew further attention to the expressive potential of the human form. Although Alberti condemned such 'fervent and furious' figures, by the late fifteenth century artists began to express such emotion; a generation later, it was not only the accepted but often the preferred mode.[18]

The precedent for the over-life-size, energetic figure was set by Signorelli at Orvieto. Never before had an artist used such monumental figures or so many nudes in a religious setting; rarely before had an artist used figures as vehicles of expression or handled them with such skill. A half-century later Giorgio Vasari, noting Michelangelo's admiration for Signorelli, praised Signorelli's compositions as possessing 'bizarre and capricious invention ... nudes, foreshortenings and many beautiful figures; imagining the terror that there shall be on that last and awful day'.[19] For visitors to the Cappella Nuova, Vasari and Michelangelo as well as modern viewers, Signorelli's images fill the onlooker with fear; in contrast and consistent with rhetorical antithesis, other of the images also convey calming reassurance.

The events of the Apocalypse and Last Judgment surround one of the most basic tenets of Christianity, one that had been illustrated repeatedly in manuscripts, murals and stone since the earliest days of Christianity: the belief in divine judgment and the eternal life in the world to come, with heavenly reward for the blessed and damnation for the wicked. Signorelli's challenge was to charge these time-worn images with new life, to engage the viewer as no other previous artist had done; yet, at the same time he needed to honor long-established religious and compositional conventions and make his work compatible with the images left by his predecessor. Signorelli met these challenges, the greatest of his career, with success that few before or since have achieved.[20] Moreover, the figures in the Cappella Nuova do not simply recount a biblical narrative or a theological truth, but, in the tradition of oratorical rhetoric, they evocatively persuade – indeed, they force – spectators not only to witness, but also to experience, the events of the End-time. For the first time, Signorelli presents the End-time as a human drama rather than as a ghoulish nightmare, which makes the events come to life. The sense of immediacy is almost claustrophobic: as with compelling theatrical dramas, the viewer has no escape.

Eloquent disposition, edifying correspondences

The complexity of Signorelli's fresco program continues to build as multiple levels of meaning become apparent. Scholars have consistently demonstrated that Byzantine and Italo-Byzantine artists arranged frescoes so that meaning-ful correspondences exist between facing paintings or paintings stacked in a vertical row on the wall.[21] As we have seen, Signorelli placed the paintings vertically in a hierarchical order; at the same time, the images correspond

meaningfully across the space of the chapel. In the vaults and upper walls, the artist depicted a narrative that operates within proscribed liturgical texts, preaches a message and, finally, arranges the scenes so that convincing correspondences exist between opposite and diagonally opposite panels. Signorelli arranged his paintings on the walls as purposefully as an orator composing a speech that, in the words of Cicero, 'instructs, delights and moves the minds of his audience'.[22] On a practical level, the available wall space and its architectural configuration, along with the size of Signorelli's compositions and the narrative configuration within each, determined the number of events cited in liturgical texts that he could depict. To fill the south bay, Signorelli extended the Last Judgment in the vaults and on the altar wall to include *The Torture of the Damned* and *The Blessed in Paradise*. Like those scenes, these also concur with the liturgical texts for All Saints' Day. In the north bay, the liturgical texts for Advent sharply limited the selection of apocalyptic scenes. However, in addition to the liturgical and liturgically related texts, and consistent with spiritual exegeses and Dante's writings, correspondences among the scenes clarify Signorelli's choices and multiply the meaningful dimensions of the fresco program.

First, the paintings in the Cappella Nuova murals have been interpreted as a chronological narrative, beginning with the scene of *The Rule of the Antichrist* and moving in a counterclockwise circle. Since one could argue that the events, especially those of the Last Judgment, could occur simultaneously, the paintings also could be interpreted as two complementary, yet antithetical, mural triptychs that face each other.[23] The apocalyptic events in the north bay take place in this world. The events of the Last Judgment in the vaults and the south bay take place in the world to come. Simultaneously, diagonally facing scenes in the chapel also pair symbolically, forming a modified X-shaped pattern, or a variation on the Chi Rho monogram.[24]

On another level, the arrangement of the paintings again exhibits the rhetoric of antithesis. Beginning with the narrative sequence in the north bay, *The Rule of the Antichrist* warns against the dangers of heresy, the allure of false gods and turning away from God. The Antichrist symbolically pairs with the scene of *The Torture of the Damned* diagonally across the chapel in the first bay. The arrangement forms a cause-and-effect relationship, for *The Torture of the Damned* depicts the ultimate destiny of the heretics: the punishment of the wicked in the next world and eternal separation from God. As mentioned earlier, the placement of *Doomsday* over the entrance facing Christ and the Last Judgment follows Advent scripture. The arrangement also forms two beginning-and-end, or antithetical, relationships: Doomsday destruction faces final glory; events of this world face those of the next. Finally, the joyful celebration of the doctrine of *The Resurrection of the Dead* juxtaposes with *The Blessed in Paradise* diagonally across the space of the chapel in the south bay, for ultimately the Resurrected will join the Elect.

At the same time, adjacent frescoes contrast good and evil. Note that in the south bay the good stand to the right of Christ and the officiating priest, while evil occupies the left, or 'sinister', position. The placement of *The*

Ascent of the Blessed to Heaven beside *The Damned Led to Hell* on the wall over the altar, and their extensions, *The Blessed in Paradise* and *The Torture of the Damned*, reflect this orientation. The same is true of the lunettes in the north bay, as Mary Magdalene faces Christ: *The Resurrection of the Dead* is on her right, while *The Rule of the Antichrist* is on her left. With the long walls, on the other hand, the orientation of good and evil changes to the perspective of the viewer. On the viewer's left when facing the west wall, *The Torture of the Damned* contrasts with *The Resurrection of the Dead* to the right. In addition, the downward motion of the Damned contrasts with the upward movement of the Resurrected. The same juxtaposition of good and evil, as well as upward and downward motion, appears on the facing wall: *The Rule of the Antichrist* is to the viewer's left, while *The Blessed in Paradise* is to the right. In the arch over the door, on the right the prophets standing on the ground line look up and watch their prediction develop into a reality; to the left, the condemned, hunched over, attempt to flee the scene.

Wisdom: the Masters of the Sacred Page and Signorelli

The eloquent, complex rhetorical style peculiar to Dominican spiritual expositions is evident in the arrangement and deeper meanings veiled in Signorelli's frescoes; the rhetorical style also reveals the involvement of Signorelli's theological advisors and confirms that these men were Dominicans.[25] As previously noted, Signorelli's second contract with the Opera del Duomo clearly states that Orvietan theologians, 'Masters of the Sacred Page of this City', advised him on the 'theologies'.[26] The venerable Dominican *studium generale* would have had such scholars in residence. Moreover, that institution, along with the frequent presence of the papal court, attracted some of the greatest theologians in Europe to Orvieto in the fifteenth century, including Cardinals Pietro Barbo, Nicholas of Cusa and Fra Tommaso. In addition to teaching, Masters of the Sacred Page routinely advised on theological matters.[27] Thus, the lead faculty members of this institution were the obvious candidates for the Opera del Duomo to appoint as advisors to Signorelli. Modern scholars note that artists working in the Vatican in the first two decades of the next century, Michelangelo and Raphael in particular, probably received advice from papal theologians.[28] These papal scholars always came from the Order of the Dominicans.[29] As stated earlier, humanists residing in Orvieto had connections to Roman intellectual circles, especially those at the Vatican; circumstantial evidence strongly indicates theological advisors who directed Signorelli did as well. The logical direct link would have been Fra Tommaso. In 1455, he had served as prior of the *studium generale* at S. Domenico in Orvieto, and in 1493 returned to that post from the Vatican, where he had served as a revered lecturer in the *studio* of the Sacred Palace (1483–84).[30] Perhaps he knew Signorelli when he worked for Pope Sixtus IV in the 1480s. No better place existed for the revival of Thomist theology than Orvieto, a city that not only had an enclave of

humanists, but also an important Dominican *studium* with a legacy of ties to papal circles.

More than other fresco programs, those influenced by the Dominican reflect wisdom, incorporating doctrinal issues into narrative and emblematic scenes. Earlier Dominican programs, such as that in the fourteenth-century Guidalotti Chapel (later called the Spanish Chapel) at S. Maria Novella in Florence (*c.* 1348–55) reflect the dense exegesis of Dominican treatises.[31] In the cathedral of Orvieto, the fresco program in the Cappella Corporale (1350–64) reflects liturgical texts and Thomist ideas, with many Dominicans participating in the narrative scenes.[32] Perhaps those Orvietan priest–artists, one of whom was a friar, were associated with the local Dominican Order either formally or for advice. In the Cappella Nuova, we recall that Signorelli's predecessor was a Dominican. Signorelli, with the assistance of his Dominican advisors, applied the Dominican method to his epic frescoes in the Cappella Nuova, just as Dante had done in his epic poem.

Poetic theology

In the mid-fifteenth century, Thomist theology, recently renewed, helped give poetry a firmer place in the Renaissance rhetorical system. The revival also influenced Signorelli's use of poetry as theology and poetic allegory, including epic structure, metaphor and the license to be bold, inventive and expressive.[33] The emulation of the poet by the artist dates back to ancient times, most notably with the analogy made by Horace, 'as painting, so poetry'.[34] Over time, scholars, beginning with Pope Gregory the Great, gave this directive Christian meaning for teaching and meditative purposes. In the Middle Ages, poetry, recognized as a type of eloquence but not as a discipline, did not hold a set position in the medieval system of learning (the *trivium* and the *quadrivium*). Instead, it was associated with rhetoric and sometimes sandwiched in among grammar, logic and even music.[35] Scholastic theologian Thomas Aquinas (*c.* 1225–74) was the first to include poetry in the medieval hierarchy of disciplines, and gave it a separate status; in addition, he aligned poetics with theology. He based his ideas on scripture, especially the psalms, classical literature, and the early church fathers, who typologically paired scriptural stories with pagan myths. In addition, like St Augustine, Aquinas believed metaphor that disguised truth encouraged the faithful to study and prevented the infidels from knowing the holy mysteries of the faith.[36] Although Aquinas ranked poetry as the lowest form of knowledge, he was not being derogatory; instead, his intention was positive: to recognize the intellectual value of poetry and categorize it.[37] He could have referred to poetry as base, confused or irrational; instead, he defended the value of poetry as more accessible to mankind than intellectual discourses. Poetry, since it derives from the senses, persuades through fiction rather than by reason, the method used in intellectual discourses. Aquinas justified the use of naturalistic images in poetry and painting by approving knowledge gained

through sensation if it had higher meaning. Thus poetry, if governed by higher truth, could be the first step toward deeper understanding, and thus toward salvation.[38] In this context, the use of reasoned poetry – or allegorical paintings – as instructional images corresponded to the duty of the Church and its preachers to move the believer from the world of sensory understanding to theological truth, the gateway to salvation.

Thomas Aquinas also noted that the lower apprehensive powers in particular, that is, poetry and art, strengthened the memory and helped intellectual comprehension.[39] Among the human senses, Aquinas believed that sight was the highest, thus the closest to the intellect. Just as soul and body joined, so sense and intellect did as well, and in a hierarchical fashion. He believed that even the phantasms of the poets began with a mental image. Especially when memorized and repeated, these mental images, which, in addition to poetry, included allegories, parables, liturgical ceremony, theatrical productions and visual pictures, could help bridge the gap between the level of sense and that of higher intellective powers, or as he called it, 'the beautiful'. In turn, intellective understanding helped shape moral decisions; thus, these sensory images – poetic, allegorical and visual – could positively affect moral behavior.[40]

Not all ancient and medieval scholars endorsed using poetry in theology and philosophy. For some, philosophy was considered abstract and frank; poetry, concrete and charming, and thus a lesser branch of learning.[41] Macrobius (c. 430) had denigrated poetry, stating that poets 'ape philosophers'.[42] Thomas Aquinas's contemporary, Dominican friar Giovannino of Mantua, like Aquinas, placed poetry low in the intellectual system, although he saw it as a man-invented discipline rather than as a first step to higher learning.[43] Giovannino did not condemn poetry; however, he also did not believe that it could be divine, theological or a conduit to higher learning. Poetry, he said, served to delight, whereas biblical metaphors veiled truths, so they could be revealed to the worthy and remain hidden from the unbelievers.

Albertino Mussato (b. 1261) responded to Fra Giovannino by fervently defending the value of poetry, saying that it was a heaven-ordained science. He equated pagan myths and prophecy and claimed that the myths told the same truths as the Bible, only in a more mysterious manner. Moreover, he wrote that 'the divine poets of the early ages … [were] called by the name *vates*; whoever was a *vates* was vessel (*vas*) of God. Therefore, that poetry which we must consider was once a second theology.'[44] In his mind, the ancient poets were prophets and their poetry was theology. Justification for the high standing of poetry lay partly in the renewed interest in classical poetry (particularly Cicero's religious poetry) and in poetry's long association with theology, going back to Aristotle.[45] From these beginnings, a Christian poetic theology developed; by the fourteenth century, the alignment of poetry with theology was generally accepted.[46] In addition, from at least the thirteenth century moralized versions of Ovid's *Metamorphoses* and other classical texts built upon this idea.

In the fourteenth century, the triad of Italian poets, Boccaccio, Petrarch and Dante, continued to defend the value of poetry, for only recently had poetry emerged as separate from rhetoric.[47] Boccaccio (d. 1350) stated that poetry was a 'messenger from the very bosom of God, mistress of all knowledge'.[48] He equated poets with philosophers, saying that both veiled thoughts in beauty and art, and used scripture, including Psalm 147:4–5, to defend and support his argument.[49] Petrarch (d. 1374) wrote of poetic theology to his brother Gherardo, a Carthusian monk:

Poetry is in no sense opposed to theology. I might almost say that theology is a poetry which proceeds from God. When Christ is called now a 'lion', [Rev. 5:5] now a 'lamb', [John 1:29] and now a 'worm', [Ps. 21:7] – What is that if not poetic? …What are the Savior's parables but allegories? But the subject matter is different! Who denies it? The Bible treats of God and the divine things, poetry of gods and men, wherefore we read in Aristotle that the poets were the first to practice theology …[50]

Petrarch's younger contemporary Coluccio Salutati (d. 1406), with whom he corresponded, also ardently defended poetry. He stated that poetry was the most vital human endeavor, and since it did not have its own place in either the *trivium* or the *quadrivium*, it could participate in all of the disciplines.[51] Cennino Cennini (c. 1370–c. 1440) aligned painting and poetry in his *Libro dell'Arte*, stating that it gave the artist license to invent. Though the book is a handbook of formulae rather than a theoretical work, Cennini aligned the painter and the poet, and thereby gave the artist license to invent:

an occupation known as painting, which calls for imagination, skill of hand, in order to discover things not seen … And it justly deserves to be enthroned next to theory, and to be crowned with poetry. The justice lies in this: that the poet, with his theory, though he have but one, it makes him worthy, is free to compose and bind together, or not, as he pleases, according to his inclination. In the same way the painter is given freedom to compose a figure standing, seated, half-man, half-horse, as he pleases, according to his imagination. So then, either as a labor of love for all those who feel a desire to understand; or as a means of embellishing … that they may be set forth …[52]

By the late fifteenth century, poetry and rhetoric were seen as at least equal; moreover, the emulation of the poet by the artist was an accepted identification.[53] Leon Battista Alberti (d. 1472) echoed the analogy in his *De Pictura* (1435), his new theoretical approach to the visual arts. Many of the scholars in the Medici household in the 1490s, men Signorelli would have known, including Lorenzo Valla (d. 1457), Giovanni Pico della Mirandola (d. 1494) and Marsilio Ficino (d. 1499), played a role in reviving and perpetuating these literary endeavors.[54] Signorelli, then, was not out of step with his contemporaries in his emulation of the poet; he was simply more bold.

The emulation of the poet by Signorelli extended beyond content to form: he narrated like a poet. Just as Dante wrote in the highest literary form, epic poetry, Signorelli composed in the highest form of painting, *istoria* or history.

Signorelli's paintings, however, broad in scope and deeper in meaning, present more than history: they present epic poetry. Boccaccio, following Aristotle, separated historians from poets by stating that historians 'begin their account at some convenient beginning and describe events in the unbroken order of their occurrence to the end. … But poets, by a far nobler device, begin their proposed narrative in the midst of events …'[55] Moreover, as Aristotle held, historians recounted what had happened; poets told what might happen and historians presented facts; poetry gave truths. Thus, scholars considered poetry as more scientific and serious than history.[56] Signorelli's paintings begin *in medias res* collectively and in the individual segments; they not only tell what might happen, but, like mute poems, they present timeless truths, first and on the lowest level in the accessible medium of poetry, and afterward in ascending layers of theological meaning.

Moreover, just as Virgil literally, rhetorically and figuratively guided Dante in the *Divine Comedy*, so Dante, the poet–theologian, himself educated by Dominicans two centuries earlier, inspired Signorelli on deeper and increasingly arcane levels and in more subtle ways than previously realized. In the Cappella Nuova, theological wisdom, allegorical literature and rhetoric join to form an eloquent sermon – this one visual – the final unifying element of the fresco program. In addition to following the form for poetic theology, Signorelli's murals, like Dante's epic, conform to the standard four-fold rhetorical method used in the medieval and Renaissance spiritual exposition that originated with the scholastics, especially the Dominicans. Dante included in his *The Banquet* (*Il Convivio*) a letter to his patron, the Lord of Verona, Can Grande della Scala, in which he explained that the *Divine Comedy* was a complex work that should be read on four levels, the same ones used in the spiritual *exposito*:[57]

For the comparison of the things we have to say, however, it must be observed that the meaning of this work is not simple, but rather … has many meanings; because the meaning of the letter is quite different from the things signified by the letter. The first is called literal, the second allegorical or mystical … at the moral sense we perceive the conversion of the soul from the tears and misery of sin to a state of grace; … at the anagogical we recognize the passage of the holy soul from the slavery of present corruption to eternal glory.[58]

Although from the thirteenth century onward, this form of spiritual exposition became systemized and evolved into a highly artificial form,[59] much as happens with musical variations on a common melody, the originality of the context continued to intrigue the scholar; it also served as a method of teaching theology.

The four-fold method of exposition, in a systematic manner, builds upon the idea that parables and mythological stories hold several levels of meaning. Scholars said this protected the mysteries of the faith from the infidels; the allegories were also more understandable models of moral virtues. They compared their methodology to Christ's manner of teaching with parables and cited scripture for justification:[60] '[Christ said] This is why I speak to

them in parables, because in seeing they do not see, in hearing they do not hear, nor do they understand' (Matthew 13:13, NRSV).

The rhetoric of a parable calls first for a similitude, the illustration of a point by giving a seemingly simple example, usually in narrative form. The story cannot be taken at face value and must have an open ending, so that it closes only when interpreted. Some parables give simple lessons; others prove elusive. Most parables offer several levels of interpretation. In the final analysis, a parable gives over to the interpretation once deciphered; the lesson, not the story, remains important.[61] The more complex the parables, or metaphors, the more fascinating and rewarding it was for those who succeeded in deciphering them and discovering the mysteries.

The four expository divisions are hierarchical, with each level giving an increasingly arcane, and yet progressively more enlightening, interpretation to those who understood them:[62] 'The historical sense is easier, the moral sweeter, the mystical sharper; the historical is for beginners, the moral for the advanced, the mystical [anagogical] for the perfect' (Peter Lombard).[63] The latter two levels form the basis of standard medieval interpretation of scripture and pagan literary texts: 'Holy Scripture is God's dining room, where guests are made soberly drunk … History is the foundation … allegory the wall … tropology the roof … (Peter Comestor).[64]

The final level, that of anagogical or mystical meaning, developed around the eleventh century, and served as an important part of the system from the fourteenth century onward.[65] Dominican scholars and preachers embraced, preserved and perpetuated the four-fold method; Dante internalized it under Dominican tutelage. His writings, in turn, will inspire Signorelli for form and content in his frescoes in the Cappella Nuova. As with Dante's epic, the general audience appreciated Signorelli's fresco program for narrative and to some degree for typology; the educated audience expected to find disguised meaning.

In the Cappella Nuova, the first of the four levels, the literal, or historical, chronicles the Apocalypse and Judgment, along with various supportive narratives in the socle. No theme fit the model of epic poetry better than the combined Apocalypse and Judgment, although the combination of these subjects was virtually without precedent. The two subjects always had appeared separately in monumental painting and mosaic decoration.[66] Unfortunately, viewers rarely make the leap from parts to the whole in Signorelli's program. However, the unifying threads follow Dante's poetic lead.

Allegory, or metaphor, forms the second level. To complement the already monumental history subjects in the vaults and upper walls, Signorelli placed in the socle, author portraits and episodes from the narrative poetry of Dante and classical writers. Events from Dante's *Il Purgatorio*, as well as deeds of exemplary classical heroes overcoming evil with good and entering and returning from the Underworld, serve as metaphors for the virtuous life and the Christian pilgrimage to Heaven. In so doing, Signorelli was entirely within established decorum; this understanding was incorporated into poetic theory from at least the fourteenth century onward.[67] Following Augustine

and Aquinas, Boccaccio elaborated that the veil protected the truth from the misunderstandings and desecrations of the weak and unbelievers.[68] In his great Christian allegory, Dante also concealed truth in the guise of fiction. He and Petrarch suggested that poetry could edify, functioning much as the metaphors of Plato or the parables of Christ.[69] The poetic scenes in Signorelli's chapel silently perform the same function.

The tropological level, the third level, demonstrates moral behavior by showing the rewards of vice and virtue. Signorelli's juxtaposition of poets and scenes of poetry on the lowest level of the chapel with religious scenes above also conforms to the view of Thomas Aquinas, who saw the relationship between sense – which governs language and therefore governs poetry – and intellect, or reason, as not only hierarchical, but also as a conduit between understanding and moral choices. Selected classical heroes in the Cappella Nuova serve as exemplars of Christian virtue, in the same manner as those recorded in moralized versions of Ovid, retellings of selected myths.

Ancient scholars Quintilian and Cicero urged scholars to avoid insularity by seeking knowledge outside their narrow discipline.[70] Likewise, Thomas Aquinas taught that one should mix secular and sacred learning.[71] The medallions in the socle, classical as well as those depicting *Il Purgatorio* and emblematic virtues, serve as tropes, or moral metaphors, for the message of the triumph of good and punishment of evil implicit in the Apocalypse and impending Judgment. The message occurs repeatedly throughout the chapel, enacted by different characters. Fifteenth-century humanists would have recognized the symbolic value of these stories.

The fourth and highest level, the anagogical or the mystical level, speaks to the revelation of truth, which in Signorelli's program culminates in the vaults of the chapel. Set before the viewer is revealed truth in the form of the liturgical texts and the heavenly hosts, the ultimate goal of the Christian; revealed truth is the goal of the pilgrim Dante, guided by Beatrice to Paradise, where he beholds the heavenly hosts.

Beatific vision

The journey through Signorelli's fresco cycle is a visual feast and a theological *exposito*, rhetorically structured after Dante and held together by liturgy and allegory. Reminiscent of the verses of a mute poem, the individual paintings guide the viewer step by step; together they form an allegorical epic. Signorelli's pilgrimage begins at the lowest level, the socle, which entreats the worshiper to meditate upon the allegories and then climb upward from the level of sense – that is, poetry and allegory – to reason and discourse in the deeper levels of theological history and truth. Seen as a whole, the frescoes set before the viewer revealed truth in the form of the beatific vision, the ultimate goal of the Christian.

The idea of the beatific vision originates in ancient writings. For example, Plato, in his *Timaeus*, claims that, among the senses, only sight has the virtue

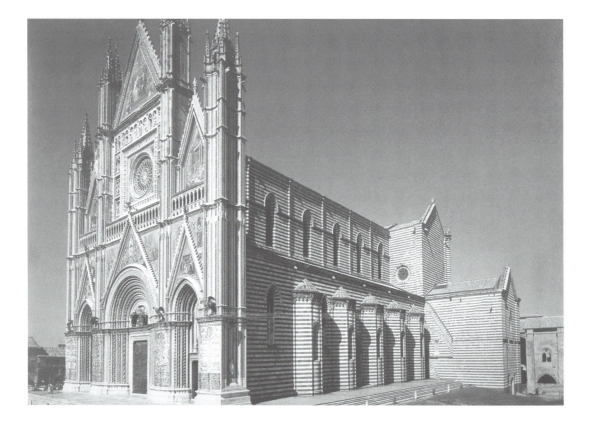

9.3 Cathedral of
Orvieto from the
south (author)

of making attainable, or at least accessible, not only knowledge, but wisdom:
'rectifying the revolutions within our head, which were distorted at our
birth, by learning the harmonies and revolutions of the universe, and thereby
making the part that thinks like unto the object of thought'.[72] Thomas Aquinas,
we recall, ranked sight as the highest of the senses. Revealed truth in the
form of knowledge is the goal of theological writers St Augustine, Pseudo-
Dionysius and Thomas Aquinas, all of whom use metaphors of the beatific
vision and the beautiful. For Aquinas, the beautiful, related to cognitive
knowledge, or the *via cogniscitiva*, was a means to higher facilities; it came
through sight, which he considered the most intellectual of the human
senses.[73] Such a vision is the culmination of a process, the revelation of the
knowledge of God, gradually gained through self-purgation by those who
actively seek it. St Augustine states that: '[In the beatific vision] will our
constantly turning cogitations perhaps not be going and returning from one
thing to another, but we shall have all our knowledge at one glance'.[74] Dante
articulated this journey in rhymed verses his *Divine Comedy*; Signorelli
illustrated it in the Cappella Nuova.

Visitors enter another world as they walk through the iron gate that
separates the tranquil, zebra-striped nave of the cathedral from the Cappella
Nuova in the south transept (Fig. 9.3). Suddenly, as if arriving at a theater-in-
the-round during a performance, the strong colors and tumultuous action of

gigantic figures that seem to spill over the edge of the architecture create a startling sense of immediacy (Pls 2–4). Viewers experience this world and the next, ante-Christian and Christian in a state of Parousia, with everything present at once. The large chapel seems inadequate to contain all that happens simultaneously. Like Dante's message of hope in the world to come, the paintings silently preach penance and reform, and demonstrate by human example that heavenly reward is obtainable. Moreover, following the description of the beatific vision, the frescoes give the viewer an abundance of spiritual knowledge in a single, seemingly ever-moving panoramic vision. Thus, not only do the viewers experience the event as an ever-present reality, but they also witness Signorelli's self-conscious effort to portray himself as an epic poet–theologian in the fashion of ancient and medieval writers, especially Dante.

The frescoes in the Cappella Nuova are the culminating statement in the iconographic program of the cathedral. This program centers around the intense devotion of the citizens of Orvieto to two particular Christian feasts: Corpus Christi and the Assumption of the Virgin. Together these feasts reaffirm the basic tenets of the Christian faith: belief in the essential role of the sacraments in salvation, especially the Eucharist, with the miracle of Transubstantiation at each celebration, and the anticipation of the Resurrection of the Body and heavenly reward for each devoted Christian believer. The liturgical texts for the Feast of All Saints, Advent and Lent, which are embedded in the chapel decoration, amplify these basic tenets, stressing human choices by punishments and rewards of the afterlife.

The underlying subject of the frescoes is a spiritual metamorphosis, a chapel-wide theme closely related to both the local cult of the Eucharist and the cult of the Magdalene, exemplified by her exalted position in the iconography of the chapel. Mary Magdalene, who achieved a spiritual metamorphosis through penance, serves the worshiper as an example of hope. Spiritual metamorphosis also is available to the worshiper through the instruction given in the cameo scenes in the socle and the example of literary heroes, such as Dante, Hercules, Perseus and Aeneas. A strong sub-theme also emerges: the importance of the church itself in purgation and ultimately salvation through its sacraments.

The sacrament of the Eucharist confirms the faithful who seek penance with true contrition and strengthens their desire to resist sin and do good works. The Eucharist is an essential step in the quest for salvation, preceded by penance, both sacraments that the Mendicant Orders, most importantly here the Dominicans, were, as of the 1480s, able to perform. The Eucharist unites the faithful with the body of Christ through transubstantiation, which is a spiritual metamorphosis. Transubstantiation was proved in the Miracle of Bolsena, whose relic is in the chapel facing the Cappella Nuova. Amplified by the example of the Assumption of the Virgin and the heavenly seat of the Saints (depicted in the original altar window and in the vaults of the chapel, respectively), the Eucharist gives hope of participation in the afterlife. It promises eternal bliss, evident among the Resurrected and the Elect on the

chapel walls; faithlessness, wickedness, heresy and denying pure doctrine (the mission of the Antichrist) condemn the Damned and separate them from God, as seen in *The Torture of the Damned* and *The Damned Led to Hell*.

The cycle confirms the mission of the Dominican Order: to preach, to save souls, and to keep doctrine pure; it also demonstrates the particular reverence of the Dominicans for Mary Magdalene, and the positive nature of the judgment message, which has its basis in the theology of Thomas Aquinas. While the Roman liturgical texts and the underlying poetic sermon unite the frescoes and simultaneously reflect dogmatic issues of greatest concern to the Orvietans, the paintings also have a universal appeal. They reflect the basic tenets of the Christian faith: the intercessory role of the Virgin; the belief in the judgment of the living and dead by Christ; the infallibility of the holy Catholic Church; the communion of Saints, particularly Mary Magdalene; the sanctity of the sacraments, especially the forgiveness of sins through penance and the union with Christ in the Eucharist; the resurrection of the body; and life in the world to come.

Notes

Introduction

1. Beginning with the early sixteenth-century published travelogues of DuBellay and Francesco de Hollanda, Signorelli's frescoes received enthusiastic praise. Gladys Dickinson, *DuBellay in Rome* (Leiden, 1960), p. 43. In 1622, the Cappella Nuova was rededicated to honor the Madonna of San Brizio. In 1715–16 a new altar was installed that covers some of the original decoration. Liliana Barroero, 'Gli interventi settecenteschi', in Giusi Testa, ed., *La Cappella Nuova o di San Brizio nel Duomo di Orvieto* (Milan, 1996), pp. 289–99; Luigi Fumi, *Il Duomo di Orvieto e i suoi restauri* (Rome, 1891), pp. 427–29; Dugald McLellan, 'Luca Signorelli's Last Judgment Fresco Cycle at Orvieto: An Interpretation of the Fears and Hopes of the Commune and the People of Orvieto at a Time of Reckoning', 2 vols (unpubl. Ph.D. diss., University of Melbourne, 1992), vol. I, pp. 50–51.

2. Giorgio Vasari, *Lives of the Painters, Sculptors and Architects*, trans. Gaston du C. de Vere and intro. by David Ekserdjian (New York, 1996), pp. 609–14; Giorgio Vasari, *Le vitae de'più eccellenti pittori, scultori e architettori*, Enrico Bianchi, ed. (Florence, 1930), vol. III, pp. 359–70, especially 364–65.

3. Rose Marie San Juan discusses the poets in the socle in 'The Illustrious Poets in Signorelli's Frescoes for the Cappella Nuova of Orvieto Cathedral,' *Journal of the Warburg and Courtauld Institutes* 52 (1989), 71–84. Laurence Kanter, 'The Late Work of Luca Signorelli and His Followers: 1498–1559' (unpubl. Ph.D. diss., New York University, 1989), pp. 32–49, ties scenes in the socle to the lunettes in a general way. Neither scholar ties the socle to contemporary literary practices or to the Roman liturgy; nor do they note the allegory of the spiritual pilgrimage. Jonathan Riess, *The Renaissance Antichrist: Luca Signorelli's Orvieto Frescoes* (Princeton, 1995), pp. 34–35, 43–46, 122–34 and *passim*, and Stanley Meltzoff, *Botticelli, Signorelli, and Savonarola: theologia poetica and painting from Boccaccio to Poliziano* (Florence, 1987), also address the socle, but do not tie it to the chapel at large. Ludovico Luzi, *Il Duomo di Orvieto descritto e illustrato* (Florence, 1866), identifies all of the figures in the chapel based on Dante. His work 'set a canon' that has, until recently, remained unchallenged. Robert Vischer, *Luca Signorelli und die italienische Renaissance* (Liepzig, 1879), gives description and plans.

4. Authors who note liturgical themes or liturgical texts in the inscriptions include Pietro Scarpellini, 'L'inspiration dantesca negli affreschi del Signorelli a Orvieto', *Bollettino Instituto Storico Artistico Orvietano* 21 (1967), 1–29; Kanter (1989), p. 42; Donato Loscalzo, 'Le fondamenta dei classici', in Testa (1996), pp. 191–213; and Riess (1995), pp. 37–38 and 81, but they do not recognize a liturgical format for the program.

5. Kurt Weitzmann, *The Age of Spirituality: Late Antique and Early Christian Art Tradition Third to Seventh Century* (New York, 1977), pp. 4–5; John O'Malley, 'The Theology behind Michelangelo's Sistine Ceiling', in Carlo Pietrangeli et al. eds, *The Sistine Chapel: The Art, the History, and the Restoration* (New York, 1986), pp. 107–8; Kathleen Weil-Garris and John D'Amico, *The Renaissance Cardinal's Ideal Palace: A Chapter from Cortesi's* De Cardinalatu (Rome, 1980), p. 93.

6. Henry Maguire, 'The Art of Comparing in Byzantium', *Art Bulletin* 70, no. 1 (March 1988), 88–103 and *Art and Eloquence in Byzantium* (Princeton, 1981).

7. Carol Lewine, *The Sistine Chapel Walls and the Roman Liturgy* (University Park, PA, 1993). Other scholars who link Byzantine programs to liturgical and rhetorical sources include Weitzmann (1977), pp. 4–5 and Maguire (1988), pp. 88–103 and (1981), *passim*.

8. Guglielmo Della Valle, *Stampe del Duomo di Orvieto* (Rome, 1791). This book contains 32 leaves of engraved plates illustrating the cathedral, including reproductions of some of Signorelli's lunettes, the first illustrations of the frescoes that I know of. Moretti's photographs, some of which are reproduced here, are among the earliest photographic images of the chapel. Neither illustrates full-wall views or gives the images' contexts.

9. Jacobus de Voragine, *The Golden Legend*, 2 vols, trans. William Granger Ryan (Princeton, 1993), vol. I, p. 4, note 1.

10. R. Pascal, 'On the Origins of the Liturgical Drama of the Middle Ages', *The Modern Language Review* 36, no. 3 (1941), 379–80; C. Clifford Flanigan, 'The Roman Rite and the Origins of the

Liturgical Drama', *University of Toronto Quarterly* 43, no. 3, (1974), 263–84, esp. p. 265; and David Summers, *The Judgment of Sense* (New York, 1987), p. 255.

11. Recent scholars whose writings on theoretical and rhetoric issues in Italian Renaissance art have been indispensable for my work include Michael Baxandall, Rensselaer Lee, John Spencer and especially David Summers. See Chapter 9.

12. John F. D'Amico, *Renaissance Humanism in Papal Rome: Humanists and Churchmen on the Eve of the Reformation* (Baltimore, 1983), p. 115.

13. George Kennedy, *Classical Rhetoric and its Christian Secular Tradition from Ancient to Modern Times* (Chapel Hill, NC, 1980), pp. 190–91.

14. Anthony Grafton, 'The Ancient City Restored: Archaeology, Ecclesiastical History, and Egyptology', in Grafton, ed., *Rome Reborn: The Vatican Library and Renaissance Culture* (Washington, DC, 1993), pp. 88–99.

15. Charles Stinger, *The Renaissance in Rome* (Bloomington, 1985), p. 142.

16. Charles Trinkaus, *In Our Image and Likeness: Humanity and Divinity in Italian Humanist Thought* 2 vols (Chicago, 1970) is a thorough scholarly source for information on Renaissance humanism. James Hankins, 'The Popes and Humanism', in Grafton (1993), pp. 47–86 and A. Grafton, 'The Vatican and its Library', in Grafton (1993), pp. 3–46 give information on intellectual trends and libraries in Rome.

17. The revival of Thomism came sooner than often realized. Paul Kristeller, 'Thomism and Italian Thought of the Renaissance', in *Medieval Aspects of Renaissance Learning*, ed. and trans. Edward P. Mahoney (Durham, NC, 1974), pp. 29–49. See also Stinger (1985), pp. 140–43, and Kennedy (1980), pp. 190–91. The theology of Thomas Aquinas was officially accepted as the cornerstone of Roman Catholic theology at the Council of Trent (1545–63); Stinger (1985), pp. 141–47.

18. Lesley Smith, *Masters of the Sacred Page: Manuscripts of Theology in the Latin West to 1274* (Notre Dame, 2001), pp. 13–20.

19. Beryl Smalley, *The Study of the Bible in the Middle Ages*, 2nd edn (Notre Dame, 1964), pp. 73–75; 179; L. Smith (2001), p. 15.

20. L. Smith (2001), p. 15; Smalley (1964), pp. 178–79 and 240.

21. Smalley (1964), pp. 197–98 and 373.

22. Langton, quoted in Smalley (1964), pp. 253–54 and 254, note 2.

23. L. Smith (2001), p. 20. The eventual outgrowth of Dominican doctrinarism was, less admirably, their prominent role in the Inquisition, an institution that did not gain momentum until after the Counter-Reformation and the Council of Trent.

24. Smalley (1964), pp. 253–54.

25. Daniel Lesnick, *Preaching in Medieval Florence: The Social World of Franciscan and Dominican Spirituality* (Athens, 1989), pp. 98–99.

26. *S. Bonaventurae Op. Omn.* V, 440, quoted in Smalley (1964), pp. 268–69 and 269, note 1.

27. Trinkaus (1970), vol. II, pp. 613–14. The methodology will be explained in detail and the relationship to the Cappella Nuova will be developed in Chapter 9.

28. O'Malley (1986), p. 107; Stinger (1985), pp. 145–47.

29. Jonathan Riess has published several articles, the contents of which are distilled in his previously mentioned *The Renaissance Antichrist* (1995). He is among the first to correctly note the Orvietan context, pp. 9–22; the importance of Purgatory, pp. 40–50; and the Eucharistic sources of inspiration, pp. 36–41. However, he emphasizes the Antichrist scene at the expense of the program as a whole.
 McLellan (1992), vol. I, pp. 10–33, 291–99 and *passim*, expands the Orvietan context. His major contribution is the full transcription and chronological organization of important documents in vol. II, which were previously either unpublished or abbreviated in Fumi, *Il Duomo* (1891). (Fumi organized the documents according to category at the end of each chapter.) Using the documents, McLellan traces the commission from the construction of the chapel into the eighteenth century, incorporating such issues as the details of contracts, patronage, working procedures, Signorelli's workshop and the relationship with cathedral officials. Subsequently, most of these documents were published by Laura Andreani in Testa (1996), Apps I and II, pp. 422–59.
 Donato Loscalzo discusses classical sources in Testa (1996), pp. 191–214. Among those who discuss Dante and Signorelli, see Corrado Gizzi, ed., *Signorelli e Dante* (Milan, 1991); Scarpellini (1967), pp. 1–29, and Adolfo Venturi, *Luca Signorelli Interprete de Dante* (Florence, 1921).

30. Riess (1995), pp. 6–8; 11–14, 135–44 and *passim*.

31. Meltzoff (1987), *passim* addresses aspects of poetic theology in the socle. For further development, see Sara James, 'Poetic Theology in Luca Signorelli's Cappella Nuova at Orvieto' (unpubl. Ph.D. diss., University of Virginia, 1994), Chapter Ten.

32. Vasari–Bianchi (1930), vol. III, pp. 359–70 and Vasari (1996), vol. I, pp. 609–14.

1 Orvieto and the Cathedral

1. Luigi Fumi, *Il Duomo di Orvieto e i suoi restauri* (Rome, 1891), pp. 317–18; Pericle Perali, *Orvieto: note, storiche, and biographiche* (Città de Castello, 1891; reprint Rome, 1979), p. 71. The doctoral dissertation of Dominique Surh is the first extensive, scholarly study of the iconography of the complex Cappella del Corporale and the history of Corpus Christi in Orvieto. The relic probably did not come to Orvieto immediately, but was there (perhaps stolen from Bolsena) by 1317. The frescoes of the Cappella del Corporale and the enamel reliquary give the earliest accounts of the legend. Dominique Surh, 'Corpus Christi and the *Cappella del Corporale* at Orvieto' (Ph.D. diss., University of Virginia, 2000), pp. 4–36 and 46–48. The fourteenth-century Orvietan *Rappresentazione sacra*, or liturgical drama, gives the oldest textual account. Vicenzo de Bartholomaeis, *Laude drammatiche de rappresentazioni sacre*, 3 vols (Florence, 1943), vol. I, pp. 368–81 and Gina Scentoni, ed., *Laudario Orvietano* (Spoleto, 1994), pp. 409–23.

2. For the bull, Henricus Denzinger, *Enchiridion Symbolorum: Definitionum et Declarationum de Rebus Fidei et Morum* (Rome, 1973), p. 846; Miri Rubin, *Corpus Christi: The Eucharist in Late Medieval Culture* (New York, 1991), pp. 177–78.

3. Although Aquinas did not document such a work, he probably wrote the office. Suhr cites the first attribution of the liturgy to Thomas Aquinas in Ptolemy of Lucca, *Historia Ecclesiastica Nova*, c. 1315. Surh (2000), pp. 155–65.

4. Corpus Christi was first celebrated in Orvieto August/September 1264. The feast may have been celebrated in Liège as early as 1246, but was not universally established until 1311. Archdale A. King, *Liturgies of the Roman Church* (Milwaukee, 1957), p. 198. The date of Corpus Christi later was moved to Holy Week before Easter, then finally to the Thursday following the Second Sunday in Pentecost (usually in June). A. King, *Liturgies of the Religious Orders* (New York, 1955), p. 360.

5. The Virgin Assunta, protectress of the city, is still honored by a procession so ancient that its origin is unknown, but extends back to at least 1216. The procession began at S. Andrea and ended at the cathedral. The Corpus Christi Procession encircled the city, beginning and ending at the cathedral. Lucio Riccetti, ed., *La città construita: Lavori, pubblici e imagine in Orvieto medievale* (Florence, 1992), pp. 157, 178, and 197. Della Valle emphasizes Orvietan devotion to the Assumption, in G. Della Valle (1791), pp. 91, 95.

6. For detail on papal involvement in Orvieto, see James (1994), Ch. II, pp. 38–75.

7. Lucio Riccetti (1992), figs X and XIV. In the last decade, a small portion of the underground network on the south side of Orvieto has been opened. The caves were excavated in the late Middle Ages for building material and afterwards served as cellars and dovecotes. Some excavations in other parts of the city date to Etruscan times. Although no one mentions the use of the caves and tunnels for defense, they were known to the population and would have made ideal hiding places.

8. Tommaso Piccolomini-Adami, *Guida Storico artistica della Città di Orvieto* (Siena, 1883), p. 293. The Albigensians at Albi in France, against whom Pope Innocent III mounted the only crusade in a European theater, were Cathar heretics.

9. Pope Innocent III recognized Parenzo's contribution to orthodoxy. Soon after 1200, the bishop of Chiusi offered a candle to Orvieto on either the Feast of the Assumption (showing the long-standing devotion to that feast) or that of Peter Martyr, meaning Orvietan protector saint Pietro Parenzo. The more famous Dominican St Peter Martyr was murdered in 1252, also by Cathars. D. Waley, *Mediaeval Orvieto: The Political History of an Italian City-State 1157–1334* (Cambridge, 1952), pp. 13–15; L. Fumi, *Codice diplomatico della città d'Orvieto: documenti e regesti dal secolo XI al XV e la Carta del popolo: codice statutario dal commune di Orvieto* (Florence, 1884), p. 49; Vincenzo Natalini, *S. Pietro Parenzo: La Leggenda Scritta dal Maestro Giovanni Canonico di Orvieto* (Rome, 1936), pp. 88 and 121–24.

10. The Dominican Order was confirmed at the Fourth Lateran Council 1215, and in Bulls of 1216 and 1217. In 1215, transubstantiation was declared *de fides* and immortality of soul was declared dogma. F.D.A. Mortier, *Historie de maîtres généraux de l'ordre des Fréres Prêcheurs*, 3 vols (Paris, 1902–20), III (1907), pp. 352–57; Waley (1952), pp. 22–23. Pope Honorius III resided in Orvieto in 1220, during which time St Dominic came to Orvieto for the dedication of an oratory, perhaps the one that housed the relic before the new cathedral was built. Piccolomini-Adami (1883), pp. 220; 293.

11. G. Moroni, *Dizionario di Erudizione Storico-Ecclesiastica* (Venice, 1852), vol. 49, p. 112; Piccolomini-Adami (1883), pp. 220 and 293. Horace Mann, *Lives of the Popes in the Middle Ages* (St Louis, 1929), pp. 17 and 154; Renato Bonelli, *Il Duomo di Orvieto e l'Architettura Italiana del Duecento Trecento* (Rome, 1972), pp. 75–79. James Weisheipl, O.P., *Friar Thomas d'Aquino: His Life, Thought,*

and Work (New York, 1974), p. 161, argues that this was not a full-fledged, degree-granting *studium generale* in Aquinas's time, but a priory or a *studium provincale*. Regardless, it served as an important center of learning, though perhaps not degree granting, from the thirteenth century. It predates the prestigious *studium generale* at St Jacques in Paris (1229). Smalley (1964), p. 264.

12. The pope's staff of theologians in Urban's time included Cardinal Ugone, a prolific scholar and the first Dominican elevated to cardinal, and William of Moerbeke, O.P., the great Flemish translator of philosophy and science. Piccolomini-Adami (1883), pp. 225–27 and Weisheipl (1974), pp. 148–50. Albert the Great, renowned Dominican scholar, resided in Orvieto from 1261 to 1263, as did his student Thomas Aquinas (1260–68), first at the Studium at San Domenico as a professor of theology and later as a papal advisor. Weisheipl (1974), pp. 161–63. Thomas served and was honored by Popes Urban IV and Clement IV, French popes who lived in Orvieto. Fr. Angelus Walz, *St. Thomas Aquinas: A Biographical Study* (Westminster, 1951), pp. 87–112; Moroni (1852), vol. 49, pp. 207, 212; Rubin (1991), pp. 185–87.

13. Urban built the first of three papal palaces, freeing the episcopal palace for the bishop. Martin IV (1281–85) built the second and Boniface VIII (1297–1304) the third and most imposing. Fumi, *Il Duomo* (1891), p. 75; Waley (1952), pp. xx, 44, 48, n. 1, 69 and 83; Bonelli (1972), p. 75; Perali (1891), p. 83. S. Dominico, which replaced a Dominican church of 1233, was the first church dedicated to Saint Dominic, who had been canonized in 1234. Perali (1891), p. 60; Mann (1929), pp. 17 and 154; Bonelli (1972), pp. 75–79.

14. Orvieto, Archivi del Commune, 1288, febbraio 14–settembre 24, Orvieto, Archivo del Capitolo, settembre 6, 1290 in Fumi, *Il Duomo* (1891), doc. III, p. 175, and doc. IV, p. 176; Waley (1952), pp. 48; 59; 59, n. 3. A detailed history outlining the building program is given in Bonelli (1972), pp. 72–82; chronological table, p. 60 and fig., p. 75; Gary Radke, 'Medieval Frescoes in the Papal Palaces of Orvieto and Viterbo', *Gesta* 23, no. 1 (1984), 27–38. Riccetti (1992), pp. 176–78 and pl. 5; Della Valle (1791), pp. 91, 95.

15. The Archivo del Opera del Duomo, Orvieto (hereafter AODO) holds three sets of incomplete documents, excerpts of which were first transcribed by Luigi Fumi in his aforementioned *Il Duomo di Orvieto e i suoi restauri* (Rome, 1891). Recently Dugald McLellan transcribed full documents in his 1993 dissertation and Laura Andreani included full documents in Giusi Testa, ed., *La Cappella Nuova o di San Brizio nel Duomo di Orvieto* (Milan, 1996). The *Riformanze* consists of minutes of the meetings of the Opera; the *Memorali* are yearly summaries written by the Camerlengo, and the *Camerari* give accountings. See McLellan (1992), vol. II, pp. 1–3 for a full explanation of the documents. AODO Ivi *Mem.* (1356–81), c. 87, in Fumi, *Il Duomo* (1891), doc. XXVII, pp. 387–88 and text pp. 362–65; Surh (2000), pp. 4–48; Bonelli (1972), p. 60; and Della Valle (1791), pp. 91, 95.

16. AODO Ivi *Mem.* (1384–90), c. 20, 8 November 1384, in Fumi, *Il Duomo* (1891), doc. XLIV, pp. 365–67, AODO Ivi *Cam.* IX (30 May 1388–2 November 1402), in Fumi, *Il Duomo* (1891), docs XLV–XLVII, pp. 389–91 and AODO *Rif. e Mem.* (1384–90), 28 July 1388, c. 136, in Fumi, *Il Duomo* (1891), doc. LI, p. 390. R. Van Marle, 'La scuola pittorica orvietana del '300', *Bolettino d'Arte* 3 (1924), 310; Enzo Carli, *Il Duomo di Orvieto* (Rome: 1965), pp. 83–97. With 32 captioned episodes, M. A. Lavin, *The Place of Narrative: Mural Decoration in Italian Churches* (Chicago, 1990), pp. 94–95, calls it the most extensive monumental Marian cycle known. Moreover, three of the ten plays in the Orvietan cycle concern the Virgin. Two local liturgical dramas recount the story of her conception, intended for 7 and 8 December, and one recounts the story of her Assumption. De Bartholomaeis (1943), vol. I, pp. 334–66 and 381–407. These plays concur with accounts in *The Golden Legend*. De Voragine (1993), vol. II, pp. 77–97.

17. Surh (2000), pp. 92–215 for the Cappella del Corporale.

18. AODO *Rif.* 3 (1391–1411), 23 Feb. 1406, c. 330v. Andreani in Testa (1996), App. I, doc. 3, p. 422; AODO *Rif.* 4 (1411–17), c. 14v., Andreani in Testa (1996), App. I, doc. 20, pp. 422–23. Bonelli (1972), pp. 31 and 75. McLellan (1992), vol. I, pp. 10–13. Raffaele Davanzo and Luciano Marchetti, 'La construzione della cappella le varie fasi edilizie e gli interventi attauli', in Testa (1996), pp. 23–33. The smaller foundations for the earlier structures are visible if one is able to steal a glance underneath the chapel into what now serves as a storage area and a garage. The space never served as a Monaldeschi family chapel, but an ecclesiastical one. Private family chapels are common in parish churches but rarely occur in cathedrals, which function as administrative centers for bishops.

19. McLellan (1992), vol. I, p. 10 and n. 1, and vol. II, doc. III, pp. 242–44. Fumi, *Il Duomo* (1891), pp. 171; Della Valle (1791), p. 211; and Moroni (1852), vol. 49, p. 204. Unfortunately, no known documents discuss the date or circumstances of the actual dedication. See Chapter 2 for details on the correlation between feast and decoration.

20. The round windows were closed in 1482 and 1493 to make room for the fresco program, but are still visible from the outside. McLellan (1992), vol. I, pp. 33–36. AODO Ivi, *Cam.* (1490–98), August 1492 and 12 November 1493, in Fumi, *Il Duomo* (1891), docs CC and CCXI, pp. 243–44.

21. AODO, *Rif.* 6 (1421–26), c. 167, 25 February 1425 in Fumi, *Il Duomo* (1891), doc. LXV, p. 392 and ibid., c. 196r., 3 September 1425, Andreani in Testa (1996), App. I, doc. 30, p. 423 and Fumi, *Il Duomo* (1891), p. 142.

22. For the original decoration, see McLellan (1992), vol. I, pp. 47–51.

23. McLellan (1992), vol. I, pp. 32, 47.

24. Perali (1891), pp. 59–61.

25. AODO *Rif.* 12 (1484–1526), c. 360r. in Andreani in Testa (1996), App. I, doc. 223, pp. 434–35. The document is Signorelli's second contract. It is translated and discussed in Chapter 4.

26. André Chastel, 'L'Apocalypse en 1500: la fresque de l'Antichrist à la Chapelle Saint-Brice à Orvieto', *Humanisme et Renaissance* 14 (1952), 124–40; *Art et Humanisme à Florence au temps de Laurent le Magnifique* (Paris, 1959). André Chastel was the first scholar to treat the fresco cycle in terms of contemporary politics, calling the Antichrist Savonarola, based on time spent by Signorelli in the court of Lorenzo de' Medici in Florence in the 1490s. Though I disagree with Chastel's Florentine interpretation, he is the first to consider the fresco cycle in the broader context of fifteenth-century intellectual movements. See also Jonathan Riess, 'Luca Signorelli's Frescoes in the Chapel of San Brixio as Reflections of their Time and Place', in *Renaissance Studies in Honor of Craig Hugh Smyth* (Florence, 1985), pp. 383–93; Riess (1995), pp. 136–38; Riess, 'Signorelli's Dante Illustrations in Orvieto Cathedral: Narrative, Structure, Iconography, and Historical Context', *College Art Association Abstracts* (1987), p. 65; Riess, 'La genesi degli affreschi del Signorelli per la Cappella Nova', in Riccetti, ed., *Il Duomo di Orvieto* (Rome, 1988), pp. 247–71; 'Republicanism and Tyranny in Signorelli's *Rule of the Antichrist*', in Charles Rosenberg, ed., *Art and Politics in Late Medieval and Early Renaissance Italy: 1250–1500* (Notre Dame, 1990), pp. 157–85.

27. Mortier (1902–20), pp. 352–7, and *passim*.

28. Stinger (1985), p. 150; Lewine (1993), p. 25.

29. Stinger (1985), p. 149.

30. Leopold Ranke, *The History of the Popes: Their Church and State*, trans. E. Foster, 3 vols (London, 1947), vol. I, pp. 44–45.

31. L. Smith (2001), pp. 25–26; Smalley (1964), pp. 268–71, 361.

32. W. A. Hinnebusch, 'Dominican Spirituality', *New Catholic Encyclopedia* (1967), vol. 4, pp. 971–74.

33. William Hood, *Fra Angelico at San Marco* (New Haven, Yale University Press, 1993); Georges Didi-Huberman, *Fra Angelico: Dissemblance and Figuration*, trans. Jane Marie Todd (Chicago, University of Chicago Press, 1995), *passim*. Vincenzo Marchese, *Memorie dei più insigni Pittori, Scultori e Architetti Domenicani*, 2 vols (Florence, 1854), *passim*. The Guidalotti Chapel (*c.* 1350s), S. Maria Novella, Florence presents a visual Dominican theological discourse. The lunette of the *Wisdom of St Thomas Aquinas* depicts the enthroned saint squashing three heretics under his feet. It faces the lunette of *Triumph of the Church*, which includes a pilgrimage to salvation, an underlying theme in the Cappella Nuova as well.

34. This late fifteenth-century image depicts the Florentine Procession of Corpus Christi; it also illustrates the Dominican ties to the cult of Mary Magdalene. See also Chapter 6, note 19. For more illustrations of Dominicans in Corpus Christi processions, see Rubin (1991), pp. 167–69; 245; 250; 260 and *passim*.

35. The importance of Mary Magdalene will be explained in Chapters 4 and 6.

36. Stinger (1985), p. 141.

2 Fra Angelico and the Formulation of a Liturgical Plan

1. AODO *Rif.* 9 (1443–48), c. 222r., 10 May 1446, in Andreani in Testa (1996), App. I, doc. 34, p. 423. Angelo Serafini, *L'Epopea Cristiana nei Dipinti di Beato Angelico* (Orvieto, 1911), gives a description and was the first scholar to fully transcribe documents surrounding Fra Angelico. Creighton Gilbert has a forthcoming book on the chapel that includes Fra Angelico's contributions. C. Gilbert, *How Fra Angelico and Signorelli Saw the End of the World* (University Park, 2003).

2. AODO *Rif.* 9 (1443–48), c. 286v., 11 May 1447 in Andreani in Testa (1996), App. I, doc. 45, p. 424.

3. AODO *Rif.* 9 (1443–48), c. 288v.–290r., 2 June 1447, and 14 June 1447, in Andreani in Testa (1996), docs 46 and 49, pp. 424–25; McLellan (1992) gives details and records documents, vol. I, pp. 60–77; vol. II, doc. 14, p. 12 and docs 25 and 27, pp. 17–20.

4. John Pope-Hennessey, *Fra Angelico* (Florence, 1981), p. 3. Fra Angelico suggested as a substitute his abbot, Dominican theologian Fra Antonino of San Marco. For the dense iconography in Fra Angelico's work, see Didi-Huberman (1995), *passim*, and Hood (1993), *passim*.

5. McLellan (1992), vol. I, pp. 13–19; Perali (1891), pp. 120 and 123; Fumi, *Il Duomo* (1891), pp. 370, 375; Moroni (1852), vol. 49, p. 204; and n. 15; Della Valle (1791), p. 211.

6. Perali (1891), pp. 126–30 and see below, note 25.

7. See Chapter 1 of this text for the dedication. McLellan (1992), vol. I, pp. 46–59, gives a detailed description of the furnishings. The statue of the Assumption was transferred to the chapel from the back of the church, along with an elaborate gilded crucifix that dated from the 1490s. In 1647, the chapel was rededicated to the Madonna di San Brizio and these objects were transferred to Albèri's Library, which was converted into a chapel called 'Cappelletta' and remained there until 1833. Perali (1891), pp. 255–56. The present location of these furnishings is not known.

8. McLellan (1992), vol. I, pp. 38–39, discusses changes in the windows and walls between Fra Angelico and Signorelli.

9. AODO *Rif.* 9 (1443–48), c. 288v., and c. 289v.–290r., 2 June and 14 June 1447, Andreani in Testa (1996), docs 46 and 49, pp. 424–25 (not recorded in Fumi). See also Eugenio Mario, O.P., 'Art Criticism and Icon-Theology', in Timothy Verdon and John Henderson, eds, *Christianity and the Renaissance* (Syracuse, 1992), pp. 584–85. Mario erroneously gives the date as 1499. The second document specifies terms of the contract, payment and that he will return every summer until finished, but does not mention subject matter.

10. G. Testa, 'Et vocatur dictas magister pictor frater Johannes', in Testa (1996), p. 84 and related illustrations.

11. AODO *Rif.* 10 (1448–57), c. 17r., in Andreani, in Testa (1996), App. I, doc. 100, p. 426. McLellan (1992), vol. I, p. 72 and vol. II, doc. 70, p. 35; Diane Cole Ahl, *Benozzo Gozzoli* (New Haven, 1996), p. 39 and n. 148; and Creighton Gilbert, 'Fra Angelico's Fresco Cycles in Rome: Their Number and Date', *Zeitschrift für Kunstgeschichte* 38, (1975), 259, n. 63.

12. Bernadine Barnes gives a thorough treatment of the Last Judgment tradition in Italy and the spectator's role in the paintings. B. Barnes, *Michelangelo's Last Judgment: The Renaissance Response* (Berkeley, 1998), Ch. I, pp. 7–28.

13. For a nearby precedent, Riess (1988), pp. 247–71 and Riess (1995), pp. 17 and fig. 10.

14. For Michelangelo's judging Christ as merciful, see Marcia B. Hall, 'Michelangelo's *Last Judgment*: Resurrection of the Body and Predestination', *Art Bulletin* 58, no. 1 (spring 1976), 85, 89, and *passim*.

15. For the music for All Saints' Day, including the *Te Deum laudamus*, see *Liber Usualis* (New York, 1961), pp. 1721–32 and *Breviarium Romanum* (Malines, 1876), p. 12. Modern texts concur with all of the fifteenth-century texts that I examined, including *Breviarium Romanum* BAV, Vat. Lat. XIV, 348r.–v.

16. Luzi (1866), pp. 136–46, named all of the figures on the ceiling. Until recently, his suggestions, supported with lines from the *Divine Comedy*, were unchallenged. His precatory language, indicated by conditional and subjunctive verb forms, is not convincing.

17. G. Testa, 'Et vocatur dictas magister pictor frater Johannes', in Testa (1996), p. 73.

18. In 1990, at close range from the scaffold, I noticed Fra Angelico's shop painted all of the ribs, as did McLellan (1992), vol. I, p. 272, and Kanter (1989), p. 6.

19. G. Testa, 'Et vocatur dictas magister pictor frater Johannes', in Testa (1996), pp. 81–82.

20. The Sistine Chapel was also dedicated to the Assumption of the Virgin. The dedication was reaffirmed on All Saints' Day following Michelangelo's completion of a *Last Judgment* on the altar wall. Howard Hibbard, *Michelangelo* (New York, 1974), p. 242.

21. The *Magnificat*, Luke 1:39–56, is the Gospel reading; I Corinthians 15:20–26 is part of the Epistle reading. *The Hours of the Divine Office in English and Latin* (Collegeville, 1964) pp. 1431–49.

22. *Breviarium Romanum* BAV, Vat. Lat. XIV, 348r. The breviary contains the della Rovere coat of arms on 4v. In Orvieto, see AODO ms. 190, also mentioned by Luigi Fumi, ed., *Ephemerides Urbevetanae; Rerum Italicarum Scriptores*, vol. XV, no. V (Città di Castello, 1902–20), p. 300 and n. 3.

23. The time between Fra Angelico and Signorelli is vividly recounted in detail by McLellan (1992), vol. I, pp. 65–100.

24. Piccolomini-Adami (1883), p. 294.

25. In 1441, Nicholas of Cusa came to Orvieto to visit Cardinal Barbo and later established a residence there. In 1463, Orvietans named him Perpetual Governor. Erich Meuthen, *Die Letzten Jahre des Nikolaus von Kues* (Cologne, 1958), pp. 111, 117, 120–21 and the final chapter; and Meuthen, 'I Primi Commendatari dell'Abbazia dei SS. Severo e Martirio in Orvieto', *Bollettino* 10 (1954), 37–39.

26. *Commentaries*, Book IV, cited by Moroni (1852), vol. 49, p. 205; Luigi Fumi, *Statuti e Regesti dell'Opera di Santa Maria di Orvieto* (Rome, 1891), pp. 22–23.

27. Riccetti (1992), pp. 157 and 104; Perali (1891), p. 21. St Faustino was an early Christian drowned by heretics; St Pietro Parenzo was the city governor murdered by Cathars in 1199. For St Pietro Parenzo, see Natalini (1936), p. 124 and *passim*.

28. The central lancet window, installed by Neri Monti di Perugia (1472–73) represented the Virgin dressed in a blue mantle surrounded by angels. AODO *Rif.* 11 (1458–82), 21 December 1471, c. 503r. and AODO *Cam.* (1470–79), 31 October 1473, c. 153v.; in Andreani (1996), docs 149 and 159, p. 430. In 1502, transparent glass replaced it to admit additional light. Ivi *Rif.* 12 (1484–1525), c. 410r.–411r., 8 September 1502, in Andreani (1996), doc. 241, p. 437; McLellan (1992), vol. I, pp. 56–59.

29. Cardinal Pietro Barbo, later Pope Paul II, resided at nearby La Badia and then built a small palace in Piazza dell'Erbe. Other family members also kept close ties to Orvieto. Cardinal Marco Barbo (1487–91) and others stayed in the Abbey of Sts Servio and Martino. Pietro Barbo admired the philosophical works of Nicholas of Cusa. Perali (1891), pp. 128–29; Meuthen (1954), pp. 37–39; and Moroni (1852), vol. 49, pp. 205, 206, 215.

30. Giorgio della Rovere served as bishop of Orvieto from 1476 to 1505. Conradus Eubel, ed., *Hierarchia Catolica Medii Aevi*, vols II and III (Padua, 1960; reprint of Regensburg, 1914), vol. II, p. 260; Fumi, *Statuti* (1891), pp. 103–5.

31. Fumi, *Ephemerides Urbevetanae* (Città di Castello, 1902–20), vol. XV, no. V, pp. 251ff.

32. Pier Matteo d'Amelia was invited to submit a sample of his work, but was not hired; AODO *Rif.* 11 (1458–88), 617r., 20 February 1482, Andreani in Testa (1996), App. I, doc. 177, p. 431. For Pier's ceiling in the Sistine Chapel in the 1480s see Hellmut Wohl, *The Aesthetics of Italian Renaissance Art: A Reconsideration of Style* (Cambridge, 1999), pp. 140–41 and John Shearman, 'The Chapel of Sixtus IV', in Pietrangeli, Chastel, Shearman et al., eds, *The Sistine Chapel: The Art, the History, and the Restoration* (New York, 1986) pp. 22–87, here p. 40.

33. AODO *Rif.* 12 (1484–1525), 29 and 30 December 1489, 186v. and 187r., in Andreani (1996), doc. 181–82, p. 431.

34. Ibid., McLellan (1992), vol. I, pp. 81–84 and E. Hall and H. Uhr, 'Patrons and Painter in Quest of an Iconographic Program: the Case of the Signorelli Frescoes at Orvieto', *Zeitschrift für Kunstgeschichte*, no. 1 (1992), 35–36.

35. AODO, *Mem.* 1484–1500, June 1492, c. 208t, in Fumi, *Il Duomo* (1891), doc. CXV, p. 400; not in Andreani.

36. Archivi del Commune, original letter of 2 June 1492, in Andreani in Testa (1996), doc. 207, p. 433.

37. McLellan (1992), vol. I, pp. 92–100.

38. Luigi Fumi, *Alessandro VI e Il Valentino in Orvieto* (Siena, 1877), introduction, preface and *passim*; McLellan (1992), vol. I, pp. 242–45.

39. The single exception was Clement VII, who sought refuge in Orvieto in 1527 to escape the Sack of Rome. His bull of 1527 denying Henry VIII of England an annulment was the last papal bull issued from the city.

40. Creighton Gilbert, 'Signorelli and the Young Raphael', in James Beck, ed., *Raphael before Rome: Studies in the History of Art*, vol. XVII (1986), pp. 111–12; Vischer (1879), pp. 352–55.

41. Raphael's frescoes, like those of the Cappella Nuova, indicate the involvement of Dominican advisors. Helen Ettlinger, 'Dominican Influences in the Stanza della Segnatura and the Stanza d'Eliodoro', *Zeitschrift für Kunstgeschichte* 46 (1983), 181–82.

3 Tradition and Innovation

1. Funding came primarily from the coffers of the Opera del Duomo. Wills of Achille di Baccio de' Monaldeschi (1494), and Pietroantonio de' Monaldeschi (1495), gave money toward pictures and ornament to the Cappella Nuova. The bequest of the latter may account for the family coats of arms in the *vela* of the vault with the Virgins. These two identical images do not specify the branch of the family. McLellan meticulously clarifies previous misconceptions about funding. McLellan (1992), vol. I, pp. 13–19. Documents: *Rif.* (1484–1526), 29 February 1500, cc. 367r.–367v., in McLellan (1992), vol. II, doc. 360, pp. 164–65; and *Rif.* (1484–1526), July 1505, c. 189v. and *Mem.* (1500–23), c. 52, vol. II, docs 408 and 409, pp. 204–5; not in Andreani.

2. McLellan discusses at length the Perugino saga, McLellan (1992), vol. I, pp. 81–95 and *passim*. *Rif.* (1484–1526), 8 March 1499 in McLellan (1992), vol. II, pp. 151–52, doc. 351 and Andreani in Testa (1996), doc. 217, pp. 433–34.

3. AODO *Rif.* 12 (1484–1526), 5 April 1499, cc. 344r.–345r., recorded in Andreani (1996), docs 218–20, p. 434. McLellan (1992), vol. II, pp. 101–94.

4. Tom Henry, 'The Career of Luca Signorelli in the 1490s', 2 vols (unpubl. Ph.D. diss., University of London, Courtauld Institute, 1996), vol. I, pp. 94–95, 103–5, 145, 161, 170–74, 231, 241 and *passim*.

5. Vasari (1996), p. 614; Vasari (1930), vol. III, pp. 369–70.

6. Cited by Fiorenzo Canuti, *Il Perugino*, 2 vols (Siena, 1931), I: p. 29; Gloria Kury, *The Early Work of Luca Signorelli: 1465–1490* (New York, 1978), pp. 41–42, and Henry, 'Career of Luca Signorelli' (1996), vol. I, pp. 31–32.

7. Vasari–de Vere (1996), pp. 609–10; Vasari–Bianchi (1930), vol. III, pp. 359–60. For an explanation of '*creato*', see Kury (1978), pp. 40–43 and 49–73.

8. Pricked drawings assigned to Signorelli survive. Although the painting for which the *Head of a Man* was prepared has not been identified, the cartoon verifies his use of *spolveri* for transfer. *Head of a Man* (1500–10?), black chalk on paper, pricked for transfer, later overworked with pen and ink, 11 ¾" × 9 ⅝" Robert Lehman Collection, Metropolitan Museum, New York (1975). Hilton Brown, 'Looking at Paintings: Head of a Man by Luca Signorelli', *American Artist* 48 (Nov. 1984), s44–49, and Bernard Berenson, *The Drawings of the Florentine Painters*, 3 vols (Chicago, 1970), vol. III, p. 334. *Kneeling Shepherds* (National Gallery, London, no. 1985–9–15–602), Berenson (1970), vol. II, fig. 97; *Standing Figure* (Louvre, Paris, no. 342), Berenson, vol. II, fig. 103 and vol. III, p. 334; *Madonna and Child with the Infant John the Baptist* (Uffizi, 17820F), Berenson (1970), vol. II, fig. 116 and vol. III, p. 331; and London, British Museum 1860–6–16–93, Berenson (1970), vol. III, p. 332. A drawing associated with *The Resurrection of the Dead* shows *spolveri*. Tom Henry, 'Signorelli, Raphael, and a "mysterious" pricked drawing in Oxford', *Burlington Magazine* 135, no. 1806 (September 1993), 612–19.

9. Signorelli was born *c*. 1450–54. Kury (1978), p. 49. Vasari implies that age was a factor in Signorelli's return to his workshop in Cortona and his reduced commissions for frescoes. 'Finalmente, avendo fatte opere quasi per tutti i principi d'Italia, ed essendo già vecchio, se ne tornò a Cortona, dive in que suoi ultimi anni lavorò più per piacere che per altro, come quello che avvezzo alle fatiche non poteva nè sapeva starsi ozioso.' Vasari–Bianchi (1930), vol. III, p. 366. Signorelli worked in fresco for Pope Julius II in the Vatican Stanze (destroyed) and in Siena *c*. 1509 for Pandolfo Petrucci (two detached fragments of mythological subjects survive in the National Gallery, London) after Orvieto. Henry, 'Career of Luca Signorelli' (1996), vol. I, p. 288; Tom Henry and Laurence Kanter, *Luca Signorelli: The Complete Paintings* (New York, 2002), pp. 224–25.

10. Hannelore Glasser, *Artists' Contracts of the Early Renaissance* (New York, 1977), p. 76 and Michael Baxandall, *Painting and Experience in Fifteenth Century Italy: A Primer in the Social History of Pictorial Style* (New York, 1972), p. 23.

11. Leonardo da Vinci recommends the single-field compositions in his treatise on painting, stating that stacking frescoes was irrational. Martin Kemp, ed., *Leonardo On Painting* (Yale, 1989), pp. 217–18.

12. Theological advisors to Michelangelo and other artists; see O'Malley (1986), pp. 102–7; Esther Gordon Dotson, 'An Augustinian Interpretation of Michelangelo's Sistine Ceiling', parts II and I, *Art Bulletin* 61 (1975), 223–56; 405–29; and James Beck, 'Cardinal Alidosi, Michelangelo, and the Sistine Ceiling', *Artibus et Historiae* 11 (1990), 63–77.

13. Leopold D. Ettlinger, *The Sistine Chapel before Michelangelo: Religious Imagery and Papal Primacy* (Oxford, 1965), *passim*; Lewine (1993), p. 5 and *passim*. The program also has been shown to demonstrate the Franciscan spirituality of Pope Sixtus IV. Although Sixtus was a noted theologian, this virtue was not a prerequisite for election to the Renaissance papacy. Rona Goffen, 'Friar Sixtus IV and the Sistine Chapel', *Renaissance Quarterly* 39, no. 2 (Summer 1986), 218–62.

14. Nicole Dacos, *La Découverte de la Domus Aurea et la Formation des Grotesques à la Renaissance* (Leiden, 1969); N. Dacos, 'Con ferrate e spiritelle', in Testa (1996), pp. 223–32, and Wohl (1999), ornate classical style, pp. 125–52.

15. Vasari–Bianchi (1930), vol. III, pp. 295 and 359–60. Scholars generally agree that they collaborated on the Uffizi *Crucifixion* panel of 1480; Maude Cruttwell, *Luca Signorelli* (London, 1901), p. 20; Luitpold Dussler, *Luca Signorelli* (Stuttgart, 1927), p. 151; Kury (1978), pp. 103–16.

16. Fumi, *Orvieto* (Bergamo, 1919), p. 115, cites Balbo. Also, Chapter 4 below.

17. Henry, 'Career of Luca Signorelli' (1996), vol. I, pp. 97–108 and *passim*; Henry and Kanter (2002), pp. 173–74.

18. *c*. 1490–91; Henry, 'Career of Luca Signorelli' (1996), vol. I, pp. 105–6.

19. Noted also by Henry in ibid., p. 161.

20. Ibid., pp. 232–33.

21. E. H. Gombrich, *Norm and Form*, 4th edn (Chicago, 1985), pp. 55–57; and David Summers, *Michelangelo and the Language of Art* (Princeton, 1981), pp. 250–61.

22. Summers (1981), pp. 250–51.

23. Influence of Pollaiuolo: Mario Salmi, *Luca Signorelli* (Florence, 1927), p. 33 and Cruttwell (1901), *passim*.

24. Pope Pius II (whose family were patrons) visited in 1462, and praised its fine furnishings. Pius

II, *Memoirs of a Renaissance Pope: The Commentaries of Pius II*, ed. and intro. Ruth O. Rubenstein, trans. Florence A. Gragg (New York, 1959), book X, p. 293.

25. Ghiberti employed this method in his *Gates of Paradise* for the Florence Baptistery (1425–52) and Signorelli used it in the Sistine Chapel and at Monteoliveto Maggiore. For continuous narrative, see Lew Andrews, *Story and Space in Renaissance Art* (Cambridge, 1995). For space, see Sven Sandström, *Levels of Unreality: Studies in Structure and Construction in Italian Mural Painting during the Renaissance* (Uppsala, 1963). For arrangements of frescoes, see Marilyn Lavin (1990), especially pp. 6–10 and 229–32. See also Wohl (1999), *passim*.

26. Signorelli began in autumn 1498 and probably left for Orvieto in March 1499. Henry, 'Career' (1996), vol. I, pp. 243–50; Kanter (1989), pp. 72–115, believes Signorelli returned and finished his work in 1501. Sodoma, who painted the remaining three walls (1505–8), incorporated Signorelli's paintings into his narrative chronology.

27. Personally observed in1992; also noted by Henry, 'Career' (1996), vol. I, pp. 279–82.

28. Kury alludes to the concentration on the male figure but does not probe the reason. Kury (1978), pp. 228, 246, and 251, n. 56. Marianne Kline Horowitz, 'Aristotle and Women', *Journal of the History of Biology* 9, no. 2 (1976), 183–213, discusses the Aristotelian idea of the superiority of the male body, and its influence on art. She does not illustrate her argument with Signorelli.

29. AODO *Rif.* 12 (1484–1525), c. 371v., 23 April 1500, recorded in Andreani in Testa (1996), doc. 225, p. 435.

30. Andrew Martindale, 'Luca Signorelli and the drawings connected with the Orvieto Frescoes', *Burlington Magazine* 103 (June 1961), 216–20; Berenson, (1970), vol. I, p. 42.

31. Paris (Louvre, no. 347); copy, Florence (Uffizi, no. 34F). Berenson (1970), vol. II, figs 100 and 102, and vol. III, pp. 331 and 334. For more detail on drawings associated with the frescoes, see Claire van Cleve, 'I disegni preparatori', in Testa (1996), pp. 241–51 and T. Henry, 'I cartone', in Testa (1996), pp. 253–67.

32. Leon Battista Alberti, *On Painting*, trans. with intro. by John R. Spencer (New Haven, 1966), p. 74.

33. Uffizi, Florence, no. 1246E.

34. Windsor Castle; London, British Museum no. 1946.7.13.10; Paris, Louvre, no. 1794.

35. The sketches were first discovered and published in 1941 after a scaffold was erected and the frescoes were viewed at close range for the first time in many years. Achille Bertini Calosso, 'Designi tracciati ad affresco da Luca Signorelli nel Duomo di Orvieto', *Rivista d'Arte* 23, nos 3–4 (1941), 195–202; van Cleve in Testa (1996), pp. 249–50. I was able to study them from the scaffold in the 1990s.

36. Details of payment in McLellan (1992), vol. I, pp. 147–61.

37. Archivi del Commune, original letter of 14 April 1504, in Andreani in Testa (1996), doc. 254, p. 438.

38. AODO, *Rif.* 12 (1484–1526), 5 April 1499, c. 345r. in Andreani in Testa (1996), doc. 220, p. 434, and 25 November 1499 c. 360r., in Andreani in Testa (1996), doc. 223, pp. 434–35.

4 In Festo Omnium Sanctorum

1. For the contract and two other preliminary documents of the same date: AODO *Rif.* 12 (1484–1526), 5 April 1499, c. 344r.–345r., in Andreani (1996), pp. 219–20, docs 218–20, p. 434. McLellan gives details of the commission and documents. McLellan (1992), vol. I, pp. 101–37; vol. II, pp. 161–63.

2. D. Ahl, *Benozzo Gozzoli* (New Haven, 1996), p. 38, makes a convincing case for Fra Angelico having left *sinopie* drawings on the plaster.

3. C. Via, 'Signum inducium indicantia: Riflessioni sul programma iconologio della Cappella Nuova', in Testa (1996), p. 171, mentions the Virgin as intercessor, but does not tie the imagery to either the Deësis or the liturgy. For the Deësis in Last Judgments reflecting the Feast of All Saints, see L. B. Philip, *The Ghent Altarpiece and the Art of Jan van Eyck* (Princeton, 1971), pp. 78–79. For a Last Judgment Deësis in a chapel dedicated to the Assumption, the relationship of the Assumption to the Resurrection and the intercessory role of the Virgin, see Barnes (1998), pp. 62–66. Although Deëses appear less often in the west than in Byzantine programs, they appear in Last Judgments by Pietro Cavalini at S. Cecilia Trastevere in Rome (*c.* 1290) and Fra Angelico's San Marco (*c.* 1431) and Barberini (1450–55) altarpieces.

4. St Paul replaces Judas Iscariot in Byzantine compositions depicting the apostles after the Crucifixion. He appears with Sts Peter in the *Communion of the Apostles*, an apocryphal heavenly scene frequently found in Byzantine chancels. This pair of papal surrogates often lead the

apostles; for example, the south porch of Chartres Cathedral (*c.* 1225) and Fra Angelico's San Marco and Barberini *Last Judgment* altarpieces. Their feast day is celebrated together on 29 June.

5. The fourth-century Eucharistic prayer, Roman Rite I, is regularly recited at daily Mass and on feast days. Lassance and Walsh, eds, *The New Roman Missal* (New York, 1945), p. 778. Luzi (1866), pp. 146–49, identifies the apostles as in the prayer (which he does not cite). He does not name St Paul, but calls him 'the Apostle to the Gentiles'.

6. Verses 1, 2 and 4 of 'Alma cunctorum celebremus omnes', in Ulysse Chevalier, *Poésie Liturgique du Moyen Age: Rythme et Historie Hymnaires Italiens* (Paris, 1893, reprinted by Geneva, Slatkine Reprints, 1997), pp. 211–12. The hymn concurs with the saints in the north bay. Verses 5–7 address Patriarchs, Martyrs and Virgins, and verses 5–9 plead the intercession of all of the saints. Verse 10 concludes with a *Gloria Patri*.

7. Signorelli's contract: AODO *Rif.* 12 (1484–1525), 25 November 1499, *c.* 36or., recorded in McLellan (1992), vol. II, doc. 358, pp. 161–62; Luzi (1866), p. 470; Serafini, doc. 63, 25 November 1449 [*sic*], pp. 122–23; and Vischer (1879), pp. 348–9; and slightly abbreviated in Fumi (1891), doc. CLVIII, p. 408 and Andreani in Testa (1996), doc. 223, pp. 434–35. Because of the unique nature of the document, I believe that it is useful to quote it here in English translation:

25 November 1499.
In the name of God, Amen. In the year 1499, the third in the time of Pope Alexander VI, the 25th day of the month of November, called into session by the decree of Placidi Oddi, treasurer of the Fabrice [the governing board of the cathedral], Peregrino Lazari, Ser Barnabutio Paulis pictoris, and Toma Octaviani Conservatoribus, Johanne Ludovico Nalli Benincasa, Johanne Bernabei Superstites etc. Lanzilotto Spere, Marchisino Gasparis. – City of Orvieto.
In the presence of the honorable lord Conservators, Supervisors and citizens, etc., the treasurer made the motion written below which bears on the present and is very profitable and necessary in the said building, that is:
First, whereas Master Lucas of Cortona, honorable painter, was contracted to paint and finish the new chapel of the Church of Santa Maria Maggiore in Orvieto, of which new chapel half had a design [*designum*] already given by the reverend man, brother Giovanni, who began to paint the said new chapel. And now the said design is finished, and there exists no design for the other half; and in the said contract for it the said Master Lucas undertook to make or to paint in the said chapel, according to the designs that would be made for the same chapel. Which designs he now requests be given to him so that he can get on with his work. About which proposal your honest and profitable advice is asked for, and what you think should be done.
The respected gentleman Giovanni Ludovico Benincasa, one of the said Supervisors of the said building, rising to his feet with the intention of offering his opinion, having first called upon the names of Almighty God and his mother, the Virgin Mary, spoke and gave his advice about the said proposal. That the work on the said new chapel continue, and that it be done and be painted in the said chapel according to the decisions made orally on other occasions by the venerable Masters of the Sacred Pages of this city. And let it proceed, provided that it not depart from the materials (theme) of the [Last] Judgment. When this had been said the vote was taken and beans were given and returned and counted, as was customary, there were found [to be] 14 black beans for 'yea'; against, no white bean was found for 'nay'.

The translation of the first paragraph is mine. Professor Mark P. O. Morford of the Department of Classical Literature of the University of Virginia graciously provided the translation of the document as recorded in Fumi.
Concerning the vote of beans: 'fuit obtentum per fabas nigras quatuordecim de(l) sic nulla alba in contrarium reperta de non' (not recorded identically in Andreani), Father Justin Cunningham, O.P. says that the Dominican tradition of voting in beans continues: black is nay and white is yea, the reverse of what is recorded here. Perhaps the reversal reflects an inadvertent error by the fifteenth-century secretary.
Since its inception, the Dominican Order was strong at Orvieto, partially because of papal interests there. For additional information concerning the Masters of the Sacred Page, see Smalley (1964), Chapters V–VI, pp. 196–355.

8. In addition to governing affairs of the cathedral, the members exerted substantial influence in city politics. Edwin Hall and Horst Uhr, 'Patrons and Painter in Quest of an Iconographic Program: The Case of the Signorelli Frescoes at Orvieto', *Zeitschrift für Kunstgeschichte* I (1992), 36–37, confirmed by dott. Lucio Riccetti, social historian and former archivist at OPSM, Orvieto, in conversation July 1992 and May 2001.

9. For artists' contracts and Signorelli's being the first to record theological advisors, see Hannelore Glasser, *Artists' Contracts of the Early Renaissance* (New York, 1977) and Mario (1990), p. 585.

10. The idea of artists receiving unwritten theological advice is not new. Scholars believe theologians advised Michelangelo. O'Malley (1986), pp. 102–7; E. G. Dotson, 'An Augustinian Interpretation of Michelangelo's Sistine Ceiling', parts II and I, *Art Bulletin* 61 (1975), 223–56 and 405–29; and James Beck, 'Cardinal Alidosi, Michelangelo, and the Sistine Ceiling', *Artibus et Historiae*, 11 (1990), 63–77.

11. Hibbard (1974), pp. 101–5. Drawings of 1508 for preliminary ideas for the ceiling include a black

chalk one at the British Museum in London, and a pen and chalk one in the Detroit Institute of Arts.

12. For Masters of the Sacred Page, see Lesley Smith (2001), pp. 1–39; Smalley (1964), Ch. V and p. 271. In 1227, Gregory IX confirmed the *studium generale* in Orvieto, one of the first schools of theology in Europe. Moroni (1852), vol. 49, p. 212; Piccolomini-Adami (1883), pp. 220–22. The institution at Orvieto was two years older than the prestigious one in Paris at St Jacques, established in 1229. Smalley (1964), p. 264. In the 1930s, Mussolini destroyed the nave of S. Domenico, once the largest church in the city, along with the *studium*, to make space for a military school.

13. Among scholars supporting Albèri's involvement as advisor are Riess (1995); Testa and Davanzo, 'Vicende della decorazione problemi di committenza e piani iconografi', in Testa (1996), p. 40: 'Se è vero ciò che dice il Balbo, che a mezzo il secolo XVI, nel duomo di Orvieto, come a Santa Maria di Fiore, si leggesse e si commentasse la *Commedia*, si può pensare quanto giovasse la tradizione del culto dantesco ad infiammare l'umanista Albèri, arcidiacono orvietano, lettore nello studio perugino e maestro di Pio III, di quella tradizione sapiente interprete accanto al Signorelli.' See also L. Fumi, *Orvieto* (Bergamo, 1919), p. 115, citing Balbo and Tommaso di Silvestro, *Diario 1482–1514*, ed. L. Fumi, in *Ephemerides Urbevetanae:Rerum Italicarum Scriptores*, 15, pt 5/11 (Città di Castello, 1902–20), p. 231. McLellan argues against Albèri's leadership and in favor of advice from the Camerlengo and members of the Opera (Soprastanti). McLellan (1992), vol. I, pp. 140–45, 261–68 and vol. II, pp. 1–2 and 154, nn. 1–2. The Camerlengo held office for one year. During Signorelli's period Placido Oddi, Nicolò Angeli and Teodoricho Petri Pauli (1500–1501) who kept no records, were among these officers. The frequent change in command, coupled with the lay education of these men, when considered in light of the dense iconography – not to mention the document invoking the authority of theologians – all conflict with McLellan's opinion.

14. Perali (1919), pp. 128, 157.

15. Pius III earned his degree in Perugia. Giuseppe Bernetti, ed., *I Commentari Pio II*, 5 vols (Siena, 1972), vol. II, p. 22. See also Chapter 2 for local humanists.

16. Moroni (1852), vol. 49, pp. 205–7, 215 and vol. 71, p. 117; appointed bishop on 11 November 1503, Silvestro in Fumi (1902–20), pp. 231, 235, 300–301. Conradus Eubel's meticulous record of medieval bishops includes Albèri, but does not specify his membership in a religious order, as was his custom. Conradus Eubel, ed., *Hierarchia Catolica Medii Aevi*, 3 vols (Regensberg, 1914; reprinted Padua, 1960), vol. II, p. 244 and vol. III, p. 306.

17. Silvestro in Fumi (1902–20), pp. 231, 235, 266, 300–301 and 300, n. 2; Fumi, *Orvieto* (Bergamo, 1891), p. 115. See also A. A. Strnad, 'Francesco Todeschini-Piccolomini: 'Politick und Mäzenatentum im Quattrocento', in *Sonderdruck die Römische Historiche Mitteilungen*, 8–9 (1964–66), 137–38; 396–97 and Riess (1995), pp. 12, 21–22.

18. Andreani (1996), doc. 261, p. 438; James (1994), pp. 216–29, 335, 367–68 and Creighton Gilbert, 'La libreria dell'arcidiacono Albèri', in Testa (1996), pp. 307–19.

19. Riess (1995), pp. 123–24, links the library iconography to the Cappella Nuova.

20. Several of Albèri's liturgical books rest in the Archives of the Opera del Duomo, Orvieto, including AODO mss. C1 and 187–90. Ms. C1 contains Albèri's *stemme*; ms. 190 is signed on the verso of the last page in the codici corali illuminati di Antonio Albèri: 'Iste liber illuminatus est per me fratrem Valentinum de ungaria, ordinis predicatorum', Tommaso di Silvestro cites the provenance of the manuscript. Silvestro, *Diario*, in Fumi (1902–20), p. 300, n. 3. The book is one of four unsigned manuscripts of similar size and illumination style (AODO mss. 187–90). They may also have been the work of the same friar for Albèri. Mss. 187 and 188 are graduals; Mss. 189 and 190 appear to be a pair of service books as well, labeled *alingua officia propria*'. Ms. 190, a choral book, contains extensively illuminated pages for the feasts of Dominican saints Peter Martyr (conflated perhaps with the Orvietan saint of the same name) and Thomas Aquinas, 24v. and 134v. respectively.

21. AODO Ms. C1, pp. 305r.–316v.

22. Fumi, *Il Duomo* (1891), p. 369 supported by AODO, *Rif.* 12 (484–1527), 25 November 1504, c. 425r., doc. CLXX, p. 410, also recorded in Andreani in Testa (1996), doc. 261, p. 438.

23. Lesley Smith (2001), p. 25 for the training of a '*magister in sacra pagine*'.

24. E. Paoli, 'Il programma teologico-spirituale del Giudizio Universale di Orvieto', in Testa (1996), pp. 66–67, especially n. 19; Strnad (1964–66), pp. 137–38 and 396–97; Piccolomini-Adami (1883), p. 226.

25. Dom Gaspar Lefebvre, O.S.B., *Saint Andrew Daily Missal with Vespers for Sundays and Feasts* (St Paul, 1952), p. 1653; Voragine (1993), vol. II, pp. 272 and 280.

26. Explanation opening the liturgy for All Saints' Day. Lefebvre (1952), p. 1653.

27. The *Te Deum laudamus* consistently occurs in liturgical texts for the Feast of All Saints from at least the fourteenth century (the oldest manuscript I have examined) to the present. 'Codici corali', AODO (unnumbered 14c), p. 285v. *Breviarium Romanum* (Venice, 1565), 363 r.&v.; Joannis

Thomae de Boxadors, ed., *Collectarium Sacri ordinis FF. Praedicatorum auctoritate apostoloca*, Jussu editum (Rome, 1757), p. 350v., Benedictines of Solesmes, eds, *The Liber Usualis* (New York, 1961), p. 1724.

28. Philip (1971), p. 36, n. 66 and p. 106, n. 215. At Orvieto, two groups must be omitted for lack of space. The Judges and Knights (merciful) and the Hermits and Pilgrims (meek) are expendable to both the liturgical structure and the correspondences. Moreover, neither group is a part of the chronicle mentioned by Philip, above. The groups are not mentioned in AODO ms. C1, pp. 305r.–316v.

29. 'Codici corali' (AODO, 14c unnum.), 272r. The book is not signed or dated. The hymn appears in the liturgy for All Saints in *Breviarium Romanum, manuale corale* (BAV, S. Maria Maggiore 100, Rome, 1527), p. cixr.; *Breviarium Romanum Venetiis*, p. 361r.; *Collectarium Sacri ordinis FF. Praedicatorum auctoritate apostoloca*, Jussu ed. (Rome, 1757), 348r.; and *The Liber Usualis* (1961), pp. 1653–54; 1721–22.

30. AODO, ms. C1, pp. 305r.–316v. The liturgy for the Feast of All Saints includes sixteen hymns that give homage to martyrs, confessors, virgins, and doctors of the church. Many of these hymns do not appear in any other liturgical book that I have consulted. Ms. C1 is unsigned and undated, but Antonio Albèri's *stemma*, along with the style, would indicate a late fifteenth-century date. Note also that Orvieto had a liturgical drama for the Feast of All Saints. De Bartholomaeis (1943), vol. I, pp. 408–16.

31. The All Saints' hymns *Jesu salvator saeculi* from AODO ms. C1, 306r.–307v., *Exultet celum laudibilis resultet*, 307r.–307v. *Eiterna Christi munera apostolorum gloriam laudes*, 308r.–308v. praises the apostles and invokes their intercession. The judgment theme with John the Baptist also concurs with Advent texts, which govern the choice of scenes on the north walls. The second Sunday in Advent honors the Baptist: Matthew 3:1–12 or Mark 1:1–8. The Epistle, II Peter 3:8–18, also speaks to the Second Coming of Christ.

32. Voragine (1993), vol. II, p. 279.

33. De Bartholomaeis (1943), vol. I, pp. 407–20, especially pp. 407–11.

34. De Bartholomaeis (1943), vol. I, pp. 407–20 and Gina Scentoni, ed., *Laudario Orvietano*, preface by Maurizio Perugi (Spoleto, 1994), pp. 409–23. All plays in the Orvietan cycle are written in rhymed Italian verse, eight lines to a stanza. The initial rubric identifies the play as originating in the second half of the trecento (1350–) and as a troped Mass, which would have been sung. De Bartholomaeis (1943), pp. 331–36 and Perugi in Scentoni (1994), pp. ix–xv. Before the thirteenth century, liturgical dramas were written in Latin. Dr Fletcher Collins, Jr in conversation and notes, May 2000. The editors make no mention of music, and I know of no musical scores for any of the Orvietan dramas.

35. McLellan (1992), vol. I, p. 277, recognizes the Old Testament/New Testament and pagan/ Christian typologies, but does not connect them to liturgical practice.

36. *Jesu salvator saeculi* by Rabanus Maurus (776–856) was used for Lauds at the Feast of All Saints. AODO, ms. C1, 306r.–307r. Verses 1–6 transcribed in Aquinas Byrnes, O.P., ed., *Hymns of the Dominican Missal and Breviary* (London, 1943), hymn 89, pp. 324–27; verses 1–4 appear here. Other often-used hymns for the feast of All Saints also recount the groups of saints:

Christe redemptor omnium/ conserua tuos famulos,/ Beate semper Virginis/ Placatus sanctis precibus./ Beata quoque agmina/ Cælestium Spirituum,/ Præterita, præsentia,/ Futura mala pellite./ Vates æterni Judicis,/ Apostolique Domini,/ Suppliciter exposcimus/ Salvari vestris precibus./ Martyres Dei inclyti,/ Confessoresque lucidi,/ Vestris orationibus/ Nos ferte in cælestibus./ Chori sanctarum Virginum,/ monachorumque omnium,/ Simul cum Sanctis omnibus/ Consortes Christi facite. AODO ms. C1, pp. 305r.–306v. and AODO 14c. 'Corale', unnum. ms, p. 273r.

This hymn is ascribed to Rabanus Maurus and is transcribed by Byrnes (1943), hymn 90, pp. 327–30.

37. Luzi (1866), pp. 149–53; Hall and Uhr (1992), pp. 44–45, calls the beardless youth positioned in the upper center 'Eve' because of the blue robe (which seems no different from the others), and lack of beard. I believe a female figure would never appear in a group labeled Patriarchs, or Fathers.

38. Vespers for the Common Commemoration of Saints, *Liber Usualis*, pp. 261–62. The AODO ms. C1, pp. 312r.–312v. calls them confessors but does not name individuals. Luzi (1866), pp. 153–58, connects the doctors with Dante in *Paradiso* XXXI.

39. Thomas Aquinas was canonized in 1323 and made a doctor of the church in 1567; Bonaventure was canonized in 1482 and declared a doctor in 1588; Francis, canonized in 1228, still is not a doctor of the church; Pius III was neither canonized nor a declared doctor of the church. St Anthony of Padua was declared a doctor of the church in 1946. Delaney, *Dictionary of Saints* (New York, 1980), pp. 63, 110, 181, 234–35, 552–53.

40. Luzi (1866), pp. 159–61, names all the figures, but in doing so, he uses 'credere potrebbesi …'

and other subjunctive forms. The martyrs are lauded in four hymns for All Saints' Day in the AODO ms.C1, 309v.–311r.

41. AODO ms. C1, 314r.–135r. contains two hymns praising the Virgins.

42. Luzi (1866), pp. 162–5, tentatively identifies all the women, using precatory language to tie them to various well-known virgin saints.

43. Kaftal lists Mary Magdalene as an Early Christian virgin. G. Kaftal, *The Iconography of the Saints in Italian Painting from its Beginning to the Early Sixteenth Century*, 3 vols (Florence, 1952), vol. I, p. 1198 and figs 809–12. She is named first among the virgin saints, after the Virgin Mary, in the litany. Mary Magdalene routinely appears among the virgins in paintings of the 'Virgo inter Virgines'.

44. Kaftal (1952), vol. I, p. 1198 and figs 809–12, notes that Mary Magdalene is the only female saint to carry an ointment jar. The basis for her attribute rests in scripture and in *The Golden Legend*. Scripture names her three times: Jesus cast seven demons from Mary Magdalene, Luke 8:2; she was present at the Crucifixion and the burial of Christ, Matt. 27:55–61, Mark 15:40–47; all of the Gospels name her on Easter morning as one who carried ointment to Christ's tomb. She was the one to whom Christ appeared first. John 20:1–18; Matt. 28:1–10; Mark 16:1–11; Luke 24:10; John 20:1–18. Pope Gregory the Great (540–604) is the first to conflate several women in the New Testament, some named Mary, some unnamed, into the persona of Mary Magdalene. Latin Church Fathers (but not Greek) and Jacobus Voragine followed this identification. Sarah Blake Wilk [McHam], 'The Cult of Mary Magdalene in Fifteenth Century Florence and its Iconography', *Studi Medievali*, vol. 26, ser. 3, no. 2 (1985), pp. 685–98, pp. 685–86 and n. 2. Voragine, in *The Golden Legend* account of Mary Magdalene, calls her a reformed adulteress. He conflates Mary of Bethany, sister of Martha and Lazarus, and the one who anointed Jesus with perfume and wiped his feet with her hair, John 11:1–8, with an unnamed penitent woman who anoints Jesus in the home of a Pharisee (location unmentioned), washes his feet with her tears, and dries them with her hair. Luke 7:36–50. Second, Voragine cites an unnamed penitent woman with an alabaster jar of costly ointment who anointed Christ's head at Bethany in the home of Simon the Leper, Matt. 26:6–13 and Mark 14:3–9. For Mary (never called Magdalene) as the sister of Martha, Luke 10:38–42; John 11:1–44 includes Lazarus. Voragine (1993), vol. I, pp. 374–83. AODO ms. C1, pp. 4r.–4v. supplement, contains a hymn for the feast day of Mary Magdalene that specifies that Lazarus is her brother.

45. In medieval art and drama, Mary Magdalene wears the clothing of a prostitute, following the account in *The Golden Legend*. For a description, see Fletcher Collins, Jr, *The Production of Medieval Church Music Drama* (Charlottesville, 1972). 'Something of her voluptuous sexuality is expressed in … her long hair', p. 163; 'Her [red] costume is described as *"habitu meritricio"*, the dress of a whore', p. 160; see also p. 162. Mary Magdalene appears in the rear of the group of hermit saints in the *Ghent Altarpiece* (the Virgins carry palms of martyrdom). Dressed in a red cloak without a veil, exposing long golden curls, she clutches in her left hand an ointment jar with a pointed lid.
 Her image as a reformed prostitute became more fixed in the thirteenth century. S. Haskins, *Mary Magdalen: Myth and Metaphor* (New York, 1993), pp. 134–35; 192–95. She was the paradigm example of a converted sinner, especially in the West. M. La Row, 'The Iconography of Mary Magdalen' (unpubl. Ph.D. diss., New York University, 1982), pp. xxi, xxvi. Her tears, apparent in the painting at close range, and her hair, used to dry Christ's feet, are mentioned in hymns for her feast day, including 'Lauda mater ecclesia' and 'Nardi Maria pythici'. AODO ms. C1, pp. 5v.–6v. The texts emphasize her contrition, grace received, and important place in heaven. Other traditional hymns, 'Maria castis osculis', ascribed to Pope Gregory the Great (540–604), and 'Summi Parentis luce' by St Odo of Cluny (879–942), emphasize her contrition and allude to her former life of sin. C. Mulcahy, ed., *The Hymns of the Roman Breviary and Missal* (Dublin, 1938), pp. 171–72.

46. Voragine (1993), vol. I, p. 380.

47. Thomas Aquinas, *Summa Theologica*, trans. Fathers of the English Province (New York, 1947), II-II Q.152. A.3, pp. 1807–8.

48. D. McLellan, *Signorelli's Orvieto Frescoes: A Guide to the Cappella Nuova of Orvieto Cathedral* (Perugia, 1998), p. 60.

49. AODO *Cam.* dal 1501–16, c. 149r. 5 December 1504. 'Item rettulit solvisse dicte magistro Luce pro pictura cappelle Sancte Marie Matalene intergranum vinum et alias expensas et salarium …' McLellan (1992), doc. 405, vol. II, pp. 203–4 and Andreani (1996), doc. 262, p. 438; not included in Fumi, *Il Duomo* (1891). In Andreani, this document follows four that discuss the celebration of the feast of Mary Magdalene, and proposing the paintings of the Magdalene. Andreani (1996), docs 255–60, p. 438. The hymn 'Lauda mater ecclesia' mentions that she is the sister of Lazarus. AODO ms. C1, 4v.–5v. For a description of the original decoration see Giusi Testa, 'La cappellina dei Corpi Santi e la cappellina della Maddalena', in Testa (1996), pp. 269–75.

50. Riess (1995), p. 34 and W. H. Bonniwell, *History of the Dominican Liturgy: 1215–1945*, 2nd edn (New York, 1945), p. 220. Dominicans were keepers of her relics. Dominican ties to Mary Magdalene appear throughout the scholarship of Haskins (1993), p. 147; La Row (1982), pp. 144, 147–48 and 172; and Wilk (1985), pp. 685, 687,691–98.

51. For the altarpiece and identity of the friar, see Haskins (1993), pp. 135 and 147–49. The Cathars viewed Mary Magdalene as the concubine of Christ. Perhaps the Orvietan revulsion for the Cathar heresy may have played a part in the prominence of Mary Magdalene in the chapel.

52. AODO, ms. C1, supplement, 4v.–4r. 'Lauda mater ecclesia lauda Christi clmenentia ... In uas translata gloriae. De uase contumelie.'

53. They are paired by way of the Tireseas legend. See R. Copeland, *Rhetoric, Hermeneutics, and Translation in the Middle Ages* (New York, 1991), p. 123, and C. de Boer, M. de Boer, and J. van't Sant, 'Ovide moralisé', in *Verhandelingen der Koniklijke Nederlandse Akademie van Wetenschappen*, afd. Letterkunde 98 vols (Amsterdam, 1915), vol. XV, Book 3, lines 1273–91.

54. See also Rubin (1991), *passim*.

55. AODO, *Rif.* 12 (1484–1527), 6 January 1500, 363v.–364r., in Andreani (1996), doc. 224, p. 435; see also Hall and Uhr (1992), p. 41.

56. Signorelli received final payment for the vaults between 27 April and late June of 1500. For documents from Orvieto, see, citing AODO, *Rif.* 12 (1484–1526), 23 April 1500, c. 371v. and 27 April 1500, 372r.–373r., in Andreani (1996), docs 225–26, p. 435; Vischer (1879), pp. 349–53, includes Orvietan documents as well as documentary evidence that Signorelli was in Cortona in February.

57. My discussion follows the liturgy, not the sequence of execution. For the sequence, see Laurence Kanter, '... da pagarsi di tempo in tempo secundo el lavoro che farà ...', pp. 95–132, in Testa (1996), pp. 95–134. Dr Kanter graciously shared an unpublished manuscript of 1998, revised and updated from his 1996 article. Based on his observations and those of restorer Carla Bertorelli, he established that Signorelli began with *The Torture of the Damned* followed by *The Resurrection of the Dead*. *The Rule of the Antichrist* and *Doomsday* were the last wall paintings.

58. L. Marchetti, 'L'architettura dipinta: da un ambiente gotico a uno apazio rinascimentale', in Testa (1996), pp. 151–63, discusses illusion and linear perspective.

59. Antonio Paolucci, 'La rappresentazione teatrale di Luca Signorelli', in Testa (1996), pp. 135–45. The author ties Signorelli's paintings to theatricality and sceneography, but not to contemporary liturgical dramas in form, spirit or script.

60. Flanigan (1974), p. 265 and Pascal (1941), pp. 379–80.

61. Although this division is unusual, Nardo di Cione makes the same differentiations in his Last Judgment in the Old Strozzi Chapel at S. Maria Novella in Florence. In Nardo's one-bay chapel, Heaven and Hell face each other on the side walls, and Paradise and the Condemnation of the Wicked flank the altar.

62. 2 Peter 2:9; for further confirmation, Luke 16:19–31 and Romans 8:23.

63. 'They count it a pleasure to revel in the daytime ... For if, after they have escaped the defilements of the world through the knowledge of our Lord and Savior Jesus Christ, they are again entangled in them and overpowered, the last state has become worse for them than the first', 2 Peter 2:13, 14 and 20.

64. For the Archangel Michael and angel warriors at the End-time, see Revelation 12:7ff. For armor to ward off evil and its symbolic meaning, see Ephesians 6:11–17.

65. The central Assumption window and the two flanking it were reglazed in 1502, but exactly when that occurred is uncertain. McLellan (1992), vol. I, pp. 34–44; vol. II, docs 373, 386 and 390, pp. 180–81, 194, 196. See also Chapter 2, note 28.

66. Previously Uriel has been identified as either Michael or Gabriel. The scripture, Enoch 20:2 and II Esdras 4:1, confirms my reidentification.

67. Della Valle (1791), pp. 209–10; 212; S. Brizio d. 444 (or Brice), Delaney (1980), p. 118; the cult of Constantius of Bernocchi was confirmed in 1811; ibid., p. 159.

68. Meiss ties Signorelli's egg to Resurrection iconography: M. Meiss, '*Ovum Struthionis*: Symbol and Allusion in Piero della Francesca's Montefeltro Altarpiece', and Meiss and Theodore Jones, 'Once Again Piero della Francesca's Montefeltro Altarpiece', *Art Bulletin* 36 (1954), 221ff. and 48 (1966), 203–6, both reprinted in *The Painter's Choice* (New York, 1976), pp. 105–29 (especially pp. 114–15) and pp. 130–47. Gilbert cites Durandus (d. 1296) as a source. Creighton Gilbert, 'The Egg Reopened Again', in *Art Bulletin* 56 (1974), 252–58, here 253–54. See also Via, in Testa (1996), p. 171.

69. The Cappella Nuova houses tombs of Cardinal Filippo Gualtiero, Cardinal Muratori, Cardinal Ludovico Anselmo Gualtiero, Cardinal Carlo Gualtiero, and Cardinal Nuzzi; Moroni (1852), vol. 49, p. 204.

70. McLellan (1992), vol. I, p. 33 and n. 82.

5 *Adventus*

1. Whereas Last Judgments occur often in murals, depiction of the Apocalypse is rare. For example, the baptistery in Padua contains the Vision of St John from the Book of Revelation (Guisto de' Menabuoni, *c.* 1378), but the frescoes bear no resemblance to Signorelli's in style or iconography. Nardo di Cione's *Last Judgment* in the Old Strozzi Chapel at S. Maria Novella in Florence (*c.* 1355) contains Judgment, Heaven, and Hell with Purgatory (an unusual feature), but no apocalyptic vision. The Antichrist figure appears in the large Last Judgment in the Campo Santo in Pisa (1330s), but no other apocalyptic stories appear. See J. Polzer, 'The Role of the Written Word in the Early Frescoes in the Campo Santo of Pisa', in Irving Lavin, ed., *World Art: Themes of Unity and Diversity*, 3 vols (University Park, PA, *c.* 1989), vol. I, pp. 361–66.

2. Hall and Uhr (1992), pp. 45–55, make a case for the *Nuremberg Chronicle* (1490s) as the source for apocalyptic imagery. Only the scene of the Destruction of the Antichrist bears any resemblance. Soon after, Albrecht Dürer illustrated the Book of Revelation, but none of his images concur with Signorelli's. See Fig. 5.1.

3. Voragine (1993), vol. I, p. 4. The Advent fast is no longer observed, although the tone of the season remains serious, ominous and penitential rather than celebratory.

4. Scripture citations throughout the text come from contemporary liturgical books for Advent. *Brevarium Romanum* (Venice, 1565), 69r.–78v., concurs with *Brevarium Romanum* (14c, Vat. Lat. 4761), 359v. ff. and with the later *Liber Usualis* (1993), pp. 4–12, and other pre-Vatican II texts. D'Ancona notes that the Gospel lesson for the first Sunday in Advent, Luke 22, is sometimes replaced with Matthew 24 or 25. Alessandro d'Ancona, *Origini del Teatro Italiano*, 2nd edn, 2 vols (Turin, 1891), vol. I, p. 140.

5. Riess (1995), *passim*, privileges the lunette of the Antichrist above all else. He relates the scene to the German Antichrist drama, apocalyptic fears at the turn of the millennium and a half and Florentine Dominican preaching. He undervalues the importance of *The Golden Legend* and mentions no liturgical sources. For the tradition of the Antichrist: Riess, *passim*; W. Bousset, *The Antichrist Legend: A Chapter in Christian and Jewish Folklore* (London, 1896), and R. Emmerson, *Antichrist in the Middle Ages* (Seattle, 1981); and B. McGinn, *Antichrist: Two Thousand Years of the Human Fascination with Evil* (San Francisco, 1994). Young gives the rhymed Latin text of the twelfth-century drama from Tegernsee in Germany. Karl Young, *The Drama of the Medieval Church*, 2 vols (Oxford, 1933), vol. II, pp. 371–87. John Wright, trans., *The Play of the Antichrist* (Toronto, 1967) provides an English translation of this drama.

6. Young cites Adso and gives his text. Young (1933), vol. II, pp. 370; 496–500. Wright (1967), p. 109, provides an English translation of Adso.

7. Voragine (1993), vol. I, pp. 4–12, especially pp. 7–8, where he cites Luke, 21:25, Matthew 24:21 and Revelation 6.

8. Riess states that the text of the Orvietan performance of 1508 is lost, and, as far as I can tell, indeed it is. He mentions only the German Antichrist drama. Riess (1995), p. 75 and n. 3. Although no Antichrist drama occurs in the Orvietan series (which he does not mention), it appears in varying forms in the other places, including Perugia, Florence, and England. De Bartholomaeis (1943) and Scentoni, ed. (1994). In England, an Antichrist drama appears in the Chester cycle, which recounts the history of salvation. It precedes dramas of Doomsday and the Last Judgment. McGinn (1994), pp. 133, 191, 333, n. 68, and David Mills, *The Chester Mystery Cycle* (East Lansing, 1992), pp. 375–438. A shorter play in rhymed Italian, similar to the Chester version, occurs in the thirteenth-century Perugian Advent cycle, played the first Sunday in Advent. De Bartholomaeis, vol. I (1943), pp. 35–52. A drama of prophets at the End-time occurs in the Perugian cycle for the third Sunday in Advent. De Bartholomaeis, vol. I (1943), pp. 53 ff.; d'Ancona (1891), vol. I, pp. 141–53, transcribes an almost identical version of the play from Tuscany. For the French tradition, see Berengier (13c.) in Emmanuel Walberg, *Deux versions inédites de la Légende de l'Antéchrist en vers français du XIIIe siècle* (Lund, 1928).

9. In his diary, Tommaso di Silvestro records this performance on the Sunday following the Feast of the Assumption (15 August). No detail of the text or the acting troupe survives. In addition to being a notary and a historian, Tommaso served as cathedral canon and organist (1467–87). Tommaso di Silvestro, *Diario, 1482–1514*, in L. Fumi, ed., (1902–20), p. 372. B. Brumana and G. Cliberti, *Orvieto: una cattedrale e la sua musica* (Florence, 1990), p. 20.

10. *Ovide moralisé*, XIV: 1195–731; 'Ovide moralisé' en prose (texte du quinzième siècle)', in C. De Boer et al., eds, *Verhandelingen der Koninklijke Nederlandse Akademie van Wetenschappen, afd. Letterkunde* (Amsterdam, 1954), vol. LXI: 2, pp. 351–55.

11. Riess notes some Dominican influence. He cites three fifteenth-century Dominicans, St Vincent of Ferrer, Annius of Viterbo, and St Antoninus of Florence, but does not connect them to Orvieto in more than a general way. He does not tie the frescoes to Dominicans in Orvieto or to Thomas Aquinas. J. Riess, 'Republicanism and Tyranny in Signorelli's *Rule of the Antichrist*', in Rosenberg, Charles, ed., *Art and Politics in Late Medieval and Early Renaissance Italy: 1250–1500* (Notre Dame, 1990), pp. 162–65 and Riess (1995), pp. 82–104.

12. For an overview of Savonarola, see Chapter 1, note 26.

13. In addition to denying the sacraments and the divinity of Christ, Cathars stressed the powers of witchcraft, and the devil. They preached that the Antichrist would prevail in the End-time. Waley (1952), pp. 13–15; Riess (1995), pp. 14, 51–54 and 154.

14. M. D. Lambert, *Medieval Heresy: Popular Movements from Bogomil to Hus* (London, 1977) p. 199; Natalini (1936), pp. 90–91.

15. Kanter (1996), pp. 95–134 and Chapter 4, note 57.

16. S. H. Butcher, *Aristotle's Theory of Poetics and Fine Arts with a Critical Text and a Translation of the Poetics* (London, 1911), vol. VIII: 9–X: 3, pp. 35–39; Charles Osgood, *Boccaccio on Poetry* (Princeton, 1930), vol. XIV, pp. 67–68.

17. The 'evidence' that that man is Signorelli rests in a double portrait, now in the Museo Opera del Duomo, Orvieto, with the same man on the left. It is variously called 'Self-Portrait with E. N. Vitelli' or, according to a questionable inscription, 'Nicolai Franchi', and given the date of 1503. McLellan and Longhi doubt the identification of the latter figure and the authenticity of the inscription, but they accept the left figure as Signorelli. McLellan (1993), vol. I, pp. 252–57; Roberto Longhi, *L'autoritratto del Signorelli del museo di Orvieto è un falso?* (Florence, 1953), p. 63.

18. My thanks to Father Justin Cunningham, O.P. for noticing the lack of a tonsure and for identifying the sleeved garment as that of a canon. Smalley (1964), p. 83, also describes the dress of a canon as a black cloak over a white habit, as it appears here. Vasari embraces Signorelli as a relative and states they had met, so he would have known his appearance. Other portraits in Vasari's study, including those of Michelangelo and Vasari himself, resemble likenesses in other portraits. Moreover, Vasari states that he carefully gathered the portraits. Vasari (1930), vol. III, p. 357. See also Liana Di Girolami Cheney, *The Paintings in the Casa Vasari* (New York, 1984), pp. 32, 33 and 130.

19. For Adso's commentary and the Antichrist drama, see Wright (1967), p. 82; 104–7. For the convention of *festaiuoli* in Italian Renaissance art and drama, see L. B. Alberti in J. Spencer (1966), p. 78, and M. Baxandall, *Painting and Experience in Fifteenth Century Italy: A Primer in the Social History of Pictorial Style*, 2nd edn (New York, 1988), pp. 73–74 and S. James (1994), pp. 158–60. Loscalzo in Testa (1996), p. 220 concurs that these portraits are not depictions of Angelico and Signorelli. Paolucci discusses theatricality in Signorelli's paintings, but does not tie these portraits to *festaiuoli* or to the local liturgical dramas. Paolucci in Testa (1996), pp. 119–49.

20. Young (1962), vol. II, p. 370. C. Gilbert hypothesizes that Bramante, traveling from Milan to Rome in the fall of 1499 with the knowledge of Signorelli's prestigious work in progress, stopped by Orvieto with some of Leonardo da Vinci's drawings in his possession. Allegedly inspired by Leonardo's centrally planned churches, Bramante, Gilbert says, designed the Temple for Signorelli. Creighton Gilbert, 'Bramante on the Road to Rome (with Some Leonardo Sketches in his Pocket)', *Arte Lombarda* 66, no. 3 (1983), 5–14. However, such a top-heavy building would be unstable; thus, it is unlikely that an architect of Bramante's stature would design such a building. Moreover, the Temple bears no resemblance to Bramante's work in Milan or his subsequent work in Rome. Instead, the building resembles more closely the fanciful, but architecturally inexact, centrally planned, domed structures in Signorelli's paintings of the 1490s, including his *Madonna and Child* (Uffizi, Florence) and in his *Crucifixion* (National Gallery, Washington).

21. Young (1933), vol. II, pp. 371–87 and Wright (1967), pp. 82; 104–7.

22. For Thomas Aquinas's corpulence, see Walz (1951), p. 171. Riess (1990), p. 166, calls the man St Vincent Ferrer, a recent Dominican theologian who warned of the impending coming of the Antichrist.

23. Young (1933), vol. II, pp. 371–87; Wright (1967) pp. 104–7; Mills (1992), pp. 410–13.

24. Nuremberg, 1492, see note 2 above; Riess (1995), pp. 107–10; Scarpellini, *Luca Signorelli* (Milan, 1964); and Via in Testa (1996), p. 173.

25. See Chapter 4 for the relationship between this monogram, still used by the Opera del Duomo, and Mary Magdalene in the vaults above.

26. Hugh Henry, 'Two Medieval Hymns', *American Ecclesiastical Review* (April 1890), pp. 247–61; J. Jungmann, *The Mass of the Roman Rite: Its Origins and Development* (Westminster, 1986), vol. 1, p. 439; and McLellan (1992), vol. I, p. 305. Although later incorporated into Requiem Masses, the personal tone of the *Dies Ire* more appropriately fits the liturgies for Advent and All Souls' Day, 2 November, the day following All Saints' Day. An older Advent hymn, *Apparebit repentina dies magna Domini*, reflects the Gospel reading for the first Sunday in Advent, Matt. 25:31–36.

27. *Ovide moralisé* XIV: 089–1194; *Ovide moralisé en prose* (1954) pp. 350–51; Henry (1890), pp. 258–59.

28. The resurrection of the flesh is a subordinate part of several Last Judgment compositions prior to Signorelli's, such as those of Maitani, on the façade of Orvieto Cathedral (*c.* 1300), Nardo di Cione (*c.* 1350) in the Old Strozzi Chapel, Florence; Fra Angelico (*c.* 1435) in the Convent of San Marco, Florence and Rogier van der Weyden (1445–48) Musée de l'Hôtel Dieu, Beaune.

29. 1 Corinthians 15:35–58, 2 Corinthians 5:6–8; 1 Thessalonians 4:13–18 and Ezekiel 37:1–14. The Corpus Christi drama and *The Golden Legend* augment biblical texts. V. A. Kolve, *The Play Called Corpus Christi* (Stanford, 1966), pp. 50–56 and Voragine (1993), vol. I, p. 8.

30. Thomas Aquinas, *Summa Theologica*, II-II Q. 145, A. 2, noted in a different context by Testa (1996), p. 80. http://www.newadvent.org/summa/; Margaret Ruth Miles, 'The Revelatory Body: Signorelli's Resurrection of the Flesh at Orvieto', *Harvard Divinity Bulletin* 22, no. 1 (1992), 10–13.

31. Saint Augustine, *Concerning the City of God Against the Pagans*, trans. by Henry Bettenson, intro. by John O'Meara (New York, 1984), Book XXII: 8, p. 1059.

32. Signorelli used the same canon of proportion of 9.5 palms for the resurrected bodies as Leonardo da Vinci used for his drawing entitled the 'Virtuvian Man' ('Canon of Proportion') *c*. 1485–90. Pen and ink, 34.3 × 24.5 cm, Accademia, Venice. For the importance of the canon, David Summers, *Michelangelo and the Language of Art* (Princeton, 1981), pp. 384–92, 402, 566, n. 25.

33. Augustine, *City of God* XXII: 17.

34. The immortality of the soul was made dogma of the Church at the Lateran Council of 1513; thus, in 1499 the issue would have been current. Marsilio Ficino, a well-known philosopher at the school of Lorenzo de' Medici whom Signorelli would have known while he was working in Florence, brought attention to the issue in his treatise *Theologica platonica de immortalitate animae*, of 1487; see also Marina Warner, *Alone of All Her Sex: The Myth and the Cult of the Virgin Mary* (New York, 1983), pp. 97, 102; Miles (1992), pp. 10–13.

35. Thomas Aquinas, *Summa Theologica* I-I Q. 47, A. 1. http://www.newadvent.org/summa/

36. Noted when comparing Signorelli's second contract, AODO *Rif.* 12 (1484–1526), cc. 344v., 5 April 1499 with his third contract, which stipulates the 'cappella corpe sancta' as well as the walls. AODO *Rif.* 12 (1484–1526), cc. 372r.–373r., 27 April 1500, in Andreani (1996), App. I, docs 219 and 226, pp. 434–35.

6 Liturgy Meets Poetry

1. Signorelli's third contract includes the 'cappella corpe sancta' as well as the walls. AODO *Rif.* 12 (1484–1526), cc. 372r.–373r., 27 April 1500, in Andreani in Testa (1996), App. I, doc. 226, p. 435. The Cappellina della Maddalena was the last area of the Cappella Nuova to be decorated. See ASO, ASCO *Bastardelli delle Riformagioni* 550 c. 526r. e.v.–530r., 25 April 1504, 28 April 1504 and 2 May 1504 in Andreani in Testa (1996) App. I, docs 255–57, p. 438.

2. Stanley Meltzoff (1987) is among the first to treat these scenes in detail. He correctly notes a relationship to poetic theology, but his interpretation has flaws. He accepts Luzi's identifications (1866), pp. 166–96, which I have found not only to be suggestions, but often incorrect ones. Moreover, like André Chastel (1952), he interprets the scenes through the eyes of a Florentine and stresses the influence of Savonarola. Rosemarie San Juan calls the paintings Roman wall decoration turned upside down. San Juan, 'The Function of Antique Ornament in Luca Signorelli's Fresco Decoration for the Chapel of S. Brizio', *Canadian Art Review* 12 (1985), 235–42. Riess discusses some scenes, especially those below the Antichrist. Riess (1995), pp. 23–39. Loscalzo in Testa (1996), pp. 191–214, notes the classical influence.

3. Luciano Marchetti, 'L'architettura dipinta: da un ambiente gotico a uno spazio rinascimentale', in Testa (1996), p. 153, makes an allusion to cameo shapes, but not the material or classical reference. The ancients fashioned cameos from various shells (pale pinkish orange) and stones, including onyx (black), such as the Gemmae Augustea, *c*. AD14, 9 × 23 cm (Kunsthistorisches Museum, Vienna) and agate (blue). Botticelli's portrait of Simonetta Vespucci (?), (Frankfurt am Main, Städelsches Kunstinstitut, *c*. 1480–85) shows an antique cameo owned by the Medici that depicts the *Flaying of Marsyas*. See also William Voelkle, catalogue entry 13, in J. J. G. Alexander, ed., *The Painted Page: Italian Renaissance Book Illumination 1450–1550* (New York and London, 1994), p. 70. I am grateful to jeweler Kyle Leister for information concerning the materials used for ancient cameos.

4. Gerolamo Clementini in 'Gerolamo Curzio Celmentini e la descrizione della Cappella Nova' (AODO ms. 594), transcribed in Andreani (1996), App. II, p. 457 and Della Valle (1791), pp. 216–18 and McLellan (1992), vol. II, p. 331.

5. *Head of a Poet Wearing a Cap*, 23.7cm × 15.5 cm, Kupferstichkabinett, Stätliche Museen, Berlin, cited by Steffi Roettgen, *Italian Frescoes: The Flowering of the Renaissance*, trans. Russell Stockman (New York, 1997), p. 396.

6. A hymn for the feast of Mary Magdalene in AODO ms. C1 supplement, 4v.–4r., recounts that Lazarus is her brother, as does legend. See Chapter 5 above for a discussion of Mary Magdalene. In the eighteenth century, a porphyry tomb covered Signorelli's paintings. Giusi Testa, 'La cappellina dei Corpi Santi e la cappellina della Maddalena', in Testa (1996), pp. 269–75, for a

description of the original decoration. For the earliest accounts see Clementini (AODO ms. 594), in Andreani (1996), App. II, pp. 456–59 and Della Valle (1791), p. 218.

7. De Bartholomaeis (1943), vol. I, pp. 169–74. Other Italian liturgical dramas refer to Lazarus, but he does not appear as a character in them. Ibid., pp. 135, 168; vol. II, pp. 390, 401; vol. III, pp. 106 and 356.

8. John 5:25–29; 11:53–54; 12:9–11 and 12:24–29.

9. Smalley (1964), p. 25.

10. Anonymous twelfth-century poet in 'Electio Hugonis', *Memorials of St. Edmundsbury*, ed. T. Arnold (Rolls series), ii, p. 60, quoted in Smalley (1964), p. 25.

11. Dacos (1969), *passim*; for the illusionistic architecture, see Marchetti in Testa, (1996), p. 163.

12. Summers, (1981), p. 103.

13. Wohl (1999), Chapter 4, pp. 115–53.

14. Edgar Wind, *Pagan Mysteries in the Renaissance*, rev. and enlarged edn (New York, 1968), p. 237.

15. For Andrea del Castagno's series of famous men and women for the Villa Carducci in Legnaia (now in the Uffizi) see Roettgen (1996), pp. 272–85 and 449. For the Studiolo of the Duke of Urbino, see Luciano Cheles, *The Studiolo of the Duke of Urbino: An Iconographic Investigation* (University Park, 1986). For the library of Antonio Albèri, see James (1994), pp. 212–29 and Gilbert in Testa (1996), pp. 307–20.

16. James (1994), pp. 189–97, discusses manuscript illumination as a source at length. Wohl (1999), p. 206, makes passing mention of the relationship of Signorelli's socle to contemporary manuscript practices, but does not discuss function.

17. BAV Urb. Lat. 1, fol. 7 (1476–78) illuminated in Florence for Federigo da Montefeltro (d. 1482) by Francesco d'Antonio del Chierico and others in Alexander (1994), pl. 2, pp. 11–12.

18. Francesco Rosselli, illuminator (attr.), Origen, *Homilies on Genesis, Exodus and Leviticus* (Modena, Biblioteca Estense, Ms. Lat. 458, vol. IV, fol.1r., in Alexander (1994), cat. 2, pp. 52–53. This manuscript was illuminated in Florence for the king of Hungary.

19. This Florentine *graduale* depicts the procession in Florence; it also illustrates the Dominican ties to the cult of Mary Magdalene. The center panel features the bishop walking through the streets of the city under a canopy holding a monstrance (an elaborate receptacle for the Host), surrounded by a multitude of Dominicans wearing the white robes of summer. The right center of the marginalia features a little octagon holding St Dominic who faces the penitent Mary Magdalene, depicted praying, her body clothed only by her long, red hair. Mary Magdalene, who was especially revered by the Dominicans, was fed on celestial manna, as illustrated here, which the Eucharistic wafer imitates in form. Biblioteca Mediceo Laurenziana, Altavante degli Attavante, corali 4, c. 7v., 1505, illustrated in Rolfi (1992), p. 220, fig. 8.8.

20. Plautus, *Comedies* (BAV, Vat. Lat. 3870, fols 1v. and 2r.). The border was added in the fifteenth century to 'update' the book. Cardinal Nicholas of Cusa, who had a home in Orvieto, once owned this ninth-century book and took it to Rome, where it passed to Cardinal Giordano Orsini and from him to Pope Leo X. A. Grafton, ed., (1993), pl. 9 and pp. 13–14, and in personal correspondence with A. Grafton, 5 September 2001.

21. The scribe signed and dated this manuscript in Florence, 4 December 1488. The king of Hungary commissioned the manuscript, but when it left Florence is unknown. It would be impossible to say that Signorelli saw this particular manuscript, although he worked in Florence in the 1490s. Other similar works, however, surely were available to an artist in the Medici circle. Wohl (1999), pp. 206–7, cites this example in passing, but he does not discuss function.

22. No contemporary sources document Signorelli's intentions in the Cappella Nuova. The earliest published description of the chapel is Della Valle (1791), pp. 126–221, especially pp. 142 and 216–18 for these scenes. His identifications for hidden scenes usually follow the essay of Clementini of *c.* 1714 in Andreani (1996), App. II, pp. 456–59. In 1866, Lodovico Luzi, using precatory language, identified all of the visible portraits and tondi according to Dante's list of major poets in Limbo (*Inferno* IV:85–93); until recently, these have been accepted universally. Luzi (1866), pp. 166–96.

23. Clementini in Andreani (1996), App. II, pp. 456–59; Della Valle (1791), p. 218, politely disagrees, identifying the portrait as Dante. For a chart, see McLellan (1992), vol. I, p. 331.

24. Portraits of Dante by Andrea del Castagno (Uffizi) and Domenico de Michelino (Florence, Museo del Opera del Duomo) are in three-quarter view. Benozzo Gozzoli's (Montefalco) appears full-face. That from the Studiolo at Urbino, perhaps by Justus of Ghent (Louvre), appears in profile. All wear the traditional costume and have similar facial features. For reproductions see Patrizia Castelli, 'Immortales animae: gli uomini illustri di Orvieto e l'esegesi dantesca', in Testa (1996), pp. 215–21. Moreover, Dante wears the traditional costume in Dante Alighieri, 'La Commedia Divina', illustrated by Sandro Botticelli 1482–90 (BAV, Vat. Reg. Lat. 1896) and in Dante Alighieri, *La Commedia Divina*, Guglielmo Giraldi, illustrator, 1480–82 (BAV, Vat. Urb. Lat. 365).

25. Luzi (1866), pp. 170–79; 171: 'Io lo credo Virgilio.' He calls this man Virgil because he is situated next to Dante, whom he guides through Purgatory.

26. Loscalzo in Testa (1996) pp. 191–213, especially pp. 198–99; Riess (1995), pp. 32–33.

27. Testa and Davansi in Testa (1996), p. 45.

28. Clementini in Andreani (1996), App. II, p. 457. Della Valle (1791), p. 216, follows Clementini. Loscalzo (1996), p. 203, calls him Virgil.

29. Luzi (1866), p. 190, calls him Horace; Loscalzo in Testa (1996), p. 208, calls him Ovid. Most modern authors concur that he is Virgil, including San Juan (1985), p. 240; (1989), p. 75; Kanter (1989), pp. 45–46; Riess (1995), fig. 20 and p. 33; and Carla Bertorello, 'Scheda di restauro degli affreschi e dell'altare della Gloria', in Testa (1996), p. 372.

30. Virgil tells of Aeneas in Hades in Book VI of the *Aeneid* and recounts the deeds of Hercules in VIII: 280–305.

31. The family of the bishop of Orvieto, Giorgio della Rovere, used the oak leaf and acorns as an emblem. Oak crowns are associated with Roman authors.

32. Luzi (1866), p. 194 identified the scenes as the *Massacre of Pompey and his Followers*, from Lucan's *Pharsalia*, IV–VIII. Riess (1995), pp. 126–31 and McLellan (1994), vol. I, pp. 319–20, accept this identification. Professor Mark Morford, Lucan scholar in the Department of Classical Literature at the University of Virginia, disputed the traditional identification based on the reasons cited in the text.

33. Loscalzo in Testa (1996), pp. 194–96, identifies the author as Tibullus (54–19 BC). Albius Tibullus, *The Elegies*, ed. Kirby Smith (1913).

34. Enzio Carli, *Luca Signorelli: Gli Affreschi nel Duomo di Orvieto* (Bergamo, 1946), unpaginated, compares the appearance of the poet, whom he calls 'Homer', to Donatello's *Zuccone*.

35. Luzi (1866), pp. 168–70; Fumi (1891), p. 377, concurs, as does Meltzoff (1984), pp. 318–19, who relates Homer to Dante's description of him as a poet of war, but no sword appears here. Della Valle (1791), p. 218, calls the scene *Fortune with Three Soldiers who Present Two Prisoners*, based on writings of Clementini. Riess (1990), p. 168, re-identified the author as the philosopher–rhetorician Cicero, basing the portrait on the representation of Cicero as bald in Albèri's library. He identifies the surrounding scenes as being from Cicero's *Philippics*. Other portraits in the library, however, such as those of Virgil and Ovid, do not match figures in the chapel. Furthermore, he has not convincingly related Cicero to the iconography of the whole chapel.

36. Loscalzo in Testa (1996), pp. 192–93, identifies the author as Sallust (86–34 BC) who wrote *The History of Catiline's Conspiracies*, a copy of which was held in Albèri's library. Cicero's fourth published oration, entitled 'Against Catilina', treated the same subject. Sallust, *The Conspiracy of Catiline and the War of Jugurtha*, trans. T. Heywood in 1608 (New York, 1967), pp. 55–118.

37. Luzi (1866), pp. 166–96, called him Empedocles, who appears in a list of secondary poets in Limbo (*Inferno* IV:133–44).

7 Purgatory and *Il Purgatorio*

1. Recent scholarship includes Patrizia Castelli, 'Immortales animae: gli uomini illustri di Orvieto e l'esegesi dantesca', in Testa (1996), pp. 215–21, Riess (1995), pp. 40–51 and 101, and Gizzi (1991) *passim*. See also Ronald B. Herzman, '"Visible Parlare:" Dante's *Purgatorio* 10 and Luca Signorelli's San Brizio Frescoes', *Studies in Iconography* 20 (1999), 155–83.

2. Jacques Le Goff, *The Birth of Purgatory*, trans. Arthur Goldhammer, Chicago (1984), pp. 52, 61, 246–84, and 334–55; Dante Aligheri, *The Divine Comedy: II: Purgatorio*, trans. and notes, John Sinclair (New York, 1961), pp. 27–28.

3. Among the few to illustrate Purgatory, Nardo di Cione (*c.* 1350) places the Mount of Purgatory in the upper part of Inferno in his *Last Judgment* frescoes in the Old Strozzi Chapel at S. Maria Novella in Florence.

4. Kanter (1989), p. 39, cites Signorelli's drawing of Archbishop Ruggeri and Count Ugolino in *Inferno* XXXII–XXXIII (British Museum) as evidence of this intention.

5. See Innocent IV's official letter in LeGoff (1984), pp. 283–84, and Thomas Aquinas, *Summa Theologica*, II-II.24–9 and III.2.

6. Dante Alighieri, *The Divine Comedy of Dante Alighieri: Purgatorio*, Allen Mandelbaum, ed. and trans. (New York, 1984), p. 317, nn. 4–6; Le Goff (1984), pp. 346–48.

7. Kanter (1989), pp. 38–43, separates the importance of Dante's literature from the doctrine of Purgatory. Riess (1995), pp. 40–51, discusses Purgatory and Ante-Purgatory. They do not connect the scenes from Dante to the Roman liturgy, however.

8. Riess (1995), pp. 40–51, notes that Purgatory gives a positive message. Herzman (1999), pp. 171–72, concurs, but neither extends the message of hope to the entire program.

9. Archibald T. MacAllister, cited in Dante Alighieri, *The Purgatorio*, trans. and notes by John Ciardi (New York, 1961), p. 111.

10. Stinger (1985), pp. 149–50.

11. Pope Sixtus IV instituted this practice on 3 August 1476 in his bull *Salvator Noster*. Stinger (1985), p. 149.

12. Dante Alighieri, *La Commedia Divina*, ill. Sandro Botticelli, 1482–90 (BAV, Vat. Reg. Lat. 1896). See also Barbara J. Watts, 'Sandro Botticelli's Drawings for Dante's *Inferno*: Structure, Topography, and Manuscript Design', *Artibus et Historiae* 32 (1995), and Hein-Th. Schultze Altcappenberg, et al., *Sandro Botticelli: The Drawings for Dante's Divine Comedy* (London, 2000).

13. Dante Alighieri, *La Commedia Divina*, ill. Guglielmo Giraldi, 1478–82 (BAV, Vat. Urb. Lat. 365).

14. Clementini in Andreani in Testa (1996), p. 457 c. 3 and Della Valle (1791), p. 216, mention a scene of Ulysses, now destroyed.

15. Dante Alighieri, *The Divine Comedy, Purgatorio 2: Commentary*, trans. and commentary by C. Singleton (Princeton, 1991), p. 23.

16. Mandelbaum (1983), p. 319, nn. 40–41.

17. Ruth Mary Fox, *Dante Lights the Way* (Milwaukee, 1958), pp. 259–60.

18. Dante Alighieri, Ciardi (1961), p. 39.

19. Dante Alighieri, *Purgatory*, trans., intro and notes by Mark Musa (New York, 1985), p. xiii. For a liturgical table and reference to the hymn, sung at Paschal Lauds since the sixth century (Psalm 114, Vulgate Psalm 113), see Fox (1958), pp. 305 and 327, Singleton, *Purgatorio*: 2 (1991), pp. 31–33 and Mandelbaum (1983), p. 321.

20. Literal: historical event; allegorical: Christian redemption through Christ; tropological: souls turning from the miserable state of sin to grace; anagogical: the passing of the souls from the bondage of sin to the freedom of grace, prefiguring Christ's Resurrection. This method will be discussed further in Chapter 9. Dante Alighieri, *The Banquet (Il Convivio)*, trans. Katherine Hillard (London, 1889), section 7 of 'The Epistle to Can Grande della Scala', pp. 93–94.

21. Dante Alighieri, *Purgatory*, trans. and notes by Dorothy Sayers (New York, 1955), p. 107; (1955) p. 84; see also Singleton (1991), vol. II, Part 2, p. 41. Translations in the text throughout are from Sayers.

22. Stinger (1985), p. 149; Leopold Ranke, *The History of the Popes: Their Church and State*, trans. E. Foster, 3 vols (London, 1947), I, pp. 44–45.

23. Musa (1985), p. xv.

24. *Antiphonale Monasticum … ordinis Sancti Benedicti* (Paris, Desclée et Cie, 1934); Psalm 51 is also often used for funerals. Fox (1958), p. 323; Musa (1985), p. xv. Sayers (1955), p. 107.101.

25. Fox (1958), p. 313.

26. Dante takes poetic license here, for the *Salve Regina* was rarely sung before Compline. Dominicans still use the *Salve* in daily procession; Benedictines use it at Compline, *Ant. Monasticum* (1934), p. 176; Musa (1985), p. 77; Fox (1958), p. 328.

27. Jeffrey B. Russell, *A History of Heaven: The Singing Silence* (Princeton, 1997), pp. 161–62.

28. Ciardi (1961), p. 89; Musa (1985), pp. 76–77.

29. Musa (1985), pp. 86–88; Ciardi (1961), p. 98; Sayers (1955), p. 131. Shades, however, do not sleep or dream.

30. Ciardi (1961), p. 108 and Musa (1985), p. 103, allude to baptism by fire. Dreams after midnight were considered to be prophetic. Singleton (1973), vol. II, p. 179.

31. Musa (1985), p. 105; Sayers (1955), p. 139.

32. Fox (1958), p. 312.

33. Sayers (1955), p. 142. Matins was often composed of three Nocturnes, at 9:00 pm, midnight, and 3:00 a.m. Fox (1958), p. 305.

34. The system of parallels originated with St Jerome's *supra*. In the eleventh century, Baudri systematically implemented the idea. Not coincidentally, he drew parallels between the Virgin Mary, David and Trajan. Dante must have known his writings and the tradition. E. R. Curtius, *European Literature and the Latin Middle Ages*, trans. Willard Trask (New York, 1963), pp. 362–63. Chapters 8 and 9 of this text elaborate further on the use of parallels of exemplary figures in the chapel.

35. Ciardi (1961), p. 118; Musa (1985), pp. 114–16; Sayers (1955), p. 148; Singleton, *Purgatorio*: 2 (1991), pp. 201–12. Legend held that Pope Gregory the Great saved Trajan by weeping over an

image of him and thus baptizing him with his tears, and that he raised Trajan from the dead so that he could accept Christ. Russell (1997), pp. 128–29.

36. Sayers (1955), pp. 65–67; 147; Ciardi (1961), pp. 118–19.

37. Loscalzo (1996), pp. 202–3 relates it to *Purgatorio* XV:37–57.

38. Singleton, *Purgatorio:* 2 (1991), pp. 321–22, and a citation of Thomas Aquinas, *Summa Theologica*, II-II, Q.36 A.3.

8 Classical Allegories

1. Charles Trinkaus, *In Our Image and Likeness: Humanity and Divinity in Italian Humanist Thought*, 2 vols (Chicago: University of Chicago Press, 1970), vol. II, pp. 683–90; Jean Seznec, *The Survival of the Pagan Gods: The Mythological Tradition and its Place in the Renaissance and Humanism in Art*, trans. Barbara Sessions (New York, 1953), pp. 84–121.

2. The scholars who note the classical heroes do not relate them to the iconography as a whole. McLellan (1992), vol. I, pp. 349–55, discusses some of the scenes representing Hercules. Meltzoff (1987), pp. 334–36 and 350–51, recognizes Hercules as an exemplary 'Christianized' pagan hero. In the latter passage he interprets Hercules as representing Cesare Borgia in Orvieto, which I believe is incorrect and out of context.

3. In Signorelli's era, Boccaccio and the moralized versions of Ovid, especially the *Ovide moralisé*, were the primary sources for moralized pagan stories. See C. G. Osgood, *Boccaccio on Poetry* (Princeton, 1930) xvi–xvii and n. 4. Many examples existed, however. For example, Stephen Langton (d.1228) moralized Ovid; Smalley (1964), p. 373. Petrarch mentions in a letter Pierre Bersuire (d.1362), a Frenchman, who wrote a moralized version of Ovid, the *Ovidus moralizatus*. This book was subsequently edited by Ghisalberti and published in Paris in 1509. Ernest Wilkins, *Studies on Petrarch and Boccaccio*, A. S. Bernardo, ed. (Padua, 1978), pp. 74–75; 84–85. The *Ovide moralisé* is attributed by some scholars to a thirteenth-century Frenchman Chrétien Legouais. Wilmon Brewer, *Ovid's Metamorphoses in European Culture*, 2 vols (Boston, 1923), I: 20; Edward K. Rand, *Ovid and his Influence* (Boston, 1925), p. 135. Recent scholars attribute the work to an anonymous French scholar in the first quarter of the fourteenth century. Joseph Engles and J. Dupic, *Études sur l'Ovide moralisé* (Groningen, 1943), pp. 3–22 and 46–62; and Rita Copeland, *Rhetoric, Hermeneutics, and Translation in the Middle Ages* (New York, 1991), pp. 107–8. The text for the *Ovide moralisé* is transcribed in C. De Boer, M. De Boer, and J. van't Sant, *Ovide moralisé*, in *Verhandelingen der Koniklijke Nederlandse Akademie van Wetenschappen, Afdeeling Letterkunde*, 98 vols (Amsterdam). *Ovide moralisé in poetry*: books I–III in tome I, vol. XV, no. 1 (1915); books IV–VI in tome II, vol. XXI, no. 2 (1920); books VII–IX in tome III, Vol. XXX, no. 3 (1931); books X–XIII in tome IV, vol. XXXVII (1936); books XIV and XV in tome V, vol. XLIII (1938); and the *Ovide moralisé in prose*, vol. LXI, no. 2 (1954).

4. *De Houtsneden van Mansion's Ovide Moralise* (M. D. Henkel, Bruges, 1484, reprinted by P. N. van Kampen & Zoon, Amsterdam, 1922).

5. Text and allegories were written and interpreted by Ioani de Buonsignore of Città di Castello and woodcut illustrations attributed to Zoan Andrea. *Ouidio Methamorphoseos vulgare* (L. A. Giunta, Venice, 1497). I am grateful to April Oettinger for introducing me to the Italian Ovid. Both this book and the *Ovide moralisé* are organized according to the book numbers used by Ovid in his *Metamorphoses*. This Italian version of 146 leaves is far shorter than the *Ovide moralisé*, but the spirit of the moralizations remains similar. The shorter Italian version truncates the text, but it also includes some information not in the *Ovide moralisé*.

6. St Augustine, *Concerning The City of God against the Pagans*, trans. by H. Bettenson and intro. by J. O'Meara (New York, 1972), XI: 19, p. 450; XVIII: 41, p. 819.

7. Curtius (1963), pp. 219, 362–63.

8. Copeland (1991), p. 110.

9. Baudri of Bourgueil, cited in Curtius (1963), pp. 362–63.

10. Charles Martindale, ed., *The Cambridge Companion to Virgil* (Cambridge, 1997), *passim.*

11. Francesco Petrarch, *Invective contra medicum*, ed. Pier Giorgio Ricci (Rome, 1950), book III: 58–80; Osgood (1930), pp. xxi–xl; Trinkaus (1970), vol. II, pp. 691–97.

12. Boccaccio XV:8–9, in Osgood (1930), pp. xxxviii and 121–29.

13. *Ovide moralisé* I: 1–14, trans. in Copeland (1991), p. 110. This page (along with a few others) was missing from the copy of the *Ouidio Methamorphoseos vulgare* (1497) that I consulted at the Library of Congress.

14. Copeland (1991), pp. 109–24; O'Malley (1986), pp. 108, 116 and n. 15; Trinkaus (1970), vol. II, pp.

687–94; Engles and Dupic (1943), vol. II, pp. 2; 110–15; Emile Mâle, *The Gothic Image: Religious Art in France of the Thirteenth Century*, trans. D. Nussey (New York, 1972), pp. 339–40.

15. *Ovide moralisé* XV:2525–57, trans. in Copeland (1991), p. 113. *Ouidio Methamorphoseos vulgare* (1497), book XV, pp. cxlr.–cxlir. recounts this passage in abbreviated form.

16. A. Mandelbaum, ed. and trans., *The Metamorphoses of Ovid*, vol. I (1993), lines 1–6, p. 3.

17. See introduction for further explanation of the *exposito*.

18. *Ovide moralisé* I: 26–30 in De Boer (1915), vol. XV, no. 1, p. 62, as trans. in Copeland (1991), p. 111. This page was missing from the copy of the *Ouidio Methamorphoseos vulgare* (1497) that I consulted at the Library of Congress.

19. Thomas Aquinas in his *Summa Theologica*, I-II. 51.3, speaks of the virtue of meditation. Boccaccio in Osgood (1930), XIV: 11, pp. 54–58; Thomas Bergin, *Boccaccio* (New York, 1981), p. 239; Petrarch, 'On Solitude', third tractate, in Harold Blanchard, *Prose and Poetry of the Continental Renaissance in Translation* (New York, 1949), pp. 63–69.

20. Boccaccio, *Genealogie* XIV: 11, in Osgood (1930), pp. 54–58.

21. Seznec (1953), *passim*, and Mâle (1972), pp. 332–40.

22. Seznec (1953), p. 90.

23. Leopold D. Ettlinger, 'Hercules Florentinus', in *Mitteilungen des Kunsthistorisches Institutes in Florenz*, vol. XVI, no. 2 (1972), 119–42; Erwin Panofsky, *Hercules am Scheidewege und andere Antike Bildstoffe in der Neueren Kunst* (Berlin, 1930), p. 126; De Boer (1931), book IX: lines 487–1029, pp. 221–46. For the role of Hercules in the chapel, see James (1994), pp. 289–98.

24. L. Ettlinger (1972), pp. 120, says that here Hercules personifies Fortitude; Frederick Hartt, *History of Italian Renaissance Art: Painting, Sculpture, Architecture*, 4th edn rev. by David Wilkin (New York, 1994), fig. 39, calls the figure Daniel; James Snyder, *Medieval Art: Painting, Sculpture, Architecture, 4th to 14th Century* (New York, 1989), fig. 573, labels the figure as a virtue.

25. Seznec (1953), p. 20, n. 26; L. Ettlinger (1972), pp. 119–42.

26. Trinkaus (1970), vol. II, p. 695; Seznec (1953), p. 31.

27. Seznec (1953), pp. 95–96 and n. 53.

28. Scholars generally agree on the identification of this emblem. McLellan (1992), vol. I, pp. 355–56; Kanter (1989), pp. 48–49. Loscalzo in Testa (1996), p. 203, identifies the texts: *Purgatorio* XVIII:28–33 and the *Elegies* of Virgil.

29. Kanter (1989), p. 48; McLellan, vol. I, pp. 356–67 and McLellan, *Signorelli's Orvieto Frescoes: A Guide to the Cappella Nuova of Orvieto Cathedral* (Perugia, 1998), p. 73 cites Petrarch as the source. Loscalzo in Testa (1996), p. 203, identifies the scene as *Aeneid* I:312–20; 657–94, but I find that Signorelli's image does not fit the text. The four figures here do not concur with the number and genders of the three mentioned in the text. Moreover, the text describes Aeneas carrying two iron-tipped spears; here he carries only one.

30. Clementini in Testa (1996), p. 458. McLellan (1992), p. 357; Loscalzo in Testa (1996), p. 203, concurs and cites the source as *Aeneid* I:723–56.

31. Clementini in Andreani in Testa (1996), p. 457 c. 3 and Della Valle (1791), p. 216, label a now-ruined tondo below *The Damned Led to Hell* as Ulysses (Odysseus). Ulysses ventured into the end of the world to visit shades of the dead in the *Odyssey* XI:15; *Iliad*, VIII:13–16. Ovid does not retell this tale.

32. Seznec (1953), p. 90; Edgar Wind, *Pagan Mysteries in the Renaissance*, rev. edn (New York, 1968), p. 157; *Ovide moralisé, passim*. *Ouidio vulgare* (1497), book XV, ch. VII, p. cxxxiir.

33. *Ouidio vulgare* (1497), book III: XXIII, p. xxx and book V:XXIIII, p. xlv.–xlir. for moralizations and story; illustration p. xlv. The illustration is rendered in simple outline using the continuous narrative compositional format. The figures wear contemporary costume. *The Rape of Persephone* occurs, left to right, in the background; the pool of Cyane is prominently placed in the right foreground.

34. Luzi (1866), pp. 188–89 establishes the names for the scenes. He calls the third scene Pluto and the passage of Mount Aetna, and scholars have followed suit. However, Signorelli's scene, when compared to Ovid's text, clearly suggests my new identification.

35. *Ovide moralisé* V:3041–144 in Seznec (1953), p. 93 and *Ovide moralisé* X: 4128–40 in De Boer (1936), vol. XXXVII, p. 109.

36. For William of Conch, see Copeland (1991), pp. 85 and 131–32. Boccaccio moralizes the myth in *Genealogie* 5:12, in Osgood (1930), p. xxix, n. 46. *Ouidio vulgare* (1497), book X: V, p. lxxxiiiiv.

37. *Ovide moralisé* X:396–445 in De Boer (1936), vol. XXXVII, p. 20–21; and *Ovide moralisé in prose*, in De Boer (1954), vol. LVI, pp. 257–58.

38. *Ouidio vulgare* (1497), book X, chapter V, p. lxxxiiiiv.

39. Loscalzo in Testa (1996), pp. 203–5, states that the scenes are from Virgil.

40. Loscalzo in Testa (1996), p. 205; Clementini in Testa (1996), p. 457, c. 3.

41. Piccolomini-Adami (1883), p. 103 and Meltzoff (1984), fig. 5, identify the centaur as Nessus without explanation; McLellan (1992), pp. 352–52, identifies the hero as Hercules, but the centaur as Cacus. He looks to Dante's *Inferno* XXV as the source. Loscalzo (1996), p. 204, cites the mention of Hercules' victory over a centaur in the *Aeneid* VIII:293–94.

42. Ovid, *Met.* IX:127–29.

43. *Ovide moralisé* IX:347–486, in De Boer (1931), vol. XXX, pp. 229–32.

44. Hercules armed himself with a club as he set out against the giant Cacus, whom he killed by strangling in the *Aeneid* VIII:200–270. McLellan (1992), vol. I, p. 355, identifies the figure as Caucus. However, the figure is not a giant and the fight is not a strangling. However, Hercules killed Lichas, who brought the fateful shirt from Deianira, with a club. *Met.* IX:200–320; Ovid, *Metamorphoses*, trans. with notes by A. D. Melville (New York, 1986), p. 427; see also Mark 15:34.

45. Ovid, *Met.* IX:193–200; *Ovide moralisé* IX: 732; *Ouidio vulgare* (1497) IX, pp. lxxi v – lxxii v. Throughout the gloss portions of the *Ouidio vulgare*, the author praises Hercules' ingenuity.

46. Ovid, *Met.* IX: 66–70; *Ovide moralisé* IX: 768–73; 976–77; *Ouidio vulgare* (1497), IX: XXIX–XXX, p. lxxv v.

47. Ovid, *Met.* IX: 1–98 and 188; *Ovide moralisé* IX: 1–346; *Ouidio vulgare* (1497), IX: V, p. lxxiii r.

48. Ovid, *Met.* VII: 403–20; IX: 184–85; *Aeneid* VI: 370–85. *Ovide moralisé*, VII: 1681–2069 in De Boer (1931), vol. XXX, pp. 55–64. The author of the *Ovide moralisé* quotes Psalm XII:16. See also McLellan (1992), vol. I, pp. 339–40.

49. *Ovide moralisé*, VII: 2040–47, in De Boer (1931), vol. XXX, p. 63, where Theseus shared the same virtues as Hercules. *Ouidio vulgare* (1497), VIIII: XIII, p. lxxiiii r. See also Wind (1968), p. 266.

50. *Ovide moralisé* IX: 810–72, in De Boer (1931), vol. XXX, pp. 241–42; *Ouidio vulgare* (1497), book XIIII: XLIIII, p. lxxvi v. Other authors, such as Eupolemius in his *Messaid*, interpret Hercules as the Old Testament hero Sampson. Curtius (1963), p. 220.

51. Panofsky (1930), p. 90.

52. For the tradition see Ettlinger (1972), p. 128; Panofsky (1930), *passim*.

53. Loscalzo in Testa (1996), pp. 204–5. Deiphobus married Helen of Troy after the death of Paris. Ulysses (Odysseus) and the Greeks, perhaps aided by Helen, killed him after the fall of Troy. *Aeneid* VI: 494–530. Traditionally scholars identify the scene as Hercules subduing the rebellious Spartans, the sons of Hippocoön: Della Valle (1791), p. 216; Luzi (1866), p. 185; and Meltzoff (1987), p. 351. McLellan (1992), vol. I, pp. 352–54, sees it as a generalized scene of human torture.

54. Loscalzo in Testa (1996), n. 32, p. 205.

55. Scholars disagree on the subject of the scene. Loscalzo in Testa (1996), pp. 204–6, identifies it as the city of Dis, described in Ovid's *Metamorphoses* IV: 432–46.

56. *Ovide moralisé en prose* XVI: 4, in De Boer (1954), vol. LXI, no. 2, pp. 349–55.

57. *Ovide moralisé*, XIV: 4591–670 in De Boer (1938), vol. XLIII, pp. 126–32; *Ouidio vulgare* (1497), book XIIII: LII, p. cxxvi r.

58. Copeland (1991), pp. 85; 131–32; Martindale (1997), *passim*.

59. *Genealogie* Book XIV: XVII in Osgood (1930), p. 75. In *Genealogie* Book XIV: X Boccaccio also praised Virgil as a philosopher, p. 53.

60. Ovid, *Metamorphosis* IV: 611ff; *Ovide moralisé* IV: 6862ff. in De Boer (1920), vol. XXI, no. 2; *Ouidio vulgare* (1497), book IIII: LVII, p. xxxvi v.

61. See elaboration on the method in Chapter 9. Boccaccio, *Genealogie* XIV: 10, 12 defends poetry. Osgood cites the example of Perseus, p. xviii, and Seznec cites Perseus in Boccaccio, p. 223. Boccaccio also cites other methods of interpretation less similar to that of Dante. See Osgood (1930), pp. xviii–xv.

62. Treatise by John Ridewall, O.F.M., mid-fifteenth century, cited by Seznec (1953), p. 94.

63. *Ovide moralisé* IV: 6862–end in De Boer (1954), vol. LXI, no. 2, p. 168; Vischer (1866), pp. 198–99.

64. Marjory Strauss, 'The Death of Meleager', (M.A. thesis, University of North Carolina at Chapel Hill, 1971), discusses the Renaissance appropriation of the Meleager composition, especially for the carrying of the body of Christ, but does not include this image. Signorelli, like Alberti before him, would have known the composition of the Death of Meleager from classical sarcophagi. Alberti (1966), pp. 73–74. Today such sarcophagi are, among other places, in the collections of the Vatican Museums, Rome; the Galleria Doria-Pamphili, Rome; and the Metropolitan Museum, New York.

65. Gilbert (1986), pp. 118–20, mentions a Meleager sarcophagus as a source, but identifies the scene as the *Carrying of the Body of Christ*; Scarpellini (1964), plate XIX, labeled the scene *Il Compianto*

(*The Mourning*); Kanter (1990), p. 70, calls the scene *Lamentation*. James (1994), pp. 235–41, calls the corpse Meleager. Koch, whose subject is ancient sarcophagi that portray Meleager, includes Signorelli's fresco – the lone painting and only work that is not antique – which he calls *Meleager*. Koch says the painting is lost; perhaps instead a large sculpture of a Pietà by Ippolito Scalzo, which formerly stood in front of the *cappellina*, obscured it. Guntram Koch, *Die Mythologischen Sarkophage*, 6: *Meleager* (Berlin, 1975), pp. 28, 33, 113, pl. 81e.

66. Strauss (1971), p. 36; 'Li filz mori par le tison / de la crois ... ('The son died by the fire brand of the cross ...') ou il estendi/ Son cors et son sanc espandi./ Dou feu de voire charité / Fist embraser la deïté/ Le cors de son beneoit fill, ... *Ovide moralisé* VIII: 2690–95, in De Boer (1931), vol. XXX, no. 3, p. 173. I thank Professor Anne McGovern for the English translation.

67. *Ouidio vulgare* (1497), book VIIII: XXX, p. lxvii v. – lxviii r. and in XIIII: XXXII, p. lxviii r.

68. Loscalzo, in Testa (1996), pp. 194–96 and nn. 12–17. *Elegies*, book I, verse 10, lines 1–10. Dante probably did not know Tibullus' work; Boccaccio and Petrarch might have known it. By the late fifteenth century, however, Tibullus' works had been published. Albius Tibullus, *The Elegies of Tibullus*, ed. and notes by Kirby F. Smith (New York, 1913), pp. 63, 89, and 107–33. The tale is also told in the *Aeneid* VI: 771ff. This story does not appear among the Roman histories in the *Ouidio vulgare* (1497).

69. Loscalzo in Testa (1996), pp. 192–93 and Sallust, *The Conspiracy of Catiline and the War of Jugurtha*, trans. T. Heywood in 1608 (New York, 1967), pp. 55–118. This story does not appear among the Roman histories in the *Ouidio vulgare* (1497). However, Sallust appears among the great historians in Albèri's library, situated on the window jamb below and to the left of Quintius Curtius. He faces Campanus, beneath whom a charming ape, wearing a capuchon and spectacles and holding a book, mimics the pursuits of the scholars. See James (1994), pp. 222–24.

70. For the tradition of correspondences in Byzantine and early Italian frescoes see Henry Maguire, 'The Art of Comparing in Byzantium', *Art Bulletin* 70, no. 1 (March 1988), 88–103; *Art and Eloquence in Byzantium* (Princeton, 1981), *passim*; Michael Alpatoff, The Parallelisms of Giotto's Paduan Frescoes', in *Giotto: The Arena Chapel Frescoes*, ed. James Stubblebine (New York, 1969), pp. 149–54.

9 Wisdom and Eloquence: Signorelli as Renaissance Painter–Poet–Theologian

1. Robert of Basevorn, 'The Form of Preaching' (*c.* 1322), quoting Pope Leo I (the Great), cited in Kennedy (1980), p. 192.

2. In 1568, Giorgio Vasari credited Signorelli with playing a foundational role in the development of the High Renaissance style. Vasari–Bianchi (1930), pp. 359–70; Vasari (1996), pp. 609–14.

3. For Fra Angelico, *Rif.* 9 (1443–48), c. 286v., 11 May 1447, in Andreani in Testa (1996), doc. 45, p. 424. For Signorelli, *Rif.* 12 (1484–1526), c. 344r.–360r. Six documents in Andreani in Testa (1996), docs 218–23, p. 434. Eugenio Mario, O.P., 'Art Criticism and Icon-Theology' in T. Verdon and J. Henderson, eds, *Christianity and the Renaissance* (Syracuse, 1992), pp. 572–91, esp. pp. 585 and 591.

4. 'Gold worked by the art of painting outweighs an equal amount of gold unworked. If the figures were made by the hand of Phidias or Praxitiles from lead itself – the lowest of the metals – they would be valued more than silver ... Moreover, painting was given the highest honor by our ancestors. For although almost all other artists were called craftsmen, the painter alone was not considered in that category.' Alberti in Spencer (1966), p. 64. Alberti wrote *De Pictura* in 1435; the Italian translation, *Della Pittura*, appeared in 1436. Although not widely circulated until after 1500, when the printing press came into broader use, the ideas were part of the late quattrocento artistic vocabulary and vision.

5. For further evidence, a drawing assigned to a figure in *The Resurrection of the Dead* shows *spolveri* and bears the marks of a stylus used for transfer. Tom Henry, 'Signorelli, Raphael, and a "Mysterious" Pricked Drawing in Oxford', *Burlington Magazine* 135, no. 1806 (September 1993), 612–19.

6. Henry in Testa (1996), pp. 253–67.

7. Henry (1996), p. 116 and *passim*.

8. Summers (1981), p. 44.

9. See ibid., pp. 129 and 133.

10. Primarily Maguire (1981) and (1998).

11. Among them, David Summers, 'Contrapposto: Style and Meaning in Renaissance Art', *Art Bulletin* 59, no. 4 (1977), 336–61; Summers (1987) and (1981); John R. Spencer, 'Ut Rhetorica

pictura: A Study in Quattrocento Theory of Painting', *Journal of the Warburg and Courtauld Institutes* 20 (1957), 26–44; Michael Baxandall, *Giotto and the Orators* (Oxford, 1971); Baxandall (1972); and Wohl (1999). These scholars focus on the presence of rhetorical conventions in various works of art rather than on how rhetoric shaped full artistic programs. For two Italian programs that show meaning beyond narrative (but not necessarily rhetorical practices), see Alpatoff in Stubblebine (1969), pp. 156–69, for Giotto at Padua; for the lower walls of the Sistine Chapel, see Lewine (1993), *passim*, and Goffen (1986), pp. 218–62.

12. According to Cicero and later Angelo Poliziano, rhetoric could make use of poetic devices and poetic symmetry. Summers (1977), p. 345.

13. Cicero, *De Optimo genere oratorium* I:1–4 and *De oratore*, I.ix.53, quoted in Christine Smith (1992), pp. 82–83.

14. Summers (1981), pp. 177–85, esp. pp. 179–80 on *difficultà* and its relation to Signorelli and the Grand Manner of painting.

15. Maguire (1981), p. 20 and pp. 22–52.

16. Baxandall (1971), pp. 1–37; Summers (1981), pp. 41–44.

17. Vasari-Bianchi (1930), vol. II, p. 369; '"Speak, damn you, speak!"', Giorgio Vasari, *Lives of the Artists*, 2 vols, selection trans. by George Bull (New York, 1965), vol. I, p. 178.

18. Summers (1977), p. 341.

19. Vasari (1996), vol. II, pp. 611–12; Vasari–Bianchi (1930), vol. III, p. 365.

20. For the tradition of Italian Last Judgment compositions and the spectator's place, see Barnes (1998), pp. 7–27.

21. For correspondences in Byzantine and early Italian frescoes see Maguire (1988), pp. 88–103 and (1981), *passim*. For two Italian examples see Alpatoff (1969), pp. 149–54 and Carol Lewine (1993), *passim*; James (1994), pp. 183–86.

22. Cicero, *De Optimo genere oratorium* I:1–4 and *De oratore*, I.ix.53, quoted in Christine Smith, *Architecture in the Culture of Early Humanism: Ethics, Aesthetics and Eloquence 1400–1470* (New York: Oxford University Press, 1992), pp. 82–83.

23. For the use of antithesis in art, see Maguire (1981), pp. 53–83 and Summers (1977), pp. 336–61.

24. Marilyn Lavin has studied the arrangement of religious murals. She calls the arrangement in the Cappella Nuova a classic 'wraparound', or a chronological narrative. I do not see the arrangement as simply narrative, since one could argue that the events on each facing group could occur more or less simultaneously. Instead, I believe the paintings fit what she calls as a 'festal mode', an arrangement reflecting meaning beyond narrative, such as liturgical considerations. Lavin calls the X-shaped arrangement a 'horizontal cat's cradle', named after a children's string game, but she does not apply this arrangement to these paintings. Lavin also notes the counterclockwise arrangement of these paintings (which she calls unique) and ties the configuration to the rotations of the planets. M. Lavin (1990), pp. 4–9 and 229–33. However, the strict formula of the Last Judgment composition determines that the apocalyptic scenes must be in the north bay. Moreover, *The Resurrection of the Dead* was already in place on the northwest wall. Laurence Kanter, 'da pagarsi di tempo in tempo secondo el lavoro che farà …' in Testa (1996), p. 103. Therefore, the Antichrist would necessarily have to stand on the northeast wall, making the narrative sequence counterclockwise. Thus, the counterclockwise sequence is not symbolic. Furthermore, a precedent for a counterclockwise arrangement was set forty years earlier at the Orange Cloister in Florence. I thank Laurence Kanter for this observation.

25. Marchese includes the Cappella Nuova in his text on Dominican art. Vincenzo Marchese, O.P., *Memoriae dei più insigni Pittori, Scultori, e Architetti Domenicani* (Florence, 1854), pp. 299–310 and 312.

26. AODO *Rif.* 12 (1484–1526), c. 360r., in Andreani in Testa (1996), App. I, doc. 223, pp. 434–35. Signorelli's second contract is discussed and translated in Chapter 4.

27. Smalley (1964), pp. 254–55 and 268–74, and Lesley Smith (2001), pp. 23–29.

28. O'Malley (1986), pp. 92–148, esp. pp. 102–7; Esther Gordon Dotson, 'An Augustinian Interpretation of Michelangelo's Sistine Ceiling', parts I and II, *Art Bulletin* 61 (1975), 223–56; 405–29; James Beck, 'Cardinal Alidosi, Michelangelo, and the Sistine Ceiling', *Artibus et Historiae* 11 (1990), 63–77; Howard Hibbard, *Michelangelo* (New York, 1974), p. 105; and Helen Ettlinger, 'Dominican Influences in the Stanza della Segnatura and the Stanza d'Eliodorio', *Zeitschrift für Kunstgeschichte* 46 (1983), 176–86.

29. Stinger (1985), p. 142; see also the Introduction.

30. Paoli in Testa (1996), pp. 66–67, especially n. 19. Piccolomini-Adami (1883), p. 226.

31. Serena Romano, 'Due Affreschi del Cappellone degli Spagnoli: Problemi iconologici', *Storia dell'Arte* 28 (1976), 181–213.

32. Surh (2000), pp. 79–100 and 150–225.

33. Scholars do not concur on exactly how or when rhetoric and poetry and/or oratory were intertwined or in what ways they were separate. Although poetry seems to have been perceived as a separate form, poetic structure, like that of oratory, could be seen as a type of rhetoric. Barilli understands poetry to have been not only separate from rhetoric, but superior. Barilli (1989), p. 53; Summers, following Dante and Cennino Cennini, associates poetry and painting with daring, fantasy and inventiveness. He notes, following Cicero, that rhetoric and oratory are closely aligned with poetry, but that Cicero did not mean to align all of rhetoric with poetry; rather only the middle, embellished style. Summers (1977), pp. 191 and 345–47 and (1981), pp. 130–37 and 481, n. 48. Spencer (1957), pp. 26–44, esp. p. 39 for likeness of painting to oratory and Curtius (1963) on Quintillian's influence, pp. 436–38.

34. The close interrelationship between poetics and painting, based on Horace, is discussed by R. W. Lee, '"Ut Pictura Poesis:" The Humanist Theory of Painting', Art Bulletin 22 (1940), 197–269, published separately under the same title, New York, 1967; Spencer (1957), pp. 26–44; and by Summers (1977), esp. pp. 344–46.

35. Based on the writings of the classical authors and St Augustine, by the twelfth century the seven arts were divided into the quadrivium, the sciences, arithmetic, geometry, astronomy and music; and the trivium, grammar, rhetoric and dialectic. Philosophy was above them all. Emile Mâle, The Gothic Image: Religious Art in France of the Thirteenth Century, trans. Dora Nussey (New York, 1972), pp. 74–94. Summers (1977), pp. 344–45.

36. Thomas Aquinas, Summa Theologica, I, 1.9 and II-II, 101.2 ad 2; Summers (1987), pp. 187–91; 191, n. 17; 226–27 and 261.

37. Summers (1987), pp. 221–26 and 261. Curtius (1963), pp. 217–24. Curtius notes Aquinas's systemization of poetry, but he does not recognize the positive message Aquinas gave poetry by including it in the system.

38. Summers (1981), pp. 106–10; Summers (1987), pp. 191–92 and 223–27; Wind (1968), p. 19.

39. Thomas Aquinas, Summa Theologica, I-II, 51.3; see also Patricia Bizzell and Bruce Herzberg, The Rhetorical Tradition: Readings from Classical Times to the Present (Boston, 1990), p. 7 for rhetoric and memory.

40. Summers (1987), pp. 220–27, 314 and 334, n. 41.

41. Curtius (1963), pp. 206–13.

42. Boccaccio, Genealogie XIV:17 and XV:9 in Osgood (1930), pp. 78–80 and 176; Summers (1987), p. 207, n. 26.

43. Curtius (1963), pp. 215–16.

44. Translated by Curtius (1963), p. 216.

45. Renato Barilli, Rhetoric, trans. Giuliana Menozzi (Minneapolis, 1989), pp. 52–55 and O. B. Hardison, The Enduring Monument (Westport, 1973), pp. 3–23.

46. Hardison (1973), p. 6.

47. Curtius (1963), pp. 148–50; 205; 213–17.

48. Boccaccio, Genealogie XV:5, in Osgood (1930), p. 33.

49. Bergin (1981), pp. 238–42; Boccaccio, Genealogie XIV:17 and XV:9 in Osgood (1930), pp. 78–80, 123, and 176–77; see also the introduction xxxv–xlix and ff.

50. Petrarch in Curtius (1963), p. 226.

51. Barilli (1989), pp. 54–55.

52. Cennino Cennini, The Craftsman's Handbook: Il Libro Dell'Arte trans. D. Thompson (New York, 1960), pp. 1–2.

53. Leonardo da Vinci, a contemporary of Signorelli's, discusses at length in his treatise On Painting painting as poetry and the relationship of the poet and the painter, whom he regards as equals. Although Leonardo's writings were not published until about 1550, they express late fifteenth-century thought. He indicates that the issue was not only on his mind, but also on the minds of his contemporaries. Martin Kemp, ed., Leonardo On Painting, trans. M. Kemp and M. Walker (New Haven, 1989) pp. 22–34. See also Barilli (1989), p. 53; Summers (1977), pp. 191 and 345–47, and (1981), pp. 130–37 and 481, n. 48.

54. Barilli (1989), pp. 53–62.

55. Boccaccio XIV in Osgood (1930), pp. 67–68; Aristotle, Poetics: VIII:9 in S. H. Butcher, Aristotle's Theory of Poetry and Fine Art with a Critical Text and a Translation of the Poetics, 4th edn (London, 1911), p. 35.

56. Aristotle in Butcher (1911), p. 35.

57. Dante Alighieri, The Banquet, trans. Katharine Hillard (London, 1889), pp. 390–406, sections 7–9 are especially important, pp. 393–95.

58. Ibid.

59. Smalley (1964), pp. 248–60 and 355.

60. Julius R. Weinberg, *A Short History of Medieval Philosophy* (Princeton, 1967), p. 201, n. 40; Thomas Aquinas, *Summa Theologica*, II-II, 94.4; II-II, 101.2 ad 2.

61. Kermode (1979), pp. 23–24.

62. Kennedy (1980), p. 159; 190–91; Smalley (1964), pp. 244–46; 263–68; 287.

63. From a sermon by Peter Lombard quoted in Smalley (1964), p. 245.

64. Peter Comestor, prologue to *Historica Scholastica* in Smalley (1964), p. 242.

65. Kennedy (1980), p. 191.

66. In the baptistery at Padua, Giusto de' Menabuoi (*c.* 1378) depicted a combination of Christ in Judgment encircled by the Heavenly Court with events from the apocalyptic vision of St John and other biblical narratives. Hall and Uhr (1992), pp. 35–56 make a case for the *Nuremberg Chronicle* as the source. See also Chapter 5, note 2. I shall demonstrate that Signorelli was not illustrating St John's vision.

67. Kennedy (1980), pp. 158–59, citing Augustine's *De Doctrina Christiana*; Curtius (1963), pp. 214–15.

68. Boccaccio, *Genealogie* xiv: in Osgood (1930), pp. 39–42.

69. Dante Alighieri, 'Epistle to Can Grande della Scala', in *The Banquet* (1889), pp. 391–406; see esp. section 29, pp. 404–5; Petrarch (1950), vol. III, pp. 58–80.

70. Bizzell and Herzberg (1990), pp. 1–7.

71. Harry Caplan, *Of Eloquence: Studies in Ancient and Mediaeval Rhetoric* (Ithaca, 1970), pp. 41–43.

72. Plato, *Timaeus* 90d, quoted in Summers (1987), p. 32.

73. Summers (1987), pp. 224–25.

74. St Augustine, *The Trinity*, trans. Stephen McKenna (Washington, 1963), XV.16, p. 491.

Appendix: List of Scenes in the Cappella Nuova

South vault (above altar)

I *Christ in the Seat of Judgment* by Fra Angelico, assisted by Benozzo Gozzoli

II *Choir of Prophets* (including John the Baptist, David and Moses; by Fra Angelico and Benozzo Gozzoli) (12 figures)

III *Angels with the Signs of Judgment* by Luca Signorelli

IV *Apostles with the Virgin Mary* (12 apostles, including Peter, Paul and John the Evangelist) (13 figures) by Luca Signorelli

North vault (above entrance)

I *Choir of the Martyrs* (7 figures)

II *Choir of the Old Testament Patriarchs* (16 figures)

III *Choir of the Virgins* (8 figures with Mary Magdalene in the center)

IV *Choir of the Doctors of the Church* (15 figures)

Upper walls (counterclockwise beginning in NE lunette)

I *The Rule of the Antichrist*

II *Doomsday*

III *The Resurrection of the Dead*

IV *The Torture of the Damned*

V *The Damned Led to Hell*

VII *The Ascent of the Blessed to Heaven*

VIII *The Blessed in Paradise*

Lower walls (clockwise beginning in SE panel under *The Blessed in Paradise*)

I Beneath *The Blessed in Paradise*

A (left) Poet: Dante

1 (lower) *Purgatorio* Canto I; Matins

2 (left) *Purgatorio* Canto II; Lauds

3 (top) *Purgatorio* Canto III; Prime

4 (right) *Purgatorio* Canto IV; Terce

B (right) Author: Statius?

1 (lower) *Purgatorio* Canto V; Sext

2 (top) *Purgatorio* Canto VI; None

3	(left) *Purgatorio* Canto VII; Vespers
4	(right) *Purgatorio* Canto VIII; Compline.

Scenes in outer corners. 4 small tondi represent the Labors of Hercules

5	upper left: *Hercules Slaying the Thespian Lion*
6	upper right (damaged): *Hercules Slaying the Lernaean Hydra*
7	lower right: *Hercules and Achelous*
8	lower left: *Slaying of Lichas*

II	Beneath and adjacent to *The Ascent of the Blessed to Heaven*
A	Left (outer) scenes:

1	*Purgatorio* Canto IX (rectangle): Matins
2	*Purgatorio* Canto X (tondo): morning; enter purgatory
3	*Purgatorio* Canto XI (rectangle): morning; end instruction

B	Right (inner) scenes:

1	Emblem of *The Triumph of Charity over Envy* (tondo)
2	*The Triumph of Chastity* (rectangle)
3	destroyed tondo: perhaps Ulysses (Odysseus)? (Della Valle)

C	Left window:

1	Left (outer): *Archangel Uriel Wrestles with Demon*
2	Eight (inner): *Archangel Michael Holding Scales*

III	Center window: saints facing each other in upper window with musician angels above (inscriptions)

A	Left: *San Brizio*	B	Right: *San Costanzo*

Lower wall: hidden inside altar: center: *Portrait of Boccaccio?* with tondi above and below; perhaps another row of grisaille scenes on each side of the central author. The space allows for this, but destroyed.

IV	Beneath and adjacent to *The Damned Led to Hell*
A	Left (inner) scenes:

1	*Hercules Kills Centaur* (tondo) (Ovid, *Metamorphoses*, XII)
2	*Aeneas Speaking with Deiphobus in Hades* (rectangle) (*Aeneid* VI: 494–530)
3	destroyed tondo; perhaps Ulysses (Odysseus)? (Della Valle)

B	Outer scenes:

1	*Aeneas Crossing the Threshold into Hades Aeneas and Witnessing Floggings* (rectangle) (*Aeneid* VI: 557–73)
2	*Perseus Frees Andromeda* (tondo) (*Metamorphoses*, Book IV)

3 *Perseus with Gorgon Head* (takes Andromeda as his bride) (rectangle) (*Metamorphoses*, Book IV)

C Right window

1 Right (outer): *The Archangel Raphael and Tobias*
2 Left (inner): *Archangel Gabriel Holding a Lily*

V Beneath *The Torture of the Damned*

A Poet: (left) Ovid (laurel crown; scenes from Ovid)

1 top: *The Questioning of Persephone* (*Metamorphoses* V: 372–95)
2 right: *The Rape of Persephone* (*Metamorphoses* V: 390–400)
3 bottom: *Pluto Sinking into the Pool of Cyane* (*Metamorphoses* V: 408–38)
4 left: *Ceres (Demeter) mourns Proserpine* (*Metamorphoses* V: 440–62)

B Poet: (right) Virgil (dressed as Virgil in tondi; laurel crown; surrounded by grisaille stories)

1 top: *Aeneas's Visit to Hades* (*Aeneid* VI: 269–87)
2 right: *Orpheus Rescues Eurydice* (*Metamorphoses* X: 1–107)
3 left: *Eurydice brought back from Inferno* (*Metamorphoses* X: 1–107)
4 bottom: *Hercules Overthrows Cerberus* (*Metamorphoses* X: 1–107)

C Four damaged little tondi in the outer corners: perhaps Labors of Hercules

VI Beneath *The Resurrection of the Dead.*

A Roman author: *Tibullus* scenes from the opening of the *Elegies* (holds scroll, wears oak wreath)

1 top: *The Horrors of War* (hand-fighting, 8 nude figures)
2 right: *The Horrors of War* (clubbing, 4 figures)

B Cappellina della Pietà (Chapel of the Holy Relics)
 'Keystone' above: figure of a nude Judith with head of Holofernes is against foliage.

1 *Pietà* (with Sts Pietro Parenzo and Faustino)
 a. sarcophagus with *Death of Meleager* (*Metamorphoses* VIII: 513–36)
1 right tondo: *Martyrdom of St Pietro Parenzo*
2 left tondo: *Martyrdom of Santo Faustino*

VII Beneath Doomsday: no grisaille paintings. Imaginative *grotteschi*. Bilaterally symmetrical.

A left tondo: destroyed portrait. No grisaille paintings. Imaginative field of *grotteschi*.

B right tondo: Portrait of a Man wearing a Turban (Empedocles?)

VIII Beneath *The Rule of the Antichrist*

A Roman author: Sallust with scenes from *The Conspiracy of Catiline and the War of Jugurtha*

1 top: *Catiline Rages Throughout Italy*
2 left: *The Release Of Five Prisoners*
3 partial: single figure seems to run with spear

B Architrave keystone: destroyed (now covered by eighteenth-century tomb)

C Cappellina della Magdalena

1 *Resurrection of Lazarus* (destroyed)
2 tondo: *Mary Magdalene* (destroyed)
3 tondo: *Martha Subdues a Dragon* (destroyed)

Bibliography

Documents and primary sources

Andreani, Laura (ed.) (1996), 'I documenti', Appendix I, in *La Cappella Nova o di San Brizio nel Duomo di Orvieto*, ed. Giusi Testa, Milan: Rizzoli, pp. 422–55.

Clementi, Girolamo (1715), 'Gerolamo Curzio Celmentini e la descrizione della Cappella Nova', transcribed by Laura Andreani in *La Cappella Nova o di San Brizio nel Dueomo di Orvieto*, ed. Giusi Testa, Milan: Rizzoli, Appendix II, pp. 456–59.

Dante Aligheri (1482–90), *La Commedia Divina*, ill. Sandro Botticelli, BAV, Vat. Reg. Lat. 1896.

—— (1478–82), *La Commedia Divina*, ill. Guglielmo Giraldi, BAV, Vat. Urb. Lat. 365.

Fumi, Luigi (1884), *Codice diplomatico della città d'Orvieto: documenti regesti dal secolo XI al XV e la Carta del popolo: codice statutario dal commune di Orvieto*, Florence: G. P. Vieusseux.

—— (ed.) (1902–20), *Ephemerides Urbevetanae; Rerum Italicarum Scriptores*, 15 (5),Città di Castello.

Tommaso di Silvestro (1902–20) *Diario, 1482–1514* in Luigi Fumi (ed.), *Ephemerides Urbevetanae; Rerum Italicarum Scriptores*, 15 (5), Città di Castello.

Brevarium Romanum (14c.), BAV, Vat. Lat. 4761.

Breviarium Romanum, manuale corale (1527) BAV, S. Maria Maggiore MS.100, Rome: S. Maria Maggiore.

Breviarium Romanum, manual corale (1527), BAV, R.G. Liturgie III.

Breviarium Romanum Venetiis (1565), Venice, BAV, R.G. Liturgie V. 457.

alingua officia propria (c. 1490) (called 'Codici corali alluminati di Antonio Albèri'), 2 vols, Fra Valentinus de Ungaria, illuminator, MSS. 189 and 190 AODO, Orvieto.

graduale (c. 1490) (called 'Codici corali alluminati di Antonio Albèri'), 2 vols, Fra Valentinus de Ungaria, illuminator, MSS. 187 and 188, AODO, Orvieto.

MS. C1, AODO (c. 1490), AODO, Orvieto.

Published sources

Aichele, Klaus (1974), *Das Antichristdrama des Mitteilalters der Reformation und Gegenreformation*, The Hague: Martinus Nijhoff.

Adorno, Piero (1978), 'Gli Affreschi della Cappella Paradisi nella Chiesa di San Francesco a Terni', *Antichità Viva*, 6, pp. 3–18.

Ahl, Diane Cole (1996), *Benozzo Gozzoli*, New Haven, CT: Yale University Press.

Alberti, Leon Battista (1966), *On Painting*, rev. edn, trans. with intro. by John R. Spencer. New Haven, CT: Yale University Press.

Alexander, J. J. G. (ed.) (1994), *The Painted Page: Italian Renaissance Book Illumination 1450–1550*, New York: Pierpont Morgan Library.

Alpatoff, Michael (1969), 'The Parallelisms of Giotto's Paduan Frescoes', in *Giotto: The Arena Chapel Frescoes*, ed. James Stubblebine, New York: W. W. Norton & Co., pp. 156–69.

d'Ancona, Alessandro (1891), *Origini del Teatro Italiano*, 2nd edn, 2 vols, Turin: Ermanno Loescher.

Andrews, Lew (1995), *Story and Space in Renaissance Art*, Cambridge: Cambridge University Press.

Antamore, Pablo Francesco (1791), *Notizie Istoriche dell'Antica e Presente: Magnifica Cattedrale d'Orvieto*, Rome: Presso I Lazzarini.

Augustine, Saint (1984), *Concerning the City of God Against the Pagans*, trans. Henry Bettenson, intro. by John O'Meara, New York: Penguin Books.

Bailey, Shackleton (1986), *Cicero: Philippics*, ed. and trans. D. R. Shackleford, Chapel Hill, NC: The University of North Carolina Press.

Barilli, Renato (1989), *Rhetoric*, trans. Giuliana Menozzi, Minneapolis, MN: University of Minnesota Press.

Barkin, Leonard (1986), *The Gods Made Flesh: Metamorphosis and the Pursuit of Paganism*, New Haven, CT: Yale University Press.

Barnes, Bernadine (1998), *Michelangelo's Last Judgment: The Renaissance Response*, Berkeley, CA: University of California Press.

—— (1986), 'The Invention of Michelangelo's *Last Judgment*', unpubl. Ph.D. dissertation, University of Virginia.

Barroero, Liliana (1996), 'Gli interventi settecenteschi', in *La Cappella Nova o di San Brizio nel Duomo di Orvieto*, ed. Giusi Testa, Milan: Rizzoli, pp. 289–99.

de Bartholomaeis, Vicenzo (1943), *Laude drammatiche de rappresentazioni sacre*, 3 vols, Florence: Le Monnier.

Baxandall, Michael (1971), *Giotto and the Orators: Humanist Observers of Painting in Italy and the Discovery of Pictorial Composition 1350–1450*, Oxford: Clarendon Press.

—— (1972), *Painting and Experience in Fifteenth Century Italy: A Primer in the Social History of Pictorial Style*, 2nd edn, New York: Oxford University Press.

Beck, James (1990), 'Cardinal Alidosi, Michelangelo, and the Sistine Ceiling', in *Artibus et Historiae*, 11 (22), pp. 63–77.

Benedictines of Solesmes (eds) (1961), *The Liber Usualis*, New York: Desclée Company.

Benois, N., A. Resanoff and A. Krakau (1877), *Monographie de la Cathédrale d'Orvieto*, Paris: A. Morel.

Berengier (13c.), in Walberg, Emmanuel (1928), *Deux versions inédites de la Légende de l'Antéchrist en vers français du XIIIe siècle*, Lund: C. W. K. Gleerup.

Berensen, Bernard (1970), *The Drawings of Florentine Painters*, 2 vols, amplified edn, Chicago: University of Chicago Press.

—— (1932), 'Les dessins de Signorelli', *Gazette des Beaux Arts*, 74 (7), pp. 173–210.

Bergin, Thomas G. (1981), *Boccaccio*, New York: The Viking Press.

—— (1967), *Perspectives on the Divine Comedy*, New Brunswick, NJ: Rutgers University Press.

Bernetti, Giuseppe (ed.) (1972), *I Commentari Pio II*, 5 vols, Siena: Cantagalli.

Bertini, Calosso A. (1941), 'Designi tracciati ad affresco di Luca Signorelli nel Duomo di Orvieto', *Rivista d'Arte*, 23, pp. 194–202.

Bertorello, Carla (1996), 'Scheda di restauro degli affreschi e dell'altare della Gloria', in *La Cappella Nuova o di San Brizio nel Duomo di Orvieto*, ed. Giusi Testa, Milan: Rizzoli, pp. 357–86.

Bizzell, Patricia and Bruce Herzberg (1990), *The Rhetorical Tradition: Readings from Classical Times to the Present*, Boston, MA: Bedford Books of St Martin's Press.

Blanchard, Harold (1949), *Prose and Poetry of the Continental Renaissance in Translation*, New York: Longman, Greens.

Boccaccio, Giovanni (1951), *Genaeologie Deorum Gentilium Libri*, 2 vols, ed. Vincenzo Romano, Bari: Gius Laterza e figli.

de Boer, C. M. and J. van't Sant (1915–54), '*Ovide moralisé*', in *Verhandelingen der Koniklijke Nederlandse Akademie van Wetenschappen*, afd. Letterkunde, 98 vols (Amsterdam), vols 15, 20, 21, 30, 37, 43 and 61.

Bolgar, R. R. (1954), *The Classical Heritage and its Beneficiaries*, Cambridge: Cambridge University Press.

Bonelli, Renato (1972), *Il Duomo di Orvieto e l'Architettura Italiana del Duecento Trecento*, Rome: Officina Edizioni.

Bonniwell, William H., O.P. (1945), *History of the Dominican Liturgy: 1215–1945*, 2nd edn, New York: J. F. Wagner.

Borsook, Eve (1980), *The Mural Painters of Tuscany: Cimabue to Andrea del Sarto*, 2nd edn, Oxford: Clarendon Press.

Bousset, Wilhelm (1896), *The Antichrist Legend: A Chapter in Christian and Jewish Folklore*, London: Hutchison and Co.

de Boxadors, Joannis Thomae (1757), *Collectarium Sacri ordinis FF. Praedicatorum auctoritate apostoloca*, Jussu editum, Vatican City: Typographi Vaticani.

Breviarium Romanum (1876), Mechliniae (Malines): H. Sessain.

Brewer, Wilmon (1933), *Ovid's Metamorphoses in European Culture*, 2 vols, Boston, MA: The Cornhill Publishing Company.

Brieger, Peter, Millard Meiss and Charles Singleton (1969), *Illuminated Manuscripts of the Divine Comedy*, 2 vols, Princeton, NJ: Princeton University Press.

Brown, Hilton (1984), 'Looking at Paintings: Head of a Man by Luca Signorelli', *American Artist*, 48 (November), pp. s44–s49.

Brumana, Biancamria and Galliano Cliberti (1990), *Orvieto: una cattedrale e la sua musica: 1450–1610*, Florence: Olschki.

Butcher, S. H. (1911), *Aristotle's Theory of Poetry and Fine Art: With a Critical Text and a Translation of the Poetics*, 4th edn, London: Macmillan and Co.

Byrnes, Aquinas O.P. (ed.) (1943), *Hymns of the Dominican Missal and Breviary*, London: B. Herder Book Company.

Calosso, Bertini (1941), 'Designi tracciati ad affresco da Luca Signorelli nel Duomo di Orvieto', *Rivista d'Arte*, 23 (3–4), pp. 195–202.

Canuti, Fiorenzo (1931), *Il Perugino*, 2 vols, Siena: Editrice d'arte.

Caplan, Harry (1970), *Of Eloquence: Studies in Ancient and Mediaeval Rhetoric*, Ithaca, NY: Cornell University Press.

Carli, Enzio (1962), *L'Abbazia di Monteoliveto*, Milan: Electra Editrice.

—— (1965), *Il Duomo di Orvieto*, Rome: Instituto poligrafico dello Stato, Libreria dello Stato.

—— (1946), *Luca Signorelli: Gli Affreschi nel Duomo di Orvieto*, Bergamo: Institutio Italiano d'Arti Grafiche.

Carra, Massimo (1965), *Signorelli: Gli Affreschi del Signorelli ad Orvieto*, Milano: Fratelli Fabbri.

Castelli, Patrizia (1996), 'Immortales animae: gli uomini illustri di Orvieto e l'esegesi dantesca', in *La Cappella Nova o di San Brizio nel Duomo di Orvieto*, ed. Giusi Testa, Milan: Rizzoli, pp. 215–21.

Cennini, Cennino (1960), *The Craftsman Handbook: 'Il Libro dell'Arte'*, trans. Daniel V. Thompson, Jr, New York: Dover Publications.

Cerretti, C. (1891), 'Rappresentazione del Miracolo di Bolsena', in *Album Poliglotto ecc.*, L. Fumi (ed.), Rome, pp. 163–78.

Chastel, André (1959), *Art et Humanisme à Florence au temps de Laurent le Magnifique: études sur la Renaissance et l'humanisme platonicien*, Paris: Presses Universitaires de France.

—— (1952), 'L'Apocalypse en 1500: la fresque de l'Antichrist à la chapelle Saint-Brice à Orvieto', *Humanisme et Renaissance*, 14, pp. 124–40.

Cheles, Luciano (1986), *The Studiolo of the Duke of Urbino: An Iconographic Investigation*, University Park, PA: Pennsylvania State University Press.

Cheney, Liana Di Girolami (1984), *The Paintings in the Casa Vasari*, New York: Garland.

Chevalier, Ulysse (1893), *Poésie Liturgique du Moyen Age: Rythme et Historie Hymnaires Italiens*, Paris: reprinted by Geneva, Slatkine Reprints, 1997.

Clementi, Girolamo (1715), 'Gerolamo Curzio Clmentini e la descrizione della Cappella Nova', transcribed by Laura Andreani in *La Cappella Nova o di San Brizio nel Duomo di Orvieto*, ed. Giusi Testa, Milan: Rizzoli, Appendix II, pp. 456–59.

van Cleve, Claire (1996), 'I disegni preparatori', in *La Cappella Nova o di San Brizio nel Duomo di Orvieto*, ed. Giusi Testa, Milan: Rizzoli, pp. 241–51.

Clough, Cecil H. (1976), *Cultural Aspects of the Italian Renaissance*, New York: A. F. Zambelli.

Cohen, Norman R. C. (1970), *The Pursuit of the Millenium: Revolutionary Millenarians and Mystical Anarchists of the Middle Ages*, New York: Oxford University Press.

Collins, Fletcher, Jr (1972), *The Production of Medieval Church Music Drama*, Charlottesville, VA: University Press of Virginia.

Copeland, Rita (1991), *Rhetoric, Hermeneutics, and Translation in the Middle Ages*, New York: Cambridge University Press.

Cruttwell, Maude (1901), *Luca Signorelli*, London: George Bell and Sons.

Curtius, Ernst Robert (1963), *European Literature and the Latin Middle Ages*, trans. from German by Willard R. Trask, New York: Pantheon Books.

Dacos, Nicole (1996), 'Con ferrate e spiritelle', in *La Cappella Nova o di San Brizio nel Duomo di Orvieto*, ed. Giusi Testa, Milan: Rizzoli, pp. 223–31.

—— (1969), *La Découverte de la Domus Aurea et la Formation des Grotesques à la Renaissance*, Leiden: E. J. Brill.

D'Amico, John F. (1983), *Renaissance Humanism in Papal Rome: Humanists and Churchmen on the Eve of the Reformation*, Baltimore, MD: The Johns Hopkins University Press.

Dante Alighieri (1994), *The Inferno of Dante*, ed. and trans. by Robert Pinksey, New York.

—— (1991), *The Divine Comedy*, 6 vols, *Purgatory*, vol. 2: *Commentary*, trans. with commentary by Charles Singleton, Princeton, NJ: Princeton University Press, Bollingen Series 80.

—— (1984), *The Divine Comedy of Dante Alighieri: Purgatorio*, ed. and trans. by Allen Mandelbaum, New York: Bantam Books.

—— (1984), *The Divine Comedy*, 3 vols, trans. with notes by Mark Musa, New York: Penguin Books.

—— (1961), *The Divine Comedy*, 3 vols, vol. 2: *Purgatorio*, trans. and notes by John D. Sinclair, New York: Oxford University Press.

—— (1955), *The Divine Comedy*, 3 vols, vol. 2: *Purgatory*, trans. and notes by Dorothy Sayers, New York: Penguin Books.

—— (1961), *The Purgatorio*, trans. and notes by John Ciardi, New York: New American Library.

—— (1889), *The Banquet: Il Convito*, trans. by Katharine Hillard, London: Kegan Paul, and Trench.

—— (1564), *Dante con i'espositione di Christoforo Landino et di Alessandro Vellutello sopra la sua comedia dell'Inferno del Purgatorio, e del Paradiso*, Venice: Annresso Gianbattista Marchi.

Dante Urbinate della Biblioteca Vaticana reproduzione del Codice Urb. Lat. 365 (1965), Vatican City.

Davanzo, Raffaele and Luciano Marchetti (1996), 'La construzione della cappella le varie fasi edilizie e gli interventi attauli', in *La Cappella Nova o di San Brizio nel Duomo di Orvieto*, ed. Giusi Testa, Milan: Rizzoli, pp. 23–33.

Delaney, John J. (1980), *Dictionary of the Saints*, New York: Doubleday.

Della Valle, Guglielmo (ed.) (1791), *Stampe del Duomo di Orvieto*, Rome, Presso I Lazzarini.

—— (1791), *Storia della Duomo di Orvieto*, Rome: Presso I Lazzarini.

Denzinger, Henricus (1973), *Enchiridion Symbolorum: Definitionum et Declarationum de Rebus Fidei et Morum*, edn 35, Rome: Herder.

Dickinson, Gladys (1960), *DuBellay in Rome*, Leiden: E. J. Brill.

Didi-Huberman, Georges (1995), *Fra Angelico: Dissemblance and Figuration*, trans. by Jane Marie Todd, Chicago, IL: University of Chicago Press.

Dixon, John W. (1983), 'Michelangelo's Last Judgment: Drama of Judgment or Drama of Redemption?', *Studies in Iconography*, 9, pp. 67–82.

Dotson, Esther Gordon (1975), 'An Augustinian Interpretation of Michelangelo's Sistine Ceiling', parts I and II, *Art Bulletin*, 61, pp. 223–56; 405–29.

Dussler, Luitpold (1937), 'Luca Signorelli', in *Allegemeines Lexikon der bildenden Künstler von der Antike bis zur Gegenwart*, vol. 31, by U. Thieme and F. Becker, Liepzig: W. Engelmann.

—— (1927), *Luca Signorelli*, Stuttgart: Deutsche Verlags-Anstalt.

Eisler, Colin (1948), 'Luca Signorelli's *School of Pan*', in *Gazette des Beaux Arts*, 33 (6), pp. 77–92.

Emmerson, Richard Kenneth (1981), *Antichrist in the Middle Ages*, Seattle: University of Washington Press.

—— (1979), 'Antichrist as Anti-Saint: The Significance of Abbot Adso's *Libellus de Antichristo*', in *The American Benedictine Review*, 30, pp. 179–90.

Engles, J. and J. Dupic (1943), *Études sur l'Ovide moralisé*, 2 vols, Groningen: Batvia.

Ettlinger, Helen (1983), 'Dominican Influence in the Stanza della Segnatura and the Stanza d'Eliodorio', *Zeitschrift für Kunstgeschichte*, 46, pp. 176–86.

Ettlinger, Leopold D. (1972), 'Hercules Florentinus', *Mitteilungen des Kunsthistoriches Institutes in Florenz*, 16 (2), pp. 119–42.

—— (1965), *The Sistine Chapel before Michelangelo: Religious Imagery and Papal Primacy*, Oxford: Clarendon Press.

Eubel, Conradus (ed.) (1913–68), *Hierarchia catholica medii et recentioris aevi*, 7 vols, Patavii [Padua]: Il Messaggero di San Antonio di Padua, reprint of Regensburg: Monasterii, sumbtibus et typis Librariae Regensberginanae (1913–68).

—— (ed.) (1913–68), *Hierarchia catholica medii aevi*, 8 vols, Regensburg: Monasterii, sumbtibus et typis Librariae Regensberginanae.

Fitch, John G. (1987), *Seneca's Hercules Furens: A Critical Text with an Introduction and Commentary*, Ithaca, NY: Cornell University Press.

Flanigan, C. Clifford (1974), 'The Roman Rite and the Origins of the Liturgical Drama', *University of Toronto Quarterly*, 43 (3), pp. 263–84.

Fox, Ruth Mary (1958), *Dante Lights the Way*, Milwaukee, WI: Bruce Publishing Company.

Fumi, Luigi (1919), *Orvieto*, Bergamo: Instituto italiano d'artigrafiche.

—— (1891), *Il Duomo di Orvieto e i suoi restauri*, Rome: La Società Laziale Tipografico-Editrice.

—— (1891), *Orvieto: note storiche e biografiche*, Città del Castello: S. Lapi.

—— (1891), *Statuti e Regesti dell'Opera di Santa Maria di Orvieto*, Rome: Tipografica Vaticano.

—— (1877), *Alessandro e il Valentino in Orvieto*, Siena: Tip. sordomuti di L. Lazzeri.

Gabel, Leona C. (ed.) (1959), *Memoirs of a Renaissance Pope: The Commentaries of Pius II*, trans. Florence A. Gragg, New York: E. G. Putnam's Sons.

Gathercole, Patricia M. (1974), *Tension in Boccaccio: Boccaccio and the Fine Arts*, University, MS: Romance Monographs, Inc.

Geiger, Gail (1986), 'Filippino Lippi's Carafa Chapel', *Essays and Studies*, 5: *Renaissance Art in Rome*, Kirkville, MO: Sixteenth Century Journal Publishers, Inc.

Gilbert, Creighton (2003), *How Signorelli and Fra Angelico Saw the End of the World*, University Park, PA: Pennsylvania State University Press, in press.

—— (1996), 'La libreria dell'arcidiacono Albèri', in *La Cappella Nova o di San Brizio nel Duomo di Orvieto*, ed. Giusi Testa, Milan: Rizzoli, pp. 307–19.

—— (1986), 'Signorelli and the Young Raphael', in James Beck (ed.), *Raphael before Rome: Studies in the History of Art*, 17, pp. 109–24.

—— (1983), 'Bramante on the Road to Rome (with Some Leonardo Sketches in his Pocket)', *Arte Lombarda*, 66 (3), pp. 5–14.

—— (1975), 'Fra Angelico's Fresco Cycles in Rome: Their Number and Date', *Zeitschrift für Kunstgeschichte*, 38, pp. 245–65.

—— (1974), 'The Egg Reopened Again', *Art Bulletin*, 61, pp. 252–58.

Gizzi, Corrado (ed.) (1991), *Signorelli e Dante*, Milan: Electra.

Glasser, Hannelore (1977), *Artists' Contracts of the Early Renaissance*, New York: Garland.

Goffen, Rona (1986), 'Friar Sixtus IV and the Sistine Chapel', *Renaissance Quarterly*, 39 (2), pp. 218–62.

Gombrich, E. H. (1985), *Norm and Form*, 4th edn, Chicago, IL: University of Chicago Press.

Grafton, Anthony (ed.) (1993), *Rome Reborn: The Vatican Library and Renaissance Culture*, Washington, DC: Library of Congress.

—— (1993), 'The Ancient City Restored: Archaeology, Ecclesiastical History, and Egyptology,' in Anthony Grafton (ed.), *Rome Reborn: The Vatican Library and Renaissance Culture*, Washington, DC: Library of Congress, pp. 87–123.

—— (1993), 'The Vatican and its Library', in Anthony Grafton (ed.), *Rome Reborn: The Vatican Library and Renaissance Culture*, Washington, DC: Library of Congress, pp. 3–46.

Hall, Edwin and Horst Uhr (1992) 'Patrons and Painter in Quest of an Iconographic Program: The Case of the Signorelli Frescoes at Orvieto', *Zeitschrift für Kunstgeschichte*, 55 (1), pp. 35–56.

Hall, Marcia B. (1976), 'Michelangelo's *Last Judgment*: Resurrection of the Body and Predestination', *Art Bulletin*, 63 (1), pp. 85–92.

Hankins, James (1993), 'The Popes and Humanism', in Anthony Grafton (ed.), *Rome Reborn: The Vatican Library and Renaissance Culture*, Washington, DC: Library of Congress, pp. 47–86.

Hardison, O. B. (1965), *Christian Rite and Christian Drama in the Middle Ages: Essays in the Origin and Early History of Modern Drama*, Baltimore, MO: Johns Hopkins Press.

—— (1973), *The Enduring Monument*, Westport, CN: Greenwood Press.

Hartt, Frederick (1994), *History of Italian Renaissance Art: Painting, Sculpture, Architecture*, 4th edn, rev. by David Wilkin, New York: Prentice-Hall.

Haskins, Susan (1993), *Mary Magdalen: Myth and Metaphor*, New York: Harcourt, Brace and Company.

Henry, Hugh (1890), 'Two Medieval Hymns', *American Ecclesiastical Review* (April), pp. 247–61.

Henry, Tom (1996), 'I cartone', in *La Cappella Nova o di San Brizio nel Duomo di Orvieto*, ed. Giusi Testa, Milan: Rizzoli, pp. 253–67.

—— (1996), 'The Career of Luca Signorelli in the 1490s', unpublished Ph.D. dissertation, Courtauld Institute of Art, The University of London.

—— (1993), 'Signorelli, Raphael, and a "mysterious" pricked drawing in Oxford', *Burlington Magazine*, 85 (September), pp. 612–19.

Henry, Tom and Laurence Kanter (2002), *Luca Signorelli: The Complete Paintings*, New York: Rizzoli.

Herzman, Ronald B. (1999), '"Visible Parlare:" Dante's *Purgatorio* 10 and Luca Signorelli's San Brizio Frescoes', *Studies in Iconography*, 20, pp. 155–83.

Hibbard, Howard (1974), *Michelangelo*, 2nd edn, New York: Icon Books.

Hinnebusch, William A. (1973), *The History of the Dominican Order: Intellectual and Cultural Life to 1500*, 2 vols, New York: Alba House.

—— (1967), 'Dominican Spirituality', *New Catholic Encyclopedia*, 4, pp. 971–74.

Hood, William (1993), *Fra Angelico at San Marco*, New Haven, CT: Yale University Press.

—— (1990), 'Fra Angelico at San Marco: Art and the Liturgy of Cloistered Life', in T. Verdon and J. Henderson (eds), *Christianity and the Renaissance*, Syracuse: Syracuse University Press.

Horowitz, Marianne Kline (1976), 'Aristotle and Women', *Journal of the History of Biology*, 9 (2), pp. 183–213.

De Houtsneden van Mansion's Ovide Moralise (1922), Amsterdam: P.N. van Kampen & Zoon, reprint of M. D. Henkel, Bruges, 1484.

James, Sara Nair (2001), 'Penance and Redemption: The Role of the Roman Liturgy in Luca Signorelli's Painted Sermon at Orvieto', *Artibus et Historiae*, 22 (44), pp. 119–47.

—— (1994), 'Poetic Theology in Signorelli's Cappella Nuova at Orvieto', unpublished Ph.D. dissertation, University of Virginia.

Jungmann, Josef A. (1986), *The Mass of the Roman Rite: Its Origins and Development*, trans. Francis Brunner, 2 vols, Westminster, MD: Christian Classics.

Kaftal, George (1952), *The Iconography of the Saints in Italian Painting from its Beginning to the Early Sixteenth Century*, 3 vols, 1: *Iconography of the Saints in Tuscan Painting*, Florence: Sansoni.

Kanter, Laurence (1998) '...da pagarsi di tempo in tempo secondo el lavoro che farà [...]' rev. and trans. by L. Kanter, unpublished manuscript, pp. 1–39.

—— (1996), '...da pagarsi di tempo in tempo secondo el lavoro che farà [...]' in *La Cappella Nova o di San Brizio nel Duomo di Orvieto*, ed. Giusi Testa, Milan: Rizzoli, pp. 95–134.

—— (1989), 'The Late Work of Luca Signorelli and His Followers: 1498–1559', unpublished Ph.D. dissertation, New York University.

—— (1983), *Orvieto: Chapel of San Brizio, Luca Signorelli*, Florence: Scala.

Martin Kemp (ed.) (1989), *Leonardo On Painting*, trans. by M. Kemp and M. Walker, New Haven, CT: Yale University Press.

Kennedy, George A. (1980), *Classical Rhetoric and Its Christian Secular Tradition from Ancient to Modern Times*, Chapel Hill, NC: The University of North Carolina Press.

Kermode, Frank (1979), *The Genesis of Secrecy: On the Interpretation of Narrative*, Cambridge, MA: Harvard University Press.

King, Archdale A. (1955), *Liturgies of the Religious Orders*, New York: Longmans, Green and Co.

Koch, Guntram (1975), *Die Mythologischen Sarcophage*, 12 vols, 6: *Meleager*. Deutches Archäologisches Institut, Die Antiken Sarcophagreliefs herausgeghen vor Frederich Matz und Bernhard Andreae, Berlin: Gebr. Mann Verlag.

Kolve, V. A. (1966), *The Play Called Corpus Christi*, Stanford, CA: Stanford University Press.

Kristeller, Paul Oskar (1974), 'Thomism and Italian Thought of the Renaissance', ed. and trans. by Edward Mahoney, in *Medieval Aspects of Renaissance Learning*, by P. O. Kristeller, Durham: Duke University Press, pp. 29–91.

—— (1970), 'The Contribution of the Religious Orders to Renaissance Thought and Learning', *American Benedictine Review*, 21, pp. 1–55.

Kury, Gloria (1978), *The Early Work of Luca Signorell: 1465–1490*, New York: Garland Publishing Co.

Lambert, M. D. (1977), *Medieval Heresy: Popular Movements from Bogomil to Hus*, London: E. Arnold.

La Row, Sr Magdalen (1982), 'The Iconography of Mary Magdalen: The Evolution of Western Thought until 1300', unpublished Ph.D. dissertation, New York University.

Lasance, Rev. F. X. and Francis A. Walsh (1945), *The New Roman Missal*, New York: Benzinger Brothers.

Lavin, Marilyn Aaronberg (1990), *The Place of Narrative: Mural Decoration in Italian Churches, 431–1600*, Chicago, IL: University of Chicago Press.

Lee, Egmont (1978), *Sixtus V and Men of Letters*, Rome: Edizione di Storica e Letteratura.

Lee, Rensselaer W. (1940), '"Ut Pictura Poesis:" The Humanist Theory of Painting',

Art Bulletin, 22, pp. 197–269, published separately under the same title, New York: W. W. Norton, 1967.

Lefebvre, Dom Gaspar, O.S.B. (1953), *Saint Andrew Daily Missal with Vespers for Sundays and Feasts*, St Paul, MN: E. M. Lohmann.

Le Goff, Jacques (1984), *The Birth of Purgatory*, trans. by Arthur Goldhammer, Chicago, IL: University of Chicago Press.

Lesnick, Daniel (1989), *Preaching in Medieval Florence: The Social World of Franciscan and Dominican Spirituality*, Athens: University of Georgia Press.

Lewine, Carol (1993), *The Sistine Chapel Walls and the Roman Liturgy*, University Park, PA: Pennsylvania State University Press.

Longhi, Roberto (1953), L'autoritratto *del Signorelli del museo di Orvieto è un falso?* Florence.

Loscalzo, Donato (1996), 'Le fondamenta dei classici', in *La Cappella Nova o di San Brizio nel Duomo di Orvieto*, ed. Giusi Testa, Milan: Rizzoli, pp. 191–213.

Luzi, Ludovico (1866), *Il Duomo di Orvieto descritto e illustrato*, Florence: Le Monnier.

Lyra catholica (1884), trans. by Edward Caswall, M.A., New York: Burnes and Oates, Catholic Publication Society.

Macdonald, Inez (1941), 'On the Origins of the Liturgical Drama of the Middle Ages', *Modern Language Review*, 36 (3), pp. 369–87.

Macrobius (1952), *Commentary on the Dream of Scipio*, trans. with intro. and notes by William Harris Stahl, New York: Columbia University Press.

Maguire, Henry (1988), 'The Art of Comparing in Byzantium', *Art Bulletin*, 70 (1), pp. 88–103.

—— (1981), *Art and Eloquence in Byzantium*, Princeton, NJ: Princeton University Press.

deMaio, R. (1970), 'Savonarola, Alessandro IV e il mito dell'Anticristo', *Revista storica italiana*, 83, pp. 533–59.

Mâle, Emile (1972), *The Gothic Image: Religious Art in France of the Thirteenth Century*, trans. Dora Nussey, New York: Harper and Row Icon editions.

Mancini, Girolamo (1903), *Vita di Luca Signorelli*, Florence: Carnesecchi.

Mann, Horace K. (1929), *Lives of the Popes in the Middle Ages*, 18 vols, St Louis, MO: B. Herder Books.

Marchese, Vincenzo, O.P. (1854), *Memorie dei più insigni Pittori, Scultori e Architetti Domenicani*, 2nd edn, 2 vols, Florence: Felice Le Monnier.

Marchetti, Luciano (1996), 'L'architettura dipinta: da un ambiente gotico a uno spazio rinascimentale', in *La Cappella Nova o di San Brizio nel Duomo di Orvieto*, ed. Giusi Testa, Milan: Rizzoli, pp. 151–64.

Mario, Eugenio, O. P. (1990), 'Art Criticism and Icon-Theology', in Timothy Verdon and John Henderson (eds), *Christianity and the Renaissance*, Syracuse: Syracuse University Press, pp. 572–91.

Martindale, Andrew (1961), 'Luca Signorelli and the drawings connected with the Orvieto Frescoes', *Burlington Magazine*, 53 (June), pp. 216–20.

Martindale, Charles (ed.) (1997), *The Cambridge Companion to Virgil*, Cambridge: Cambridge University Press.

—— (1988), *Ovid Renewed: Ovidian Influences on Literature and Art from the Middle Ages to the Twentieth Century*, New York: Cambridge University Press.

McGinn, Bernard (1994), *Antichrist: Two Thousand Years of the Human Fascination with Evil*, San Francisco: HarperSanFrancisco.

—— (1979), *Visions of the End: Apocalyptic Traditions in the Middle Ages*, New York: Columbia University Press.

—— (1979), *Apocalyptic Spirituality: Treatises and Letters of Lactantius, Adso of Montier-en Der, Joachim of Fiore, The Franciscan Spirituals, Savonarola*, trans. and intro. by McGinn, preface by Margorie Reeves, New York: Paulist Press.

McLellan, Dugald E. (1998), *Signorelli's Orvieto Frescoes: A Guide to the Cappella Nuova of Orvieto Cathedral*, Perugia: Quattroemme.

—— (1992), 'Luca Signorelli's Last Judgement Fresco Cycle at Orvieto: An Interpretation of Fears and Hopes of the Commune and the People of Orvieto at a Time of Reckoning', unpublished Ph.D. dissertation, Melbourne University.

—— (1993), 'The Cappella Nuova at Orvieto before Signorelli: Perugino and the Opera del Duomo – A Question of Commitment', unpublished essay.

McMahon, Amos Philip (ed.) (1956), *Leonardo da Vinci's Treatise on Painting (Codex Urbinas Latinus 1270)*, trans. and annotated by A. P. McMahon, Princeton, NJ: Princeton University Press.

Meersseman, G. (1938), 'La prédication dans les congrégations mariales au XIIIe siècle', *Archivum Fratrum Praedicatorum*, 18, pp. 131–61.

Meiss, Millard (1976), *The Painter's Choice: Problems in the Interpretation of Renaissance Art*, New York: Harper and Row Icon editions.

—— (1954), '*Ovum Struthionis:* Symbol and Allusion in Piero della Francesca's Montefeltro Altarpiece', *Art Bulletin*, 36, p. 221.

Meiss, Millard and Theodore Jones (1966), 'Once Again Piero della Francesca's Montefeltro Altarpiece', *Art Bulletin*, 48, pp. 203–6.

Meltzoff, Stanley (1987), *Botticelli, Signorelli, and Savonarola: theologia poetica and painting from Boccaccio to Poliziano*, Florence: Leo S. Olschki.

Mendelsohn, Beatrice (1988), 'Quanto Signorelli deve al Fra Angelico', *Giornale dell'Arte*, 61 (November), p. 85.

Meuthen, Erich (1958), *Die Letzten Jahres des Nikolaus von Kues*, Cologne: Westdeutscher Verlag.

—— (1954), 'I Primi Commendatari dell'Abbazia dei SS. Severo e Martirio in Orvieto', *Bollettino ell'Instituto Storico Artistico Orvietano*, 10, pp. 37–39.

Miles, Margaret Ruth (1992), 'The Revelatory Body: Luca Signorelli and the Resurrection of the Flesh at Orvieto', *Harvard Divinity Bulletin*, 22 (1), pp. 10–13.

Mills, David (1992), *The Chester Mystery Cycle*, East Lansing, MI: Colleagues Press.

Morford, Mark P. O. (1967), *The Poet Lucan: Studies in Rhetorical Epic*, New York: Barnes and Noble.

Moriondo, Margherita, curator (1953), *Monstra di Luca Signorelli*, Florence: E. Ariani.

Moroni, Gaetano (1852), *Dizionario di Erudizione Storico-Ecclesiastica*, 109 vols, Venice: Tipografica Emliana.

Mortier, Daniele Antonin (1902–20), *Histoire des maîtres généraux de l'ordre des Frères Prêcheurs*, 3 vols, Paris: A. Picara.

Mulcahy, Cornelius (ed.) (1938), *The Hymns of the Roman Breviary and Missal*, Dublin: Browne and Nolan Limited.

Natalini, Dott. Vincenzo (1936), *S. Pietro Parenzo: La Leggenda Scritta dal Maestro Giovanni Canonico di Orvieto*, Rome: Instituto Grafico Tiberino.

—— (ND, *c.* 1930s), *Il Protettore del Podesta Italiani: S. Pier Parenzo Roman Podesta di Orvieto*, Orvieto.

O'Malley, John W., S.J. (1979), *Praise and Blame in Renaissance Rome: Rhetoric, Doctrine, and Reform in the Sacred Orators of the Papal Court 1450–1521*, Durham, NC: Duke University Press.

—— (1986), 'The Theology behind the Sistine Ceiling', in *The Sistine Chapel: The Art, the History, and the Restoration*, ed. Carlo Pietrangeli, New York: Harmony Books.

Osgood, Charles G. (1930), *Boccaccio on Poetry*, Princeton, NJ: Princeton University Press.

Ouidio Methamorphoseos vulgare (1497), interpreted by Ioani de Buonsignore and illustrations attributed to Zoan Andrea, Venice: L. A. Giunta.

Ovid (1993), *Metamorphoses*, trans. with notes by Allen Mandelbaum, New York: Harcourt, Brace.

—— (1986), *Metamorphoses*, trans. and notes by A. D. Melville, New York: Oxford University Press.

Panofsky, Erwin (1972), *Studies in Iconology: Humanistic Themes in the Art of the Renaissance*, New York: Harper and Row Icon editions.

—— (1930), *Hercules am Scheidewege und Andere Antike Bildstoffe in der Neueren Kunst*, Berlin: B. G. Teubner.

Paoli, Emore (1996), 'Il programma teologico-spirituale del Giudizio Universale di Orvieto', in *La Cappella Nova o di San Brizio nel Duomo di Orvieto*, ed. Giusi Testa, Milan: Rizzoli, pp. 65–76.

Paolucci, Antonio (1996), 'La rappresentazione teatrale di Luca Signorelli', in *La Cappella Nova o di San Brizio nel Duomo di Orvieto*, ed. Giusi Testa, Milan: Rizzoli, pp. 135–45.

Pascal, R. (1941), 'On the Origins of the Liturgical Drama of the Middle Ages', *The Modern Language Review*, 36 (3), pp. 369–87.

Pastor, Ludwig (1950), *The History of the Popes from the Close of the Middle Ages*, ed. and trans. by F. I. Antrobus, 5 vols, St Louis, MO: B. Herder Books.

Perali, Pericle (1919), *Orvieto: Note storiche di topografia e d'arte dalle origini al 1800*, Città de Castello; reprint: Rome: Multigrafica Editrice, 1979.

Petrangeli, Enrico (1986–87), 'Dalle Stranezze al Significato: Schede per Una Interpretazione Antropologica del Diario di Ser Tommaso Silvestro', *Bollettino Instituto Storico Artistico Orvietano*, 42–43, pp. 225–42.

Pietrangeli, Carlo (ed.) (1986), *The Sistine Chapel: The Art, the History, and the Restoration*, New York: Harmony Books.

Petrarch, Francesca (1950), *Invective contra medicum*, ed. Pier Giorgio Ricci, Rome: Storia e letteratura.

—— (1949), 'On Solitude', in Harold Blanchard, *Prose and Poetry of the Continental Renaissance in Translation*, New York: Longmans, Green.

Piccolomini-Adami, Tommaso (1883), *Guida Storico artistica della Città di Orvieto*, Siena: Tip. all' ins. di S. Bernardino.

Piccolomini, Enea Silvio (1984), *I Commentarii*, ed. Luigi Totaro, 2 vols, Milan: Adelphi Edizioni.

Pius II, Pope (1959), *Memoirs of a Renaissance Pope: The Commentaries of Pius II*, ed. and intro. Ruth O. Rubenstein, trans. Florence A. Gragg, New York: Putnam.

Philip, Lotte Brand (1971), *The Ghent Altarpiece and the Art of Jan van Eyck*, Princeton, NJ: Princeton University Press.

Polzer, J. (1989), 'The Role of the Written Word in the Early Frescoes in the Campo Santo of Pisa', in Irving Lavin (ed.), *World Art: Themes of Unity and Diversity*, 3 vols, University Park, PA: Pennsylvania State University Press, pp. 361–66.

Pope-Hennessey, John (1981) *Fra Angelico*, Florence: Scala.

Radke, Gary (1984), 'Medieval Frescoes in the Papal Palaces of Orvieto and Viterbo', *Gesta*, 23 (1), pp. 27–38.

Rand, Edward K. (1925), *Ovid and his Influence*, Boston, MA: Marshall Jones Co.

Ranke, Leopold (1947), *The History of the Popes: Their Church and State*, 3 vols, trans. by E. Foster, London: Henry J. Bohn.

Reeves, Marjorie (1972), *The Figurae of Joachim of Fiore*, Oxford: Clarendon Press.

—— (1969), *The Influence of Prophecy in the Later Middle Ages: A Study in Joachimism*, Oxford: Clarendon Press.

Réau, Louis (1957), *Iconographie de l'Art Chrétien*, 3 vols, 2: *Iconographie de la Bible*, part 2: *The New Testament*, Paris: Presses Universitaires de France.

Riccetti, Lucio (ed.) (1992), *La città costruita: Lavori, pubblici e imagine in Orvieto medievale*, Florence: Le Lettere.

—— (1987), *Dalla Storica Sociale alla Metafora Spiritulae*, trans. into English by Erika Pauli, Rome: Italsiel.

—— (ed.) (1988), *Il Duomo di Orvieto*, Rome: Editori Laterza.

Riess, Jonathan B. (1995), *The Renaissance Antichrist: Luca Signorelli's Orvieto Frescoes*. Princeton, NJ: Princeton University Press.

—— (1990), 'Republicanism and Tyranny in Signorelli's *Rule of the Antichrist*', in Charles Rosenberg (ed.), *Art and Politics in Late Medieval and Early Renaissance Italy: 1250–1500*, Notre Dame: University of Notre Dame Press.

—— (1988), 'La genesi degli affreschi del Signorelli per la Cappella Nova', in *Il Duomo di Orvieto*, ed. Lucio Riccetti, Rome: Editori Laterza.

—— (1987), 'Signorelli's Dante Illustrations in Orvieto Cathedral: Narrative, Structure, Iconography, and Historical Context', *College Art Association Abstracts*, vol. 75, p. 65.

—— (1985), 'Luca Signorelli's Frescoes in the Chapel of San Brixio as Reflections of their Time and Place', in *Renaissance Studies in Honor of Craig Hugh Smyth*, 2 vols, 2: *Art and Architecture*, ed. Andrew Morrogh, Florence: Giunti Barbèra.

Roettgen, Steffi (1997), *Italian Frescoes: The Flowering of the Renaissance*, trans. Russell Stockman, New York: Abbeville Press.

—— (1996), *Italian Frescoes: The Early Renaissance*, trans. Russell Stockman, New York: Abbeville Press.

Rolfi, Gianfranco, Ludovica Sebregondi and Paolo Viti (eds) (1992), *La Chiesa e la Città a Firenze nel XV Secolo*, Florence: Silvana.

The Roman Missal in Latin and English (1930), intro. and notes by Abbot Cabrol, New York: P. J. Kennedy.

Romano, Serena (1976), 'Due Affreschi del Cappellone degli Spagnoli: Problemi iconologici', *Storia dell'Arte*, 28, pp. 181–213.

Rubin, Miri (1991), *Corpus Christi: The Eucharist in Late Medieval Culture*, New York: Cambridge University Press.

Russell, Jeffrey B. (1997), *A History of Heaven: The Singing Silence*, Princeton, NJ: Princeton University Press.

Sallust (1967), *The Conspiracy of Catiline and the War of Jugurtha*, trans. T. Heywood in 1608 with intro. by Charles Whibley, New York: AMS Press.

Salutati, Coluccio (1951), *De Laboribus Hercules*, 2 vols, ed. B. L. Ullman, Turici: In Aedibus Thesauri Mundi.

Salmi, Mario (1953), *Luca Signorelli*, Novara: Instituto Geografico de Agostini.

—— (1927), *Luca Signorelli*, Florence: Fratelli Alinari.

Sandström, Sven (1963), *Levels of Unreality: Studies in Structure and Construction in Italian Mural Painting During the Renaissance*, Uppsala: Almquist and Wiksell.

San Juan, Rose Marie (1989), 'The Illustrious Poets in Signorelli's Frescoes for the Cappella Nuova of Orvieto Cathedral', *Journal of the Warburg and Courtauld Institutes*, 52, pp. 71–84.

—— (1985), 'The Function of Antique Ornament in Luca Signorelli's Fresco Decoration for the Chapel of S. Brizio', *Canadian Art Review*, 12, pp. 235–42.

Scarpellini, Pietro (1967), 'L'inspiration dantesca negli affreschi del Signorelli a Orvieto', *Bollettino Instituto Storico Artistico Orvietano*, 21, pp. 1–29.

—— (1964), *Luca Signorelli*, Milan: Edizione per il club del libro.

Scarpellini, Pietro and E. Carli (1968), 'Il Duomo di Orvieto', *Bollettino Deputazione Storica Patria per Umbria*, 1, pp. 197–201.

Scentoni, Gina (ed.) (1994), *Laudario Orvietano*, Spoleto: Centro Itaniano di Studi sull'altro Medioevo.

Schiller, Gertrud (1990), *Ikonographie der Christlichen Kunst*, 5 vols, 5: *Die Apokalypse des Johannes*, Gütersloh: GütersloherVerlagshaus Gerd Mohn.

Schubring, Paul (1931), *Illustrazione zu Dantes Gottlicher Kommodie*, Zurich: Amalthea-Verlag.

Schultze Altcappenberg, Hein-Th. et al. (2000), *Sandro Botticelli: The Drawings for Dante's Divine Comedy*, London: Royal Academy.

Serafini, Angelo (1911), *L'Epopea Cristiana nei Dipinti di Beato Angelico*, Orvieto: Tipografia M. Marsili.

Seznec, Jean (1953), *The Survival of the Pagan Gods: The Mythological Tradition and its Place in the Renaissance and Humanism in Art*, trans. Barbara Sessions, New York: Harper and Brothers.

Shearman, John (1986), 'The Chapel of Sixtus IV', in *The Sistine Chapel: The Art, the*

History, and the Restoration, ed. Carlo Pietrangeli, New York: Harmony Books, pp. 22–87.

Silvestris, Bernardus (1979), *Commentary on the First Six Books of Virgil's Aeneid*, trans. with intro. and notes by Earl Schreiber and Thomas E. Masesca, Lincoln, NE: University of Nebraska Press.

Smalley, Beryl (1964), *The Study of the Bible in the Middle Ages*, 2nd edn, Notre Dame: University of Notre Dame Press.

Smith, Christine (1992), *Architecture in the Culture of Early Humanism: Ethics, Aesthetics and Eloquence 1400–1470*, New York: Oxford University Press.

Smith, Lesley (2001), *Masters of the Sacred Page: Manuscripts of Theology in the Latin West to 1274*, Notre Dome: University of Notre Dame Press.

Snyder, James (1989), *Medieval Art: Painting, Sculpture, Architecture, 4th to 14th Century*, New York: Prentice-Hall.

Spencer, John R. (1957), 'Ut Rhetorica Pictura: A Study in Quattrocento Theory of Painting', *Journal of the Warburg and Courtauld Institutes*, 20, pp. 26–44.

Staff of the Liturgical Press (1964), *The Hours of the Divine Office in English and Latin*, 3 vols, 3: *August to Advent*, Collegeville, MN: The Liturgical Press.

Steinberg, Leo (1975), 'Michelangelo's *Last Judgment* as Merciful Heresy', *Art in America*, 63, pp. 48–63.

Strauss, Marjory (1971), 'The Death of Meleager', unpublished M.A. thesis, University of North Carolina at Chapel Hill.

Stinger, Charles (1985), *The Renaissance in Rome*, Bloomington, IN: Indiana University Press.

Strnad, A. A. (1964–66), 'Francesco Todeschini-Piccolomini: Politick und Mäzenatentum im Quattrocento', in *Sonderdruck die Römische Historiche Mitteilungen*, Graz, 8/9, pp. 139–39 and 396–97.

Stubblebine, James H. (ed.) (1969), *Giotto: The Arena Chapel Frescoes*, New York: W. W. Norton and Company.

Summers, David (1987), *The Judgment of Sense*, New York: Cambridge University Press.

—— (1981), *Michelangelo and the Language of Art*, Princeton, NJ: Princeton University Press.

—— (1977), 'Contrapposto: Style and Meaning in Renaissance Art', *Art Bulletin*, 59 (4), pp. 336–61.

Surh, Dominique (2000), 'Corpus Christi and the *Cappella del Corporale* at Orvieto', unpublished Ph.D. dissertation, University of Virginia.

Testa, Giusi (1996), 'La cappellina dei Corpi Santi e la cappellina della Maddalena', in *La Cappella Nova o di San Brizio nel Duomo di Orvieto*, ed. Giusi Testa, Milan: Rizzoli, pp. 269–75.

—— (1996), 'Et vocatur dictas magister pictor frater Johannes', in *La Cappella Nova o di San Brizio nel Duomo di Orvieto*, ed. Giusi Testa, Milan: Rizzoli, pp. 77–86.

—— (1990), *La Cattedrale di Orvieto: Sta. Maria Assunta in Cielo*, Rome: Instituto Poligrafico e Zecca del Stato.

Taylor, Michael D. (1969), *The Iconography of the Facade Decoration of the Cathedral of Orvieto*, Ph.D. dissertation, New York: Garland Press.

Thieme, U. and F. Becker (1907–50), *Allgemeines Lexikon der bildenden Künstler von der Antike bis zur Gegenwart*, 37 vols, Leipzig: W. Engelmann.

Thomas Aquinas (1947), *Summa Theologica*, trans. by Fathers of the English Province, New York: Benziger Brothers.

Thomas Aquinas (1964), *Summa Theologiae*, 2 vols, Latin text and English trans. by Blackfriars, New York: Blackfriars in conjunction with McGraw-Hill Book Company.

Tibullus, Albius (1913), *The Elegies*, ed. and notes by Kirby Smith, New York: The American Book Company.

Trapp, J. B. (1980), *The Poet and the Monumental Impulse*, London: Society for Renaissance Studies.

Trinkaus, Charles (1979), *The Poet as Philosopher: The Formation of the Renaissance Consciousness*, New Haven, CT: Yale University Press.

—— (1970), *In Our Image and Likeness: Humanity and Divinity in Italian Humanist Thought*, 2 vols, Chicago, IL: University of Chicago Press.

Van Marle, R. (1924), 'La scuola pittorica orvietana del '300', *Bolettino d'Arte*, 3.

Vasari, Giorgio (1996), *Lives of the Most Eminent Painters, Sculptors, and Architects*, trans. by Gaston du C. de Vere, intro. and notes by David Ekserdjian, 2 vols, New York: Alfred A. Knopf.

—— (1965), *Lives of the Artists*, 2 vols, a selection trans. by George Bull, New York: Penguin Books.

—— (1930), *Le vitae de' più eccellenti pittori, scultori, e architettori*, Enrico Bianchi, ed., 7 vols, Florence: Adriano Salani.

Venturi, Aldolfo (1921), *Luca Signorelli Interprete de Dante*, Florence: F. le Monnier.

Via, Claudia (1996), 'Signum inducium indicantia: Riflessiooni sul programma iconologio della Cappella Nuova', in *La Cappella Nova o di San Brizio nel Duomo di Orvieto*, ed. Giusi Testa, Milan: Rizzoli, pp. 165–90.

Vischer, Robert (1879), *Luca Signorelli und die italienische Renaissance*, Liepzig: Veit and Co.

Volkmann, Ludwig (1892), *Bildliche Darstellungen zu Dantes Divina Commedia bis zum Ausgang der Renaissance*, Leipzig: Breitkopf.

de Voragine, Jacobus (1993), *The Golden Legend*, 2 vols, trans. by William Granger Ryan, Princeton, NJ: Princeton University Press.

Waley, Daniel Philip (1952), *Mediaeval Orvieto: The Political History of an Italian City-State 1157–1334*, Cambridge: Cambridge University Press.

Walz, Father Angelus, O.P. (1951), *St. Thomas Aquinas: A Biographical Study*, trans. Father Sebastian Bullough, O.P., Westminster, MD: The Newman Press.

Warner, Marina (1976), *Alone of All Her Sex: The Myth and the Cult of the Virgin Mary*, New York: Vintage Books edn, Random House; reprint, New York: Alfred A. Knopf.

Watts, Barbara J. (1995), 'Sandro Botticelli's Drawings for Dante's *Inferno*: Structure, Topography, and Manuscript Design', *Artibus et Historiae*, 16 (32), pp. 163–201.

—— (1989), 'Studies in Sandro Botticelli's Drawings for Dante's *Inferno*', unpublished Ph.D. dissertation, University of Virginia.

Weil-Garris, Kathleen and John D'Amico (1980), *The Renaissance Cardinal's Ideal Palace: A Chapter from Cortesi's 'De Cardinalatu'*, Rome: Edizioni dell'Elefante, American Academy in Rome.

Weinberg, Julius R. (1964), *A Short History of Medieval Philosophy*, Princeton, NJ: Princeton University Press.

Weisheipl, James, O.P. (1974), *Friar Thomas d'Aquino: His Life, Thought, and Work*, New York: Doubleday.

Weitzmann, Kurt (1977), *The Age of Spirituality: Late Antique and Early Christian Art Tradition Third to Seventh Century*, New York: Metropolitan Museum of Art.

Westfall, Carroll William (1974), *In This Most Perfect Paradise*, University Park, PA: Pennsylvania State University Press.

White, John (1959), 'Facade Reliefs, Orvieto', *Journal of the Warburg and Courtauld Institutes*, 22, pp. 254–302.

Whitt, Ronald (1983), *Hercules at the Crossroads: The Life, Works, and Thoughts of Coluccio Salutati*, Durham, NC: Duke University Press.

Wilk [McHam], Sarah Blake (1985), 'The Cult of Mary Magdalen in Fifteenth Century Florence and its Iconography', in *Studi Medievali*, 26, ser. 3 (2), pp. 685–98.

Wilkins, Ernest (1978), *Studies on Petrarch and Boccaccio*, ed. A. S. Bernardo, Padua: Editrice Antenore.

Wind, Edgar (1968), *Pagan Mysteries in the Renaissance*, rev. and enlarged edn, New York: W. W. Norton.

Wohl, Hellmut (1999), *The Aesthetics of Italian Renaissance Art: A Reconsideration of Style*, Cambridge: Cambridge University Press.

Wright, John (1967), *The Play of the Antichrist*, trans. with an intro. by John Wright, Toronto: Pontifical Institute of Mediaeval Studies.

Young, Karl (1933), *The Drama of the Medieval Church*, 2 vols, Oxford: Clarendon Press.

Index

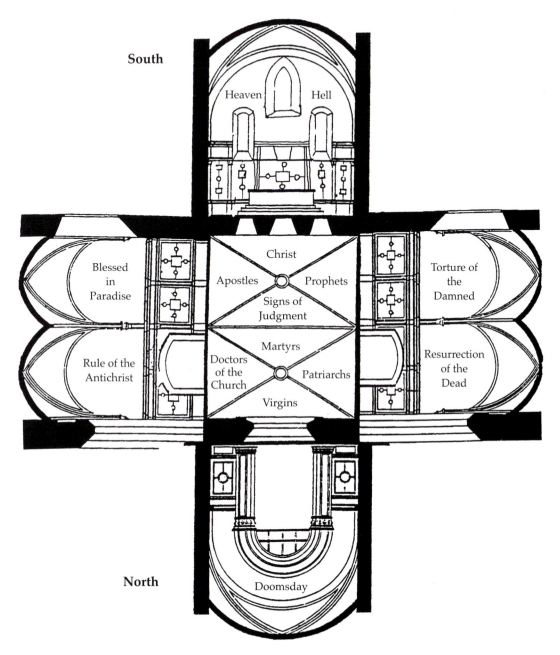

South

Heaven | Hell

Christ

Blessed in Paradise

Apostles | Prophets

Torture of the Damned

Signs of Judgment

Martyrs

Rule of the Antichrist

Doctors of the Church | Patriarchs

Resurrection of the Dead

Virgins

North

Doomsday

9 Diagram of the walls and vaults of the Cappella Nuova showing the probable configuration before the eighteenth century changes (based on Vischer)

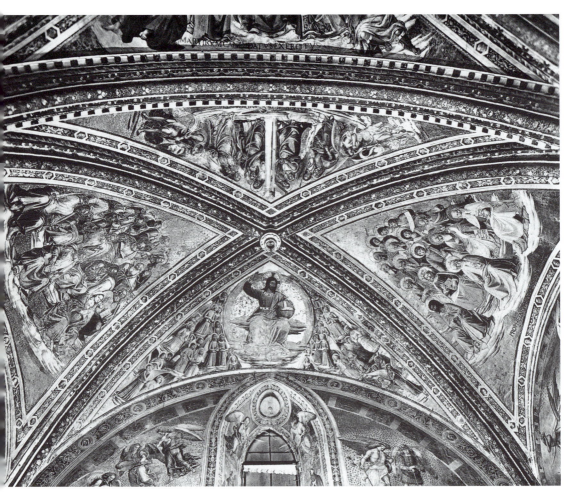

10 South vault: Christ as Judge and Prophets (Fra Angelico and Benozzo Gozzoli, 1447), Apostles and Angels with the Signs of Judgment (Luca Signorelli, 1499) (Archivio Photos Moretti, Orvieto)

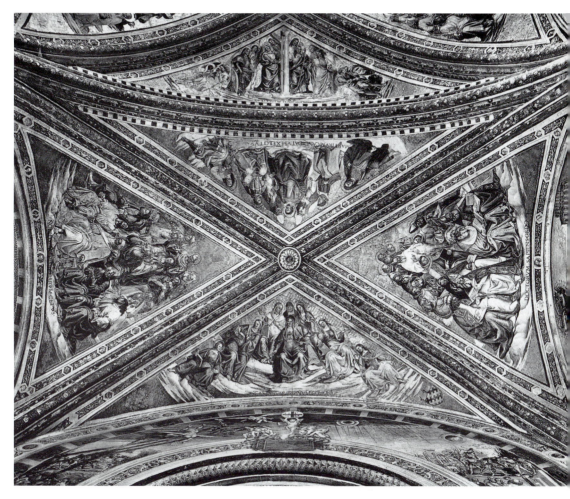

11 North vault: Patriarchs, Doctors of the Church, Martyrs and Virgins (Luca
Signorelli, 1500) (Archivio Photos Moretti, Orvieto)

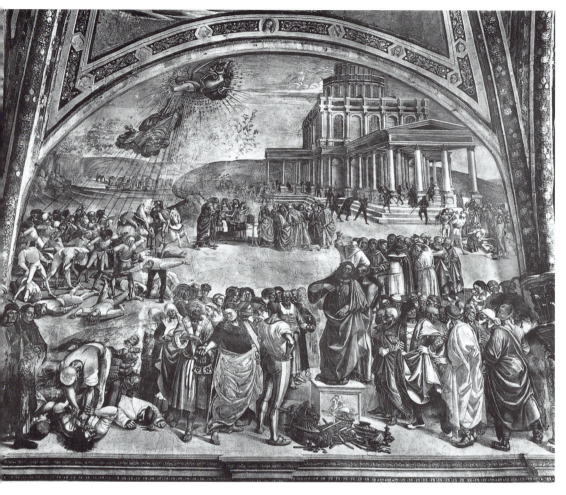

12 Northeast lunette: The Rule of the Antichrist (Archivio Photos Moretti, Orvieto)

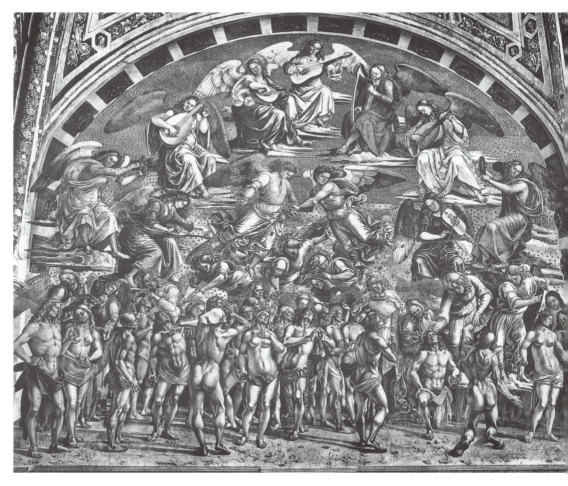

13 Southeast lunette: The Blessed in Paradise (Archivio Photos Moretti, Orvieto)

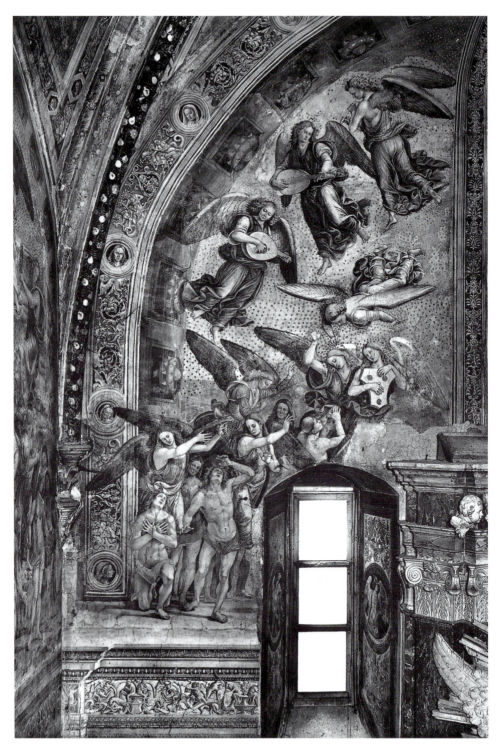

14 South wall to left above altar: Ascent of Blessed to Heaven (Archivio Photos Moretti, Orvieto)

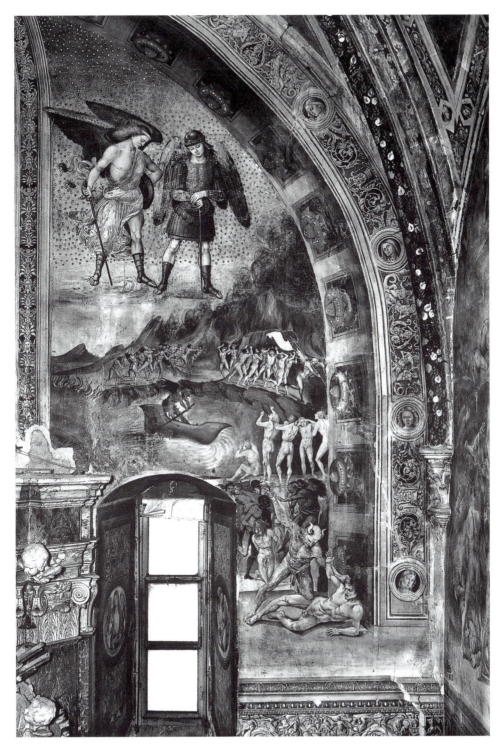

15 South wall to right above altar: The Damned Led to Hell (Archivio Photos Moretti, Orvieto)

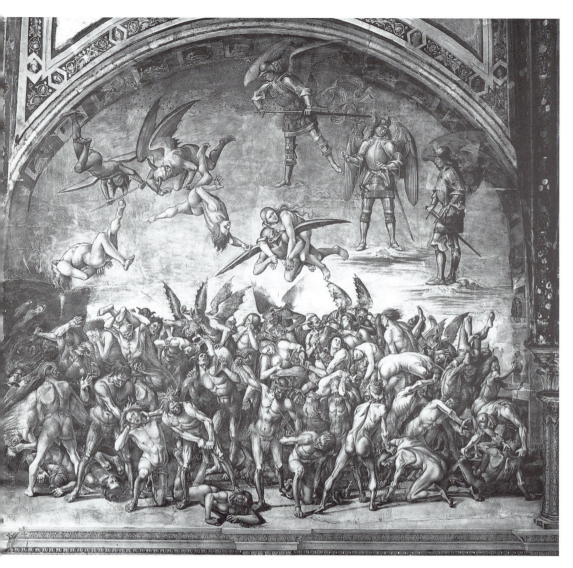

16 Southwest lunette: The Torture of the Damned (Archivio Photos Moretti, Orvieto)

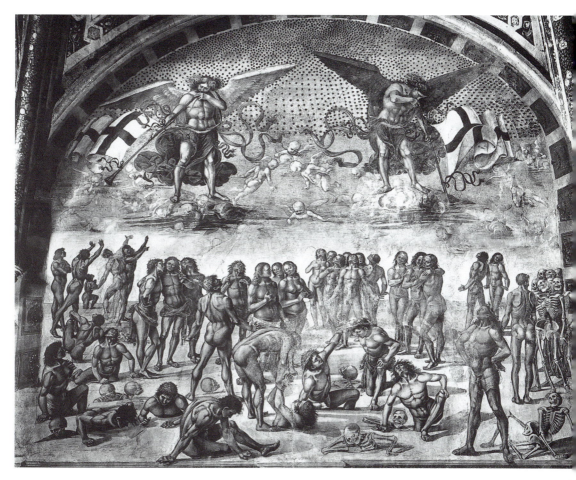

17 Northwest lunette: The Resurrection of the Dead (Archivio Photos Moretti, Orvieto)

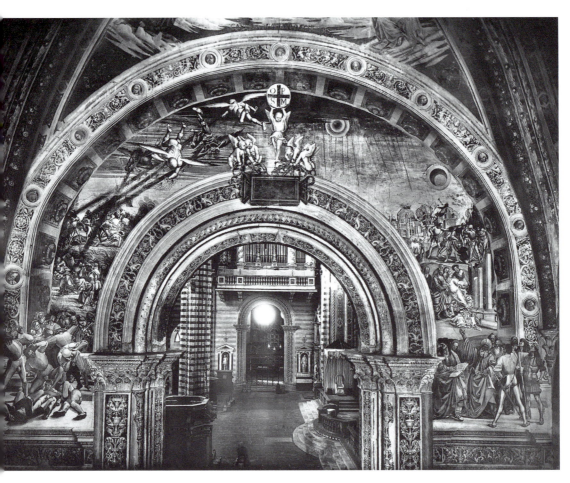

18 North wall above doorway: Doomsday (Archivio Photos Moretti, Orvieto)

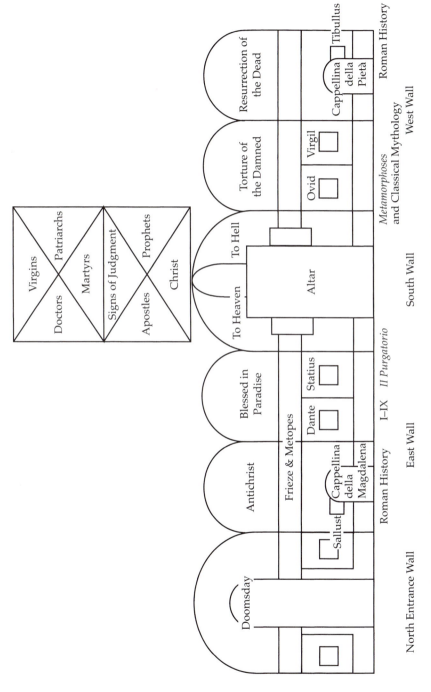

19 Elevation plan of the Cappella Nuova showing the upper wall lunettes, lower walls and the vaults

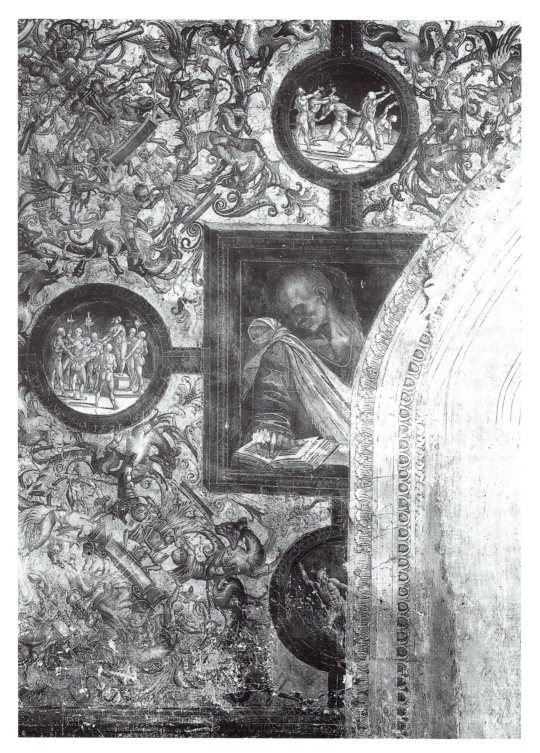

20 Northeast socle: Sallust with scenes from *The Conspiracy of Catiline and the War of Jugurtha* (Archivio Photos Moretti, Orvieto)

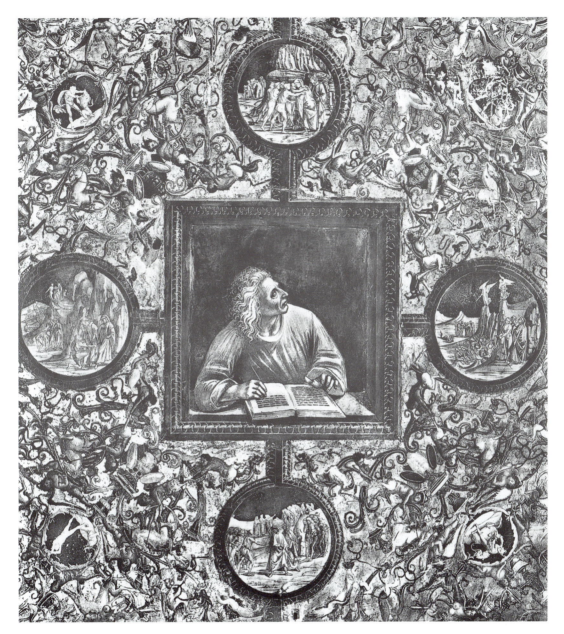

21 Southeast socle, right: Statius with canti V-VIII of *Il Purgatorio* (Archivio Photos Moretti, Orvieto)

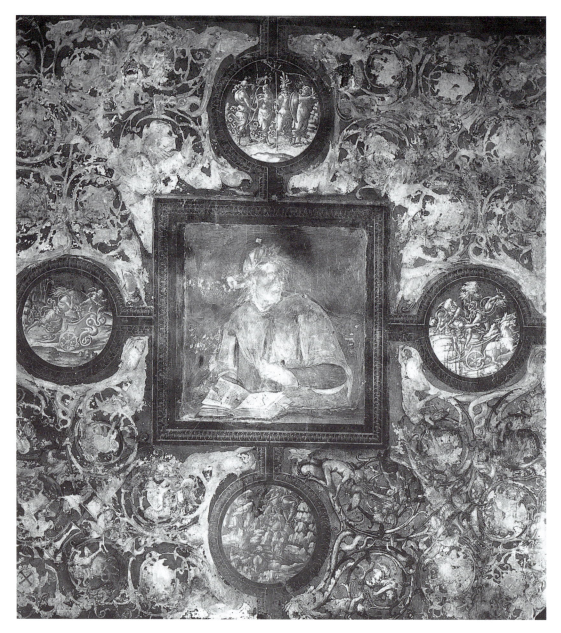

22 Southwest socle, left: Ovid with scenes from the *Metamorphoses* (Archivio Photos Moretti, Orvieto)

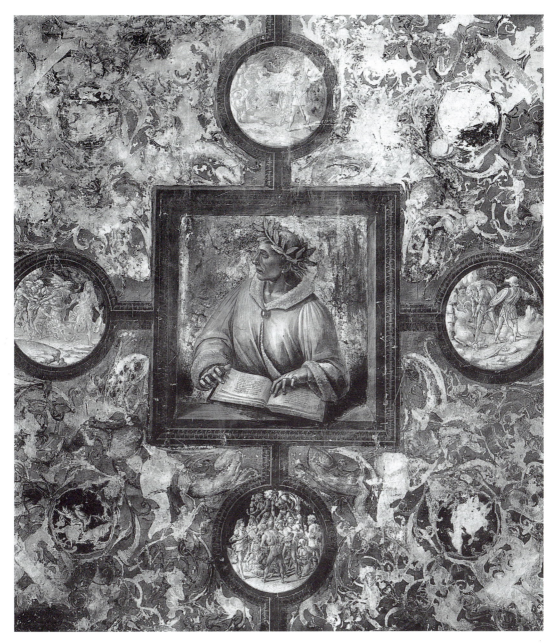

23 Southwest socle, right: Virgil with scenes from the Underworld (Gabinetto
Fotografico Nazionale, Rome)

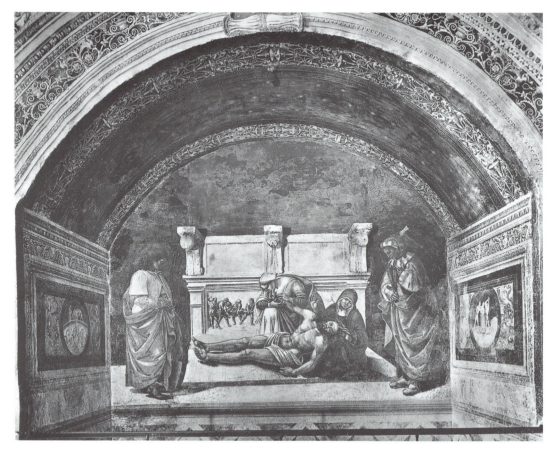

24 Cappellina della Pietà (Archivio Photos Moretti, Orvieto)

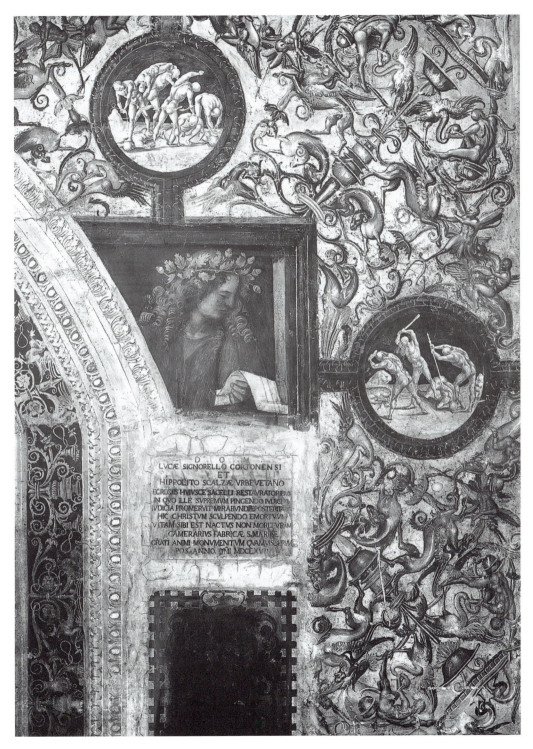

25 Northwest socle: Tibullus with scenes of the horrors of war from the opening of *The Elegies* (Archivio Photos Moretti, Orvieto)

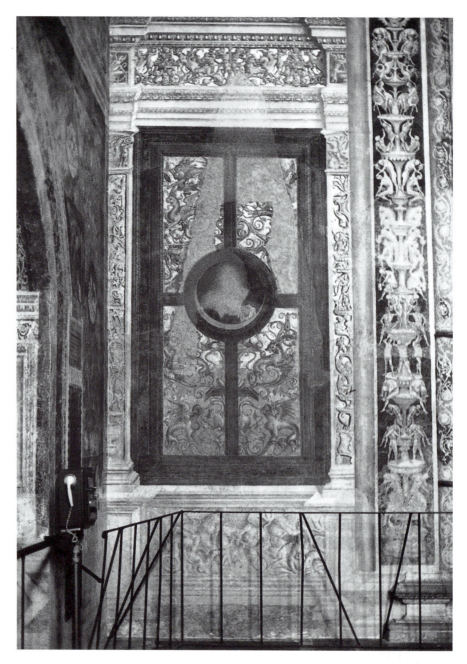

26 West socle, left, Unknown Man [face destroyed] (Archivio Photos Moretti, Orvieto)

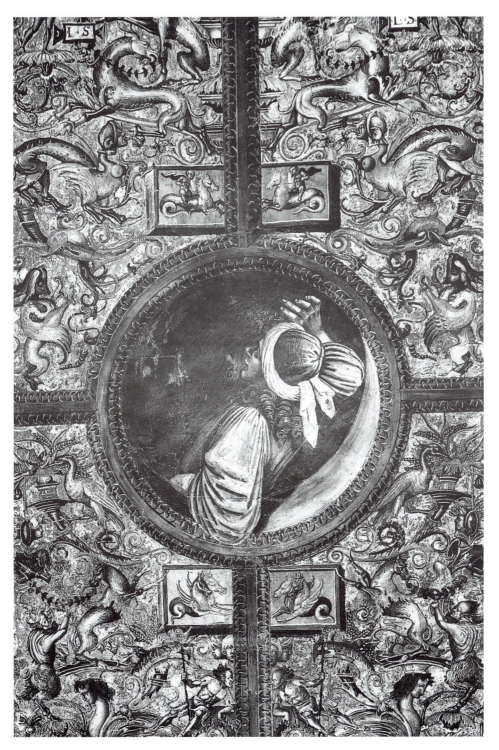

27 West socle, right, Unknown Man, (generally called Empedocles) (Archivio Photos Moretti, Orvieto)